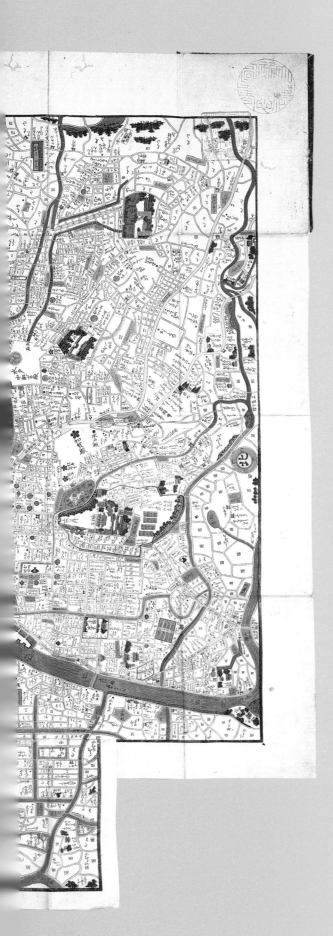

Tokyo: Form and Spirit

Essays by
James R. Brandon, Ian Buruma,
Rand Castile, William H. Coaldrake,
Liza Dalby, Chris Fawcett,
Kenneth Frampton, Martin Friedman,
Yūichiro Kōjiro, Donald Richie,
Jōhei Sasaki, Henry D. Smith II,
Marc Treib

Commentaries by
Richard Danziger, Mark Holborn,
Amy Reigle Newland, Gail Y. Okawa,
Emily Sano

Mildred Friedman, editor

Walker Art Center, Minneapolis ✓
Harry N. Abrams, Inc., Publishers, New York

Published on the occasion of the exhibition *Tokyo: Form and Spirit*, organized by Walker Art Center in collaboration with Japan House Gallery. Following its opening at Walker Art Center, the exhibition will be shown at the Museum of Contemporary Art, Los Angeles, IBM Gallery of Science and Art in collaboration with Japan House Gallery, New York, and the San Francisco Museum of Modern Art.

Tokyo, form and spirit.

 Bibliography: p. 249
 Includes index
 1. Art and society—Japan—Tokyo—Exhibitions.
2. Art, Japanese—Edo period, 1603-1868—Exhibitions.
3. Art, Japanese—1868—Exhibitions. I. Brandon, James R.
II. Walker Art Center.
N72.S6T58 1986 700'.192'135074013 85-22930
ISBN 0-935640-19-3 (pbk.)
ISBN 0-8109-1609-8 (Abrams: hard)

Printed and bound in Japan.

Throughout the text and bibliography the names of all pre-twentieth-century Japanese persons are in Japanese order, surname first. Names of all twentieth-century Japanese persons are in Western order, surname last.

Dimensions are in inches and centimeters; height precedes width precedes depth.

(cover, detail)
Tadanori Yokoo
Edo to Meiji, 1986
silkscreen on ceramic tile
96 x 96, 243.84 x 243.84
Collection the artist

(frontispiece)
Map of Edo, Tempō era (1830-1844)
color woodblock map
Collection Yūichiro Kōjiro

Major funding for *Tokyo: Form and Spirit* has come from:
National Endowment for the Humanities
First Bank Minneapolis
"Close-up of Japan" by the Mitsui Group
Honeywell Inc.
SONY Co., Ltd.
Japan-United States Friendship Commission
The Japan Foundation
The Hitachi Foundation

Additional support has come from: Sapporo Breweries Limited, Otsuka Ohmi Ceramic Co., Ltd., Nippon Telegraph and Telephone Corporation, Ohbayashi Corporation, Tokyo Metropolitan Government, Laforet Museum, Hanae Mori International, Asian Cultural Council, Tanseisha Co., Ltd., AXIS, Cray Research, Inc., Beverly Baranowski and John A. Rollwagen, Graham Foundation for Advanced Studies in the Fine Arts, Northwest Orient, T.L. Yamagiwa Laboratory, Inc., Takenaka Corporation, INAX Corporation, Mitsubishi Chemical Industries Ltd., National Endowment for the Arts, Kajima Corporation

Support for the Minneapolis presentation has come from:
Minnesota State Arts Board, The McKnight Foundation, The Bush Foundation, Institute of Museum Services, General Mills Foundation, Dayton Hudson Foundation for B. Dalton Bookseller, Dayton's and Target Stores

We gratefully acknowledge the following corporations that have provided funds, materials and services for the construction of the thematic spaces: Yoshida Kogyo K.K., Takashimaya Co., Ltd., Ishimaru Co., Ltd., TOTO, Ltd., Ajinomoto Co., Inc., Dai Nippon Printing Co., Ltd., Wacoal Corp., Ueshima Coffee Co., Ltd., Mitsubishi Rayon Co., Ltd., Kyokko Electric Co., Ltd., Nihon Keikinzoku Co., Ltd., Matsushita Electric Corporation of America, Mihoya Glass Co., Ltd., HEUGA Carpet (Japan) Ltd., Asahi Kenso Co., Ltd., Inuzuka Seisakusho, Mitsuya Kogei, Miyake Kogei, Shiba Toso, Sanshu Kogei, Shioziri Kogyo Co., Ltd., Taiyo Kogyo Co., Ltd.

Tokyo: Form and Spirit

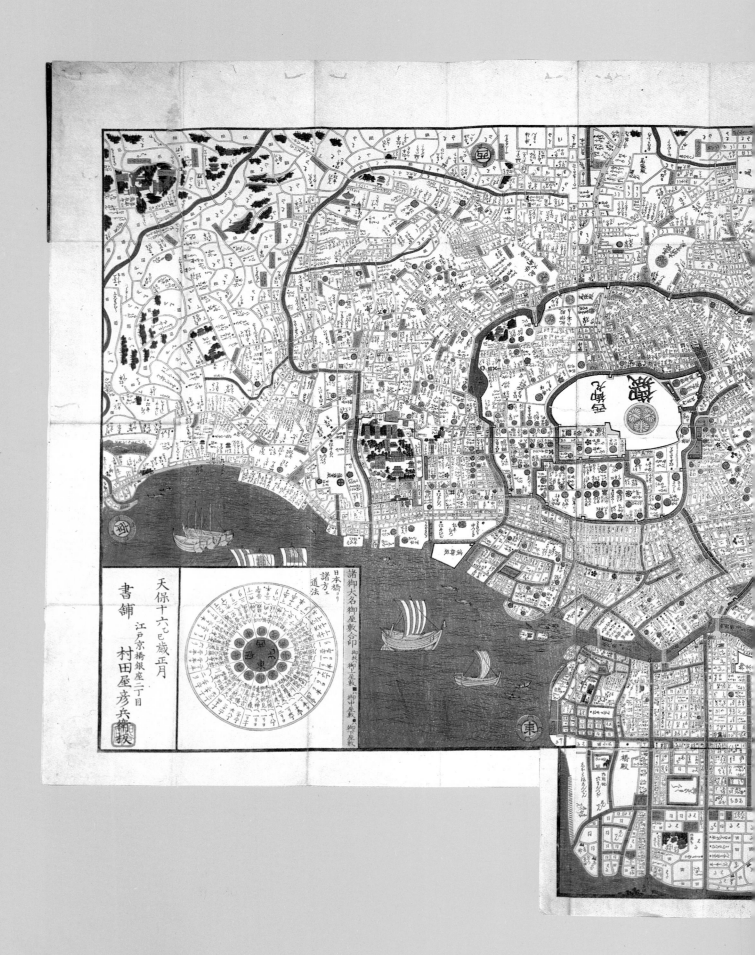

Contents

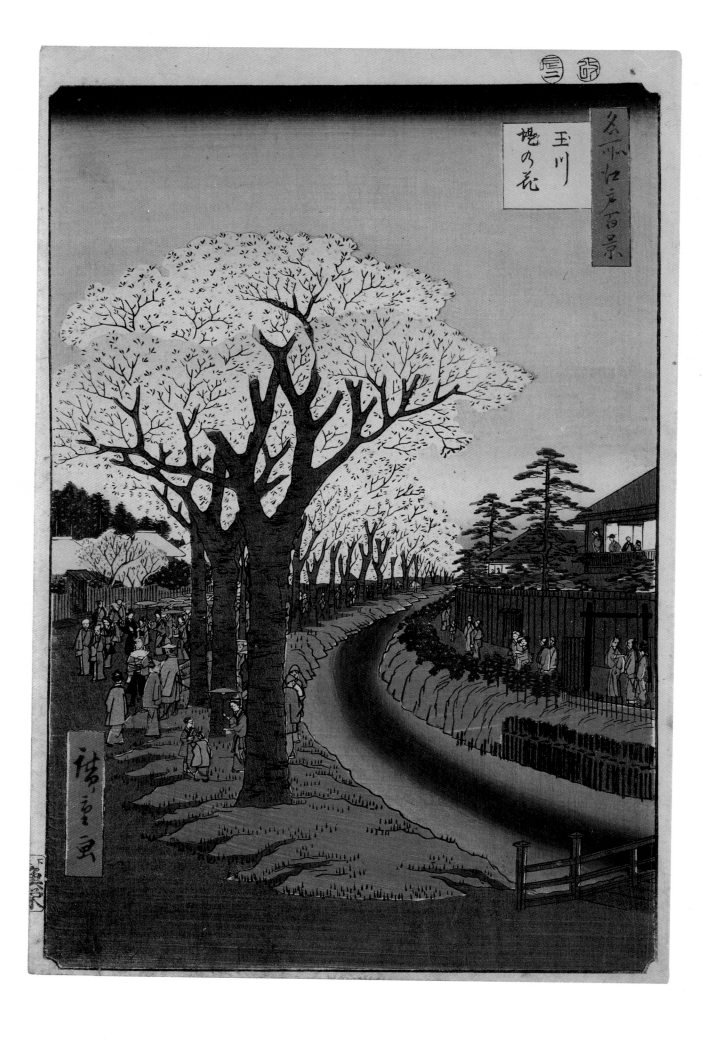

A View from the Outside

Martin Friedman

In the West, there are two distinct images of Japan: a picturesque, romantic old culture, apotheosized in the Akira Kurosawa films of *shoji*-screened teahouses and sword-wielding samurai, and an economically aggressive, post-industrial nation whose high-tech products appear in every corner of the world. Both views are valid, for Japan is an astonishing fusion of tradition and innovation, of conservative social patterns and sophisticated technology. Despite the trappings of modernity, the past is not only alive there, but is a shaping force in Japanese contemporary culture. In the arts, as in economics, technology and politics, Japan constantly displays remarkable capacity to absorb foreign ideas and processes, while maintaining strong national cohesiveness. An identifiable Japanese aesthetic sensibility continues to survive the impact of outside influences by incorporating and "Japanizing" them.

This publication, *Tokyo: Form and Spirit,* and the exhibition that inspired it represent an effort to illuminate the relationship of Japanese artistic activity to various aspects of urban existence and to stress the durability of Japanese artistic attitudes from historical times to the present.

Because Tokyo has become an important source of new activity in architecture, design, theater, music and dance, it seems especially appropriate to use that vibrant capital as the context for this endeavor. Working in Tokyo today are numerous individuals whose creativity has gained them international stature. Many, after lengthy periods abroad, have synthesized, in highly original fashion, traditional Japanese attitudes about form, light, space and color with Western ones. Unlike many Japanese artists who have completely abandoned traditional aesthetic considerations in favor of purely American or European approaches, these artists have taken a longer view. They are deeply conscious of and build upon tradition. However, the work of this post-World War II artistic population is less a literal evocation of traditional forms and techniques than a sophisticated homage to them.

With many of its cities all but obliterated during World War II, a traumatized Japan resolutely renounced militarism and feverishly set about reconstituting itself in the image of its conquerors. Revealing little of its prewar origins, Tokyo today is a sprawling megalopolis of densely packed districts, each with its own distinctive character, deployed around the vast green area whose center is the Imperial Palace.

The many *depāto* (department stores) of stately Ginza cater to the national pastime of shopping; the Akihabara electronic fantasy land is permanently festooned with giant, Day-Glo banners whose frenetic

calligraphy hawks the latest miniaturized microchip wonders; nighttime in Shinjuku, with its brilliantly illuminated movie palaces, restaurants and bars, is a memorable high-voltage experience. What once was a cluster of small villages dominated by the conical majesty of Mount Fuji, some 105 miles away, has become a throbbing urban mass, stitched together above ground by an elaborate system of elevated expressways, and below ground by a network of subways that burrow through Tokyo's fragile subsoil. Whatever attributes can be ascribed to Tokyo in the mid-1980s, stylistic purity is certainly not among them. McDonald's yellow arches and the Colonel's goateed countenance have become indispensable icons in the pantheon of adopted symbols, of which Mickey Mouse is the indisputable godhead.

But for all its ardent embrace of Western popular culture, Tokyo cherishes its Edo past. Off the grand *tōri* (streets) lined with faceless concrete steel and glass structures, indistinguishable from their counterparts in America and Europe, are vestiges of the old city. Narrow, traffic-jammed streets are bordered, collagelike, with noodle shops, Shinto shrines, bookstores, public baths and nightclubs. In Tokyo, such dizzying juxtapositions are more the rule than the exception.

In the millennia of Japanese recorded history, Tokyo is a relative youngster. When, in 1590, the powerful Shogun, Tokugawa Ieyasu (1542-1616) decided to shift his power base from Kyoto, he chose Edo Castle, an old imperial site on the Musashi Plain. For nearly three hundred years, successive Tokugawa Shoguns, suspicious of inroads being made by European traders and clerics, determined to consolidate their power by closing Japan to the world. It took Commodore Matthew Perry's (1794-1858) dramatic arrival in 1853 to pry open this long-isolated complex culture. Shortly after the Meiji Restoration in 1868, Edo was renamed Tokyo, and its role as the cultural as well as political hub of Japan grew dramatically.

Although artistic patronage flourished among the new bourgeoisie of Edo society, by the end of the eighteenth century and well into the nineteenth, strict stylistic conventions prevailed. Successful merchants built elegant dwellings whose sparsely furnished interiors contained exquisite paintings and porcelains intimately related to the tea ceremony, regarded as the ultimate expression of civilized behavior. The categories of household objects, ceremonial as well as utilitarian, were relatively few, and included screens, scrolls, flower containers, elegantly adorned lacquer boxes and wooden chests. Within this limited group of object types, there was considerable variation of form and ornamentation and styles of individual artists were recognizable. Artistic identity was even more pronounced in the less rarified arts of woodblock printing, the novel and the theater, whose content offered more opportunity for original expression.

A combination of factors—the forced opening of Japan to the West, development of private patronage during the Edo period (1603-1868), and the assertion of artistic individuality—transformed the arts in Japan from their elitist role in samurai culture to more popular expression. Consequently, the metamorphosis of the arts during the latter half of the Edo period may be viewed as the pioneering phase of modernism in Japan.

Pursuing associations between historical and contemporary artistic manifestations, however, is not without its pitfalls. Comparing old and new objects on a one-to-one basis is not the aim of *Tokyo: Form and Spirit*. Rather than systematically trace the evolution of specific objects,

McDonald's (and other fast-food establishments) has a prime location on the Ginza, one of Tokyo's most fashionable shopping streets.

(opposite, top)
An ardent Mickey Mouse fan.

(opposite, bottom)
Plastic food models of restaurant fare constitute a visual menu for the passerby.

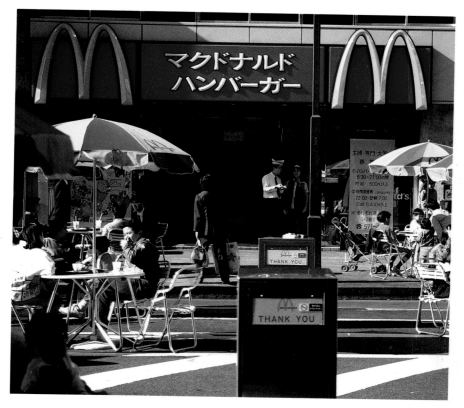

we have concentrated on less tangible qualities which, from a Western point of view, seem quintessentially Japanese. What are some of these qualities?

Ideas about space in Japan differ considerably from those of the West. Although the relationship between, say, an Edo dwelling, constructed of wood and paper, and a modern building of steel, concrete and glass might seem remote, such common denominators as an ingenious use of scale and vista, the essential relationship of exterior to interior space, and sensitivity to materials, still apply. Space in Japan has always been in short supply; multilayered social, business and recreational activities occur within extremely confined areas. But what does not actually exist can be implied in many subtle ways. To that end, the genius of the Japanese artist, designer and architect has been the ability to expand and contract space illusionistically. The modest area of the walled Zen garden is greatly increased by incorporating a "borrowed view" of a distant mountain. Meticulously shaped shrubbery and artfully placed stones in the traditional garden invite the visitor to create a picture in his own mind; within the existing microcosm, islands in the sea and planets in the cosmos seem to materialize.

Even the Edo-period woodblock print offers such ambiguous spatial experiences; figures, fragments of room interiors, and landscape are overlaid, planelike, within its shallow picture box. Such elegant manipulation of volume characterizes much of Japanese architecture today. Tadao Ando's thin-shelled, concrete structures, perforated here and there by slotlike windows, frame borrowed views of the landscape, pulling them into his bare-boned compositions.

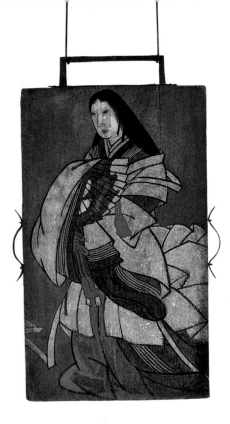

Kimono *kanban*, Edo period
polychromed wood
38½ x 21¾, 97.8 x 55.2
Collection Peabody Museum of Salem

(opposite)
A quiet aspect of a Tokyo street festival.

Spiritual and aesthetic affinities between traditional Japanese design and the art of the present exist on many levels. Frequently, contemporary artists, architects and designers quote elements of historical forms in their buildings, posters, costume and furniture designs; however, on closer inspection such references are generally points of departure for inventive new approaches. Certain ineffable ideas about volume and void, light and dark, open and closed form, which have deep associations with ancient shrine and temple architecture, resonate in the work of such architects as Arata Isozaki, Fumihiko Maki and Toyo Ito.

Another pervasive characteristic of Japanese design is an ability to combine forms and patterns that at first glance have no relationship to one another, but by some alchemy work magnificently. Such improbable combinations occur not only in such classic Edo areas as painted screens and Kabuki costumes and décor, but also in the sophisticated creations of designers such as Eiko Ishioka and Tadanori Yokoo.

Because the arts in Japan are intimately related to daily life, *Tokyo: Form and Spirit* utilizes a thematic approach that associates artistic phenomena with urban existence. In this book, as in the exhibition, works of art are presented in relation to such daily activities as Walking, represented by the street; Living, by the house; Working, by the shop and factory; Performing, by the theater; Reflecting, by the temple; and Playing, by the playground. The essays presented here analyze the evolution from Edo to Tokyo and the persistence of old forms in new contexts. Each theme has an Edo and a contemporary equivalent. The Edo sections consist of traditional objects such as ceramics, lacquerware, screens, prints and costumes. The contemporary areas are visionary environments created by architects and designers invited to address these urban themes in a philosophical, conceptual manner. They were selected not only for the originality of their work, but also for the strong historical awareness it projects.

In its organization, this publication parallels the progress of the visitor through the exhibition as he encounters Edo and contemporary manifestations of each of its themes.

A group of *kanban* (shop signs) advertising the services of the apothecary, greengrocer, kimono seller and other business enterprises introduces the Street, created by Arata Isozaki and Tadanori Yokoo. Defined by an intricate architectural framework whose details evoke various periods of Japanese history, the street is treated symbolically; on the walls are Yokoo's silk-screened ceramic tiles filled with bizarre forms of the urbanscape in wild juxtapositions. The Tokyo Tower, the beloved science fiction monster Godzilla, snaking expressways and movie marquees are combined in these hallucinatory collages. Next, Tokyo Spirit, a section designed by Fumihiko Maki and Kiyoshi Awazu, is dominated by six architectural columns whose forms and surfaces are simultaneously evocative of ancient shrines and temples and the glittering, crenellated skyline of the city.

The Living space is introduced by a small-scale classical teahouse, ceramics and lacquerware associated with the venerable tea ceremony, and highly refined Edo domestic objects. In the evocation of this theme by Tadao Ando and Shiro Kuramata, the elegantly proportioned, modular Japanese room takes on an otherworldly quality, as a hologrammed image suddenly materializes on a wall that is covered with draped fabric that is stiffened with polymer to become bas-relief. A floating glass surface is designed in the module of a traditional *tatami* floor.

Next to an area devoted to woodblock print images, a carpenter's suit, firemen's gear and the tools of Edo craftsmen, is Hiroshi Hara's Working space. There one encounters an eerie procession of robotlike figures incised on sheets of transparent plastic inlaid with flickering diodes that reflect light patterns on walls and visitors alike. Behind these figures stand rows of treelike forms of the same materials. The trees create patterns of moving color and light in a darkened, silver enclosure.

Arata Isozaki and Eiko Ishioka have created a unique Performing area consisting of a stage placed before a rectangular shrine (himorogi), surrounded by a wall of rice straw tied in thick bunches and attached to a wood structure. Beneath the glass surface of the stage are some fifty television monitors nestled in a grid whose form is reminiscent of a bentō (partitioned lunchbox). Emanating from these screens is a rapidly changing video piece by Ishioka utilizing the imagery of Japanese television commercials. The more serene, historical component of the Performing space is the display of Kabuki costumes, bunraku puppets, musical instruments, and a screen depicting Nō drama.

A group of religious objects related to Shinto and Buddhism introduces the Reflecting space designed by Toyo Ito and Kohei Sugiura. Visitors begin their cosmic journey through a doorway, whose outline is in the shape of a seated Buddha; they cross a long platform whose geometric configurations—rectangle, circle, triangle, half-moon—allude to earth, water, wind and ether. The walls are mirrorlike and the sole illumination in the room is from the floor where myriad lights flicker beneath an opalescent scrim.

In vivid contrast to this mystical space is the Playing area introduced by a collection of richly patterned Edo dolls, games and toys. Designed initially for the roof terrace of the Walker Art Center, Shigeo Fukuda's spectacular fifteen-foot-high dog is a "cubistic" variation on the familiar Japanese toy, the inu hariko. Looking inside this colorful creature, viewers will enjoy illusionistic games invented by Fukuda.

Tokyo: Form and Spirit will contribute, we hope, to broader understanding of traditional Japanese artistic forms and ideas, and how new generations add to those traditions.

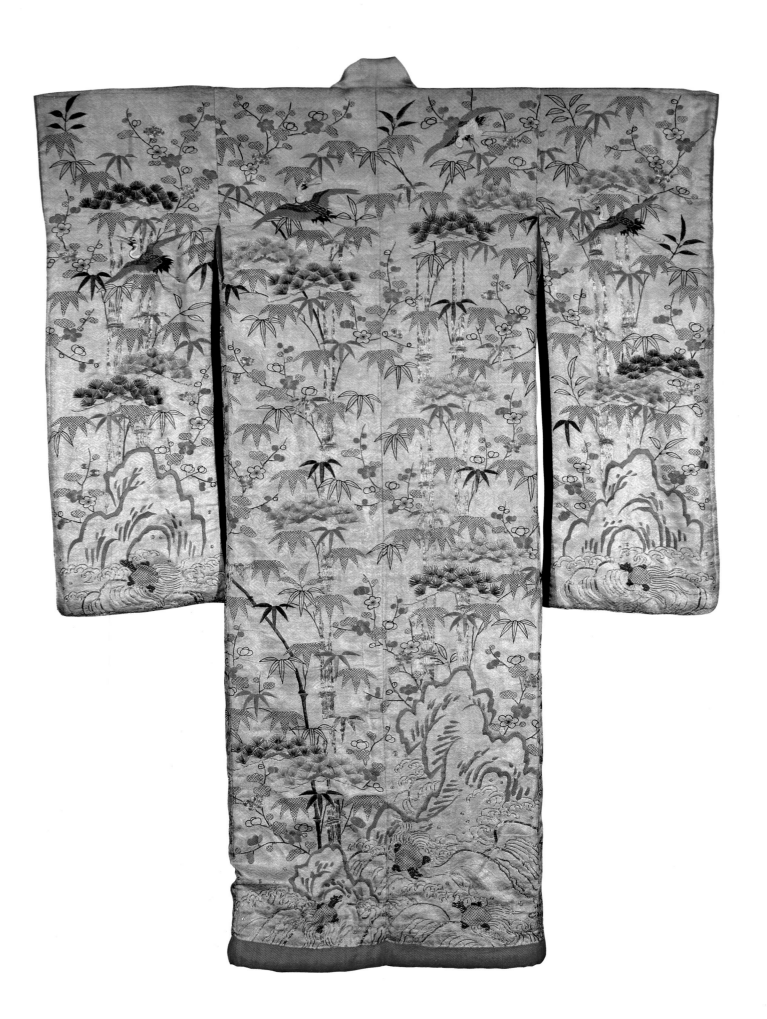

Tokyo and the West

Rand Castile

Tokyo lies by the bay like a net thrown on the shore. In the 828 square miles of Tokyo there are twenty-three wards, twenty-six cities, one county, four administrative units, and fifteen towns and villages. But this only hints at its complexity. The city has a population of about twelve million, with another fifteen million in surrounding areas. One in ten Japanese lives in the capital. It is home to the galleries and artists, the architects, museums and publications that give character to Japanese art as we know it. The art world in Tokyo is as complex as the city, with abundant factions and claques, plenty of opportunity to show and be written about, and with all the pressures moving toward—if not sales—at least, fame. And this circumstance is not new. Tokyo has long been a major center of arts activity. Even in the eighteenth century it was the largest city in the world. The artists crowded in then as they do now. The influences of the West upon Japanese art climaxed in Tokyo. The influences of Japan upon art in the West came substantially from Tokyo, or Edo, as it was known before the third quarter of the nineteenth century. But we must begin with an earlier time.

Chisaburō Yamada, former director of Tokyo's National Museum of Western Art, has succinctly divided Western influence in Japan into three periods.[1] The first begins in the mid-sixteenth century, with the arrival of the Portuguese and Spanish missionaries, and lasts until the middle of the nineteenth century and the fall of the Tokugawa Shogunate. The forced opening of Japan to trade with the West by Commodore Perry in the latter half of the nineteenth century marks the second wave of influence. The third begins in 1941, according to Dr. Yamada. With the last date one is tempted to quibble, advancing the start by four years—to 1945—and the beginning of the Allied Occupation, but, for the most part these are convenient boundaries for a discussion.

Professor Yamada also divides Japanese influence in the West into three periods. He notes the first as beginning in the mid-seventeenth century, when porcelain and lacquerware were exported from Japan by the Dutch East India Trading Company. This period, he says, lasted until the beginning of the nineteenth century, followed by a second, from the mid-nineteenth century until World War II. The second is often referred to in the West as the "first wave" and includes the substantially documented influences of *ukiyo-e* (Pictures of the Floating World) upon, principally, European painters. The third period is post-World War II.

In *Through Closed Doors*, Professor Calvin French notes the strong element of paradox in Japan's response to the Western world. "The pow-

1. Chisaburō Yamada, ed., *Japonisme in Art: An International Symposium* (Tokyo: Committee for the Year 2000, 1980).

erful pull of a conservative nationalism seems forever to do battle with the equally powerful impulse to embrace whatever is novel and exotic."[2] The *sakoku seisaku* (official policy of isolation in the Tokugawa era), lasted from 1639 until the 1854 United States-Japan Treaty of Amity, and signaled an end to previous policies of free trade with the Portuguese, Spanish, English and Dutch. It excluded missionaries. All but the Dutch were expelled, and they, finally, were limited to Dejima (Deshima), an artificial island built by Japanese traders in the port of Nagasaki between 1634 and 1636.

Having fought and won—at great costs—the battle for the unification of Japan, the Tokugawa family and its ministers eliminated any foreign threat to their rule at home by expelling Western powers, but the policies of isolation were not suffered alone by foreigners. The Japanese were forbidden travel abroad, as the shogunate sought to ensure absolute control over its subjects. Peace and isolation were thus maintained for more than two hundred years.

The regulations forced the people of Japan to look inward. The painting style brought in by the Europeans was discarded or ignored. This may have been either because the isolation rules were thoroughly effective, extending to artists' studios, or because the Japanese themselves were not yet ready to adopt alien forms and techniques.

The eighteenth century saw profound social change in Japan. The merchant class accumulated large economic power despite its official rank of last in society—after samurai, farmers and craftsmen. The merchants were a pragmatic group, interested in the real things around them. Some artists, depending upon the patronage of the merchants, changed with them and accepted a degree of Western perspective and shading, an attitude that found expression in the prints of the *ukiyo-e* artists.

The nineteenth century witnessed a previously unheard of power from the West flowing out across the world in the form of industrialization. Japan—to succeed in that world—had to understand the West, emulate its achievements and find some common ground with Europe and the United States. The new Japanese embrace of natural sciences and of nineteenth-century technology influenced the artists. *Nihon-ga* (Japanese-style painting) was forced to share studio space in Tokyo with *yo-ga* (Western-style painting). And *Nihon-ga* was affected by the new realism, with traces of this evident in the work of many traditional artists of the Meiji period (1868-1912). Foreign scholars went to Japan to assist in specific areas of study. Edward Sylvester Morse (1838-1925), as a zoologist, studied shell mounds, but he was also a director of the Peabody Museum in Salem, Massachusetts, and collected pottery, studied tea ceremony and Nō, and helped to introduce these traditional arts to the West. Morse's writing, especially *Japanese Homes and Their Surroundings* (1886) had a large influence on studies that were to follow.

He was a friend of Okakura Tenshin (1862-1913), at the time perhaps the most influential man of the arts in Japan. Through their mutual interest in the traditional arts, much of what might have been lost to Japan was saved.

Okakura, one of the founders of Japan's first art academy, stood against the dismissal by many artists of the traditional, "subjective" style of Japanese painting. The artists favored a Western realist, "objective" style. Working with Westerners, particularly Ernest Fenollosa

2. Calvin L. French, *Through Closed Doors: Western Influence on Japanese Art 1639-1853* (Kobe, Japan: 1977).

(1853-1908), under whom he studied at Tokyo University and who was a noted authority on Japanese art, Okakura was able to have "Japanese" drawing and painting reinstituted in schools in which it had been dropped from the curriculum as "unprogressive." Fenollosa had been brought to Japan by Morse to teach philosophy at the University, but his great achievements were in the fine arts. He campaigned for the preservation of traditional arts, wrote about them, and assembled a superb collection now in the Museum of Fine Arts, Boston. His interest in Nō theater was manifested in posthumous publications by his literary executor, Ezra Pound. Pound subsequently introduced the subject to William Butler Yeats, who later produced the first Western Nō play, At The Hawk's Well; this was read at Mrs. Jack Gardner's Fenway Court in Boston. Okakura's lectures on tea ceremony, held there for Mrs. Gardner and friends, were published as the Book of Tea, the first philosophical treatment of the art in English.

No theater in Japan has an unlikely story of survival. Nō had enjoyed the patronage of both the Ashikaga and Tokugawa Shogunates. It was an official theater, and when the shogun was forced from power the theater and actors were disgraced. Performances virtually stopped throughout Japan.

The renewal of this great traditional form took place a few years later because the Japanese needed an elegant and ancient form of entertainment to present before visiting Western dignitaries such as the Duke of Edinburgh in 1869. Though this did much to dispel suspicion of this ancient art, the visit to Japan by former President Ulysses S. Grant in 1879 provided the necessary impetus for its official reestablishment.

No head, nor former head of state had ever been to Japan, and Grant's visit was a major event in Japanese-American relations. He witnessed a Nō performance at the residence of Iwakura Tomomi, a prominent statesman who had traveled to America, to England and to other parts of Europe. Professor Donald Keene quotes Grant, following the Nō performance, as having said:

> So noble and beautiful an art is easily cheapened and destroyed by the changing tastes of the times. You must make efforts to preserve it.[3]

Perhaps because of Grant's enthusiasm, Iwakura soon founded the Society for Nō (Nōgakusha) and built the first public Nō stage in Japan.

Fenollosa was a friend of William Sturgis Bigelow (1850-1926), a physician who had studied at Harvard and in Paris under Louis Pasteur, and who had been invited to accompany Edward Morse to Tokyo. He was a student of Japanese art and of Buddhism. He joined with his American colleagues in urging the Japanese not to forsake their traditions in the rush to westernize Japan. His prominent standing in the Boston community lent an important air of dignity to the study of Japanese art in America and enhanced the receptivity of a conservative audience. His vast collection, too, found its way into the Museum of Fine Arts, Boston.

Lafcadio Hearn (1850-1904) (who adopted the name Yakumo Koizumi) went to Japan in 1890. He was a gifted writer, and his numerous works, including Glimpses of an Unfamiliar Japan, Japan: An Attempt at Interpretation, and Kwaidan, popularized the exotic and did much to feed the West a romantic characterization of Japan.

Thus five men—Morse, Fenollosa, Okakura, Bigelow and Hearn—of whom four were associated at one time or another with American museums, introduced Japanese art to nineteenth-century America.

3. Donald Keene, Nō: The Classical Theatre of Japan (Tokyo: Kodansha International, 1966).

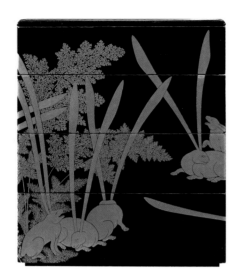

The 1867 International Exposition in Paris gave Japan an official invitation to participate. (Japan had not been represented in the first or second great European international expositions of 1851 and 1862, which had celebrated the new industrialism.) The French and the Japanese selected the objects to be included. Hundreds of lacquer, ceramic and metal works were sent. There were more than five thousand *ukiyo-e* woodblock prints in the exhibition. This exhibition and the objects included in it are of particular interest to us as a number of them appear in a painting of 1876 by Claude Monet, in which he painted his wife-model, seen wearing a theatrical kimono; she is standing before a wall of fans. We surmise these came directly from the exposition or from the famous gallery of Samuel Bing, opened in Paris in 1875.

The origins of the movement known as Art Nouveau (1875-1915) can be traced to Bing's gallery. This new style affected all the arts and was itself most strongly influenced by the linear character of Japanese prints. The two-dimensionality of the *ukiyo-e,* the organic shapes, the flatness of color and of the picture plane represented a new direction for European and American artists, architects and designers, such as James A.M. Whistler, Louis C. Tiffany, Hector Guimard and Henry van de Velde.

In the vogue that followed the expositions and the development of Art Nouveau, many exhibitions of Japanese art were organized in Europe, and later in the United States. These were of special importance to the impressionists and post-impressionists, and through them we can assess the influence of Japan on Western art.

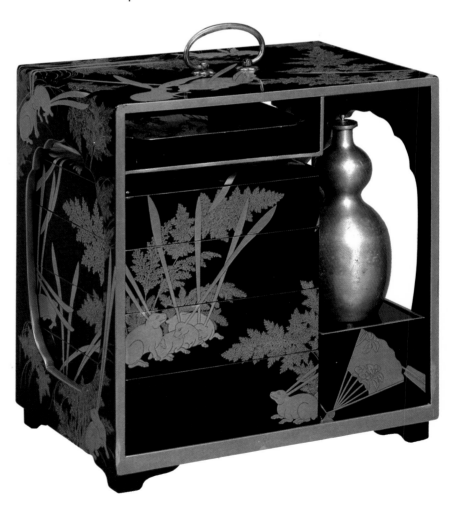

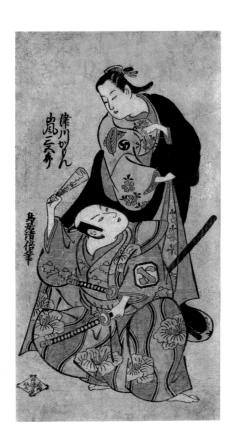

Torii Kiyomasu II
Theatrical Duo, circa 1730
hand-colored woodblock print
12⅛ x 6⅛, 30.5 x 15.8
Collection The Minneapolis Institute of Arts,
Bequest of Richard P. Gale

(opposite)
Artist unknown
Picnic Set, early Edo period
lacquered wood, *maki-e* with rabbit design
14 x 13 x 8½, 35.5 x 33.2 x 22.2
Collection Takashi Yanagi
(detail above)

We know from Edouard Manet's own work, including the portrait of Emile Zola and others, that this artist was familiar with Japanese prints. One of his patrons, Phillipe Burty, had hundreds of works of Japanese art in his collection. Whistler and Gauguin, as well as Van Gogh, show in their painting significant use of Japanese techniques and subjects. Van Gogh had a large collection of Japanese prints. His portrait of Tanguy shows *ukiyo-e* in the background, and he made straightforward copies of the prints of Andō Hiroshige (1797-1858). These were later celebrated by Japanese who traveled in Europe to study oil painting. The final effect of this was to change the course of Japanese painting. The Japanese took as European models the very artists who had been influenced by *ukiyo-e.* They understood them at first sight and enjoyed the imprimatur Europe's artists gave to the genius of Hiroshige and Katsushika Hokusai (1760-1849).

The Paris Exposition of 1900 marked the full flowering of Art Nouveau and included in the Japanese pavilion a large exhibition of classical art. Paintings, sculptures, Nō costumes and models for some of the architectural treasures of Japan were shown. This was the first great exhibition of Japanese art to be held abroad, and while the primary purposes of the world expositions seem to have been commercial and industrial, the exhibits did present individual nations with the opportunity of showing themselves through art. Japan seized upon this opportunity. The marked differences between Japan and the European nations were underlined by the industrial displays. In some instances this worked to Japan's favor. The industrial societies had paid dearly for machine productivity. European cities had sacrificed the environment and regimentalized the making of objects. Some Europeans rebelled against the new industrialization of their cities, calling for places peopled with craftsmen who had pride in their work. Japan became a major force in the support of the growing arts and crafts movement in Europe, and later, in the United States. This was a part of the movement that became *Japonisme.* We should note, however, that at the very time Japan's handwork was having a salutary effect in the West, Japan itself was rapidly turning away from the old ways, and eagerly moving toward the assembly-line production that had wrought devastation to the studios of European artisans.

The 1894 Exposition at San Francisco brought the first Japanese landscape architecture to the United States. The garden in Golden Gate Park was a feature of the Japanese participation and is preserved there permanently. Other examples followed. The Brooklyn Botanical Garden installed Japanese elements over several generations, including a reconstruction of the famous Kyoto rock garden of Ryōan-ji. The Huntington Botanical Gardens in San Marino, California, has a sand-and-stone meditation garden and an older one for strolling. Many individuals became interested in Japanese landscape architecture, producing private gardens of Japanese inspiration with varying degrees of knowledge and success.

The Japanese buildings in San Francisco and those shown the year before in Chicago began a strain of influence that added much to the American architectural vocabulary. Frank Lloyd Wright (1869-1959) and the Greene brothers of California were perhaps the earliest interpreters of Japanese style. The Greenes' house for the Gamble family in Pasadena is a brilliant adaptation of the Japanese uses of deep eaves and handcrafted wood construction. Inside, the emphasis upon handcrafted furniture, built-in woodwork and unpainted materials expressed fundamental Japanese values in domestic architecture.

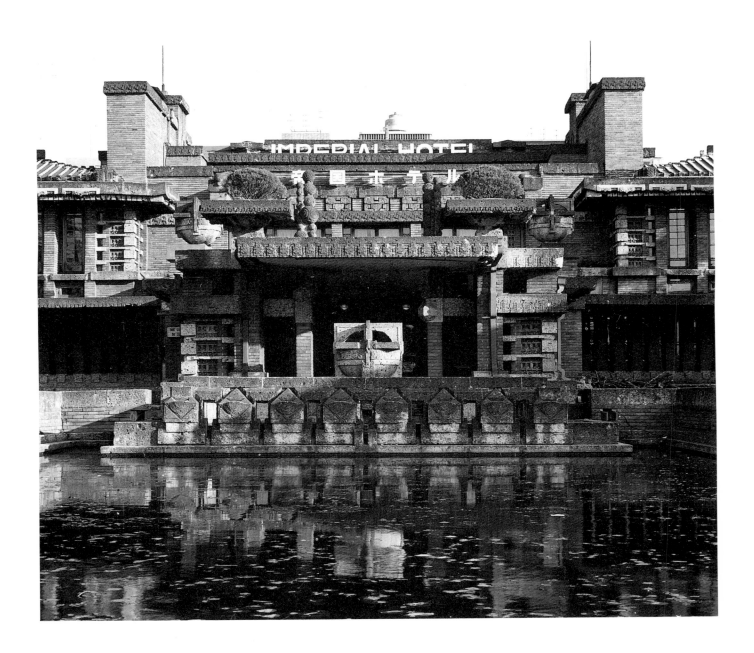

Frank Lloyd Wright
Imperial Hotel, Tokyo, 1916-1922

Wright lived and worked in Japan for many years; his great Imperial Hotel in Tokyo was built between 1916 and 1922. His disciple, Antonin Raymond, also lived and built in Japan. Among his surviving works are the Gumma Music Center (1961), Nanzan University (1964) at Nagoya, and a small church in Niigata Prefecture. Other Western architects who have worked in this century in Japan are few in number such as Le Corbusier, who completed the National Museum of Western Art in Tokyo (1959), James Stewart Polshek and Paul Rudolph. Rudolph designed the modest Daiei Building in Nagoya (1973). Perhaps the most important architecture in Japan by a Westerner since Frank Lloyd Wright is the American Embassy in Tokyo by Argentine-born Cesar Pelli. Controversial when it was built in 1976, the Embassy has blended into the general cacophony of city architecture with an elegance and ease that is as enviable as it is difficult to achieve.

It is in painting and sculpture in Japan that the greatest influence from the West is evident. It is also of interest to note that Japanese painters and sculptors, with few exceptions, have achieved only limited success abroad. The painters who came most to symbolize Japanese style abroad were two: Tsuguji (Tsuguharu) Fujita and Yasuo Kuniyoshi. Fujita lived and worked primarily in Paris from 1913 until his death in 1968. Fujita's work was well collected. His reputation was greater abroad than that of any of his contemporaries. Yasuo Kuniyoshi came to the United States at the age of thirteen. Kuniyoshi moved to New York after studying in Los Angeles, and was the first artist to have a one-man retrospective at the Whitney Museum of American Art (1948). He was refused citizenship and died, embittered, in 1953.

The significant postwar movement was Gutai, which reached its apogee in the 1960s. It was an association founded and sponsored by a gifted artist who was also a successful entrepreneur, Jiro Yoshihara. Gutai artists are acknowledged as having staged the first Happenings some years before the phenomenon appeared in America. Other artists, such as Kenzo Okada, Shusaku Arakawa, Tadaaki Kuyayama, and Ushio Shinoyama left Japan early and established themselves abroad. In turn, visits to Japan by painters, composers and dancers, such as Willem de Kooning, Jasper Johns, Robert Rauschenberg, John Cage and Merce Cunningham were influential in the postwar period, giving Japanese artists firsthand exposure to the Western avant-garde.

In the performing arts, Japan has come into its own in the West. The recent successes of Butō throughout Europe and the United States have considerably elevated the reputation of Japanese choreographers and performers. The classical forms of Nō, Bunraku and especially Grand Kabuki have been fully accepted into modern theater currency, and such American artists as Robert Wilson and Lee Breuer have been deeply influenced by their experiences in Japanese theater.

The influences of Eastern art upon the West and Western upon the East have always been open to speculation, for the significant art of an age inevitably belongs only to its own inimitable "national" self. The "foreign" element that great art can incorporate from anywhere is transformed, made new by a genius that knows no geographical boundary.

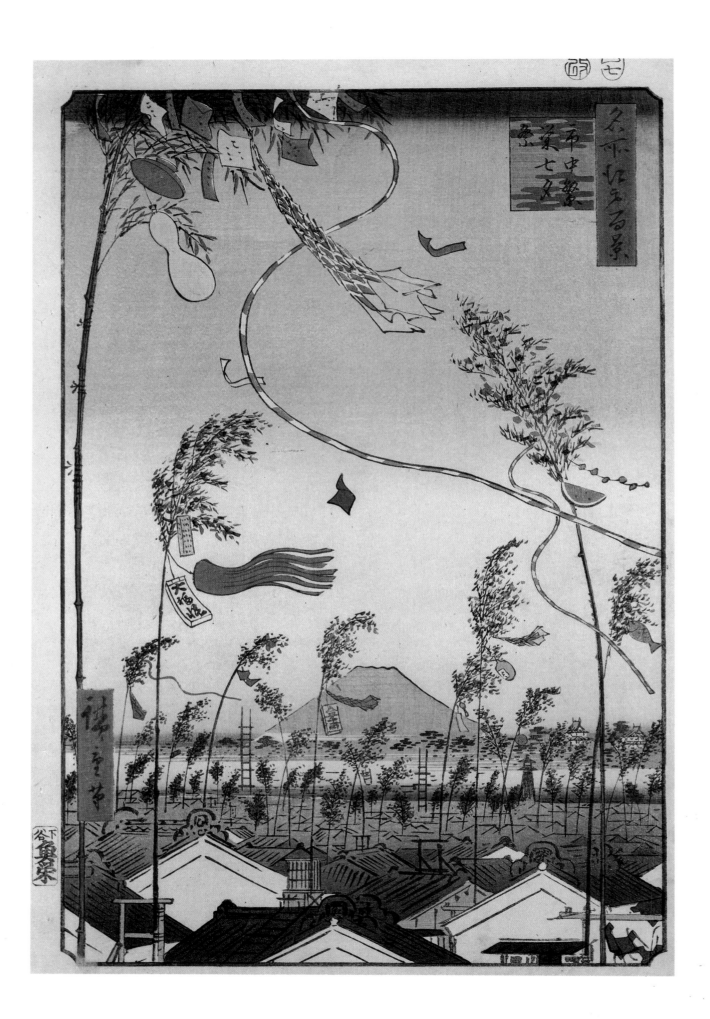

Sky and Water:
The Deep Structures of Tokyo

Henry D. Smith II

Literal-minded visitors to contemporary Tokyo may find little of relevance or appeal in the city's "sky and water." The sky is alternately invisible as they wander dazed through boundless subterranean spaces, opaque as they traverse central intersections where digital monitors display decibels of noise and parts per million of pollutants, or carved into a crazy-quilt skyline of wires, signs and unmatched buildings. "Water" seems even less accessible, with grand old moats shadowed by looming freeways, once-pure streams reduced to concrete channels of refuse, and the great Sumida River almost completely shut off from casual view.

But if they—really "we," the outside observers—look again, beyond these surface observations and quick judgments, look back through the history of the city to its Edo origins almost four centuries ago, we come to learn that "sky" and "water" in fact control the form and spirit of Tokyo. We discover no matter how the content of sky and water change, their underlying deep structures persist.

"Sky," we discover, is the structure of horizontality, of an unbounded and uncentered expanse against which the graphic vertical "face" of the city is written. "Water" is the structure of periodic gathering, of momentary release from everyday strictures of discipline and authority, of that familiar yet hard-to-place milieu called the "floating world."

Edo Sky

Like most historic settlements in Japan, Edo was oriented toward hills and mountains—but in a unique way. It lay not in a cozy basin, like the ancient capitals of Nara and Kyoto where forested mountains were close and familiar, but was founded, rather, at an intersection of three low-lying landscapes, with true mountains hovering far in the distance as low anchors of a sort wholly unprecedented in the mainstream of Japanese culture before the seventeenth century.

Edo's two landscapes to the east, Edo Bay and the Sumida-Arakawa-Edo River delta, were landscapes of water, low and flat. But from a different perspective, the true flatness of Edo lay rather in the hilly terrain to the west, toward the area that in modern times has come to be known as the Yamanote (literally, "toward the mountains," or Edward Seidensticker's "High City"), an irregular pattern of interlaced valleys and hills, with the highest elevations lying in a range of sixty to eighty feet above Edo Bay.[1] These tiny "mountains" are in fact merely the eastern

1. Edward Seidensticker, *Low City, High City: Tokyo from Edo to the Earthquake* (New York: Alfred A. Knopf, 1983).

(detail)
Map of Edo, 1632
color woodblock map
Courtesy Tokyo Metropolitan Central Library

(opposite)
Andō Hiroshige
Jūman-tsubo Plain at Susaki, Fukagawa,
from the series *One Hundred Famous Views
of Edo,* 1857
color woodblock print
13¼ x 8¹¹⁄₁₆, 33.8 x 22.2
Collection The Minneapolis Institute of Arts,
Gift of anonymous St. Paul Friends

2. Akira Naitō, *Edo no machi—kyodai toshi
no tanjō (The City of Edo: The Birth of a
Metropolis)* (Tokyo: Sōshisha, 1982), vol. 1
of 2, p. 6.
3. Shinjirō Kirishiki, "Tenshō–Keichō–Kan'ei ki
Edo shigaichi kensetsu ni okeru keikan
sekkei," ("Planning for Views in the Layout
of Edo Streets in the Tenshō/Keichō/Kan'ei
Eras"), *Tōkyō toritsu daigaku toshi kenkyū
hōkoku,* no. 24, August 1971, pp. 1-22.
4. For the worship of Mount Fuji, see Koichirō
Iwashina, *Fujikō no rekishi (The History of the
Fujikō)* (Meicho shuppan, 1983). On the
general problem of Edo's relationship to the
mountain, see my "Fuji Inside Edo: Putting
the Mountain in Place" (unpublished paper,
presented at Association of Asian Studies
Annual Meeting, Philadelphia, 21 March
1985).

edge of the more extended flatness of the Musashino (Musashi Plain),
which is epitomized in an ancient poem as follows:

The plain of Musashi:
No mountains
For the moon to enter;
It rises from the grasses,
Sinks back into the grass[2]

This landscape, so uncanny to the ancient Japanese mentality, finds visual
expression in a genre of screen painting depicting it, showing the tangled
grasses of poetic fame with a moon rising eerily from among them. Above
the grasses, as though in a wholly different space, is the far distant moun-
tainscape anchored by the sacred peak of Mount Fuji.

Architectural historian Shinjirō Kirishiki has suggested that the actual
street plan of downtown Edo, as laid out in the first decades after the
founding of the city in 1590, was consciously oriented toward the hills of
the Yamanote at close range, and the mountains of Fuji and Tsukuba at
a far more distant range.[3] It is only the latter, however, which seem to
have survived in the pictorial imagery of the city. Fuji is the greater in
both absolute and symbolic size, and its unmistakable form came to con-
stitute the most distinct element in the Edo sky, constantly reasserting the
horizontality of the Edo world. Although the highest mountain in Japan
(12,388 feet), Mount Fuji lay at a considerable distance from the city,
almost exactly one hundred kilometers from Nihonbashi, and as such was
only a diminutive presence within the visual field; yet its symbolism was
so powerful, reinforced during the Edo period (1603-1868) by a religious
cult dedicated to its worship, that Mount Fuji came to constitute the
central focus of the Edo landscape.[4]

Mount Tsukuba was less distinctive than Fuji when seen from Edo.
Closer than Fuji but less than one-quarter its height, Tsukuba was less
often visible and less distinctive in form. It was a critical presence nonethe-
less, anchoring the skyline to the northwest just as Mount Fuji anchored
it to the southeast. Whereas Fuji was seen over the hills of the Yamanote
and the intermediate Tanzawa range of mountains, Tsukuba was seen
beyond the low-lying flats of the broad delta area. Both silhouettes are
frequently captured in such classic representations of the late Edo landscape
as Andō Hiroshige's *One Hundred Famous Views of Edo (Meisho Edo
hyakkei,* 1856-1858).

This essentially centrifugal orientation of the Edo landscape toward
distant mountain anchors was abetted by a weakness of visual focus within
the basic plan of the city itself. Such focus had not always been absent.
On the contrary, the great five-story donjon of Edo Castle, probably the
tallest permanent wooden structure ever erected in Japan, dominated the
urban landscape with its sumptuous gilt finials for a half century after it
was first erected in 1607. It was the greatest central monument the city
would ever know: rising 275 feet above Edo Bay, it dominated the sur-
rounding hills and the neighboring flatlands alike.

The destruction of this great landmark in the devastating Meireki Fire
of 1657 marked the end of an era, and the start of the progressive decen-
tralizing and blurring of the castle as a primary focus of Edo. The honors
for height now passed to the Fujimi Watch of the Main Enceinte and the
Fushimi Watch of the West Enceinte, the two greatest of nineteen such

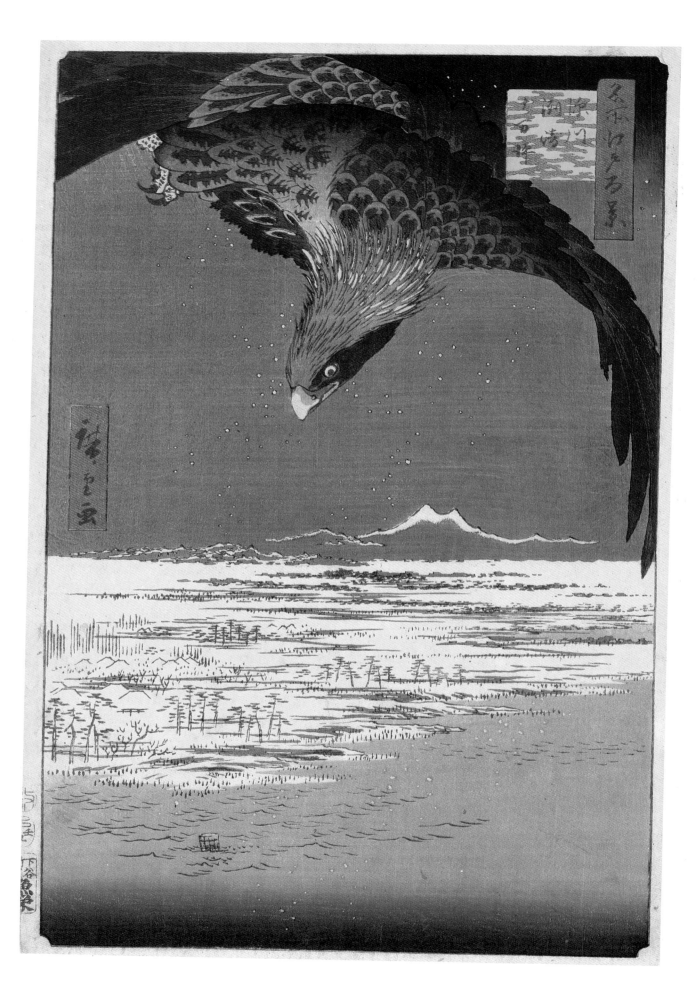

Fushimi Watch of the West Enceinte of
Edo Castle.

(gatefold)
Artist unknown
Mount Fuji and Miho Matsubara,
seventeenth century
pair of six-fold screens; color on gold leaf
66 x 144, 167.6 x 365.7
Collection Mr. and Mrs. Peter Brest

towers, both still standing today as familiar symbols of the city. But the concentrated impact of the castle was now diffused among a diversity of watches and gates.

Some other massive structures, notably Buddhist temples, continued to stand out against the Edo skyline, but the traditional forms of Japanese architecture assured that the formal thrust was outward rather than upward. The dominant roofs led the eye down and out, while the lack of eye-stopping facades encouraged a sense of progression through linear complexes of buildings, deflecting attention from the structures themselves to the surrounding landscape and enveloping sky.

These deflecting vectors of built form were reinforced by the constant expansion of vegetation throughout the Tokugawa era, the result of the systematic cultivation of trees and shrubs in the gardened environs of shrine-temple compounds and elite samurai estates. This is graphically conveyed in later depictions of Edo Castle itself, showing masses of trees competing with and even submerging the projecting watchtowers. Whereas the Edo landscape was largely deforested in the early years of the city's history, giving a disproportionate emphasis to buildings, by the early nineteenth century it was a city of densely green and cultivated aspects.[5]

The distant mountain anchors of Fuji and Tsukuba, however important symbolically, were only one element in the drawing out and de-centering of Edo. Equally important was a temporal factor, whereby patterns against the sky were not only appreciated but expressly cultivated for a sense of time. This was true of the viewing of Mount Fuji, which even under the clear skies of Edo could only be seen on about one day out of three, so close was it to the horizon and so common was the natural occlusion by fog, haze, heat and rain. The appreciation of Fuji was an appreciation of a momentary perception, rendered all the more poignant by the sublimity of the mountain's form.

And so, more broadly, the Edo conception of the sky was one inevitably mediated by atmospheric interference, as the Meiji period (1868-1912) geographer Shiga Shigetaka persuasively argued in his classic work, *The Japanese Landscape.* He noted the special importance of water vapor (always a critical element in Japanese landscapes) in Tokyo, with a humidity of over eighty percent from May through October:

> . . . water vapor is like a great ocean, a distant haze across the heavens, from which there appear and then disappear temples, palaces, and pagodas, with the peal of a temple bell pressing its way through now and again (in the words of Bashō, 'is it Asakusa or is it Ueno?').[6]

This is the essence of the aesthetic known as *miegakure* (in effect, "now you see it, now you don't").[7]

This same aesthetic applies to the miscellany of vertical accents that punctuated the Edo sky at odd moments and seasonal intervals. No cultural expression better captures this aesthetic than Hiroshige's *One Hundred Famous Views of Edo.* Their vertical format reflects the artist's concern with manifestations of temporal moment within an essentially horizontal landscape. In certain famous scenes, it is nature that "captures" the sky, but for the most part it is the upward thrusts of seasonal celebration: the arc of shuttlecocks at New Year's, or the fluttering decorations of the Tanabata Festival.

Within this quintessentially flat landscape, where verticality distinguished itself by its ephemerality, one homely and wholly functional up-

5. For a detailed study of greenery and the cultivation of plants in late Edo, see Noboru Kawazoe, *Tōkyō no genfūkei—toshi to den'en no kōryū (Tokyo's Primal Landscape: The Interaction of City and Country)* (Tokyo: NHK Books, 1979).
6. Shigetaka Shiga, *Nihon fūkei ron (The Japanese Landscape)* (Tokyo: Kōdansha Gakujutsu bunko edition, 1976), vol. I, p. 86.
7. The concept of *miegakure* in Japanese urban design is also treated in Toshi dezain kenkyūtai, *Nihon no toshi kūkan (Japanese Urban Space)* (Tokyo: Shōkokusha, 1968), p. 60, and in Fumihiko Maki, et al., *Miegakure suru toshi—Edo kara Tōkyō e (The Visible and Hidden in the Japanese City—from Edo to Tokyo)* (Tokyo: Kajima shuppankai, 1980).

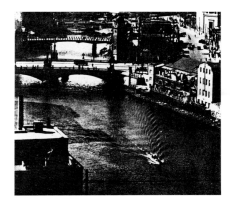

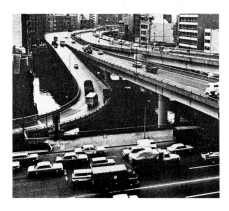

(top)
View of Nihonbashi, 1932.

View of Nihonbashi district, 1971, in which
the elevated roadway makes the river virtually
invisible.

Astonishing feats of civil engineering were required for the construction of this formal system of waterways.[10] The Kanda River was used as a source of water for the walled moats encircling the shogunal castle, a function it retains today. The river originally ran directly into the inner moat of the castle, passing then via Nihonbashi into the bay. The threat of flooding, however, demanded a separate outlet, which involved the laborious bisection of Kanda Mountain, leaving a deep east-west cut that provided a classic view of Mount Fuji and that today remains dramatically visible at Ochanomizu Station.

The moats of the castle formed a great spiral shape that unwound clockwise into the Kanda River drainage. The spiral was not self-contained, however, for from its easternmost loop exited three outlets, spreading into a gridlike pattern of canals that defined the commoner's city below the castle (hence the "Shitamachi," or "Low City"). The system then spread more eastward still, through another canal network on the left bank of the Sumida, and then on up the Sumida and Edo Rivers into an intricately maintained system of navigable waterways throughout the Kantō Plain.

Edo Bay was the other formal waterfront of the city, the point of entry for many of the essential commodities supplied from western Japan such as rice, oil, and cotton. It was also from Edo Bay that much of the land that became the heart of downtown Edo was reclaimed, just as Tokyo Bay today is the source of constantly expanding acreage for the city. And yet somehow, Edo Bay has always been a curiously passive, even negative presence within the culture of the city, in curious contradiction to its practical importance. This is seen in the astute observations of the Swiss envoy Aimé Humbert, who visited Edo in 1863-1864:

> No city presents a more inhospitable appearance than Edo as seen from the sea. It seems like a vast park to which access is prohibited. . . . One can distinguish little which accords with our own notions of a port, with its quays and wharfs: everywhere there are walls and palisades, nothing in the way of stairways, piers, or anything which invites one to set foot on land.[11]

Humbert went on to note that there was no environment to which the Edo commoner was less sympathetic than this "treacherous element, the sea, the vast bay."[12] This vague and even hostile conception of Edo Bay is one of the great perplexities of Edo culture. At most, the citizens of Edo appreciated the bay for its productive harvest of fresh fish, a legacy that remains today in the phrase *Edo-mae* (in front of Edo) as a synonym for sushi eaten raw (rather than pickled, as in western Japan). They also loved to gather shellfish at low tide in the flats near Tsukadajima or Shinagawa, but this was at best a nervous treading on the fringes of the bay. In striking contrast to the functionalism of the moats and canals, and to the aloof unsociability of Edo Bay, lay the Sumida River, the source of true hospitality in Edo culture. In modern times we call it the "Sumida," but in Edo this was only one of several names. Most commonly, it was called simply Okawa, the "Great River," but it also enjoyed a variety of localized names depending on the stretch of river involved: around Asakusa, it was Asakusa River, while residents a bit farther upstream knew it as the Miyato River. This fluidity of name suggests the cultural softness and adaptability of the river.

The Sumida was the only element of Edo's topography besides the Musashi Plain that partook of the ancient poetic tradition of a "famous

10. For details on the evolution of Edo-Tokyo waterways, both natural and manmade, see Masao Suzuki, *Edo no kawa, Tōkyō no kawa (The Rivers of Edo and Tokyo)* (Nippon hōsō shuppan kyōkai, 1978).
11. Aimé Humbert, *Le Japon illustré* (Paris: Librairie Hachette, 1870), vol. I, p. 308.
12. *Ibid.*, vol. II, p. 44.

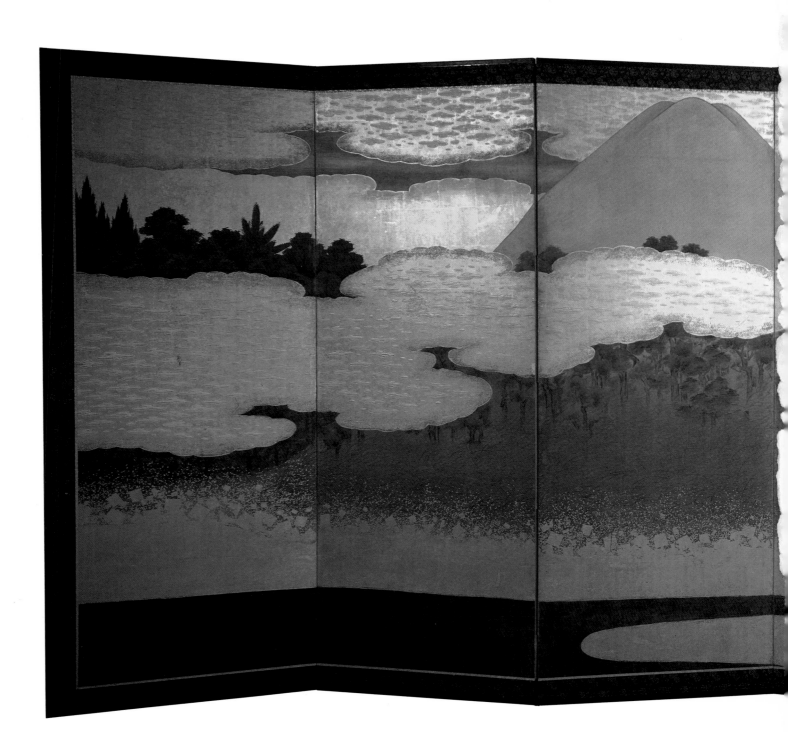

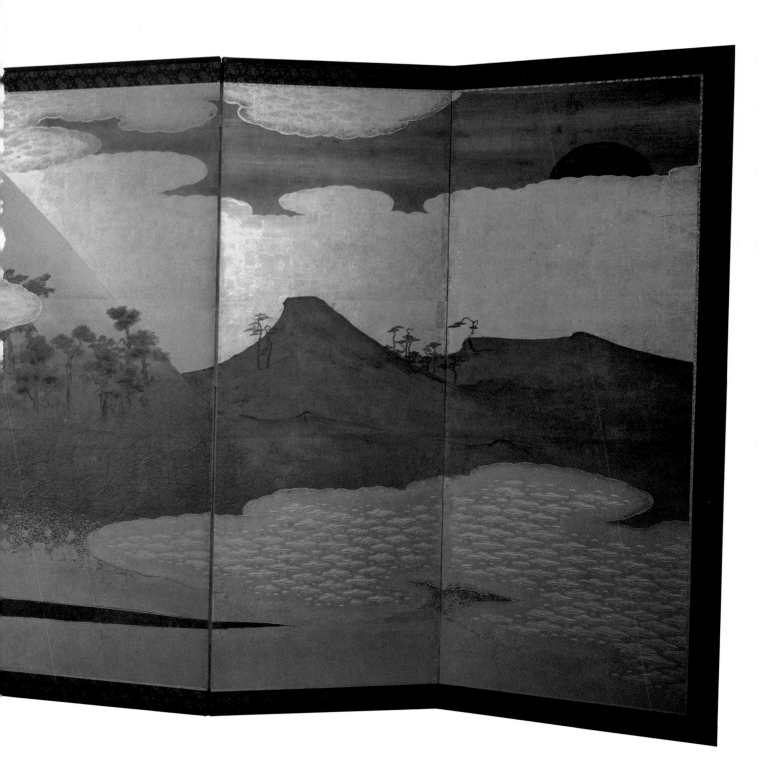

ward element persisted, the fire-watchtowers (*hinomi yagura*), whether free-standing or mounted atop buildings. They may be detected in many landscape prints of the city, but rarely are they focal. Whereas the watches of Edo Castle were of no use but to be seen, these familiar *hinomi* scattered throughout the city were of no use but to be seen from.

The essence of the Edo "sky" was thus the horizontality of a city plan that established no clear boundaries and set up no defining walls. The early focus on the shogun's castle diminished with time, allowing the natural evolution of a city where the sense of place relied less on a grand geometrical scheme than on minutely designed progressions of a wide variety. In moving along these variegated routes, certain places were denser, more active, more sociable than others. These places constituted the "water" of Edo.

Edo Water

Virtually every great city in world history has been sited on the sea or along a great river, usually both. Edo was no exception, located where the Sumida River emptied into Edo Bay, a critical junction in the geography of the Kantō Plain.

Yet with Edo there is a difference, a difference that I would explain as a latent structure of opposition between two separate systems of water.[8] One was the formal system, the manmade network of moats and canals which so often earned Edo the epithet of "Venice of the East" among mid-nineteenth century Western visitors. In actual fact, Edo was no more canal-dependent than Osaka, Hiroshima, or various other Japanese cities built out over swampy river deltas and land reclaimed from the sea; yet there was something that made the city seem an especially apt parallel to the Queen of the Adriatic.

That something was the deep structure of "water," the sense of water as more than just a conduit for the prosperity of the city, rather as the medium of sociability, as an environment of gathering and relaxation. What set Edo apart in particular was the special role played by the Sumida River, the quintessential expression of water in Edo, opposed almost by definition to the structured, manmade, productive implications of the formal system. The Sumida came to stand for informality and for release—in short, for a kind of anti-structure.

The framework of the formal system of water is well expressed in the formal siting of the city, as explained by Akira Naitō.[9] The Chinese system of geomancy, as adapted by the Japanese for city plans, demanded that the gods of the four directions (*shijin*) be in proper topographical alignment, with a mountain to the north, a river to the east, a pond or ocean to the south and a road to the west. The topographical particularities of Edo, however, demanded an *ad hoc* rotation of the geomantic compass by over ninety degrees counterclockwise, so that Mount Fuji, located to the west-south-west, corresponded to Gembu, god of the north. By this logic, the road to the west was the Tōkaidō, and the two water directions were Edo Bay to the south and the Kanda River to the east. This orientation of Edo was preserved in virtually all traditional maps of the city, which placed the west at the top, awarding primacy to Mount Fuji overlooking the city as a whole and to Edo Castle as the highest point within the city itself.

8. For the concept of the Sumida as "nature" and release, versus the castle and its moats as a formal "system," I am indebted to Ai Maeda, *Toshi kūkan no naka no bungaku (The Space of the City in Literature)* (Tokyo: Chikuma shobō, 1982), p. 66. For another provocative analysis of the Edo-Tokyo waterscape, which unfortunately appeared after I had written this essay, see Hidenobu Jinnai, *Tōkyō no kūkan jinruigaku (The Spatial Anthropology of Tokyo)* (Tokyo: Chikuma shobō, 1985), ch. 2.
9. Naitō, *op. cit., Edo no machi-kyodai toshi no tanjō*, pp. 12, 13.

place" (meisho).[13] Its most celebrated classical citation is in *Tales of Ise*, where some travelers from Kyoto spot an unfamiliar bird while crossing the Sumida; learning that it is a "capital-bird" (*miyako-dori*), one of the lonely courtiers composes a verse:

If you are what your name implies,
Let me ask you,
Capital-bird,
Does all go well
With my beloved?[14]

This mood of melancholy and separation was given even more profound expression in the medieval Nō play *Sumidagawa*, in which a mother discovers that her son has died far from his native Kyoto and has been buried on the far bank of this isolated river. Such deep poetic memories of the Sumida, steeped in a sense of loneliness and separation, formed throughout the history of Edo an ironic undertone to the sense of integration that was central to the contemporary cultural meaning of the river. Even today markers of these legends remain: Kototoi Bridge takes its name from the early poem, and the grave of the lost child Umewaka may still be visited at Mokubo-ji on the far bank of the river.

In early Edo, the Sumida was the eastern border of the city, but after the Meireki Fire, the Tokugawa authorities decided to colonize the left bank of the river to alleviate crowding. It was from this time that the Sumida River began to evolve as a medium for relaxation and release. The river was wide enough to allow a variety of pleasure boats without competing with the functional traffic, while the riverside was extended enough to offer many sites for restaurants and teahouses.

The true sense of the Sumida, however, was to be found at the junction of the river with the great bridges that spanned it. Chief among these, and the oldest within the city proper, was Ryōgokubashi, completed in 1661 as part of the policy of left-bank settlement, just south of the point where the Kanda River flowed into the Sumida. At both ends of the bridge, Japan's closest approximation of a Western plaza (*hirokōji*) was maintained as a firebreak, and from the early eighteenth century here emerged a center of pleasure and entertainment. Ryōgokubashi was the true center of the deep structure of water in Edo, the ultimate place of release, escape, variety and self-expression. No single site was more often celebrated in the woodblock prints of the period, none more rhapsodically described in the gazeteers or novelettes of the city.

Ryōgokubashi was the symbolic entrance to water. Just below the bridge was a boat landing where one could rent a great covered *yakatabune*, a pleasure vessel capable of holding several friends and an appropriate contingent of entertainers, while just north of the bridge were the stalls of the small and swift *choki*, perfect for taking one or two dapper souls upstream to a Yoshiwara brothel with neither undue delay nor unseemly haste. And nearby lay a variety of teahouses and restaurants fronting on the river, allowing communication with the water from a secure land base. Ryōgokubashi was also the site of the greatest of Edo's many festival gatherings, the Kawabiraki, the "opening of the river" to pleasure traffic in July, a grand celebration best known for the spectacular fireworks set off from boats near the bridge. (Suspended in the 1940s and then

13. For the *meisho* tradition, see Jacqueline Pigeot, *Michiyuki-bun—Poétique de l'itinéraire dans la littérature du Japon ancien* (Paris: Editions G.-P. Maisonneuve et Larose, 1982), ch. 2.
14. Helen McCullough, *Tales of Ise* (Stanford: Stanford University Press, 1968), p. 76.

again after 1958, the Kawabiraki has been recently revived, but at a site farther upstream.)

Ryōgokubashi on the one hand brought together all classes of Edo society, submerging the manifold distinctions of rank and office. At the same time, it offered a passage, however ephemeral, from the everyday world to the world of celebration and festivity. In this sense, it partook of the two contradictory meanings of *ukiyo*, the celebrated "floating world," on the one hand, the world of everyday life, and on the other the secret anti-world of carnal and theatrical pleasure. Water was the intersection between these realms in Edo.

Tokyo Sky

Over a century of industrialization and Westernization has inevitably had a dramatic impact on the Tokyo skyline, encouraging the widespread sense that "Edo" and "Tokyo" are basically different cities.[15] A close consideration of the actual changes in the visible face of the city since the name change in 1868, however, reveals that the deep structure of Edo "sky," the structure of horizontality, persists in Tokyo today.

Consider, for example, the commonsensical matter of air quality. I have already suggested that one element in the appreciation of the Tokyo landscape was the aesthetic of *miegakure*, by which distant buildings were alternately obscured and revealed by the changing effects of ground haze and precipitation. So within limits, an increase in industrial pollution made no great difference in an environment where constant clarity was not particularly prized.[16] At any rate, it was not really until the 1960s that the levels of industrial development in Tokyo brought about a serious degradation of air quality. Remember that the Japanese never took to the chimney, which so transformed Western cities. Edward Sylvester Morse remarked in 1886:

> It is a curious sight to look over a vast city of nearly a million inhabitants, and detect no chimney with its homelike streak of blue smoke. With the absence of chimneys and the almost universal use of charcoal for heating purposes, the cities have an atmosphere of remarkable clearness and purity; so clear, indeed, is the atmosphere that one may look over the city and see distinctly revealed the minuter details of the landscape beyond. The great sun-obscuring canopy of smoke and fumes that forever shroud some of our great cities is a feature happily unknown in Japan.[17]

This exquisite clarity has unfortunately been sacrificed in twentieth-century Tokyo, and one notable casualty has been the visibility of Mount Fuji, which could be seen for one day in three until the early twentieth century, but which by the smoggy 1960s was visible only one day in ten.

Other familiar features of the modern Western cityscape have challenged the traditional sense of flatness and expanse in Tokyo. One of the earliest and probably the most persistent has been the familiar tangle of utility poles and wires. This "terrifying wirescape," as the British architectural critic J.M. Richards characterized it in the early 1960s, has been a source of aesthetic irritation to visiting Westerners for over one hundred years now.[18] It made a "horrid impression" on Lafcadio Hearn in 1897, while the British writer Peter Quennell in 1930 offered perhaps the most chilling description of all:

15. For a more extended discussion of the historical problems of separating "Edo" and "Tokyo," see my essay, "The Edo-Tokyo Transition: In Search of Common Ground," in Marius Jansen and Gilbert Rozman, eds., *Japan in Transition: From Tokugawa to Meiji* (Princeton University Press, forthcoming).

16. For a modern defense of murkiness over clarity as the basis of Japanese aesthetics, see Jun'ichirō Tanizaki, *In Praise of Shadows*, trans. Thomas J. Harper and Edward G. Seidensticker (New Haven: Leete's Island Books, 1977).

17. Edward S. Morse, *Japanese Homes and Their Surroundings* (Boston: Ticknor and Co., 1886), p. 3.

18. J.M. Richards, *An Architectural Journey in Japan* (London: The Architectural Press, 1963), p. 21.

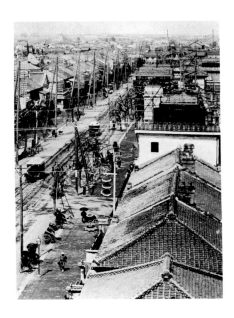

Photographer unknown
Ginza with Horsedrawn Trolley, circa 1910
printed from a lantern slide
Collection Peabody Museum of Salem

19. Lafcadio Hearn, *Letters from Tokyo*
(Tokyo: Hokuseido Press, 1920), p. 74; Peter
Quennell, *A Superficial Journey Through
Tokyo and Peking* (London: Faber and Faber,
1932), p. 54.
20. "'Total Quantitative Control' on Outdoor
Advertising Recommended by Tokyo
Metropolitan Deliberation Council on
Advertising," *Tokyo Municipal News,* 34:3,
Autumn 1984, pp. 1-3.

Vague and slatternly, a sprawling skyline of wooden houses overlooked by a massive procession of telegraph poles that marched—or rather staggered—up its slope, linked together by loose wires in a drooping curveThese telegraph poles, as though conscious of their superiority, never take the trouble to stand straight. Like street bullies, their hands deep in their pockets, they lurch drunkenly over the cowering shabby roofs and lean at affected angles on strong supports. The old Japan is changing in their shadow; the future belongs to them and all they symbolize.[19]

A look at a revealing photograph of the Ginza in 1910 certainly tends to confirm this sense of the domineering power of the telegraph poles (although in fact the new generation of poles to the right in the photograph, each boasting fully 160 insulators, were probably awaiting the wires of telephones, then spreading rapidly through the city).

But still more revealing is the aesthetic that the Japanese tend to bring to this "wirescape." In contrast to the frequent Western denunciations, Japanese artists have long found a positive aesthetic in wires against the sky, from the woodblock prints of the Meiji period to the drawings of contemporary artists. It does not seem to be, as one formulation has it, that the Japanese are sensitive to beauty but not to ugliness, but rather that they actively appreciate the striking graphic qualities offered by the wirescape (and, perhaps, the communicative power that it symbolizes). This graphic aspect of the urban skyline is an essential corollary of the basic horizontality of Tokyo.

Another profound change in the cityscape has been the introduction of monumental buildings in the Western manner, a process that was first prevalent in governmental buildings of the Meiji period and that soon spread to commercial architecture as well. Monumental facades and the sense of volume they express tended to draw attention to buildings in ways that traditional architecture did not. Only in such places as the government center of Kasumigaseki or the business center of Marunouchi, however, has Western architecture been massed in ways that contradict the traditional anti-monumentality of the flat cityscape.

The greater impact of Western architecture has been to enable the construction of buildings much higher than in the Edo tradition. Until fairly recently, a height limit of thirty-two meters (in effect eight stories) was maintained for fear of earthquakes. But this was achieved only for major buildings in the city center, thus working to accent rather than transform Tokyo's low and level skyline. A wholly new phase in the verticalization of the city was introduced, however, with advanced anti-earthquake construction techniques, beginning with the thirty-six story Kasumigaseki Building in 1968, and since, spreading to over a dozen true skyscrapers in the fifty to sixty-story range, seven times higher than the old limit.

A final realm of skyline transformation, the one that most overwhelms the foreign visitor, is the Tokyo signscape. Indeed, both the "wirescape" and the building facades are best seen as mere variants in the chaotic sea of signage that decorates the city. This in part reflects the minimal level of control exercised over outdoor advertising in Japanese cities, although a recent proposal by the Tokyo Metropolitan Government would attempt to restrict at least its density ("total quantitative control").[20] Yet precisely this "disorderly flood of outdoor advertising that deluges streets with eyesores to the cityscape" (in the words of the city report) is what seems so characteristic of modern Tokyo, as expressed in a 1931 photo-essay on "The Character of Great Tokyo."

Whatever personal aesthetic one may bring to the issue, there seems little doubt that the density and variety of the signscape is central to the profoundly graphic quality of the city as a whole. Indeed, the linguistic signs of advertising may be seen together with the "wirescape" and Western-style facades as part of the much broader tendency in Japanese civilization to graphicness, to an emphasis, as Roland Barthes has persuasively argued, on writing as the fundamental act of representation.[21] The "writing" of the Tokyo sky, by wires, billboards and facades, has served not to contradict but to complement the essential horizontality of Edo.

The continuing qualities of horizontality and unboundedness in modern Tokyo have been reflected in a variety of comparative observations about the city over the past century. The characteristic emphasis among Western observers is on uniformity. Isabella Bird, writing in 1878, noted that "The hills are not heights, and there are no salient objects to detain the eye for an instant. As a city it lacks concentration. Masses of greenery, lined or patched with grey, and an absence of beginning or end, look suburban rather than metropolitan."[22] A generation later, in 1915, one A.M. Hitchcock called it a "monotonously gray city, closely packed for the most part, practically cellarless, and hugging the earth—length and breadth in abundance, but lacking a noticeable third dimension."[23] Or still today, Donald Richie has noted, the initial impression of Tokyo is that of "an unvariegated mass. One thinks of the backside of a silicon chip made enormous, and sees only dread uniformity."[24] I shall return to this class of observations shortly, to emphasize the complementary structure of "water" which they offer, but suffice it here to note the overwhelming agreement on the city's uniformity.

A somewhat different perspective was offered by the Japanese philosopher Tetsurō Watsuji in his *Climate and Culture* (*Fūdo*), first delivered as lectures after his return from a trip to Europe in 1928. Watsuji was struck by the relative narrowness of streets in Tokyo, which he saw as "more basically a reflection of the broad and level structure of the Japanese city."[25] He explained this structure as reflecting both the Japanese attachment to the single detached house (in contrast to multi-storied European tenement) and the Japanese lack of a cooperative civic spirit of the sort that produced unified plans and monumental urban structures in Europe. Watsuji was probably wrong about the Japanese house (since most Edo/Tokyo residents have always lived in one or two-story tenements, rather than detached houses), but correct about the lack of a Western-style civic tradition as one key explanation for Tokyo's apparent formlessness.

This lack of civic unity has also been reflected in the weakness of any strong, centralized authority that might wish to impose a coherent plan. City planning in modern Japan has generally meant the fine adjustment of property boundaries in order to straighten and widen streets. This limited function in large part reflects the strength of the traditional Japanese attachment to land, a tenacity which makes it difficult for the government to move established landholders (or for landholders, for that matter, to move established tenants). Even after the devastating earthquake in 1923 and bombings in 1945, when large areas of Tokyo were literally flattened except for isolated ferro-concrete skeletons, the city sprouted up again like mushrooms from hidden spores, just as it always had done in the wake of an Edo fire. Unlike most other world cities, Tokyo has had its roots in the ground, not in the monuments erected over it.[26]

21. Roland Barthes, *Empire of Signs,* trans. Richard Howard (New York: Hill and Wang, 1982).
22. Isabella Bird, *Unbeaten Tracks in Japan* (London: John Murray, 1880), p. 169.
23. Alfred M. Hitchcock, *Over Japan Way* (New York: Henry Holt, 1917), p. 36.
24. Donald Richie, "Tokyo—The City of Villages," *Connoisseur,* 215:879, April 1985, pp. 103, 104.
25. Junzō Karaki, ed., *Watsuji Tetsurō* (*Watsuji Tetsurō*), from *Gendai Nihon shisō taikei* (*Anthology of Contemporary Japanese Thought*), vol. 28, (Tokyo: Chikuma shobō, 1963), p. 260. For a complete English translation of this work, see Watsuji Tetsurō, *A Climate—A Philosophical Study,* trans. Geoffrey Bownas (Japanese National Commission for UNESCO, 1961).
26. For more on the evolution of urban form in Edo and Tokyo, see my essay, "Tokyo and London: Comparative Conceptions of the City," in Albert M. Craig, ed., *Japan—A Comparative View* (Princeton University Press, 1979), pp. 45-99.

Keirin
Bird's-Eye View of Great Edo, circa 1860
color woodblock print
Collection Tokyo Metropolitan Central Library

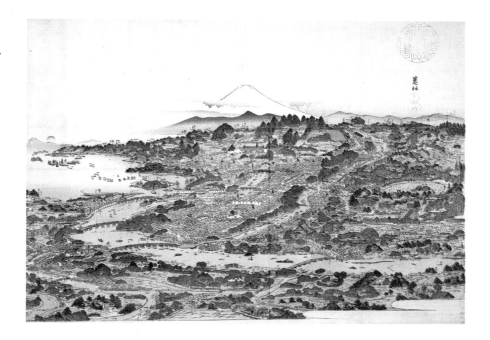

Tokyo Water

Even for the confirmed anti-sentimentalist, it is difficult not to feel a profound sense of loss in looking back over a century of systematic destruction of the Venice-like qualities of traditional Edo. Beginning in the 1880s, the shift to land-based systems of urban transport worked to decrease the number of moats and canals. Many old waterways were filled in and converted into wide roads to accommodate growing numbers of motorized vehicles, while others have been barricaded in the interests of flood control. Such is the sad fate of the great Sumida River, which has been rendered not only inaccessible but even invisible to those who pass nearby. The most devastating assault on these ancient canals and moats was the construction in the 1960s of an elevated highway that runs directly above one of the grandest and most historic stretches of Edo water, the Nihonbashi River.

A sense of loss of the essence of Edo as a city of water was consciously articulated by a variety of Japanese writers from early in the twentieth century. For men like Kafū Nagai and Mokutarō Kinoshita, the watery environs of the old Shitamachi provided a certain sensuous and atmospheric quality that was constantly threatened by the ideology of the Meiji state and its capital of "land-based Tokyo" (oka no Tōkyō).[27] For these "medievalists," as the architectural historian Takashi Hasegawa has called them, the appeal of the Edo landscape was essentially pictorial, as framed in the prints of Hiroshige or Kobayashi Kiyochika (1877-1915), just as their architectural preferences favored the qualities of line and plane over the mass and monumentalism preferred by the Meiji state. Here we can see the intersection of the horizontality and graphicness of the "sky" principle with the appeal of "water" for its encouragement of moods and atmosphere.

The chief culprit in the sacrifice of the watery medium of Edo culture was the wheeled vehicle. As borne out by the observations of Western visitors to late Edo, one of the most uncanny features of the city in

27. Takashi Hasegawa, *Toshi no kairō—aruiwa kenchiku no chūseishugi (The City Corridor: Medievalism in Architecture)* (Sagami shobō, 1975), p. 56.

comparative terms was the lack of the clatter and speed of horse-drawn carriages. Watsuji, in the essay mentioned earlier, saw the problem as one of scale, comparing an electric trolley running along Tokyo streets to a "wild boar rampaging through fields," dwarfing the low one and two-story buildings.[28] The nature of the vehicle has changed with time, from the horse-drawn carriages and jinrikishas of the 1870s to the motor vehicles of today, constantly escalating the threat to the pace and texture of the surviving city of water.

Yet if we take a second look, not at the literal waterways of Tokyo, whose sacrifice is undeniable, but rather at the deep structure of the Edo waterside, as a place of gathering, relaxation and informality, then the continuities with Tokyo begin to emerge more clearly. I would propose that this structure of "water" has in fact persisted in the city, but in a different context. "Water" has quite simply moved onto dry land, and now survives most characteristically in the areas of the city known as *sakariba* (thriving places). The *sakariba* are dense clusters of facilities for consumption—shopping, eating, drinking and amusement—which have typically formed around a transport node.

In Edo, as we have seen, the most notable such node was Ryōgokubashi, a place that linked roads, waterways and riverbanks into a single complex of gathering. Today the nodes are usually train stations, or rather complexes of interlinked stations, such as the great subcenters of Shibuya, Shinjuku, and Ikebukuro.[29] There is nothing mysterious about the siting of Tokyo *sakariba;* urban geographers have studied them closely, and can easily explain them in terms of modern location theory.[30] The critical point is that they are determined not by conscious and coordinated planning, but in spontaneous response to the logic of the transportation system and the marketplace. Like the Sumida River in Edo culture, they represent freedom from the strictures of control from above; they are the new "nature." Nowhere is the sense of waterlike flow and change more pronounced than in the vast underground spaces that serve to unify the largest of the stations into self-enclosed megastructures.

This pattern of "water" as a type of clustering is an essential complement to the pattern of "sky" as a structure of unbounded and uncentered flatness. The unity of "sky" and "water" is particularly clear in descriptions of Tokyo by Western observers, where the quality of uniformity and expanse mentioned earlier is almost inevitably countered by the remarkably persistent metaphor of Tokyo as a city of "villages."[31] The earliest use of this image which I have yet encountered is by Isabella Bird, quoted above for her perception of Tokyo's "lack of concentration." In the same passage, she attributes this diffuse quality to the city's historical origins as "an aggregate of 125 villages." As far as I can tell, there is no truth to this particular assertion, but the image of Tokyo as an aggregate of "villages" has survived to the present.

A close inspection of this enduring metaphor reveals that the definition of Tokyo's "villages" varies widely, depending on the observer and the time of observation, but may in the end be reduced to two prototypical conceptions. One is precisely the *sakariba*, the nodal point of gathering. This is what Roland Barthes had in mind in his incisive essay "Station," a virtual definition of the principle of "water" in contemporary Tokyo. Quite accurately, he referred to the great station-centered nodes of Tokyo as "districts," each with its name: Ueno, Asakusa, Ikebukuro, . . . and so

28. Watsuji, *op. cit., A Climate—A Philosophical Study,* p. 158.
29. For an analysis of the evolution of one such subcenter, see Peter Gluck and Henry Smith, "Shinjuku," *A + U: Kenchiku to toshi,* August 1973, pp. 132-156.
30. For a thorough study of the *sakariba* by an urban geographer, see Keijirō Hattori, *Sakariba—Ningen yokubō no genten (Sakariba—The Meeting Point of Human Desires)* (Kajima shuppankai, 1981).
31. I have traced the history of the "village" metaphor of Tokyo at greater length in "'Village' to shite no Edo-Tōkyō" ("Edo-Tokyo as a 'Village'") in Shinzō Ogi, ed., *Edo-Tōkyōgaku josetsu (Introduction to Edo-Tokyo Studies)* (Sanseido, forthcoming).

(detail)
Utagawa Toyoharu
*Panorama: Edo and the Sumida River at the
Ryōgokubashi*, Edo period, *Ukiyo-e* school
painting on silk
28¾ x 73¼, 73.1 x 185.9
Courtesy Freer Gallery of Art,
Smithsonian Institution
(03.217)

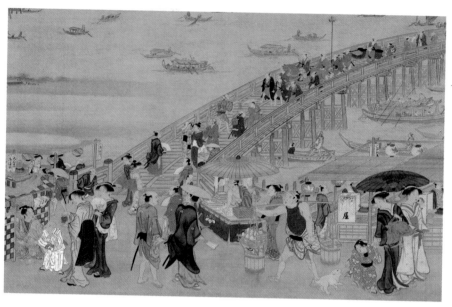

forth. "Each name," he then wrote, "echoes, evoking the idea of a village."[32] Others as well have detected the villagelike quality in the names of the great *sakariba* of Tokyo. To give a single example, Donald Richie, in the essay cited earlier, continued beyond his remarks on the initial impression of "dread uniformity," to emphasize the differences, precisely as Barthes had done, among the names: Asakusa, Ueno, Ginza, Roppongi, Harajuku, . . . and so forth.

But other Western observers, indeed the majority, have discovered the "villages" of Tokyo in a very different place, not in the cacophonous commercial clusters but rather in the traditional back alleys so reminiscent of Edo, the narrow lanes enclosed by the graphic lines of one and two-story wooden residences, occasionally shops, and dense with the greenery of potted plants. Whether or not these "villages" bear any sociological resemblance to the traditional forms of rural community (probably not), they do conform to the principle of "water" in basic ways. They are points of gathering, in the sense that the narrowness of the streets forces people together; wheeled vehicles pass, but only on the condition of peaceful coexistence with pedestrians. At the same time, like the station-centered *sakariba*, they are passages, a waterlike flow. While they gather, they also disperse: as Barthes says of the station, "an incessant departure thwarts its concentration." In the words of Takashi Hasegawa, who has written so eloquently of the city of "water" in early twentieth-century Tokyo, the back alleys of Tokyo are "rivers without water," apart from the harsh mechanical systems that dominate the main streets.[33]

And so in these two different environments, in the bustling centers and in the back alleys, we find the continuities with Edo. These are the "water" of Tokyo, the places of passage where people stop, now and then, to gather, to relax and to enjoy themselves. It is this pattern that ultimately gives meaning to the spatial structure I have called "sky," the structure of unboundedness and of writing, a structure that encourages neither concentration nor meaning. Only in combination with each other and with the Edo past do the "Sky and Water" of Tokyo finally come to make sense.

32. Barthes, *op. cit., Empire of Signs*, p. 39.
33. Hasegawa, *op. cit., Toshi no kairō-aruiwa kenchiku no chūseishugi*, p. 93.

東海道
五拾三次
之内
日本橋
朝之景

廣重画

東海道
五拾三次
大尾
京師
三條大橋

廣重画

Edo: The City on the Plain

Yūichiro Kōjiro

(top)
Andō Hiroshige
Nihonbashi, from the series *Fifty-three Stations of the Tōkaidō,* 1830s
color woodblock print
8¾ x 13¾, 22.3 x 34.9
Collection The Minneapolis Institute of Arts, Gift of Francis W. Little, 1917

Andō Hiroshige
The Great Bridge at Sanjō, Kyoto,
from the series *Fifty-three Stations of the Tōkaidō,* 1833
color woodblock print
8⅞ x 9⅞, 22.4 x 24.9
Collection Elvehjem Museum of Art,
E.B. Van Vleck Collection,
Bequest of John Hasbrouck Van Vleck,
University of Wisconsin, Madison

Katagi: Form and Spirit

> Before the Great Earthquake, Tokyo had six counties and fifteen wards. I think that was just about the right size for it . . . Each ward had its own atmosphere and *katagi,* and it was fun. Then, as Japan was defeated in war, the natives ceased to be, and each ward's atmosphere and *katagi* disappeared. And, as you see, it has become the colony Tokyo that it is. When those of us who know the good points of the Tokyo in the old days look at it, Tokyo has lost all the good points it had For the river called Tokyo to become clean, it will probably take one to two hundred years. It's only after that, that Tokyo culture will be born.[1]

These sentiments of the novelist Seijirō Kojima are common to many people who were born and grew up in Tokyo before the Great Earthquake and fire of 1923. As they see Tokyo, the good things it had were completely wiped out, first by the Earthquake, then by Japan's defeat in World War II. It may be that modern Tokyo has grown so huge that it can no longer be comprehended by the *Edokko* (native Edoites).

When I mused on the plans for the exhibition *Tokyo: Form and Spirit,* it occurred to me that the cultural value and potential of Tokyo may be assessed more objectively, more accurately, by those who live outside Tokyo, outside Japan. I was led to this thought by the words "form and spirit" used in the exhibition's title. When I saw them I immediately thought of the word *katagi,* as used by Kojima. He applied the original combination of Sino-Japanese characters in which *kata* is form, and *gi* is spirit. In more recent common usage a different set of characters is applied. But fortuitously, the "form and spirit" of the exhibition's title correspond directly to the earlier interpretation of *katagi,* exactly capturing the word's Edo-period meaning.

In broad terms *katagi* may be defined as the elements and temperament of a given community that combine to create its distinct atmosphere. In Japan, the *katagi* of a community is most apparent during a festival by the decoration of the streets and houses, the shapes of the *mikoshi* (portable shrines) and *dashi* (floats), the costumes of the participants and the way the songs and choruses are sung, the way the residents greet one another and the way food is prepared and presented. All this differs from town to town.

Differences in *katagi* exist between regions, between cities, and of course, between Edo and its contemporary manifestation, Tokyo. But it is the *katagi* of Edo that is the subject of this essay.

1. Seijirō Kojima, "The River Called Tokyo," *Edokko,* no. 5, 1975.

At the Ends of the Plain: Mount Fuji and Nikkō

In ancient times Chinese and Korean cultures initially reached northern
Kyushu, spread westward through the Inland Sea, and settled down in
the Yamato (present-day Kinki) region.[2] The streets of the region's first
capitals, Nara and Kyoto, were arranged to form grids, because those
cities were planned in the manner of large contemporary Chinese cities,
specifically the Tang Dynasty (618-907) capital of Chang-an.

The eastern region of Honshu, the largest of the four major islands
of Japan, remained undeveloped for quite a long time. It was as late as
1192 that Minamoto-no-Yoritomo (1147-1199), the first military leader
to establish a rule independent of the imperial court in Kyoto, crossed the
Hakone mountains and set up the *bakufu* (feudal government) in
Kamakura, a small village in the east. After the Kamakura government
collapsed in 1333, the shoguns of the Ashikaga government (Muromachi
period, 1392-1568) lived in Kyoto. In 1590, after Toyotomi Hideyoshi's
(1536-1598) unification of Japan, Tokugawa Ieyasu (1542-1616), the first
Tokugawa Shogun, was given the Kantō region, which included Edo, an
area said to have been a sparsely populated plain surrounded by marsh-
lands.[3] Ieyasu's serious effort to build a respectable castle and create a
"castle town" began only after he was appointed Shogun in 1603. The
Edo period, under Tokugawa rule, lasted until 1868, the onset of the Meiji
Restoration.

Throughout the Edo period the emperor, the nominal ruler, lived in
Kyoto to the west, and the shogun, the de facto ruler, in Edo to the east.
From the outset the two cities and the regions surrounding them differed
in many ways. Kyoto and Osaka were cultural and economic centers,
while Edo was a new consumer city. Kyoto was a basin surrounded by
mountains on three sides with the Kamo River bisecting it, and the imperial
palace at its northern center. In spring people visited places famous for
cherry blossoms; in summer, they enjoyed the spectacle of the Daimonji-
yaki when the giant character *dai* (as in the word *Dai*monji-yaki) is set
afire on the hillside, or else sought the evening cool by the Kamo River.
In autumn the moon and the fall colors were viewed in festal fashion.
The geography of Kyoto made dispersion of the court culture difficult. In
contrast, Edo's plain stretched in three directions, with the fourth facing
a bay. Though it had five hills, including the one on which Edo Castle was
built, the only visible mountain was Mount Fuji far to the southwest. This
is why Edo, from its initial radial urban planning, has continued to spread
outward to this day, without any visible limit.

Kyoto's surrounding hills enabled a resident to readily ascertain his
geographic position by simply looking up, wherever he happened to be.
But in Edo, where the shogunate castle was located on the central hill
and various roads radiated from it toward the rim of the plain, it was
difficult to pinpoint location. This undefinable world of Edo is described
in such folksongs as *Komurobushi,* when a woman tries to dissuade her
man from going to Edo:

> You say, do you, you're going all the way down to Edo
> Where you can't even see the mountains.
> Once you're there, I don't know when you return.
> If you go there at any cost, please kill me first of all.

This difference between Kyoto, the established city surrounded by hills,
and Edo, the latecomer on a vast flatland, remains clear even in songs

2. The Kinki region includes Shiga, Hyogo,
Nara, Mie and Wakayama, Kyoto and Osaka
Prefectures.
3. The Kantō region includes Ibaraki, Gumma,
Saitama, Kanagawa, Chiba, Tochigi and
Tokyo Prefectures.

written after Edo became Tokyo. The famous Kyoto geisha song, *Gion ko-uta*, poetically begins, "The moon is a blur above Mount Higashi," while a Tokyo school song says, "There's no rim of mountains / where the moon can enter."

Mount Fuji is closely related to ancient mountain worship. The citizens of Edo made a great number of shrines, such as the Fuji Jinja and Sengen Jinja, which were devoted to the deities that reside at Mount Fuji. Each such shrine contained a miniature Fuji. On "mountain-opening day" people climbed Mount Fuji to offer prayers to the rising sun, or made supplication to the miniature Fuji. Also, because each of the hills in the central part of Edo provided a good view of Fuji, the most common street name going up them is Fujimi-zaka (Fuji-Viewing Hill). In Katsushika Hokusai's celebrated *Thirty-six Views of Mount Fuji (Fugaku sanjūrokkei*, 1829-1833), a number of prints depict the mountain as seen from within the city of Edo.

In contrast to Mount Fuji, clearly visible to the southwest, Mount Nantai and Mount Futara, far to the northeast, could not be seen from Edo, but it was there that the Nikkō Tōshō-gū was built in 1638 to enshrine Tokugawa Ieyasu. Nikkō Tōshō-gū became a branch of Kan'ei-ji, Edo.

Nobori (Up) and *Kudari* (Down)

The Tōkaidō, the 320-mile-long road that connects Edo and Kyoto, was completed largely as a result of the *sankin kōtai* system, by which the Tokugawa Shogunate legally required all the 250-odd *daimyō* to spend part of each year in Edo. The most famous pictorial depiction of the Tōkaidō is a *ukiyo-e* series by Andō Hiroshige, *Fifty-three Stations of the Tōkaidō (Tōkaidō gojūsan tsugi*, 1833-1834), and the most famous narrative depiction is a picaresque novel by Jippensha Ikku (1765-1831), *Tōkaidōchū hiza kurige (Shank's Mare*, 1809). The Tōkaidō is usually thought to begin at the Nihonbashi (Nihon Bridge) in Edo and to end at the Sanjō-ōhashi (The Great Bridge at Sanjō) in Kyoto; others contend that it extends westward to Osaka. Whichever may be the case, the Tōkaidō, which was dotted with fifty-three "inn-stations" in the Edo period, is now traversed in about three hours by the National Railway's Shinkansen (bullet train).

A Shinkansen ticket purchased in Tokyo to go to Kyoto or Osaka is for the *kudari* or "down" line, while a ticket purchased in Kyoto or Osaka to go to Tokyo is for the *nobori* or "up" line. Because Tokyo is the capital of Japan, going there has been regarded as "coming up," and leaving there as "going down." The country bumpkin who comes to Tokyo is called an *onobori-san* (someone who comes up). But before the capital was moved from Kyoto to Edo, one went "up" from Edo to Kyoto, and went "down" to Edo from Kyoto. The culturally and economically advanced region of Kyoto and Osaka was called Kamigata (the upper direction), and though there was no exact antonym to describe Edo, the term *azuma-kudari* (going down to the east) meant fleeing the capital of Kyoto for the uncivilized land of Kantō.

Many of the "castle towns" were created to fill the needs of the warlords who developed commercial activities around their main fortresses in the shortest possible time. They were like colonies within a country, and Edo was said to be the most spectacular and successful example of

(gatefold)
Map of Tōkaidō, Edo period
color woodblock map
Collection Yūichiro Kōjiro

The Tōkaidō was a picturesque 320-mile-long road stretching from Edo to Kyoto.

this castle town development. After the Tokugawa government had the *daimyō* build Edo Castle and then settle down around it in their own mansions, seventy percent of the total area of Edo was occupied by the warrior class. The fact that two-thirds of the population were men was another distinctly colonial feature. The people of the Kamigata region felt themselves to be culturally and economically superior to Edoites.

Not until the Meiji Restoration (1868-1912), when Edo changed its name to Tokyo and the emperor moved from Kyoto to the new capital, was this hierarchical relationship reversed.

The Spiral Moat and the Radial Routes

The center of the new capital was Edo Castle, the seat of the Tokugawa government. As the shogun's residence, it had to be the greatest castle in Japan, and it was nearly fifty years in building, with major expansions continuing until about 1640. The general formation of the castle was not very different from that of other castles of the day, but Edo Castle had one thing that set it apart: the spiral-shaped moat that turned outward one and a half times, and whose outer end merged with the Sumida River near its estuary. In addition, from within the moat-enclosed castle compound, some of the major highways spread out radially: the Tōkaidō to the south; the Daisendō (also called the Atsugikaidō) to the southwest; the Kōshūkaidō to the west; the Nakasendō to the northeast; the Nikkōkaidō to the north. This layering of the moat and the highways at the center was the special characteristic of the great castle town of Edo. At each point, where the moat and one of the highways met, a guard station called *mitsuke-mon* (watch gate) was placed. Some of these, such as the Toranomon (Tiger's gate) where the Tōkaidō and the moat crossed, remain only as names now, for the sections of the moat near them have been filled in and turned into roads.

People from all over Japan headed to Edo by taking one of the five routes mentioned above, and most products made outside Edo also came in along these routes. As the people or the products approached Edo Castle, they were stopped at one of the guard stations and checked. No one was exempt. The *daimyō*, accompanied by their retainers, merchants, masterless samurai and vagabonds—all were caught in this cobweblike system.

Edo had no clear boundary from the outset. In the beginning, the strip of land just outside the spiral-shaped moat was thought to form the outer limits of Edo. However, people soon began to refer to *Edo yori shihō* (the four-*ri* square of Edo, or approximately thirty square miles of Edo). The area expanded rapidly, and by 1744 the population of Edo exceeded one million, making it the largest city in the world. (Even today, Tokyo seems to have no outer limits, as it continues to grow in geographic size and population).

Yamanote (High City) and Shitamachi (Low City)

The *daimyō* set up their mansions around Edo Castle, and their servants and followers resided just outside them. The area where the members of the samurai class lived was called Yamanote (Hillside or High City), because of its many hills, and the area where the other citizens lived was called

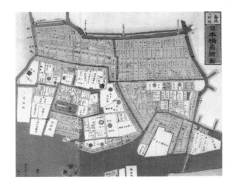

Map of Nihonbashi, eighteenth century
color woodblock print
Collection Yūichiro Kōjiro

This map illustrates the center of the Low City
in Edo—the area from Nihonbashi to
Kyōbashi.

Shitamachi (Lower Town or Low City), a relatively flat area immediately
to the east of Edo Castle. Indeed, Shitamachi is a somewhat abbreviated
form of *Shiro-shitamachi* (town below the castle).

Many of the Yamanote hills had shrines and temples on top: Kan'ei-ji,
the temple associated with the Tokugawa Shogunate, is on the Ueno-dai
(*dai* is a mound or plateau); on the hill called Atagoyama is Atago Jinja,
and below it the temple called Zōjō-ji. Kan'ei-ji belongs to the Tendai sect
of Buddhism, and is also called Tōei-zan (Mount Hiei of the East). The
name derives from Ieyasu's edict splitting the prestigious Enryaku-ji on
Mount Hiei in Kyoto into two, locating one in Edo. Following a similar
edict, Zōjō-ji was designated as the cemetery for the souls of the Tokugawa
Shoguns and their immediate family members, and was named the
dai-honzan (great headquarters) of the Jōdo sect. This was done to give
it a distinct position in relation to the Chion-in in Kyoto, which is called
the *sō-honzan* (general headquarters) of the same sect. These are only a
few of the expressions of rivalry with Kyoto articulated by the Tokugawa
Shogunate.

Interestingly, even among the members of the samurai class living in
the Yamanote, Zen did not flourish as it did in Kyoto. Among the few
notable Zen temples in Edo is the Sengaku-ji in the southern part of the
city. Non-Zen temples were more important. Most popular were the tem-
ples of the Nichiren sect, in part because Nichiren (1222-1282), the founder
of the sect, trained himself on Mount Minobu near Mount Fuji and was
closely associated with mountain worship. The Honmon-ji, in a suburb to
the south, is a representative Nichiren temple.

Many Yamanote roads had fine overlook points, and they were named
Shiomi-zaka (Tide-Viewing Hill) and Matsumi-zaka (Pine-Viewing Hill),
among others. The name that occurred most frequently was the above-
mentioned Fujimi-zaka. Outside these hilly areas were farmlands and un-
developed grasslands. The Musashi Plain was one such designated area.
Between the samurai residences, patches of grassy flatland were left un-
touched; these grassy places were called *hara* (field, or open space).
Akihabara (*bara* is *hara* phonetically changed), between Kanda-dai and
Ueno-dai, is one example, though now it is a field in name only.

If the Yamanote is characterized by "hills" and "fields," the Shitamachi
to the east is characterized by elements related to water. To the center
of what was initially called *Shiro-shitamachi*, three canals were opened
that originated in the outer moat to the west, stretched eastward, and
ended in the bay. To the north, the last section of the outer moat merged
with the Sumida River. The canals, the moat and the river naturally had
a number of bridges, and certain sections of them, the *kashi*, were
strengthened for loading and unloading the boats. The places near the
bridges and *kashi* flourished. The most famous bridge was the Nihonbashi;
the most famous *kashi* was the *Uo-gashi* (fish market), which was right
next to the Nihonbashi.

As Edo developed as a city, the areas for the townspeople sprang up
in two distinct communities. First, the *Shiro-shitamachi*, that centered on
the Nihonbashi and the Kyōbashi, where wealthy merchants set up shop.
Only in this section of Edo were the streets arranged like a grid, indicating
the initial imitation of Kyoto. The second community developed along the
banks of the Sumida River after the Meireki Fire in 1657. Here, the so-called

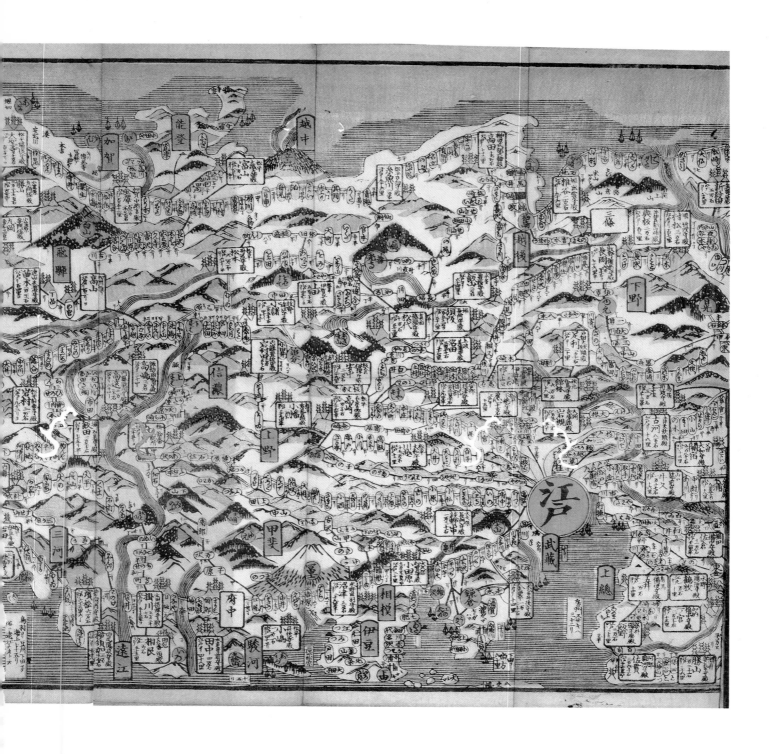

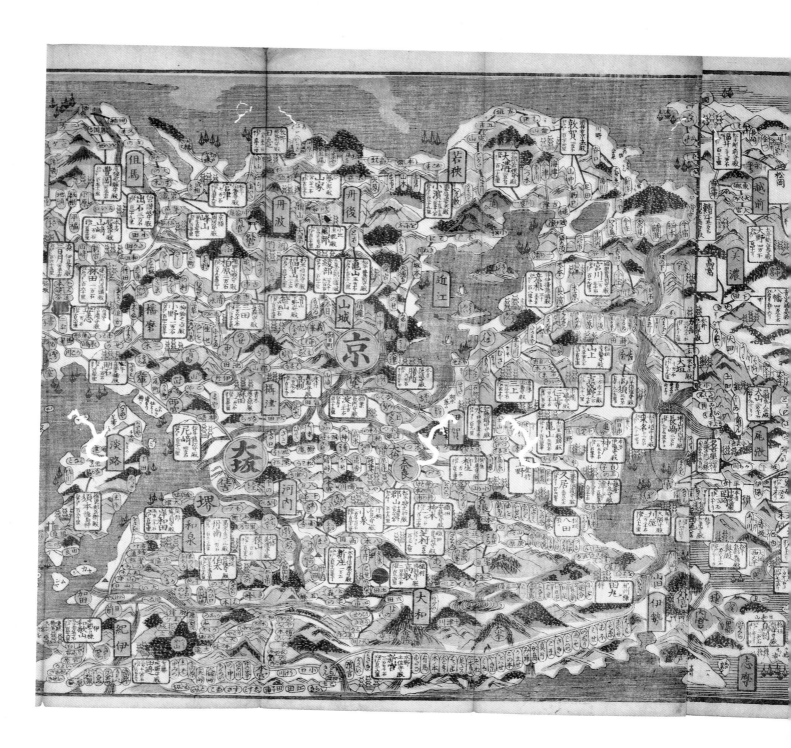

(opposite)
Andō Hiroshige
Edobashi from Nihonbashi, from the series
One Hundred Famous Views of Edo, 1857
color woodblock print
19 x 15, 48.3 x 38.1
Collection Elvehjem Museum of Art,
E.B. Van Vleck Collection,
Bequest of John Hasbrouck Van Vleck,
University of Wisconsin, Madison

shokunin (workmen) and small businessmen lived in great concentration. In effect, an extension to the north of the original *Shiro-shitamachi*, it had a different center: Asakusa.

From *Giboshi* to *Giboshi:* the *Edokko*

The samurai who came to Edo from all over Japan never created a new Edo culture of their own. They merely coexisted with the rest of the population, bringing to Edo and displaying there the characteristics of their provinces. The *daimyō* lost their economic foundations by the latter half of the Edo period, and the only legacies left from their ascendancy are the *ohori* (moats) and the parks that were the private gardens of their detached mansions.

Those who eventually created a distinct Edo culture, unlike those of Kyoto and Osaka, were the *Edokko*, residents of the citizens' quarters where merchants from all the provinces gathered and lived in a sort of vital chaos. How did the *Edokko* come about and what was his *katagi*?

Edokko is defined in a number of ways, but two definitions are notable: one, "from *giboshi* to *giboshi*" may be termed "spatial;" the other, "someone whose family has lived in Edo for three generations," is temporal. "From *giboshi* to *giboshi*" means "from the Nihonbashi to the Kyōbashi," the space between the two bridges where the Edo citizens' quarters originated. *Giboshi* is the ornamental knob placed at the top of a post that supports the railings of a building or a bridge. This ornament is made up of three parts: *hōgyoku* (the jewel), the topmost onion-shaped section; *koshi* (the hip), the compressed middle part; and *tsutsu* (the tube), the bottom part that covers the head of a post. The *tsutsu* is decorated with a *himo* (string). *Giboshi* in pre-Edo days generally had small "jewels" and short "hips." But those in the Edo period tended to be large and "loud." Because they formed the most conspicuous parts of the Nihonbashi and other important Edo bridges, they became symbols of Edo. The Nihonbashi rises in a slow curve, reaching the highest point at its center. *Giboshi* decorate the two posts at the center and the four at each end of the bridge, brilliantly accentuating the structure. Since the Kyōbashi had a similar makeup, it is clear how the phrase "from *giboshi* to *giboshi*" came to define the *Edokko*.

But the area included in this definition soon became too narrow to be useful. Although it was adequate at the outset of the Edo period, the Shitamachi soon spread north and south.

So *Edokko*, which at first referred to someone living in the confined area between the Nihonbashi and the Kyōbashi, came to mean someone who was born and grew up in the expanding area notable for its *chōnin bunka* (townspeople's culture) at the height of the city's prosperity.

hōgyoku (jewel)

koshi (hip)

himo tsutsu (tube)

himo

himo (string) giboshibashira (base)

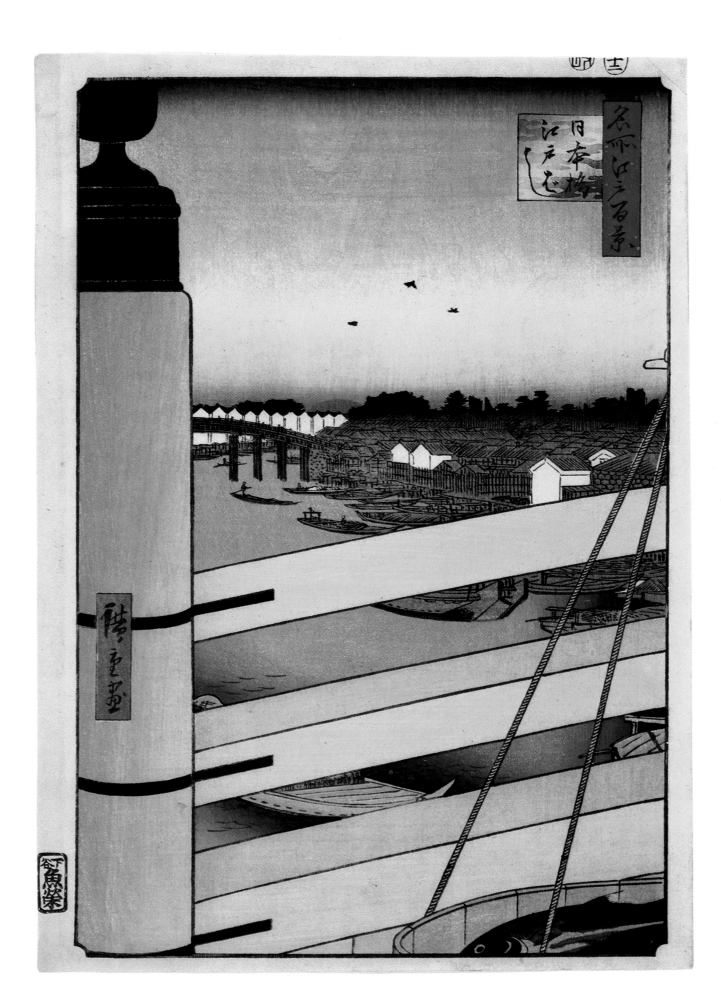

Hasegawa Settan
Three illustrations from vol. 5 of
Tōtō Saijiki, nineteenth century
(left to right)
Scene of Theater Going
Sumo Ring Near Ryōgokubashi
Sensō-ji, Asakusa
black and white album plates
7 x 5, 17.8 x 12.7 each
Collection Yūichiro Kōjiro

From *Sui* to *Tsū*

The reversal in the economic relations between the Kamigata and Edo oc-
curred during the two decades from 1760 to 1780, at about the same
time the *Edokko* came to have a psychological framework distinctly his
own. In Edo, the aesthetic notion of *sui,* which had developed in the
Kamigata, became *tsū,* a similar aesthetic notion but with Edo's own flavor.

As an Edo variety of the Kyoto *sui, tsū* was primarily born of the
pragmatic reaction of the merchant to the idealism of the samurai. A man
of *sui,* of the Kamigata, was essentially a man at ease with himself who
wasn't much concerned with lust, but was good at various of the arts:
he practiced calligraphy, served tea according to form, wrote verse and
prose in Chinese, and composed both orthodox and unorthodox *renga*
(linked poetry). Versed in Chinese scholarship and familiar with Nō and
Bunraku, he played the hand drum and *go,* and could even acquit himself
well in dancing. He was well-to-do, cheerful, never jealous. A man of *tsū,*
of Edo, was also required to be familiar at least with *renga,* theater, music,
song and food. But he tended to display greater interest in and knowledge
of the manners and other particulars of the pleasure quarters and the ins
and outs of the relations between man and woman. And overall, he would
be more of an "amorous man" (*kōshoku*) than his counterpart in the
Kamigata.

Both *sui* and *tsū* are notions born among the rich merchants who
could spend generous sums on elaborate pastimes devised in fashionable
places of pleasure. The principal difference between the two notions is
that while *sui* tended to be disposed to interpret favorably the feelings of
another person, honoring them over one's own, *tsū* tended to be more
self-centered. In this sense, *tsū* may be said to reflect the Edo merchant's
awareness of the self.

The red-light district of Edo was completed as early as 1617, only a
dozen or so years after the Tokugawa government took hold. The name
Yoshiwara (Reed Plain) derives from the fact that it was built on lowland

covered with reed and bulrush. The prostitutes at Yoshiwara numbered as many as a thousand by 1642, a strong reflection of the colonial nature of the new city where men outnumbered women by two to one. It must be noted that, as in Osaka and Kyoto, the red-light district in Edo was a place for socializing, and at first rich Edo merchants simply adopted the notion of *sui,* the standard of sophistication in "playing," from the Kamigata merchants.

But following the Meireki Fire, the government moved the red-light district from the city's center, east of the castle compound, to Asakusa in the northeast, near the banks of the Sumida River. The Shin (new) Yoshiwara was allowed to do business all night to make up for the trouble of moving, and its business grew faster than it had before. It quickly became the citizens' pleasure headquarters, in the same way that Edo Castle was the political headquarters for the samurai. And just as Edo Castle had a moat surrounding it, Shin Yoshiwara, nicknamed "Nightless Castle," had a moat of sorts surrounding it, called *ohaguro-dobu* (Tooth-blacking Ditch).

The Tokugawa government did not move the Kabuki theaters and actors to Asakusa until 1841, but from the outset it lumped together the red-light district and the theater district as *akusho* (evil places), and exercised repressive measures, such as the ban of 1629, which prohibited the participation of women in Kabuki, and the ban of 1641 on night operations in Yoshiwara. The removal to Asakusa of Yoshiwara, and much later of the Kabuki theaters, followed similar thinking. Ironically, it was in these "evil places" that a new culture came into being and in the end overwhelmed the moralistic, ascetic culture of the ruling class. The Kabuki theaters returned to the center of the city following the Meiji Restoration in 1868, and Yoshiwara continued its existence in the middle of a residential neighborhood until 1958.

It is said that in the early years of their existence, both Yoshiwara and Shin Yoshiwara had a number of Nō theaters. Undoubtedly, samurai were the predominant customers of these theaters as they were patrons of Nō. But when rich merchants replaced the "country samurai" as the main customers, the standard of behavior required of a sophisticated patron began to be called *tsū,* rather than *sui.*

Tsū and Iki

The number of prostitutes in Yoshiwara, which reached three thousand around 1780, increased to four thousand in ten years, to five thousand in another ten, and exceeded seven thousand at the end of the Edo period. This increase reflected the growing economic power of Edo's citizens, but it also showed the process by which Yoshiwara was opened first to the samurai, then the rich merchants and finally to the larger population. At the same time it must be noted that there were other readily accessible, much cheaper pleasure quarters for the *shokunin* who lived along the banks of the Sumida River and in the areas across the river to the east.

The word *shokunin* covers a lot of ground, but the carpenter, the plasterer, and the *tobi,* the type of construction worker who specialized in working in high places, were three representative *shokunin* of the Edo

period. This was because there were frequent fires in Edo; a total of nearly one hundred "great fires" occurred in the 250-year rule of the Tokugawa government. As a result, many lumber dealers accumulated considerable wealth and went about as men of *tsū,* as did the carpenters, plasterers and the *tobi,* who happened to double as firemen. There were many who earned good wages and were proud of showing off with dash and flair. "Fires and fights are the flowers of Edo," went the saying.

The places "across the river" that were occupied by the *shokunin,* such as Fukagawa and Kiba, flourished in the early Edo period as a base for dealers in fish and lumber, and at the center of this business district was the shrine of Tomioka Hachiman-gū. In the town that was established in front of the shrine there were a good many teahouses catering mainly to people visiting the shrine. The fact that waitresses working at such teahouses began to double as prostitutes is already seen in literature toward the end of the seventeenth century. When such "teahouse women" became professional prostitutes working on their own, seven pleasure places called *oka-basho* developed in Fukagawa around 1780. With the *shokunin* as their main customers, they flourished and eventually threatened the existence of Yoshiwara. What was generated in these pleasure places of Fukagawa and became a fad among the whole *shokunin* class in the early part of the nineteenth century was the attitude or characteristic known as *iki.*

The pleasure quarters that developed in Fukagawa had from the outset a free, informal air unlike Yoshiwara. There, both men and women developed a temperament that was at odds with the "real" Yoshiwara, but was *au courant,* a bit decadent, somewhat violent and lustful. That temperament may be described as *iki.* In reaction to Yoshiwara's stiff formalities of expression, conduct, clothing and language, *iki* favored a straightforwardness that was loud and full of flair but didn't have anything like a hidden feeling. Using a twist on the phrase *harawata ga miesuku* (to read someone's mind), a satirical verse of the day succinctly expressed the *iki* of the *Edokko:*

> The *Edokko* is like the carp-shaped streamer blowing in May; a real big mouth, yes, but nothing at all inside.

In sum, *tsū* was the "real" aesthetic sense of the Low City's rich merchant in formal attire, with a good deal of experience in Yoshiwara, while *iki* was the free, rebellious aesthetic sense of the "downtown" workman in his uniform, who played in the pleasure quarters of Fukagawa. As a result, if the sexual tendency of the former was "amorous," that of the latter was "lustful."

Interestingly, as the notion of *iki* spread through Edo during the early decades of the nineteenth century, it split into two extreme forms. One was a direct descendant of the original and tended to be vulgar, loud and simpleminded; the other was a transcendental form of it and tended to be elegant, subdued and understated. In any case, both forms of *iki* permeated the whole culture of Edo and became part of everyday life: in pleasure quarters, watching *sumo,* going to the theater, reading novels, viewing *ukiyo-e,* and even the manner of dress for various activities.

The Two Meanings of *Ukiyo*

The *ukiyo-e* genre was born out of and grew in relation to Yoshiwara and Kabuki, and it demonstrates the vitality of the Edo population. This art form may not be properly understood in Japan today because it is illegal to own or display the genre of *ukiyo-e* called *shunga* (erotic prints). The *ukiyo* in *ukiyo-e* is written in a combination of characters that are usually translated "floating world," but during the Edo period a homonym of *ukiyo* became popular, which may be translated as "depressing world."

The feudal society of Edo was indeed filled with depressing things. I have already mentioned some of the restrictive measures taken against various forms of pleasure, and the fact that over one hundred fires occurred during the 250 years of Edo. Fires and infectious disease struck the densely populated areas of the ordinary citizens with a calamitous force, especially because their residences were built on coastal lowlands. Under these circumstances, one could vow to overcome the "depressing things"—a rather moralistic approach. Those who "tilted away" from depressing things passed some unworried moments in "evil places," which were not bound by the constraints of the strict class system. It was apparently in such places that the pun on *ukiyo* as used in the term *ukiyo-e* came into being. The first known use occurs in *Sozoro monogatari (Idle Tales)*, published in 1641, which contains a sentence: *Yume no ukiyo ni tada kurue* (Let's get carried away in this floating world of dreams). Though the author of *Sozoro monogatari* is not known, the novelist Ihara Saikaku (1642-1693) explained the term in his preface to *Ukiyo monogatari (Tales of the Floating World)* by Asai Ryōi (d. 1691), published sometime after 1661:

> To sing a song, to drink wine, to console yourself by being carried away while afloat, not to be worried about the last penny you spent, and not to allow your heart to sink holding it like a gourd flowing in the water. That's the way to live in this floating world.

The world perceived was that depicted in *ukiyo-e*. I believe that most people think of the landscape prints by Hokusai and Hiroshige as typically *ukiyo-e*. But theirs are the works that began to be produced toward the end of the Edo period (1830s and 1840s) when the Tokugawa government started restricting the production and sale of pictures depicting Kabuki actors and Yoshiwara prostitutes. Hishikawa Moronobu (1631-1694), one of the founders of *ukiyo-e*, is said to have gone to Edo after the Meireki Fire, where he established his reputation by executing *Yoshiwara no tei (Scenes from Yoshiwara, 1678)* and other erotic and genre prints. He also illustrated the 1684 edition of Saikaku's *Kōshoku ichidai otoko (Life of an Amorous Man)*. In any case, the beginnings of *ukiyo-e* were not images of Kabuki actors or courtesans, but pictures of sexual intercourse, scenes depicting the pleasure quarters, and illustrations for amorous books. Portraits of Kabuki actors followed, but all *ukiyo-e* artists made *shunga*. The core of "the floating world," in contrast with "the depressing world," was an amorous, even lustful world where men and women delighted in one another.

Kitagawa Utamaro
Lovers on a Balcony, from
*The Poem of
the Pillow,* 1788
color album plate
15 x 10, 38 x 25
Collection Victoria & Albert Museum

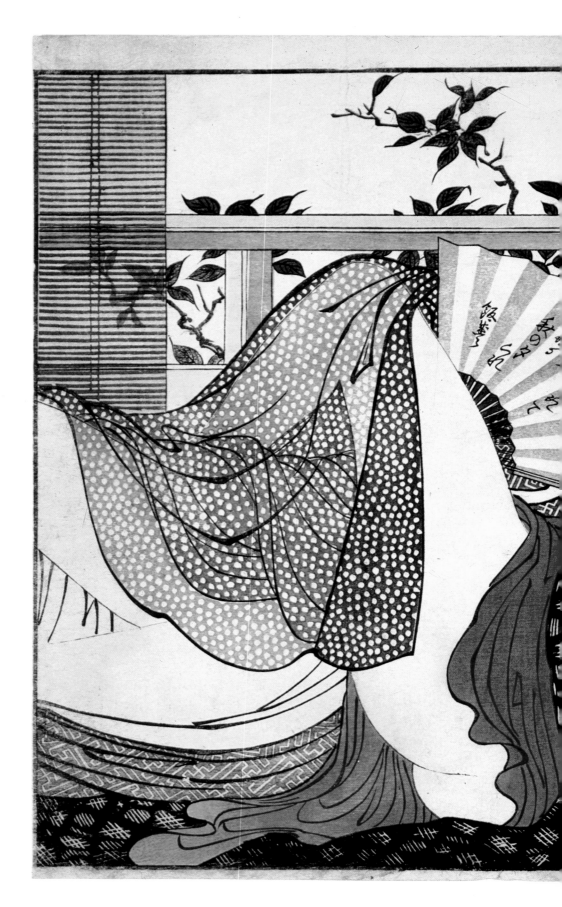

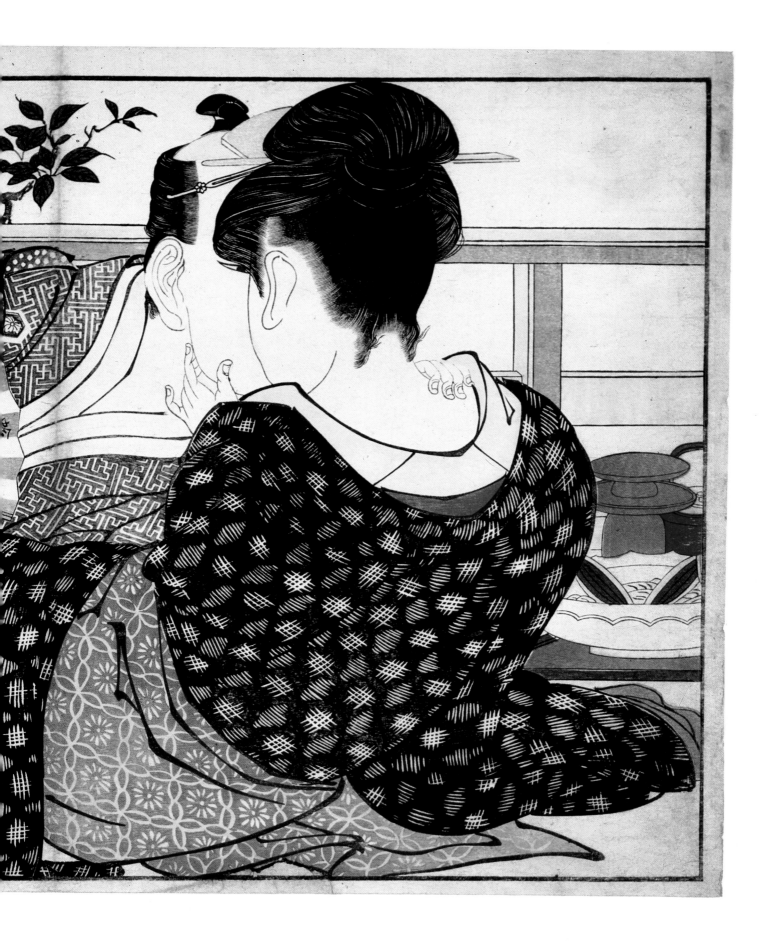

The Nikkō Tōshō-gū gate, Yōmeimon, seventeenth century.

Tokyo: Mixing and Accommodating

Japanese culture is often manifested in polarities: in architecture, Katsura Rikyū (Katsura Detached Palace), which suppresses the use of decoration, contrasts sharply with the Nikkō Tōshō-gū, which is decorated to daunting excess; in objects of worship, the Ise Jingū and Fuji Jinja are on opposite poles; in religion, the Zen sect, which centers on meditation, is different from the Nichiren sect, which centers on social interaction; in art, the formal paintings of landscapes and birds-and-flowers of the Kanō School contrast with the blatant depictions of sexual intercourse in *ukiyo-e*; and in literature, polarity exists between the elegant world of *The Tale of Genji* and the down-to-earth world described in the genre of *share-bon* (slick books).

In discussing Edo and its *katagi* I have taken a similar approach by comparing Edo with Kyoto, and by explaining the "up-down" relationship between Edo and the Kamigata and their eventual reversal. In the development of Edo itself there were polarities: the geographic division between the Yamanote, of the samurai class, and the Shitamachi, of the ordinary citizens; the social and psychological schism between those who attempted to adhere to the moral code, and those who tended to "tilt away" from it. I have described how Edo culture blossomed not in the castle at the center, but in the "Nightless Castle" of Yoshiwara, which was placed on the outer edge, and how that culture was free and amorous, rather than moralistic and ascetic. Edo caught up with the Kamigata by the second half of the eighteenth century, and by the early nineteenth century, as the popular culture of Edo attained its heights, the feudal system had begun to crumble with the weakening of the samurai class. One indication of this process is the revival, in 1846, of portraits of actors and courtesans despite the ordinances banning them. The maturing commercialism toward the end of the Edo period anticipated the coming of modern capitalism.

I stressed that in developing a distinctive Edo culture the spiral-shaped moat of Edo Castle and the national routes that radially connected Edo with other provinces were particularly effective. The culture and the *katagi* mixed and shaped in that environment did not change much even when samurai from remote corners of Japan—such as Chōshū (present-day Yamaguchi Prefecture), Satsuma (present-day Kagoshima Prefecture), and Tosa (present-day Kōchi Prefecture)—gathered in Edo and overthrew the government. Edo, and then Tokyo, mixed them all up. The same held true when the isolationist policy was abandoned and things Western began to pour in. Edo culture and Western culture first coexisted, then compromised, and finally formed an eclectic whole. In other words, Tokyo culture, too, was the result of a mixture.

During the Meiji period of Westernization popular belief held, "The Imperial Theater today, Mitsukoshi tomorrow." The Imperial Theater, in Western style, was built especially to present productions of Western music and theater, while Mitsukoshi was a department store, also built in Western style. Performances of Western music and theater coexisted with performances of Kabuki, and at Mitsukoshi, both traditional kimono and Western apparel were sold.

Just as during the isolationist period when everyone from all over Japan came to Edo and made up a *katagi* peculiar to the city, so, after the country was reopened, not only did people come from all over Japan but people from Europe and the United States came to Tokyo and gradually created the *katagi* that characterizes the city today.

Edo's culture was matriarchal taking into its fold both good and bad sons. It was not a patriarchal culture that killed or drove away sons who weren't up to standard. It did not seek to attain purity through deductions and deletions. It continued to create something new through additions, mixture and blending. Now that the post-World War II period of single-minded modernization is over, the matriarchal, productive *katagi* of Edo and early Tokyo seems to be stirring again.

Translated by Hiroaki Sato

(gatefold)
Artist unknown
Musashi Plain, seventeenth century
pair of six-fold screens; color, gold,
silver on paper
66½ x 149, 168.9 x 378.4
Collection Virginia Museum,
Glasgow Fund, 1983

A motif of tall autumn grasses and wildflowers extends across this pair of screens against a rich green ground. The upper half of the screens is covered with a broad band of gold clouds. In the right screen, low on the fourth panel from the right, a silvery moon can be seen sinking into the ground. The left screen is dominated by the unmistakable triangular shape of Mount Fuji rising majestically through the clouds. The strong lateral character of the composition is subtly balanced by the fluid, but decidedly vertical character of the grasses and flowers, and by the contrast between a circular moon and the near perfect triangular peak of Fuji.

The Musashi Plain extends west from Tokyo. For centuries its primary characteristic, memorialized in poetry since the tenth century, was the thick overgrowth of tall grass. The moon, particularly beautiful in autumn when skies are clear, is a long standing symbol of that season. Since the earliest recording of Japanese thought in the eighth century, Mount Fuji has been a singular image, one that has inspired awe, myths, legends and countless poems. A combination of these three elements is appropriately brought together in painting since Mount Fuji is clearly seen from Musashi, and autumn is the season when the grasses have reached full growth.

A combination of this imagery can be found in two poems:

On the Musashi Plain
There is no mountain
For the Moon to enter
From the grasses it rises
And into grasses it sets

Does the sky know summer?
At Fuji's base
White snow thick
Above the grasses
Of Musashi Plain[1]

Although a single verse that describes all of the elements in the painting has not yet been identified, it seems certain that the artist was inspired more by poetry than actual scenery. The practice of making literary allusions the subject of paintings, as well as the subject of decoration on ceramics and lacquerware, enjoyed particular vogue in the seventeenth century. Among the *Rimpa* artists, in particular, allusions to classical literary works such as *The Tale of Genji, The Tales of Ise,* and to poetry, are numerous. Furthermore, a number of paintings of the Musashi Plain, Mount Fuji, and the moon are extant. Their numbers suggest that after Japan was finally united in peace after many generations of warfare, the Japanese relaxed enough to enjoy their classical culture anew. Members of the growing wealthy merchant class were the perfect clients for the painting produced by the *machi-eshi* (anonymous town painters) of the seventeenth and eighteenth centuries.

It has been suggested that poetry alone was not sufficient inspiration for these screens. A certain specificity of detail, such as the shape of the mountain and the precise depiction of three wildflowers, the Chinese bellflower, bush clover, and wild carnations, indicate that a broad knowledge of Edo and its environs precipitated their composition. Nevertheless, a fine poetic quality and an impressive depth of emotional expression, enhanced by the sense of distance and deep, endless grass, are the dominant effects of this screen pair.

Emily Sano

1. *Autumn Grasses and Water: Motifs in Japanese Art* (New York: Japan Society, 1983), p. 34.

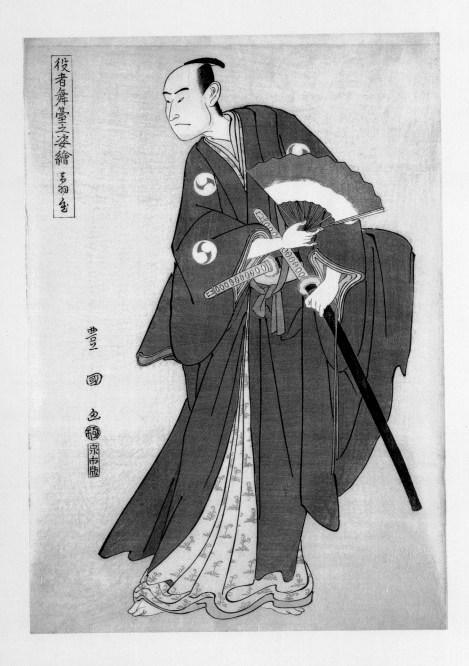

役者舞臺之姿繪

豊国

Utagawa Toyokuni
Actor Onoe Matsusuke as Yuranosuke,
circa 1795
color woodblock print
15⅞ x 10½, 40 x 26.7
Collection The Minneapolis Institute of Arts,
Bequest of Richard P. Gale

(opposite)
Kitagawa Utamaro
Balcony Scene, Edo period
color woodblock print
triptych, 15 x 10³⁄₁₆, 38.1 x 26 each panel
Collection The Cleveland Museum of Art,
Gift of Mr. and Mrs. J.H. Wade

Ukiyo-e

The term *ukiyo,* despite its association
with a colorful artistic tradition in the Edo
period (1603-1868), was derived from
the solemn Buddhist term that referred
to the transitory nature of human life in
"this world of suffering." During the
seventeenth century *ukiyo* was adopted
to describe an almost hedonistic and
ephemeral attitude toward life, shedding
its religious tone in favor of a worldly
one. The art forms that captured the
essence of this spirit were the painting,
book illustration and prints collectively
referred to as *ukiyo-e* (Pictures of the
Floating World), which flourished during
the three centuries of the Edo period.

The Japanese woodblock print
matured gradually over the course of
a hundred years, evolving from book
illustration to the single-sheet print
(ichimai-e). The townspeople were the
primary audience for *ukiyo-e* and despite
their insatiable demands on the *ukiyo-e*
artists, most masters of the media were
guided by strict standards of judgment
and quality. Women scrutinized prints
for clues to the latest fashions, and men
bought them for their striking portrayals
of actors or widely acclaimed courtesans.

As the only avenue of entertainment
and erotic diversion for the *chōnin,*
the Yoshiwara was a frequent *ukiyo-e*
theme. Hishikawa Moronobu
(1631-1694), a pioneer in the production
of print albums, established his
reputation with illustrations of everyday
life, particularly that of the Yoshiwara.

Included among the depictions of
urban Edo culture were figures of
women: courtesans and their attendants,
geisha, and women of high social status.
Pictures of beautiful women *(bijin-ga)*
were among the most popular *ukiyo-e*
subjects. Suzuki Harunobu (1725-1770),
responsible for elevating the level of the
full-color woodblock *(nishiki-e),*
produced *bijin-ga* that idealized a dainty,

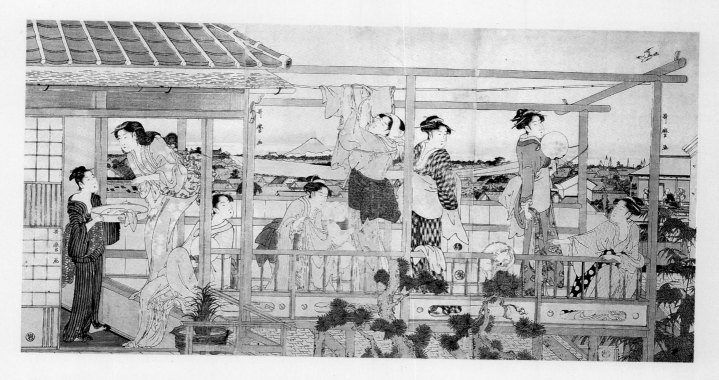

fragile beauty. The style of Torii Kiyonaga's (1752-1775) voluptuous and statuesque women dominated the genre in the late eighteenth century, and his influence is seen in the work of Shuncho, Toyokuni and Utamaro. However, it was Kitagawa Utamaro (1753-1806) who, more than any other *ukiyo-e* artist, devoted his life to the illustration of women—the courtesan suffering in love, the wives and daughters of merchants, as well as drunken prostitutes. He also recorded images of women in everyday activities—kitchen maids, for example. Utamaro brought *bijin-ga* to its maturity by concentrating on close-ups of women that expressed a distinctive style of feminine beauty, hitherto unknown.

The spectacular costumes, lavish makeup and magnificent sets of the Kabuki theater provided exciting images for the *ukiyo-e* masters, despite the constant government restrictions on the theater and on theater prints themselves. Many *ukiyo-e* artists produced *yakusha-e* (actor pictures). The dominant style of actor prints in the early period of *ukiyo-e* was created by the Torii family. They specialized in signboards for Kabuki theaters and in the portrayal of the *aragoto* acting style,

particularly under the school's founder, Torii Kiyonobu (1664-1729). The style of *yakusha-e* underwent a revival in the 1760s, influenced by the realistic portrayals of masculine actors by Katsukawa Shunsho (1726-1792). Shunsho's followers Shunko and Shunei excelled in this genre too, especially in dramatic *ōkubi-e* (close-up portraits). Tōshūsai Sharaku is perhaps the best known, yet most enigmatic *ukiyo-e* figure. His output of actor prints, the most striking being *ōkubi-e* set against a mica background, spans only a ten-month period. The last period of *ukiyo-e* actor prints was dominated by the Utagawa school, with expressive *yakusha-e* by Utagawa Toyokuni (1769-1825) and his student Utagawa Kunisada (1756-1864).

To a society thriving on the idea of the *ukiyo*, the enjoyment of sports was not excluded. Sumo, for example, reached a pinnacle of popularity during the Edo period, and many Katsukawa

school artists found in sumo a fertile motif. Shunsho and Shunei produced a number of *sumo-e*, in which corpulent wrestlers fill the space of the picture. While the Katsukawa school dominated this genre in the eighteenth century, Kunisada and Kuniyoshi were its nineteenth-century masters.

Landscape prints commonly appeared in numbered series with themes such as Mount Fuji, the provinces, and famous places in and around the cities, especially Edo. The most famous landscape artists were Katsushika Hokusai (1760-1849) and Andō Hiroshige (1797-1858). Hokusai's reputation as a landscape-print designer is primarily due to the sets he produced around the 1830s such as the forty-six prints in the *Thirty-six Views of Mount Fuji* (1829-1833). Hiroshige was catapulted to fame after a lengthy trip with a shogunal procession along the Tōkaidō, resulting in his picturesque series, *Fifty-three Stations of the Tōkaidō* (1833-1834). His last great series *One Hundred Famous Views of Edo* (1856-1858) demonstrates his mastery of the mid-nineteenth-century landscape print.

Amy Reigle Newland

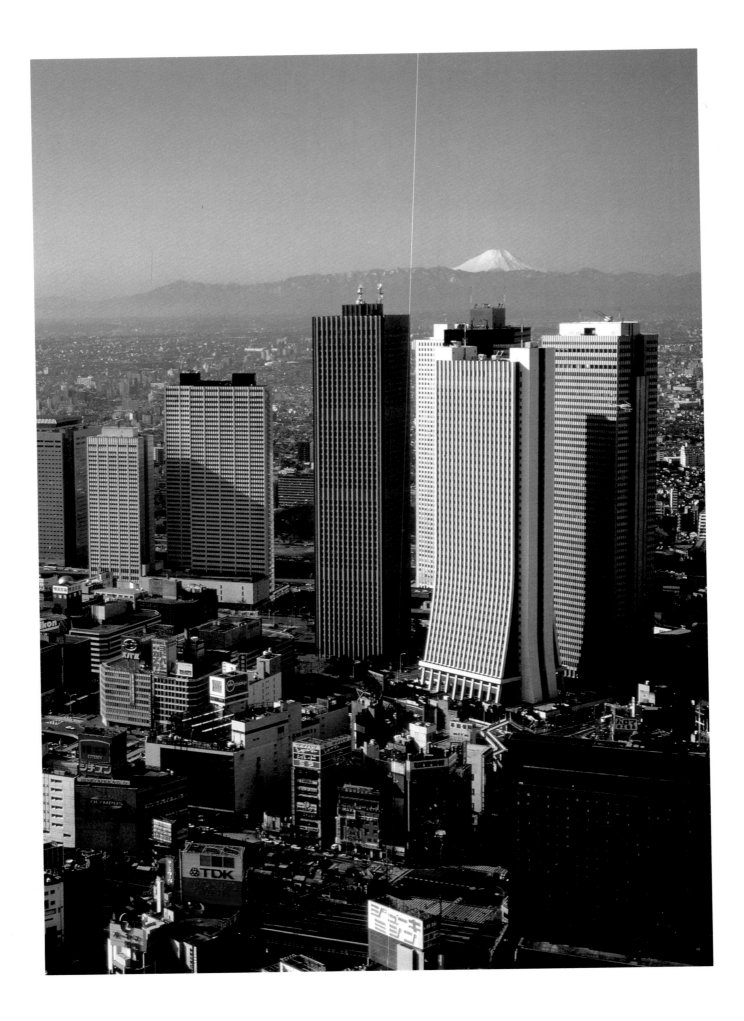

Order and Anarchy:
Tokyo from 1868 to the Present

William H. Coaldrake

Shinjuku, one of Tokyo's rapid-growth subcenters, sprang up in the 1960s.

Tokyo invites description but defies analysis. It is intimate in scale despite its mind-shattering size, infinitely varied while remaining homogeneous, Westernized, yet insistently Japanese. Although the city somehow resists interpretation it has a sense of its own identity that sets it apart from other Japanese cities and from other national capitals.

Much of the character and complexity of Tokyo can be explained by the frenetic rate of change that has taken place since 1868, when the castle city of Edo became Tokyo, capital of the Meiji imperial state. The physical appearance of the city has altered dramatically in little over a century, with Tokyo acting as the physical focus of Japan's transformation from a secluded, feudal backwater to a key position at the crossroads of international trade and technology.

On the surface there appears to be little relationship between the provincial castle city of late Edo and the mercantile metropolis of today. The high-rise towers at Shinjuku and the orderly buildings of Marunouchi seem far removed from the castle complex surrounded by a sea of single-story dwellings described by a member of Commodore Perry's 1853-1854 expedition to Edo.[1] The built-up area of modern Tokyo extends beyond the horizon and forms a continuous urban area of over twenty-eight million people upon the "extensive plain with a magnificent background of mountains and wooded country" of 1854. Reclaimed land and port facilities now fill much of the Edo Bay in which Commodore Perry anchored to negotiate commercial and diplomatic treaty concessions for the United States.

The period since the end of the Tokugawa Shogunate and the official designation of Edo as Tokyo has been characterized by constant change. The growth of Tokyo's economy and population has consistently outpaced the efforts to channel it into coherent physical form. Planning has encouraged rapid growth at the expense of the urban fabric. The disruptive effects of change have been magnified by intermittent crises. The Great Kantō Earthquake of 1923 and its subsequent fires obliterated much of the Westernized architecture and city planning of the late nineteenth and early twentieth centuries. Fire-bombing in March 1945 decimated central Tokyo and its surrounding suburbs. The oil crises of the 1970s drastically slowed the momentum of the postwar economic miracle and forced reevaluation of existing city planning and construction programs. Yet in examining the evolution of Tokyo since Edo it becomes apparent that a deeper order lies beneath the surface anarchy and accounts for Tokyo's distinct and coherent character.

1. Correspondence of the New York Tribune, 14 May 1854, and article from the China Mail (undated), collected in, George Preble, Tracts on Japan, Gift to Widener Library, Harvard University, 1865.

(above)
Akasaka *mitsuke* (approach to castle gate); new expressways subsume the old castle moat.

Akasaka Castle Gate with *jinrikisha*, 1872.

Edo to Tokyo: 1868 to 1923

The city of Edo suffered an agonizing decline during the final decades of Tokugawa rule. The year after Perry's visit an earthquake and fires destroyed more than half the downtown area. The city struggled to recover, only to be dealt another blow by the shogunate itself. In 1862 the system of compulsory attendance of the regional lords in Edo, which had been a principal reason for the city's growth in the seventeenth century, was relaxed. With the departure of these *daimyō* the population dropped to well below one million from over 1.3 million in the eighteenth century and extensive tracts of land fell vacant. The city's economy lost its mainstay of high-ranking samurai consumers and their retinues.

As the headquarters of the Tokugawa Shogunate, Edo had grown from a cluster of dilapidated villages to become the largest city in the world in the space of a few short generations.[2] With the collapse of the shogunate and the restoration of imperial government under the Meiji Emperor in 1868, Edo lost its political rationale. Edo outlived the demise of its shogunal creators by serving as a political instrument for the new establishment as it had for the old. Yet the new government needed a new physical context. It was impractical as well as a little incongruous to operate the restored imperial government from behind the gates of the old feudal mansions, although for a while they did. Public buildings in Western styles were essential to the consolidation of the consciously Westernizing state, and to symbolize a new and effective political order to the encroaching Western powers. As part of a broad spectrum of reforms in government, law, military affairs, economics and industry, the Meiji government set out to rebuild Tokyo along the most advanced principles of contemporary Western urban and architectural practice. Their first attempts were eclectic curiosities. There were no Japanese builders skilled in Western construction techniques and Western architectural styles

2. See William H. Coaldrake, "Edo Architecture and Tokugawa Law," *Monumenta Nipponica*, vol. XXXVI, no. 3, Autumn 1981, pp. 235-284.

were only vaguely understood. Buildings such as the Tsukiji Hotel, the first official government guest house constructed in 1868, projected what the Japanese believed to be a Western countenance to the outside world. In reality these early buildings were only traditional timber-frame structures awkwardly capped with Western accretions such as cupolas and towers.

A major fire destroyed much of the older downtown sector to the immediate southeast of the Imperial Palace in 1872, providing the Meiji government with the opportunity to attempt a concerted urban modernization project. Thomas J. Waters, a British architect and planner, was commissioned to build a new Western-style, fireproof commercial district that became known as the Ginza. Waters laid out a broad avenue southwest from Kyōbashi and lined it with neoclassical brick buildings covered with a veneer of portland cement. In order to facilitate the project, it was decided to make the English foot equivalent to the Japanese *shaku* so that Waters could draw up plans on the basis of his customary unit of measure and the Japanese could execute them on the basis of theirs.[3] To the Japanese, the Ginza, with its colonnaded sidewalks and paved road illuminated at night by gaslight, was a marvel of modernity.[4]

The Ginza had a profound influence on architecture in Meiji Tokyo. It offered the Japanese a tangible model for progress, a physical embodiment of *bummei kaika*, the "cultural enlightenment" of Westernization, and ushered in an era of brick construction. This exotic foreign material was enthusiastically adopted for a wide range of public and commercial buildings for several reasons. It was fireproof, could be easily manufactured, would permit larger-scale construction than wood, and it seemed to the Japanese to epitomize the building traditions of the West. Its seismic shortcomings mattered little in this age of preoccupation with Westernizing progress, although it was to be bitterly regretted later.

Another Englishman, Josiah Conder (1852-1920), became the most influential architect of the Meiji period (1868-1912). He was invited to Japan by the government in 1876 and spent most of his professional life there. Conder promoted the Second Empire style, with its heavy, symmetrical facades of brick and masonry construction and high mansard roofs, as the symbol of the Japanese establishment, in the same way that it served governments in Western Europe and Washington, D.C. His Rokumeikan (Hall of the Crying Stag), completed in 1883, epitomized the country's flirtation with foreignism. Constructed in a restrained Second Empire style, this club was used as a center for contact between foreigners and Japan's social and political elite, who were bent on demonstrating their assurance and sophistication in Western customs.

Separate private and governmental planning initiatives begun during the 1880s and 1890s redefined central Tokyo to the south and west of the Imperial Palace. The Hibiya-Marunouchi area at the front of the palace, a burnt-out wasteland long after the 1872 fire, was purchased in 1880 by Iwasaki Yanosuke, son of the founder of the powerful Mitsubishi business and industrial empire. In 1893, when he consolidated Mitsubishi into an even more powerful financial institution, Iwasaki redeveloped this area as the center of Mitsubishi corporate power. Conder was placed in charge of planning the district. Three-story, red-brick buildings in the Second Empire style were built along paved avenues in imitation of the business district of London (thus its name Mitsubishi Londontown). The initial structure was the First Mitsubishi Building, a collaborative project between Conder and his former student Sone Tatsuzō. Sone had been trained by

3. Terunobu Fujimori, *Meiji no Tōkyō keikaku (The Plan of Meiji period Tokyo)* (Tokyo: Iwanami shoten, 1982), p. 11.
4. Teijirō Muramatsu, *Nihon kenchiku gijutsushi (The History of Technology of Japanese Architecture)* (Tokyo: Chijin shokan, 1959), pp. 34-36.

Hasegawa Settan
Daimyō at the castle moat, New Year's morning, from vol. 1 of *Tōtō Saijiki,*
nineteenth century
black and white album plate
7 x 5, 17.8 x 12.7

(opposite)
View of National Museum of Art, Ueno Park, Tokyo, 1985.

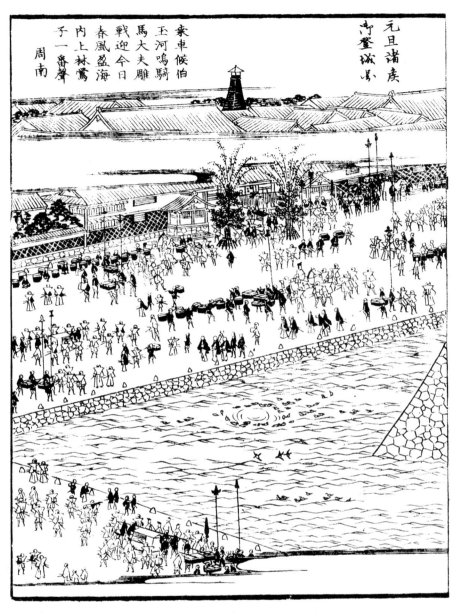

5. Fujimori, *op. cit., Meiji no Tōkyō keikaku,*
p. 213. Kōta Kodama and Hiroshi Sugiyama,
Tōkyōto no rekishi (History of Tokyo), from
Kenshi shirizu 13 (Tokyo: Yamakawa, 1969)
pp. 308, 309.
6. Kodama and Sugiyama, *Ibid.*

Conder in Western construction techniques at what later became the Faculty of Engineering at Tokyo University. Thirteen more buildings of a similar monolithic type were to be built over the next seventeen years.[5]

In 1893, at the same time that the Hibiya-Marunouchi district was being developed under Mitsubishi sponsorship, the Ministry of Internal Affairs decided that a major railway station should be built in the center of Tokyo adjacent to Marunouchi as part of plans to expand the metropolitan train system. The first steam locomotive service in Japan had been established as early as 1870 between Shimbashi and Tokyo. The new plan called for a line connecting Shimbashi with Ueno in the northern part of the city. With its completion in 1914 the transport and business focus of Tokyo shifted from Shimbashi to the Marunouchi district.[6]

The new Tokyo Station building was constructed by another of Conder's students, Tatsuno Kingō. One of the best-known landmarks in Tokyo today, this expansive Empire-style building was more grandiose than the Rokumeikan and Mitsubishi buildings. With its bright red-brick and masonry quoining, a high mansard roof above the central hall, and large octagonal cupolas over the flanking wings, the station defined the approach to the Marunouchi district from the southeast.[7] The building has a more restrained appearance today than it had in 1914 because its cupolas were destroyed in the 1945 fire-bombing.

In the mid-1880s the Meiji government centralized its main administration buildings to the west of the Imperial Palace in a belt of land sweeping down from the high ground of Kasumigaseki into Hibiya near the Sakurada Gate. A succession of large, brick buildings with multiple towers and domes was constructed in this area, starting with the Ministry of the Army and Navy in 1884, the Ministry of Justice in 1885 and the High Court in 1886.[8] This area remains the hub of Japanese government administration to the present day.

An Architecture Bureau was established in 1886 as part of the Ministry of the Cabinet to coordinate the planning of a new Diet Building for the Japanese parliament. In early Meiji the Japanese had used Bismarckian Prussia as a model for their new government. They now decided to adopt the physical as well as the theoretical forms of German statecraft and to create a Prussian-style government complex in Tokyo. Hermann Ende (1829-1907) and Wilhelm Böckmann (1832-1902) were invited to Japan to plan the buildings. When they devised a stolidly symmetrical teutonic structure capped with a fanciful cross between a cupola and a pagoda for the new Diet, the program ground to a halt. Ende and Böckmann at least realized that there was a need to reconcile indigenous traditions and foreign building styles, but the solution they offered was too much even for the Meiji Japanese.

The official flirtation with German architecture in the period from 1886 until 1890 ended the period of English domination over Meiji architecture. Seventeen builders were sent to Germany where they learned carpentry, masonry, bricklaying, roofing and decorative techniques, including painting and stained glass. Upon their return, these skills were put to good use in elevating Japanese building standards. Tsumaki Yorinaka, another architect initially trained by Conder at Tokyo Imperial University, worked in the Berlin studio of Ende and Böckmann. He later designed the Tokyo Court Building, Finance Ministry and Interior Ministry Buildings in the Kasumigaseki-Hibiya district, in a style that reflected the baroque leanings of his teutonic tutors.

Perhaps the ultimate Meiji architectural monument was the Akasaka Palace. Completed in 1909, it still stands in singular splendor on the site of the former Kii *daimyō* mansion on what was the outer moat of Edo Castle. It was designed by Otokuma Katayama as a scaled-down version of Versailles, translated into a German-inspired neo-baroque idiom. Like so many Meiji buildings, its technical accomplishments far outweigh its stylistic value. In addition to such modern conveniences as plumbing, electricity and central heating, it was built with a steel frame supplied by the Carnegie Works of Pittsburgh. Brickwork and masonry were affixed to the frame with metal clips to reinforce the cladding against earthquake vibration.

7. Teijirō Muramatsu, *Nihon kindai kenchikushi nōto (Notes on the History of Contemporary Japanese Architecture)* (Tokyo: Sekai shoin, 1968), pp. 78-108, 327, 328.
8. Fujimori, *op. cit., Meiji no Tōkyō keikaku*, p. 209.

Thus by the early twentieth century the ambitious programs to Westernize the nation had borne fruit. From a position of military vulnerability in 1868 Japan had moved to a position of international strength and recognition. The muscles of her new army, navy and industry had been successfully flexed on China in the war of 1894-1895, and czarist Russia was defeated decisively a decade later. Britain accorded Japan virtual "great power" status with the signing of the Anglo-Japanese Alliance in 1902. At the same time, Tokyo had become an impressive center of government for the new state, as well as a major center of trade, industry and educational institutions. By 1920 the city's population had swelled to 2,159,308, ranking it fifth in the world after New York, London, Paris and Chicago.[9]

Hindsight reveals that Meiji architecture and planning in Tokyo, although a remarkable achievement for the new state, also had serious shortcomings. As had been the case with Edo, Tokyo was created to serve the ends of power rather than to meet the practical needs of its inhabitants. Planning policies were arbitrary, concerned with image as much as substance, particularly image in relation to the Western powers. There was little thought for equitable representation or responsiveness to the needs of the populace. As far as architecture was concerned, there had been considerable technological progress within the span of a single generation but this had been unashamedly imitative, not closely related to indigenous physical and cultural conditions. As Frank Lloyd Wright remarked in 1923 after designing the new Imperial Hotel in Tokyo:

> Japanese culture has met with Occidental Architecture as a beautiful work of Art might meet a terrible "accident." It is trampled and obliterated by the waste of senseless German precedents or literally ironed flat by sordid facts brought over from America in ships.[10]

Therein remained the most fundamental problem of modernization: how to express the identity of the Japanese in a new age without slavish imitation of Western forms; how to create buildings and cities that not only addressed the problems of earthquake, fire and image, but also were sympathetic to Japanese climate and culture.

From the Great Kantō Earthquake to the End of World War II: 1923-1945

On 1 September 1923 an earthquake measuring 7.9 on the Richter scale struck Tokyo. The shock and the fires that raged for three days afterward devastated much of Tokyo and neighboring Yokohama. Some 400,000 buildings were destroyed and approximately sixty-five percent of Tokyo's population, or 1.5 million people, were rendered homeless.[11] As Charles Beard (1874-1948), the noted American planner, observed:

> Not since the fire which destroyed three-fourths of London in 1666 had so large a portion of a great city been wiped out. Approximately two-thirds of the Japanese capital lay in ashes—the ground swept bare except in the relatively few squares where stood the wreck and ruin of brick, stone, and concrete structures.[12]

In the wake of this calamity a single building captured both the imagination and mood of its time. Frank Lloyd Wright's Imperial Hotel, completed on the eve of the earthquake, appeared to rise above the ashes of the fires as an affirmation that technology could defeat the forces of nature. Ironically, Wright intended his building more as a statement of the way in which Japanese tradition and Western architecture could be synthesized, but the Japanese saw it as a technical pronouncement, reinforcing their

9. Shimpei Gotō, "Greater Tokyo Plan for 7,000,000 Population. Improvement Program to Make Capital Worthy of High Rank Among Great Cities," *Trans-Pacific,* vol. 5, no. 6, December 1921, p. 45.

10. Frank Lloyd Wright, "In the Cause of Architecture," *Western Architect,* April 1923, p. 44.

11. J.H. Ehlers, "Reconstruction and Development of the Tokyo-Yokohama District," *Cornell Civil Engineer,* vol. 37, January-February 1929, p. 104.

12. Charles A. Beard, "Gotō and the Rebuilding of Tokyo," *Our World,* vol. 5, no. 1, April 1924, p. 11.

Akasaka Rikyū (Akasaka Detached Palace)
of the Crown Prince, 1909.

preoccupation with technology divorced from cultural setting.

The Japanese government attempted to transform the disaster of the Kantō Earthquake into an opportunity to rebuild Tokyo in the most modern Western manner. In what J.H. Ehlers, U.S. Engineering Trade Commissioner to Tokyo described in 1929 as "one of the most comprehensive projects ever undertaken by a modern community," a special Reconstruction Commission set out to modernize transportation by increasing the area of streets and roads by fifteen to twenty-five percent of the city.[13] Zoning for industrial, commercial and residential structures was also planned, along with measures to fireproof buildings and restrict building height to cope with earthquakes.

The detailed plans for these reforms had been drawn up before the earthquake on the initiative of the mayor of Tokyo, Shimpei Gotō, as a basis for projecting the growth of the city thirty years into the future. In the well-established tradition of employing foreign experts, Charles Beard was hired as a consultant for the Tokyo Institute for Municipal Research in 1922-1923. The plans formulated at this time were to serve as the basis for the reconstruction of the city.[14]

These policies achieved some success in the central sector of Tokyo, which had been completely leveled by the earthquake and fires. The area was divided into sixty-six sections in accordance with the earlier plans. Each section was to become a unit for reconstruction in which roads were redrawn and each landowner and landholder was to be given new land. This called for the movement of some 200,000 existing houses. By 1929 it was estimated that nearly 60,000 buildings, primarily lightweight timber-frame residences, had actually been dismantled and relocated to help widen streets.[15]

In areas of the city unaffected by the earthquake, private landholders resisted giving up their property and the zoning plan was not implemented because it cut across the customary pattern of land use in operation for many generations. Moreover, the existence of so comprehensive a plan slowed down the more urgent task of providing shelter for the homeless and new space for business and government. Temporary shelter proliferated and rapidly assumed a semi-permanent nature, as the various government authorities involved debated the niceties of their longer-term schemes.

With the Depression and increasing military problems in the 1930s, little more was achieved. An exception was the completion in 1934 of a Ueno-Shimbashi link to the first subway line, which had been established between Asakusa and Ueno in 1927. By 1939 Shimbashi had been connected to Shibuya farther to the west. However, after the Japanese incursion into China in 1937, there was increased nationalism and conservatism in all aspects of Japanese life. These extinguished the first glimmerings of the International Style brought back to Japan by architects like Kunio Maekawa who had studied with Le Corbusier in Paris. Masonry monoliths decorated with castle or pagoda-style gables and turrets became the officially approved building style. Typical of this period is the main building of the Tokyo National Museum of Ueno, which was completed in 1937.

In 1941 all city planning projects were discontinued in order to concentrate national resources on World War II. As the war situation deteriorated there were increasing shortages of building materials. In 1945 death and destruction from the air became a fact of life.

13. Ehlers, *op. cit.*, "Reconstruction and Development of the Tokyo-Yokohama District," p. 104.
14. *Ibid.*, p. 105.
15. *Ibid.*, p. 107.

Postwar Recovery: 1945-1960

In March 1945, a single night of fire-bombing reduced much of the central part of Tokyo to a burnt-out desert. I can recall my father, the first Australian civilian to enter Japan after the war, describing the city as "ashes from central Tokyo to Yokohama." A persistent memory from my childhood is the smell of raw construction timber as the Japanese rebuilt their city and their lives.

In 1946 reconstruction plans were formulated by the Occupation authorities, who had appropriated the Hibiya-Marunouchi district for their headquarters. The area had emerged from the war scarred but intact. Its central location and buildings of ferroconcrete had survived the incendiaries and made it the obvious focus for the Allied Forces. The Daiichi Seimei Building, at the Hibiya crossing facing across the moat toward the Imperial Palace, became General MacArthur's headquarters.

The Japanese government and the Occupation authorities had different priorities. The Japanese were primarily concerned with the pressing practicalities of rebuilding houses, roads, bridges, schools, and of reestablishing adequate food supply to a population living on, as I recall, grasshoppers, wild birds and root vegetables. The Occupation planners were more doctrinaire, drafting extensive plans for land reallocation, and arterial road links to improve transportation in the city. Both the Japanese and the Occupation authorities agreed on the need to create a modern, Western-style city: the Japanese to restore their capital as a center of government, commerce, culture and self-respect, the Occupation authorities in the belief that a Western city would promote the cause of democracy. In substance, their plans were little different from those proposed before the 1923 Earthquake except for the preservation of areas of agricultural land in the suburbs, and vague affirmations of the need to promote the city as a cultural and social environment.[16]

The complex politics of Japanese and Occupation administrations, cost spirals, and a massive flux of population crippled these plans. Dr. Eiyō Ishikawa, Director of the Construction Bureau of the Tokyo Metropolitan Office, admitted in 1951 that the "past five years have proved by no means a rosy path to reconstruction. . . ."[17] By the end of the Occupation in 1952, little had been achieved beyond short-term solutions to the most urgent practical problems of housing and transportation.

The Economic Miracle and the Oil Crises: 1960 to the Present

With the end of the Occupation, hastened by the Korean War, the Japanese economy grew rapidly, reaching a crescendo with the "economic miracle" of a doubled GNP during the 1960s. The 1964 Tokyo Olympic Games were used as an opportunity to demonstrate Japan's recovery from the war by revealing its new mastery of technology and design in all fields. The Olympic complex with its gymnasium buildings designed by Kenzo Tange on the site of the Washington Heights Occupation forces housing at Harajuku, epitomized the transformation from defeated nation to a newfound materialist ebullience. The high-speed Bullet express train system connecting Tokyo and Osaka, and a monorail link between Haneda Airport and the Yamanote loop line, all impressed foreign visitors to the

16. Eiyō Ishikawa, *Reconstruction of Tokyo—An Interim Report* (The Foreign Affairs Association of Japan, 1951), pp. 5, 6.
17. *Ibid.,* p. 14.

Kenzo Tange's Olympic buildings, completed in 1964, demonstrated Japan's mastery of technology and design to an international audience.

(opposite)
World War II bomb devastation, Tokyo, 1946.

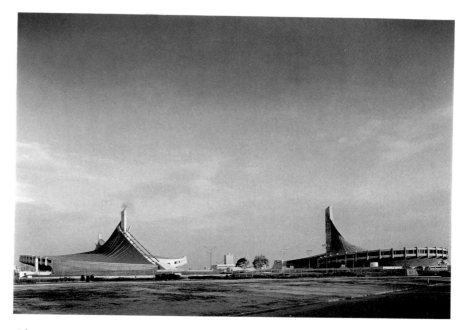

Olympics but projected a self-confidence about the physical environment that was not justified by the Japanese reality.

"Urban planning" in Japan had become sharply polarized between the ideal and the real. The phenomenon of constant and rapid change had spawned the Metabolist movement, championed by Kenzo Tange and younger architects such as Kisho Kurokawa and Arata Isozaki. Metabolism saw the city as a constantly changing organism with a slower metabolic rate for infrastructure and a more rapid replacement rate necessary for living and working units. Tange devised a master plan for linking Tokyo's districts along a new service spine run across Tokyo Bay, but like most Metabolist plans it represented a technocratic utopianism that was impossible to implement.

The reality of urban planning in the 1960s and into the 1970s was gruesomely pragmatic, opportunistic and self-serving. The economic miracle extracted its toll in deterioration in the quality of life in cities like Tokyo. Congestion both in housing and on the roads was accompanied by air and noise pollution, and inadequate services and utilities. Parts of Tokyo that had retained a sense of the past suffered a loss of identity under the physical onslaught of the forces of change. Even the evocative, long-established names of many districts were replaced with rational but unfeeling substitutes as part of the simplification of the nationwide postal system.

In the absence of effective zoning, commercial developments sprang up in residential districts and high-density housing was wedged into already congested neighborhoods. Streets were carved through blocks wherever the opportunity existed, only to become impenetrable jungles of pedestrians, cars, bicycles, telegraph poles, traffic signs, drainage ditches and automatic vending machines selling everything from Coke to condoms. Since 1961 the National Capital Construction Committee and the Ministry of Construction have created a cobweb of 150 kilometers of radial and ring roads that crisscross the metropolitan area.[18] However, the road ratio in the inner twenty-three wards of Tokyo today is still only fourteen percent, far less than the twenty-five to forty percent of most major world cities.[19] The extensive overhead expressways constructed as part of this program have failed to keep up with traffic increases and act more as

18. Tokyo Metropolitan Government, ed., *City Planning of Tokyo* (Tokyo: The Metropolitan Government, 1983), pp. 98-101.
19. *Ibid.*, p. 99.

Tokyo subway station at rush hour.

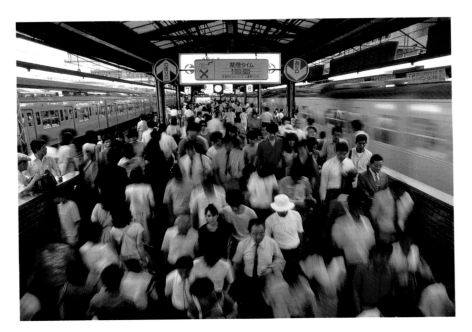

bottlenecks than as arteries. Moreover, they have cast a hostile shadow on the neighborhoods beneath, breaking up their sense of space and place.

Tokyo has become a predominantly middle-class, white-collar, service-sector city, which has had a tangible impact on its morphology. Industrial production has moved away to Chiba and Kanagawa Prefectures and the inner wards are now primarily commercial and residential in character. The city today is dominated by business, information services, research and advertising, with net output from tertiary sector activities reaching seventy percent in fiscal 1979.[20] Factory land in the Tokyo Metropolitan District in 1983 accounted for only 33 square kilometers compared to 203 square kilometers of commercial and 383 square kilometers of residential land.[21]

In the residential areas over the last twenty years a vast, homogeneous middle class has been desperately trying to achieve the dream of "My Home," the single-family, detached residence. It is an ideal hopelessly at odds with the congested realities of Tokyo and other major Japanese cities. A "salaryman" class living in medium density housing makes better demographic sense. Despite this, individual prefabricated houses with sheet-metal walls and tin roofs have proliferated in the interstices between medium-rise concrete buildings or beside railway lines, adding their uninspired ubiquity to the ugliness of the city as the middle class searches for its new identity.

The policy of preserving a "green zone" around the central city wards was abandoned in 1969 as the need to maintain market gardens for food supply to the city was outweighed by the need to provide residential land for a burgeoning population. Tokyo spread to the far horizons as the sum of its parts, not as a measured whole, as commuters were driven farther and farther out from the center by land prices, creating a ring of dormitory suburbs around the twenty-three inner wards and along the main train lines. Tokyo now forms a continuous urban sprawl with much of the neighboring Chiba, Saitama and Kanagawa Prefectures. Nearby smaller cities such as Machida, Kichijoji and Higashi Kurume, once clearly differentiated by agricultural land from Tokyo, have been absorbed in its amorphous expansion.

20. Tokyo Metropolitan Government, ed., op. cit., City Planning of Tokyo, p. 25.
21. Ibid.

Further change to the morphology of the city followed the sudden advent of high-rise buildings at the end of the 1960s. After the 1923 Earthquake the height of buildings had been restricted to 100 *shaku*, effectively ten stories. In 1963 the Building Standards Law was revised to permit high-rise construction in designated parts of Tokyo in order to allow higher density development. Advances in structural engineering permitted the erection of the Kasumigaseki Building in 1968. It rose thirty-six floors to an unprecedented height in Japan of 147 meters using a new flexible-frame construction system. The area to the west of Shinjuku Station, one of the principal transportation nodes in Tokyo, was laid out on an irregular grid plan to create a high-rise city subcenter. A succession of structures climbed skyward. Starting with the Keio Plaza Hotel, the KDD Building and the Mitsui Building, each competed with its neighbors in style and height, projecting a jagged discontinuity into the Tokyo skyline, which is typical of many rapid-growth cities with little urban design control.

The two oil crises of the 1970s struck the Japanese on their most sensitive nerve. The upward spiral in the cost of imported oil had a dramatic effect on national economic growth, and significantly slowed the expansion of Tokyo. Extensive construction programs, drawn up in the later 1960s to develop further Tokyo's systems of transportation, virtually halted. Loop 7, a 57.2-kilometer expressway encircling the twenty-three inner city wards, was completed only in January 1985, after twenty-five major changes in project plans as a result of the oil crisis and citizen complaints.[22] The final stage of the Tōhoku Bullet line linking Tokyo to the north was opened in March 1985, nine years behind schedule.

Whatever the immediate impact of the oil supply problems, it was the sense of crisis engendered by the oil shocks that caused the most profound effects on Japanese society. It called into question the self-satisfied vision of limitless expansion that had accompanied the spectacular growth in the GNP in the 1960s. It forced the Japanese to search for a better quality of life within the existing environment rather than to reach for monumental conceptions of the physical future. Under the successive administrations of Minobe and Suzuki, city government worked to improve the quality of the living and working environment. In response to the problem of shadows cast by the new medium and high-rise structures, a "sunlight" provision was added to the Building Standards Law in 1976 to guarantee a minimum of three hours of sunshine at the winter solstice in residential districts. The Metropolitan Government is currently pursuing a "My Town Tokyo" policy aimed at creating "a safe and invigorating city that the citizens can call their home" and "restoring to Tokyo the neighborly love and sense of brotherhood found in the small towns of the countryside."[23] The policy has achieved some success because it does not attempt to compete with the critical mass of Tokyo as a whole but rather to build on the small community, group-mindedness of most Japanese. It redirects the materialistic urge of the Japanese middle class from "My Car" and "My Home" into "My Town."[24]

22. See *Asahi Evening News*, 18 January 1985.
23. Tokyo Metropolitan Government, ed., *op. cit., City Planning of Tokyo*, Foreword.
24. More than seventy percent of Tokyo residents reported in the 1985 annual survey conducted by the Metropolitan Government that " . . . they feel comfortable about living in the Capital." General improvement in living standards and environmental quality, and careful attention at the local level to community centers, shopping plaza recreation areas, pocket parks and other details of the physical surroundings, are rekindling a shared sense of place. Reported in the *Japan Times Weekly*, 8 June 1985.

The Meaning of Tokyo Today

The history of Tokyo since 1868 has been a ceaseless struggle between order and anarchy. Disaster has repeatedly wiped away many of the conscious efforts to create a coherent physical order. On a less dramatic level, much of the character and form of Tokyo has been defined by a series of personal and pragmatic solutions to the pressing problems of life and livelihood. Compounded on a larger scale these individual problems have challenged city and national government with their enormity, and eroded master conceptions with their cumulative momentum.

Yet there is order in this apparent anarchy, not a consciously planned order but some inexorable, indelible pattern to the growth, development and interaction of people and built environment of Tokyo that has constantly reasserted itself, despite the disjunctions of disasters and the erosion of order by change. Though by no means immutable, Tokyo has maintained its own mysterious but compelling logic of physical forms over the course of the twentieth century. Despite its willful insistence on the here and now, the city has a presence that transcends the present.

The process of change itself helps define Tokyo. Long associated with ideas such as lineage and renewal in Japanese society, change was a constant feature of early capital cities that were rebuilt with the death of each emperor to avoid defilement and to satisfy more mundane ambitions. At Ise, on the Kii peninsula south of Nagoya, the shrine complex is rebuilt systematically every twenty years and change has been elevated to the level of sacred ritual. In Tokyo change has become a secular ritual, whether induced by natural disaster, wartime bombing, government program, business initiative or by individual need. Accustomed or resigned to change in surface forms, the Japanese have become keenly aware of underlying structure, which permits them to recreate frequently in the same pattern despite the ravages of time. As with Ise, change in Tokyo takes the form of orderly renewal. Today it seems as though every block in the inner part of the city is undergoing construction work, as the buildings of the immediate postwar years make way for structures that offer higher levels of safety against earthquakes and more efficient use of space. Throughout the metropolitan area older two-story timber-frame housing is being replaced with steel-framed buildings that permit three-story construction.[25]

Part of the pattern of Tokyo derives from the older castle city of Edo. Though mostly lost beneath the surface of the perceivable present, Edo still provides the foundation for much of the modern metropolis. In many places the distribution between public and private space is preserved from Edo. Actual buildings may have changed but the equations are unmistakable. The large tracts of land occupied by the *daimyō* mansions and Tokugawa castle complex were inherited by the Meiji government. This meant that the public sector was concentrated in the same sectors as in the older city; Edo Castle became the Imperial Palace; the *daimyō* mansions around the castle were taken over by the new organs of government; and the great temple complexes, such as Kan'ei-ji at Ueno, were converted into large public parks.

The circulation pattern of the castle city, based on the spiral swirl of the moat system built by the Tokugawa during the last decade of the sixteenth and early part of the seventeenth centuries, still asserts itself in Tokyo. The Yamanote train loop line traces the moat spiral for much of

25. Katsuhiko Ōno, "Jūtakugai-zukuri katsudō" ("The Activity of Residential Town Construction"), *Kenchiku bunka*, vol. 38, no. 446, December 1983, pp. 138, 139.

Tokyo Station from the Marunouchi side, 1982.

(opposite)
The Foreign Office, Edo (former Kuroda *daimyō* mansion), 1872.

its length, and the Chūō Line seems in danger of falling into it at Kanda and Ochanomizu. At Yotsuya both the subway and the Chūō Line run along the filled-in moat bed while the myriad train lines leaving Tokyo Station skirt the Marunouchi by running along the route of the original moat, which was filled in to provide the land. Even the expressways are sucked into the vortex of its swirl.

The general pattern of the streets also reveals interesting continuities with the past. The streets of the Nihonbashi-Ginza areas, despite all the plotting and planning since 1872, still follow the general lines established in Edo, perhaps in slightly wider and more orderly form. The progression of streets through the Marunouchi-Hibiya district follow the same path as the avenues along which the *daimyō* had their residences. The wide road to the north of the Imperial Palace, now graced by the Tokyo High Court, National Theater of Japan, the British Embassy and Kurokawa's Wacoal Building, is identifiable in panoramic views of seventeenth-century Edo. From Nihonbashi through the Ginza towards Shimbashi, the basic subdivisions established in the Edo period by moats and canals are still the basis for the street system today. The Tōkaidō to Kyoto still runs south out of town along the Edo route through Takanawa, although a procession of trucks and cars has replaced the *daimyō* and their retainers. A recent survey of Tokyo undertaken by the Tokyo Towns Research Group discovered that maps compiled in the 1850s and 1860s can still be used to navigate in many parts of Tokyo, even in places where the individual houses have changed.[26] In these areas buildings may have been transformed from wood, plaster and tile to concrete and steel, but their relationship to the streets often has not altered at all. In the midst of the frenetic cacophony of the present, many streets still speak in the older, quieter language of home life in which urban exterior and architectural interior flow together as part of one living community.[27]

Order and anarchy have something of the opposite meaning in the contemporary experience of Tokyo. Many of the conscious attempts to order the city have ultimately proven anarchic, while the apparent anarchy reveals beneath its surface confusion a deeper, self-perpetuating order. Seismologists now anticipate that a major earthquake equaling the 1923 shock in destructive power will hit Tokyo within the next decade. The damage will be extensive and the loss of life considerable, but the fundamental form of Tokyo will survive, not so much as a result of the extensive emergency planning that has been undertaken by the national and Metropolitan Government, but because of something far more fundamental in its physical and psychological dynamics as a city.

26. Hidenobu Jinnai and Fumio Itakura, *Tōkyō no machi o yomu. Shitaya Negishi no rekishiteki seikatsu kankyō (Reading the Towns of Tokyo. Historical Living Environments of Shitaya and Negishi)* (Tokyo: Sagami shobo, 1981), pp. 23, 24.
27. See further, William H. Coaldrake and Cherie Wendelken, "Streetlife at the Crossroads," *The MIT East Asian Architecture and Planning Program Newsletter*, January 1985.

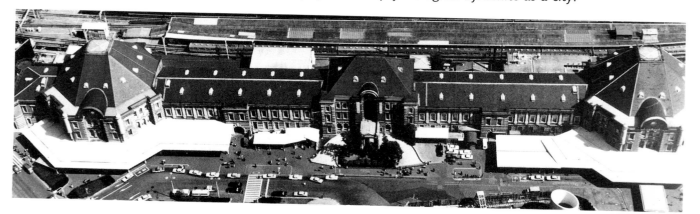

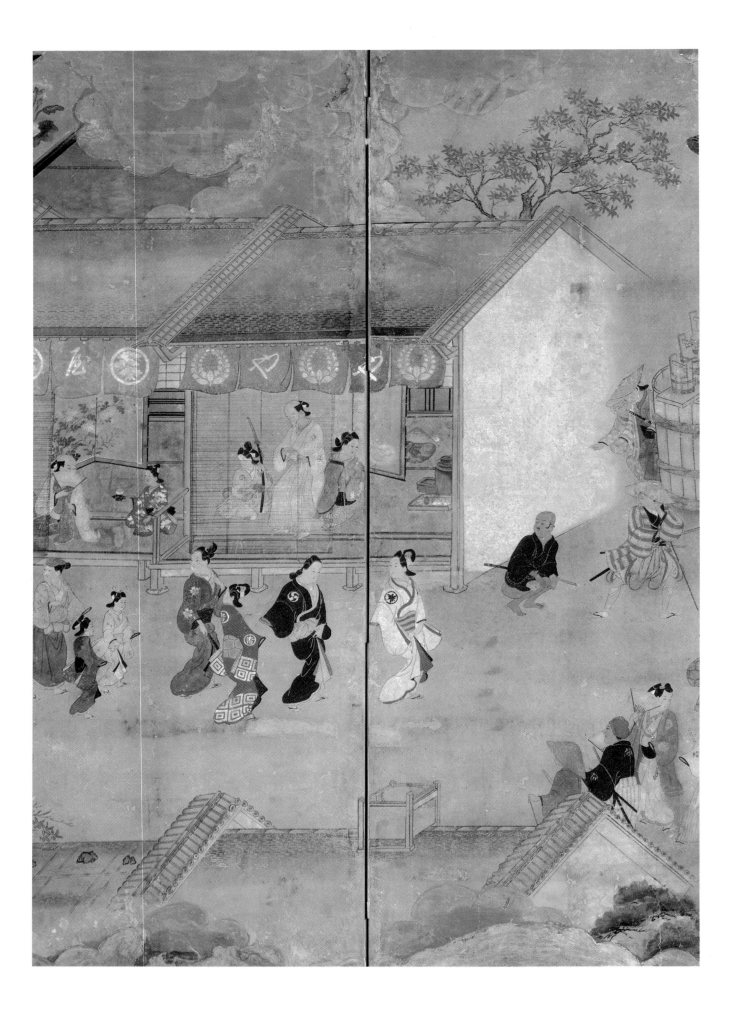

Art and the Edo Spirit

Jōhei Sasaki

The art forms of the Edo period (1603-1868) reflected the lives of the people in the three great cities of Osaka, Kyoto and Edo. Kyoto was the center of handcrafted goods; Osaka, with its navigable rivers and sea routes, was the center for the distribution of goods; while Edo, with its large military population, was essentially a consumer society—the political heart of the Tokugawa Shogunate. The urban panorama animated with bustling activity became the subject matter for Edo paintings. In such paintings the focus was unmistakably the life of the *chōnin*, often representing activities of daily life. The *chōnin* of the early modern cities, bolstered by a sense of financial security, had leisure time that allowed them to form their own salons comparable to those of the military rulers and the court nobility, and to indulge themselves in arts such as *sadō* (The Way of Tea) and *kadō* (The Way of Flowers). Rather than pursuing religious disciplines, the *chōnin* elevated the world of hobbies to that of the spiritual world known as *dō* (way). The people of the pleasure quarters—Yoshiwara in Edo, Shimabara in Kyoto and Shinmachi in Osaka—formed a "society within a society" to which the authority of the feudal system did not extend, and where the power of money reigned supreme. In the cities such districts were accepted as necessary evils; but it was in these districts that the rich cultural products of the Kan'ei era (1624-1644) made their appearance, and the Japanese values represented by such concepts as *sui*, *iki* and *tsū* germinated.

Painting

The art of the Edo period, particularly painting, was characterized by a vigor and diversity previously unknown in Japanese art. The Kanō school, which began with Masanobu (1434-1530) and achieved greatness under his son Motonobu (1476-1559), dominated the world of painting as the official school of the *bakufu*. Even in the early Edo period, the Kanō painters held a controlling position as *goyo-eshi* (official painters to the shogun). The school later became fractionalized, and the result was a polarization of the school between the Kyō Kanō in Kyoto, under the lead of Sanraku (1559-1635), and the followers of Kanō Tanyū (1602-1674), who renounced succession to the main Kanō line in 1617 and moved to Edo to form the Edo Kanō. After having been granted a house in Kajibashi by the shogunate, the position of the new Edo branch of the Kanō was assured a place as the official painting school. An influential artist and connoisseur, Tanyū established the academic art standards of the

Tokugawa government. Working in diverse brush styles—monochromatic *suiboku-ga* (ink paintings) to *kinpeki-ga* (color and gold paintings)—Tanyū painted numerous works in large and small scales. Examples of his paintings on *fusuma* (sliding door panels) are found in such places as the Shōrakuden portion of Nagoya Castle, Nijō Castle and Daitoku-ji in Kyoto. Although painters of the Kanō school continued to hold a position of power after Tanyū's time, as *okakae-eshi* (official painters) to various *daimyō,* they were content to simply maintain their family tradition. No new stylistic developments were produced henceforth. Their art mirrored the elegance and moral attitudes that were expected by the Tokugawa regime: art was to ennoble man, illustrate good government and suggest virtues. Despite the stultifying nature of the official school, rebels did surface such as Kusumi Morikage (active latter part of seventeenth century) and Hanabusa Itchō (1652-1727), the latter often affiliated with the *ukiyo-e* school.

Contemporary with the Kanō school, the Tosa school of painters to the imperial court continued the orthodox tradition of *Yamato-e* (Japanese-style painting), which developed in the Heian period (794-1185) in contrast to Chinese-style painting. In a state of decline since the days of Tosa Mitsunobu (1434-1525) and his grandson Mitsumoto, under Tosa Mitsuoki (1617-1691) the moribund Tosa *edokoro* (painting academy) was revived. As *edokoro no azukari* (a painter affiliated with the court), Mitsuoki was especially well-known for his delicate renderings of birds and flowers, and his screens of bending grasses. Mitsuoki's work represents a strange paradox as he incorporated Chinese painting techniques and subjects in order to revive a school whose major goal was the adherence to Japanese subject and technique.

Truer to the Tosa style, however, was the artist Jokei (1599-1670) and his son Gukei (1631-1705). Jokei created the Sumiyoshi school named for the thirteenth-century artist Sumiyoshi Keion.

Peace, prosperity and the status associated with money gave rise to an artistic style patronized by the rich and the merchant class. This new style utilized the canons of Momoyama-period art, adhering to nature and creating an art form in which foreign influence was forgotten and native sensibility strengthened. The shapes of objects became important; flat colors were applied to describe form, and gradation gave way to a more descriptive linear outline. Founded by Hon'ami Kōetsu (1558-1637), in conjunction with Nonomura Sōtatsu (active seventeenth century) and continued by Ogata Kōrin (1658-1716), it was characterized by the lavish use of color and decorative patterning. Although the school is called *Rimpa* (loosely, the school of Kōrin) because Kōrin was its primary practitioner, the style's beginnings are traced to Kōetsu. *Rimpa* was mainly associated with Kyoto until the end of the seventeenth century when it became popular in Edo.

Kōetsu was an artist of great skill and his talents included painting, calligraphy, pottery, metalwork and lacquer. As a respected artist, Kōetsu was granted a tract of land north of Kyoto, in Takagamine, by the Shogun Ieyasu. It provided a refuge where his colony of artists could work undisturbed.

Very little is known about Sōtatsu, as with many *Rimpa* artists. Sōtatsu, who found inspiration in *Yamato-e,* invigorated and modernized this tradition. Ingenious compositions, brilliant colors and soft, lively lines without strict adherence to old prescribed techniques, characterize his work. Many of the subjects in Sōtatsu's work were derived from classical literature of

(detail of handscroll)
Nonomura Sōtatsu
Hon'ami Kōetsu, calligraphy
Deer Scroll, late Momoyama period
ink, silver, gold on paper
12½ x 30¾, 31.8 x 78.1
Collection Seattle Art Museum,
Gift of Mrs. Donald E. Frederick
(51.127)

the Heian period and demonstrate his genius of conception.

Kōrin was the son of a rich merchant and matured as an artist during the colorful Genroku era (1688-1704). He painted in an informal style, creating a world of design based on the uses of color and composition different from Sōtatsu's, and his decorative tendencies were highly refined. His works include those with subjects chosen from traditional *Yamato-e* themes, but his forte was the depiction of flowers and plants. His stylized treatment of subject matter concealed a delicate sensibility, well-suited to the tastes of the period. Kōrin's younger brother, the potter Ogata Kenzan (1663-1743) also executed paintings in the *Rimpa* style. Toward the end of the period, Sakai Hōitsu (1761-1818) painted what remain some of the most lyrical works of the time.

Fūzoku-ga (Paintings of Customs and Manners, also referred to as genre paintings) had begun to appear during the Momoyama period (1568-1603), and with the Edo period the form was greatly advanced. Particularly in the Genroku era, *fūzoku-ga* gave rise to an art form that truly reflected popular taste, a form that was made for and by the masses. The urban life of the Edoite, most often associated with ephemeral pleasures, inspired a diversity of new pictorial themes in a school known as the *ukiyo-e* (Pictures of the Floating World). The idea of the floating world, associated with the transitory nature of Edo society, is stylistically broken down into two phases: first, *fūzoku-ga* and second, woodblock prints.

Genre paintings were often enlivened by scenes of leisure—theater, music, dance. Acquainted with the forms of pleasure openly available to the Edoite, artists like Itchō instill humor, an important element in Edo-period painting, and at times satire (he was eventually exiled for satirizing the shogunate) in their work.

Hishikawa Moronobu (1631-1694), the son of an embroiderer, opened up new technical possibilities for the *ukiyo-e* tradition. Moronobu studied illustrated books of the *machi-eshi* (anonymous town painters) and produced paintings and prints based on this style.

The earliest woodblocks were printed in black only. The two-color print was not invented until the 1740s, and gradually the number of colors was increased, culminating in the elaborate polychrome prints known as *nishiki-e* (literally, brocade prints) around 1765. Many artists worked in color prints, beginning with Suzuki Harunobu (1725-1770), who is known for his depictions of beautiful women *(bijin-ga).* Among artists who worked

(gatefold)
Hishikawa Moronobu
Gardens and Pavilions of Pleasure,
seventeenth century
six-fold screen; ink, color on paper
30¾ x 91¾, 78.1 x 233
Collection The Nelson-Atkins Museum of Art,
Nelson Fund

(opposite)
Enkū
Bodhisattva, circa 1700
wood
Collection The Metropolitan Museum
of Art, The Harry G.C. Packard Collection
of Asian Art, Gift of Harry G.C. Packard
and Purchase, Fletcher, Rogers, Harris
Brisbane Dick and Louis V. Bell funds, Joseph
Pulitzer Bequest and The Annenberg Fund,
Inc., Gift, 1975

in this medium were Kitagawa Utamaro (1753-1806) and Tōshūsai Sharaku (active in 1794), who further enhanced this new trend with their captivating prints of women and actors. Toward the end of the period, prints treating landscape instead of figure subjects became common. The masterful technique in works by Katsushika Hokusai and Andō Hiroshige marked the last flowering of the Edo *ukiyo-e* tradition.

When the eighth Tokugawa Shogun, Yoshimune (1684-1751), lifted the ban on foreign books, a new kind of Western painting developed in response to the stimulus of European book illustration (earlier suppression of Christianity by the *bakufu* terminated the budding tradition of pseudo-Western-style painting). It was characterized by a realism based on vanishing-point perspective. In a development paralleling that of Dutch studies *(rangaku)*, it was divided into three schools centered in Akita province, Edo and Nagasaki. In Edo, Shiba Kōkan (1738-1818) and Aōdō Denzen (1748-1822) were representative of the Western-style painters of the period and also experimented with the earliest copper-plate etchings in Japan.

Due to the isolationist policy under the Tokugawa, the only opportunity to experience foreign culture was through the open port of Nagasaki. Besides Western-style painting, for example, there was an influx of Chinese painting. With the stimulus arriving through Nagasaki and the introduction of Southern School Painting *(nanshu-ga)*, Japanese artists interested in studying Chinese painting and theory initiated the school of literati painting in Japan. The emergence of this school called *bunjin-ga* (literati painting) or *nanga* (southern painting) represented a decided change from the painting of the first half of the Edo period. This was due in part to the death of Kōrin and the vicissitudes of the Tokugawa government which was now turned away from the demonstration of military strength to a policy designed to rule the country through ethical education. Confucianism was the basis of national administration and the related Chinese culture was emulated. The result in art was the emergence of the *nanga* painters and a group of individualists who broke away from established tradition to give expression to their personal styles.

The first Japanese literati painter was the Confucian scholar Gion Nankai (1676-1751), who was highly skilled in calligraphy and poetry. His ink paintings have aristocratic elegance despite their feeling of naiveté. Among the students who studied under Nankai was the extraordinary artist Ike Taiga (1723-1776). Because he did not adhere strictly to a fixed painting method, he expressed himself freely, and Taiga's paintings are suffused with a carefree and untrammeled spirit. His wife, Gyokuran (1728-1784), was not only an understanding supporter of Taiga, but she was also an artist of remarkable ability and sensitivity. Yosa Buson (1716-1783), who ranks with Taiga as a painter, was also a famed haiku poet. His sense of poetic playfulness pervades paintings that are resonant with lyrical qualities.

Nanga reached its height in the Meiwa and An'ei eras (1764-1780) with further developments by artists such as Uragami Gyokudō (1745-1810), Aoki Mokubei (1767-1833), Tanomura Chikuden (1777-1835) and Watanabe Kazan (1793-1841). Each of these artists created his own individualistic style. The literati style in the capital of Edo started with Tani Bunchō (1763-1840) about a generation later than the Kyoto painters. There were also Zen monks who painted in accordance with the freedom of their spirits. These included Hakuin Ekaku (1685-1768) and Sengai (1750-1837).

The many assorted schools of Edo painting were appropriate to the new age but were based to a greater or lesser extent on existing traditions. Among them, however, was one school that stressed a modern sensibility and may therefore be distinguished from the others. Unlike literati painting, which was detached from reality and transcended the everyday world, this school sought to break the deadlock that had trapped painting in fixed patterns through its precise observation and description of nature. The leader of this school of realism was Maruyama Ōkyo (1733-1795). Ōkyo combined Western descriptive techniques with the realistic Chinese painting styles of the Ming (1368-1644) and Qing (1644-1911) dynasties, which had been brought to Nagasaki by Chen Nan-pin (active eighteenth century). One of the experiments that led to this realistic style was the making of *megane-e* (lens pictures), intended to be viewed with a peephole device called *nozoki karakuri*, which exaggerated the perspective and made the objects depicted appear three-dimensional. Ōkyo also used such methods as shading *(bokashi)*; painting shapes in color only, without the addition of an outline *(tsuketate)*; and using a flat-tipped brush instead of the usual pointed brush *(hakegaki)*.

Among Ōkyo's many followers were two outstanding painters: Matsumura Goshun (1754-1811) and Nagasawa Rosetsu (1754-1799). Goshun harmonized the realistic style of Ōkyo with the lyrical expression of the literati school and eventually established the Shijō school. After Ōkyo's death it even surpassed the Maruyama school in popularity. The Maruyama-Shijō school became the most prominent school of painting in Kyoto and helped form the foundation of modern Japanese painting.

Sculpture

Under the rule of the Tokugawa Shogunate, Buddhism lost its independence, and its lively spirit seemed to wither away. In this environment the professional Buddhist sculptors continued to toil assiduously at the making of images; but, while their work was comparable in quantity to that of previous periods, there was a conspicuous decline in quality. In the provinces, however, religious fervor burned fiercely in the hearts of sincere believers. Innumerable seekers after truth gave up fame and wealth to mingle with the people of the provinces, and to preach the Way of the Buddha. The activities of those not associated with the official religious establishments *(no no sō)* contributed to the intellectual history of modern Buddhism and led to a rich harvest in the field of art history, as well. Examples already mentioned include the painting and calligraphy of Hakuin Ekaku, who played a leading role in the revival of the Rinzai sect of Zen and the paintings of Sengai. In the field of sculpture, saintly sculptor-monks such as the expressive Enkū (1633-1695) and Mokujiki (1716-1810) produced, solely for their own satisfaction, works expressing their deep-seated beliefs. They made pilgrimages to various parts of the country, and in these locations carved images that had a fresh beauty not seen in the works of professional sculptors of their time. The unfinished feel of Enkū's work is attributed to his use of a hatchet. An extremely prolific artist, legend records that he wanted to carve 120,000 images of Buddha before he died.

Decorative Arts

(top)
Tōgyoku
Painted fan of winter landscape
early nineteenth century
ink on gold paper
12¼ x 19½, 31 x 49.5
Collection Takashi Yanagi

Comb, Edo period
tortoise shell, gold lacquer
1½ x 4⅜, 3.81 x 10.8
Collection Seattle Art Museum,
Eugene Fuller Memorial Collection
(56.262)

(opposite)
Artist unknown
Inro, iris and bridge design, Edo period
lacquered wood, *maki-e*
3⅓ x 2½ x 1, 8.5 x 6.8 x 2.7
Collection Shigehiko Yanagi

Under the protection and encouragement of the various *daimyō* of the Edo period, an assortment of decorative arts was developed, not only in Kyoto and Edo, but in other areas as well. From the Genroku era on, the tendencies inherited from the Momoyama period were left behind and the true Edo-period style began. However, as the era drew to a close, the arts gradually lost strength, and minute refinements of technique replaced the earlier definitive originality of Edo form.

Hon'ami Kōetsu displayed an original talent not only in his calligraphy and painting, but also in fields such as ceramics and lacquer. In the Genroku era, the lineage of Sōtatsu was taken up by Ogata Kōrin.

The most notable developments in the decorative arts were in the field of ceramics. Japan, until the sixteenth century, lagged far behind Chinese and Korean achievements. From the beginning of the Edo period, however, a number of interesting types of technically advanced wares, derived from the Korean prototypes, were made under the influence of immigrant Korean potters. Included within this legacy were Karatsu, Hagi and Satsuma wares. Porcelain was first produced during this period. According to legend, it was first introduced by a Korean immigrant in 1616. The porcelain industry expanded, and later in Arita, Sakaida Kakiemon (1596-1666) discovered an overglaze enamel technique and began to produce multicolored porcelain known as Kakiemon, much of which was exported to Europe. The technique was transmitted to Kaga province (present-day Ishikawa Prefecture) in the mid-seventeenth century and used in the making of Ko-kutani ware, which together with the Imari ware of Kyushu produced gorgeously colored pieces. In Kyoto, Nonomura Ninsei (active mid-seventeenth century) applied the Arita technique of overglaze enameling to pottery, to create Kyō-yaki (Kyoto ware). Later the special beauty of Kyoto ware was developed by ceramists such as Ogata Kenzan, Okuda Eisen (1752-1811) and Aoki Mokubei. Kenzan started a line of pottery by applying enamel decoration to the low-fired *raku* body, and Eisen began the production of porcelain in Kyoto.

Crafts such as lacquerware, weaving and dyeing were widespread among the general public because of their ties to daily life. The production of lacquerware stressed technical perfection; it included Aizu ware (made in the Aizu district), Tsugaru ware (a colored lacquer characterized by mottled patterns), and Shunkei ware (a clear lacquer applied over a colored surface). The art of textile making saw remarkable progress during the Edo period. The best known woven fabrics were the Nishijin weave of Kyoto, noted for the intricacy of its designs, and the Hakata weave of Kyushu. Kyoto was the center of the dyeing industry; the Yūzen dyeing technique was especially famous and was also carried on in Kaga. The charming effect of the colored dyes in pictorial designs appealed to the taste of the time and made these fabrics very popular.

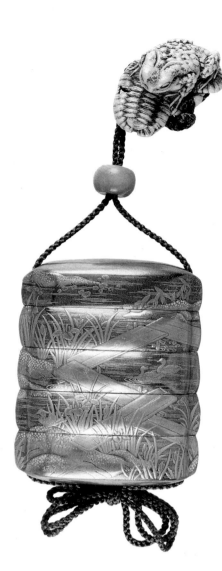

Design and the Spirit of the Edo Period

The Edo period was an age in which the long tradition of Japanese art attained a high level of refinement and technical perfection. However, this highly refined design was not created to fill the static function of decorating the homes of only warriors and nobles, but rather had begun to play an active role in the lives of many people in the newly splendid cities. Design had for the first time become part of the consciousness of the mass audience. Underlying this tendency was a zeitgeist that supported it. For example, words such as *kabuku* and *iki* reflect closely the spirit of the Edo period, and are based on concepts intimately related to the world of design.

Linguistically speaking, the verb *kabuku* meant "to behave without inhibition," with the connotations of extravagant personal appearance and sexually suggestive behavior. The *kabukimono*, who swaggered through the streets in eye-catching costumes, wearing kimono of unusually large, showy patterns and carrying extra-long swords slung over their shoulders, could perhaps be compared in spirit to the present-day young-sters who saunter down King's Road in London.

The actions of the *kabukimono* sometimes took on a rebellious charac-ter and were then subject to strict suppression by the shogunate. Despite the misdeeds of the *kabukimono*, the general public was secretly in sym-pathy with their actions, as is demonstrated by the enthusiastic response of the masses to a new form of dramatic art called Kabuki, which featured *kabukimono* appearing on the stage. We must not overlook the fact that this dynamic spirit, undermining conservatism and standardization, flows as an undercurrent through the various art forms of the Momoyama and early Edo periods.

Showy gestures and unconventional behavior necessitated costumes and accessories of appropriate sensibility and design. Thus the bold, large-scale designs seen on garments such as *kosode* may be regarded as originating in the same period sensibility reflected in the words *kabuki* and *date* (showy, or dandyish).

On the other hand, the art world of the Genroku era is also accurately depicted in the following story about Ogata Kōrin. On the occasion of a costume contest at Higashiyama in Kyoto, Kōrin was asked to design a costume for the wife of his close friend Nakamura Kuranosuke. He is said to have dressed her in a plain white ensemble with an over-jacket and *obi* of plain black, a costume that in its simplicity attracted the attention of everyone. Kōrin thus displayed his sense of style by lavishing the greatest attention and most extravagant treatment on something that would ordi-narily be unnoticed or inconspicuous. This kind of spirit, called *iki*, per-meates the entire Edo period, especially the latter half, from the Genroku era on.

The fact that the aesthetic consciousness of the Edo period was in contact with the masses gave rise to the spirit of *kabuki*, *date*, and finally *iki*, on which the culture itself was supported. There were in fact two different aesthetics running throughout the art of the Edo period: that of *kabuki* and *date*, with the underlying meaning of action—versus that of the fundamentally static *iki*. The interaction of these two aesthetic categories, active and passive, has continued to the present day.

Translated by Yasuko Betchaku, Sarah Thompson and Michiyo Morioka

Fumihiko Maki
Six drawings of columns for Tokyo Spirit
24¾ x 17⅜ each, 62. 86 x 43.94 each
graphite on paper with collage elements
Collection the architect

(left to right):
Metropolitan Life
Death and Life in a Great Japanese City
Headquarters
Festival
Caterpillar
Oku

Fumihiko Maki and Kiyoshi Awazu: Tokyo Spirit

The column is symbolic of a tree. A forest, which is a congregation of trees, is a metaphorical city. Each tree in the forest is a milepost of the journey through life.

We attempted to represent Edo/Tokyo's time and space with a variety of columns. The column in Japanese architecture does not only function as "a support," but also recognizes a spatial ambivalence— the simultaneous existence of separation and connection. Various aspects of the city are engraved in these columns: festivity and silence, freedom and confinement, nature and artifact. They are a record of the four hundred years of Edo/Tokyo's history.

Our design is comprised of six round columns in a rectangular walled space. The six columns symbolize the city's illusions and dreams, past, present and future:

Metropolitan Life
Association with the past is made with layers of skinlike membranes, the illusions of a manufacturing technology. On the top of the pillar, a large tree, symbolizing the permanence of life, waves wistfully in the wind. Destiny, architecture or a stone foundation.

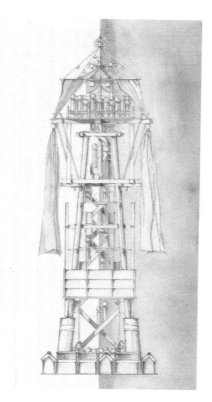

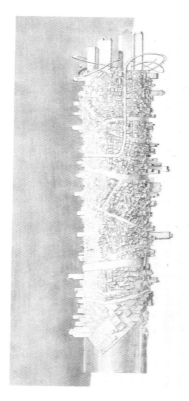

Death and Life in a Great Japanese City
Inorganic membranes form a homogeneous grid that stands pillarlike. From the fissures appearing on the surface, growth, then necrosis sets in. On the pillar's top a crane makes a structured movement. Modern homogeneous space, anonymity, renewal.

Headquarters
Three faces on the top of the pillar, crowds floating inside the shaft. People, *bunraku* puppets, crowds or community.

Festival
Large festival carts parading in the city. There is a bell-striking platform on top of the pillar. It has a winding path and flocks of pious men and women. Brilliantly colored festivals, a city's festivals, crowds, towers.

Caterpillar
A second, many-sided pillar spreads over the top of the column. A skyline viewpoint. Passing through the city a thrashing freeway soon becomes part of the top of the pillar. Speed, high density, skyline.

Oku
A number of levels cut into the body of the column ascending perspectively to the shrine at the top. Stupas stand together at the foundation. Interior, sanctity, hills, mountains, permanence.

On two of the surrounding walls, shadow patterns of the columns will be created by obliquely directed lighting. Scroll-like strips of paper will contain graphic images on the other two walls; these will relate to the themes expressed three-dimensionally in the columns.

F.M. and K.A.

Design
Fumihiko Maki
Hidetoshi Ohno
Meiji Fujita
Osamu Goto
Yasushi Ikeda
Norihiko Dan

Design Collaborators
Kazushi Obika
Toru Mitani
Masato Fujino
Ryuhei Okuyama

Scroll Design
Kiyoshi Awazu
Osamu Kawamura
Makoto Shimuzu

Lighting Consultant
T.L. Yamagiwa Laboratory, Inc.

Production
Takashimaya Co., Ltd.
Ohi Kojo Co., Ltd.

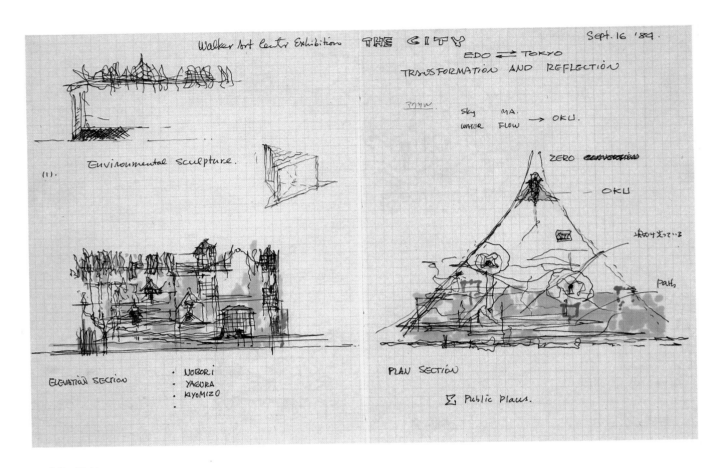

Fumihiko Maki
Conceptual sketches for
Tokyo: Form and Spirit

These sketches from the architect's notebook
are his earliest visualizations for the Tokyo
Spirit section of the exhibition. Starting with
Tokyo's sky and water, two prominent
features of the cityscape, the idea to represent
the city through the use of a series of
descriptive columns arose. The columns thus
became the architectural framework for the
expression of various Tokyo characteristics.

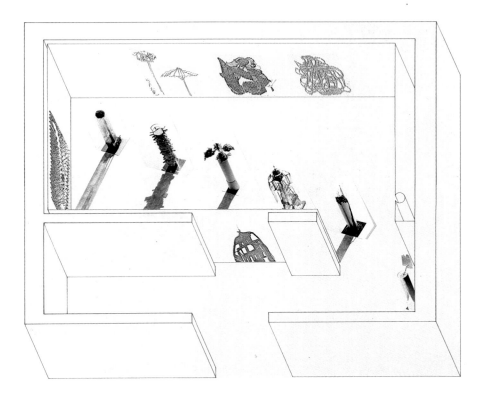

(above)
Fumihiko Maki
Study for the Tokyo Spirit space, 1985
ink, photographs, photostats on paper
24⅝ x 34¹³⁄₁₆, 62.48 x 88.13
Collection the architect

This axonometric drawing shows the six
columns and their oblique shadows, and
indicates that the visitor will first view the
columns through a translucent glass panel.
The rectangular entry space will contain an
Edo-period painted screen.

(right)
The Festival column is a delicate assemblage
of shrine and *torii* elements. A colorful
mikoshi (portable shrine) floats above the
heads of *kokeshi*-like figures enclosed by a
railing decorated with *giboshi* that sits atop
the column. Colorful silk streamers float along
the sides of the rectangular form.

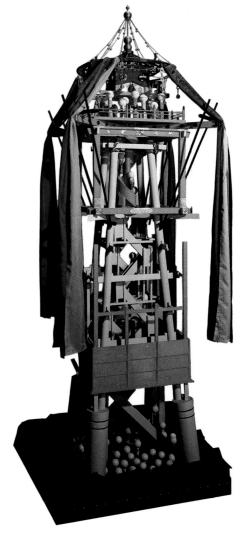

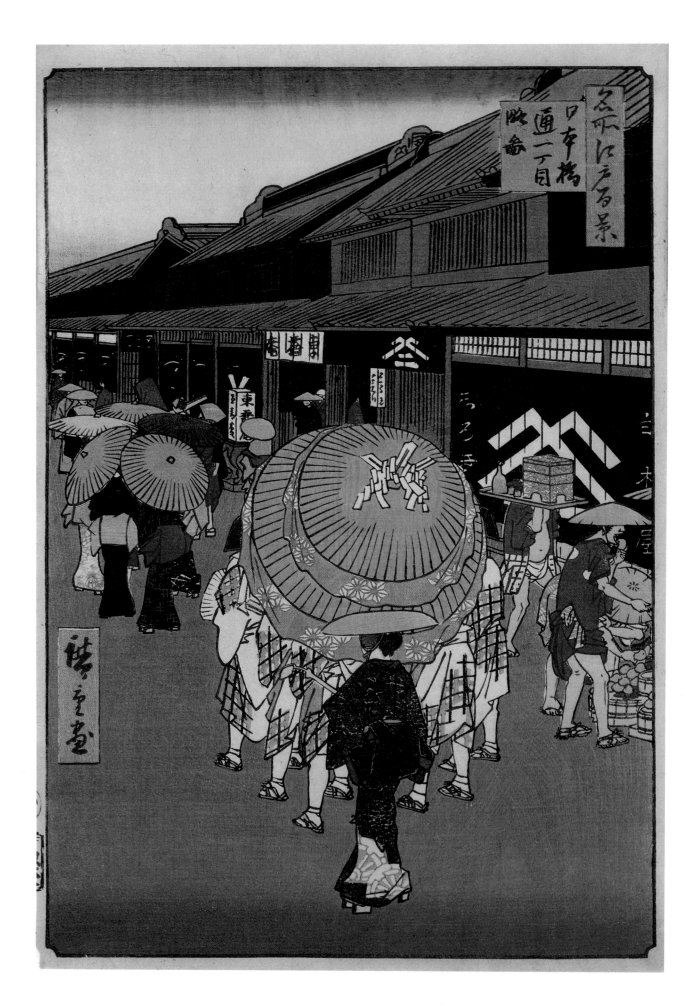

Walking in Tokyo

Donald Richie

One walks for various reasons. Often it is to get someplace. Occasionally it is to enjoy the walk.

The street leads someplace. Usually it is seen as a stretch connecting one place with another. Sometimes it is seen as itself. Different cities have different streets. The differences depend upon how the street is used and how it is seen. That is, walking in Marrakesh is different from walking in, say, Chicago.

And walking in Tokyo is different from either. Streets here have their mundane and ostensible uses but they also have something more. The Japanese street remains Asian, and it is still, in a number of senses, an area of display.

As, to be sure, are the streets of other cities. One thinks of the *plaka,* the town square, the café-lined avenue. But there are differences. In Europe, one is part of the display—to see and be seen, to look and be looked at. The street is a stage. How different Japan. There are no European-style cafés, no American-style malls. And no place at all to sit down. You, the walker, are not an actor.

Rather, you are an active spectator. The display is not you and the others about you. The display is the street itself. The direction is not from you to it but from it to you.

Shops line the street, open up, spill out. Clothes on racks and sides of beef alike are shoved onto sidewalks. The fish shop's scaly glitter is right there, still gasping. Baby televisions piled high blink at you, eye to eye. Not here the closed transactions of the supermarket. Rather, on the Tokyo street, there is the raw profusion of consumption itself.

And even in the more sedate avenues, such as the Ginza, where goods stay indoors, the display continues. Signs and flags proclaim; *kanji* (Chinese ideographs) grab and neon points. Signs, signs everywhere, all of them shouting, a semiotic babble, signifiers galore, all reaching out to the walker, the person going past.

This is what is very Asian about the Japanese street. This we would recognize if the units were mangoes or rice cakes. But here they are also calculators and microwave ovens, instant cameras and word processors. The content startles.

Yet, the form reassures. This is, even yet, the Japanese street we see in Hokusai and read about in Saikaku. In old Edo the main street was called the *noren-gai.* The better shops advertised themselves with their *noren,* those entry curtains marked with the shop crest. The *noren-gai* was the better stretch where worth and probity were the standards.

The concept remains. The *noren* may be facade-high neon, or a mile-long laser beam, but the *gai* (district) is still marked as the place of display. From Ginza's store window showcases to the piles of silicon chips out on the sidewalk, like exotic nuts in Akihabara, the display continues, a year-round drama in which all the actors are for sale.

The Japanese street is, in a way, the ideal to which all other streets must aspire. It is the ultimate in unrestrained display. Other streets in other countries are handicapped by zoning laws and citizen's associations and the like. Not so Tokyo, or not to that extent. The Japanese street is very public.

Conversely, the Japanese home is very private. In Edo all the houses had high fences. In Tokyo, though suburbia must content itself with merely a token hedge or fence, privacy remains much respected. The house and the garden (if there is one) are private property, in the most closed and restricted sense. In a city as crowded as Tokyo—Edo too for that matter—privacy is a luxury almost as expensive as space. What is acquired at great expense is zealously guarded.

What is enclosed is, thus, private property. And what is open is not—it is public. So it is with most Western cities as well. But in Japan the difference is that the public space appears to belong to no one; it seems to be no one's responsibility. As a consequence, there are few effective zoning laws, very little civic endeavor, almost no city planning, and while housing is subject to strict scrutiny, the surrounding streets are not.

Therefore, the streets of Tokyo are allowed an organic life of their own. They grow, proliferate, and on all sides street life takes on unrestricted natural forms.

Tokyo is a warren, a twisted tangle of streets and alleys and lanes. Though there are some grid-patterned streets where civic endeavor has in the past attempted some order, this enormous city is a comfortable rat's nest, the streets having grown as need and inclination directed. Opportunities to remake the city were resisted not only after the various Edo disasters, but after the 1923 Earthquake and the 1945 fire-bombing as well.

The reason was, of course, that the warren was preferred. It was seen (better, felt) to be the proper human environment. The Japanese, like the English, prefer the cozy, and consequently the streets of Tokyo are as crooked and twisting as those of London. There is a corresponding sense of belonging as well. The cozy warren is just for us, not for those outside.

Which is what one might expect from a people who make so much of what is private (ours) and so little of what is public (theirs). For such folk the neighborhood is of primary importance (and Tokyo is a collection of village-size neighborhoods), and its public aspect attains intimacy only when incorporated into the well-known.

For example, sections of old, twisted Tokyo are being torn down. Not because of any civic planning, but so that the most expensive land in the world may be more profitably used. And the new buildings are often built four-square, with straight streets. Not from any notions of urban efficiency, however; it is merely that buildings are most cheaply constructed if they are squarish and right-angled.

So, the old tangle is torn down. And it is rebuilt, incorporated within the basement of the high rise that took its place. There again are the bars, the little restaurants, the warren reborn.

Greengrocer *kanban*, late Edo,
early Meiji period
polychromed wood
16½ x 36, 42 x 91
Collection Peabody Museum of Salem

(below)
Tokyo's Akihabara district of cut-rate
appliances and electronic goods, 1984.

(opposite)
Pharmacy *kanban* for stomach medicine,
Edo period
polychromed wood
32½ x 17, 83 x 43.5
Collection Peabody Museum of Salem

The significance of public areas belonging to no one is not that they belong to everyone but that they can be used by just anyone. This means that the owners or lessees of private land in public places can be as idiosyncratic as they like.

Take modern Tokyo architecture. Visitors are astonished by its variety, given what they may have heard of the Japanese character, instead of the expected conformity, they are presented with the wildest diversity.

The glass-and-concrete box (cosmetics) is next to the traditional tile-roofed restaurant (*sukiyaki* and *shabu-shabu*), which is next to a high-tech, open-girder construction (boutiques), which is next to a pastel-plastered French provincial farmhouse (designer clothes and a tearoom).

The architecturally odd is there to attract attention. Thus Tokyo main-street architecture has much the same function as the signs and banners that decorate it. To stand out is to sell something better. (As for conformity, there is plenty of that, but it is found in nothing so superficial as architecture.)

Though profit may be a motive for eccentric architecture, it is not its only result. Among others, the stroller is presented with an extraordinary walking experience.

With space used in this distinctive fashion, one naturally wonders about the uses to which time is put.

They are, as one might have expected, equally noteworthy. It is not so much that one can time-travel in Tokyo (and can do it even better in Kyoto), go from the seventeenth to the twentieth to the eighteenth century by walking around a block. One can, after all, do that in many European cities, which have more old buildings than Tokyo. Rather it is that Tokyo provides a fantastic rate of temporal change. In Europe a building was built for a century. In Tokyo a building, it often seems, is built but for a season.

They go up and come down at an almost alarming rate. In the Shinjuku and Ikebukuro sections, if you miss a month, you might well next time get lost, so fast and frequent are the metamorphoses. What you remembered has now become something else. And the hole in the street, the vacant lot, now holds the current architectural icon, a glittering chrome-and-glass structure like a giant lipstick or a mammoth lighter. The paradigm for all of this construction-destruction is perhaps the Ise Jingū, the Vatican of Shinto. These structures are (alternately) torn down and built again every twenty years. Their invariable form is Japan's earliest architectural style (third century A.D.), and the materials (wood, sedge) are always the same. This is Japan's answer to the search for immortality. And unlike

(above)
Japanese rendition of Fontana di Trevi,
Shinjuku, Tokyo, 1985.

Street musicians celebrating the opening
of a pachinko parlor, 1984.

Egypt's pyramids, Ise offers the attractions of the ever-new in the context of the ever-old.

Old Edo had its construction-destruction compulsions as well, but they were different in that, first, there were so many fires that the reconstruction came to be seen as repair; and second, the new structures were not extreme because there were sumptuary laws and because the Edoite had only wood, tile and stone.

Now there are certainly no laws against display, and the Japanese architect has steel, glass, concrete and plastic, all of which can be forced into any shape desired.

The temporal dislocation in Tokyo is so extreme that the capital is, consequently, never finished. It is in a permanent state of construction. Like life it is always in flux. It is an illustration of itself—a metaphor for continual change.

The foreign walker in Tokyo is sometimes struck with a sense of having seen all of this before somewhere—this half-finished melange of architectural styles, this plethora of steel turning into chrome and plastic into glass, this same strange blend of the traditional and the nouveau.

Is it backstage at the opera? On the movie set? Then one remembers. Of course. It is the international exposition. That of New York or Seattle or Osaka or Paris—they are all alike. A collection of buildings in the most ornate and extreme of varied architectural styles, and put up but for some few months; built in full knowledge that before the year is out they will be down. And with this recollection comes further thought.

Why, one wonders, did the Japanese bother to franchise a Disneyland in their suburbs when the capital itself is so superior a version?

Disneyland, and the other lands it has spawned, is based upon the happy thought of geographical convenience: all of the interesting localities on earth located at one spot. Thus, there are African rivers and Swiss mountains and Caribbean islands and American towns. One feels one is seeing the world in miniature and, indeed, "It's a small world" is the slogan of one of the concessions.

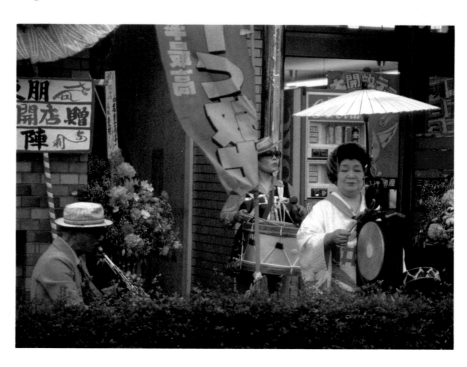

Women conversing, Tokyo, circa 1980.

Compare this now to Tokyo. There are hundreds of American fast-food stands with mock-Colonial facades. There is a plaster Fontana di Trevi in Shinjuku, and a state guest house modeled after Versailles; there are dozens of red-lacquered Chinese restaurants and an equal number of white-stuccoed Italian; there is an imitation Baker Street, straight from London; the Museum of Western Art in Ueno has Rodin castings all over the front yard, straight from Paris; and in Ochanomizu there is even an onion-domed Eastern Orthodox cathedral (Nikolaidō). All of this and much more—a glorious architectural confusion of Corinthian columns and chromium pylons, dormer windows and curved escalators, half-timber, plain red brick, sheet steel, textured lucite.

In this architectural stew, even the authentically Japanese takes on the pleasant flavor of ersatz novelty. Thus the old Tōshō-gū (1651) in Ueno, or the seventeenth-century Awashimado in Asakusa appear in Tokyo's context as pleasingly synthetic as the new Japanese modern-style restaurant modeled (almost right) as a French bistro.

Tokyo is really the home of such concepts as those Disneyland has come to exemplify. It was Japan after all that most fully elaborated the concept of the microcosm—from its earliest beginnings right down to the wristwatch TV and the smallest, fastest silicon chip yet.

In particular, Japan pioneered the geographical microcosm, the bringing together of famous places into a single locality. Look at the number of little towns in Japan that sport a Ginza, hopeful replicas of Tokyo's most famous shopping street. Look too at the number of provincial gardens that have a little Mount Fuji, small but climbable, among their attractions.

Indeed, the classical Japanese garden gives ready indication of how dear the microcosmic impulse has been to the Japanese and how early they perfected these small, visitable worlds.

Take, for example, the Koraku-en in Tokyo—an Edo garden. One climbs a small hill, which calls itself Mount Lu (Lushan), after the Chinese original. From the summit one sees a replica of the Togetsubashi, from Kyoto's Arashiyama district. But the view is not of the river but of Hangzhou's famous lake—we are back in China again. Not for long, however, for climb another hill and there is Kyoto once more, the veranda platform of the Kiyomizu-dera, one of the famous sights of the city.

Or, as another example, the Rikugi-en in Tokyo's Komagome. Here, in one place, arranged somewhat in the manner of a miniature golf course, are all of the eighty-eight classical sites, all in much reduced scale, and all with labels explaining the Chinese or Japanese association.

This microcosmification has been going on for some time. The garden of the Katsura Rikyū contains miniaturizations of things found elsewhere—the Sumiyoshi pine, the Tsutsumi waterfall, even the famous wooded spit from the other side of Japan, Ama-no-Hashidate. The elegant moss garden of Saihō-ji holds—if one knows how to find them—scenes from ten famous places, reproductions of ten famous things, ten poetic references, and ten famous pine trees.

Even the famous rock garden of Ryōan-ji has Disney attributes. These rocks—what are they besides rocks? Well, they are manifestations of the infinite, or they are islands in the ocean, or they are (a very Disney-like touch) a mother tiger and her frolicking cubs.

And, even earlier, some avatar of Walt Disney was in Japan. The Byōdō-in is a replica of a Chinese water pavilion, as were the swan boats (phoenix boats, actually) that were poled about. The tenth-century

Young lemon merchant, Tokyo, 1985.

(opposite)
View of back street, Tokyo, 1984.

Japanese could imagine himself in fabled Cathay, as his twentieth century descendant can, on the Ginza, imagine himself in fabled Paris.

Indeed, the first Japanese gardens, the very oldest, were composed of things from far away. The garden was a representation of Sukhavati, the Western Paradise of the Buddha Amitabha. And those rocks in the water were the three islands of the blessed: Hori, Hojo and Eishu. And that big rock in the middle: that was Mount Sumera itself.

The date of this garden is 1000 A.D. Think. A thousand years ago Japanese inclination had in Mount Sumera made the very first Space Mountain.

The display of the Tokyo street, the Tokyo park, the Tokyo garden is thus a varied and a complicated thing. Walking becomes a variegated experience with many a surprise.

This is not perhaps unique to Tokyo, but is certainly not typical of the world's major cities. There—Washington, D.C., Beijing, Moscow—one is presented with a view and the view is the experience. Once you have glanced at it you have comprehended and no amount of strolling about will add anything. There is nothing left to discover after the view of the Capitol, the Temple of Heaven or the Kremlin.

Obviously, human variety was not in the minds of these architects; rather, it was human similarity that was being both courted and celebrated. And Tokyo, too, has its monolithic views—but it only has two of them: the Imperial Palace and the Diet Building.

Otherwise, there are no views at all. Everywhere you look it is a quiet chaos, but what fascinating chaos it is. It is a mosaic city, a melange city. It has no center. It has no outside. It even seems to lack the structural supports we know from other cities.

One of these we know from the early medieval city and from its modern descendant, the Islamic city. This is the division into trade towns. Streets of the goldsmiths, area of the camel drivers, pits of the dyers—that sort of thing. Such remains are visible in all major cities. The West Side of New York, for example.

Tokyo has something of this, things bunched together from the old days before there was public transportation: Otemachi, where the banks' headquarters are; Sudachō, where the wholesale cloth merchants are; Akihabara, down the street, where the cut-rate appliance people are.

But this grid cannot be used to comprehend the city because it is not operative. It is simply left over. Operative is a micro-grid that finds a bank, a cloth merchant, an appliance store in every neighborhood. And there are hundreds of neighborhoods in each district, and dozens of districts in each section, and tens of sections in this enormous city.

Duplication, therefore, becomes one of the features of a Tokyo walk. When you reach another public bath you are in a different neighborhood. And each neighborhood is a small town which has its laundromat, its egg store, its hairdressing parlor, its coffee shop.

Looking at the inner structure of Tokyo one is reminded of the inner structure of the traditional Japanese house. The sizes of the *tatami*, *fusuma* and *shoji* are invariable. The construction is by modular unit and mine fit yours, yours fit mine. City construction is likewise modular—the laun-

dromat in Asakusa and the laundromat in Shinjuku are identical.

We of the West, used to large swaths of endeavor, do not know what to think of the filigree of Tokyo, its fine embroidery of human endeavor.

But we of the West know what to feel. Walking on the streets of Tokyo we are aware of a sense of human proportion that we might not have known in the city from whence we came. To walk in Tokyo is to wear a coat that fits exceptionally well.

The proportions (except where mania has taken over—the towers of west Shinjuku, for example) are all resolutely human. We raise our eyes to see buildings; we do not crane our necks. And the streets are narrow—all too narrow if it is one where cars are allowed. And there are little alleys just wide enough for a person. And there are things to look at.

Things to look at! Tokyo is a cornucopia held upside down. One does not know where to look first. If people say, and they do, that Tokyo makes them feel a child again, this is because it makes them all curiosity, all enthusiasm, all eyes.

This then is the display of Tokyo. It perhaps may be mercantile but its appeal goes far beyond the financial. Things become, in this plethora of sensation, detached from their utilitarian aspects. They exist for themselves: the cascades of *kanji*, the plastic food replicas in the restaurant windows, the facade, stories high, made entirely of TV sets.

One then remembers the woodcuts of Hokusai and Hiroshige—views of Edo—and sees the similarities. All of that detail, all of those particulars, all that decoration, the sheer movement of it—it is all real and it is all here now.

Especially on Sundays—the day (along with national holidays) when Tokyo turns itself again into Edo. The main streets in the major sections (Ginza, Shinjuku, Shibuya, Ikebukuro, Ueno) become malls. Motor traffic is forbidden (from 1 to 6 pm) and, as in olden times, people swarm into the streets. Unlike weekdays, when they rush about in the modern manner, on Sundays they stroll in the old-fashioned way. In Edo style they take their time, look at the stores, the goods, stop for a snack and saunter on.

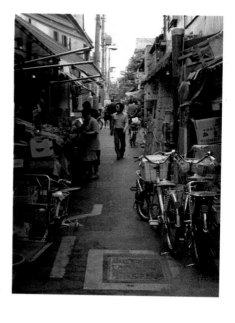

Here, one thinks, looking at the leisured throng, Edo lives on. Despite the new backdrop of TV and computer games, the true human activity is the same, now as then. To leave the house and enjoy the display, to gaze at the latest and perhaps purchase a bit—this is what old Edo did and what new Tokyo does.

The new merchants, conservative as always, greatly feared for trade when the carless Sundays went into effect several years ago. They thought no one would come if they could not park their wheels. They were ruined, they wept in large advertisements. Not at all. They had not reckoned on the Edo spirit. Now the merchants look forward to Sunday and even department stores spill out onto the crowded streets. They have more customers on Sundays than they do on any other day of the week. Now smiling management gives out free balloons and plastic flowers to the passing crowd, while overhead *kanji* dances and neon glows in the sunlight.

All of Tokyo is out walking, sauntering through the streets, enjoying that amazing display which is Tokyo.

Mikoshi (processional shrine) with two
ornamental roofs, circa 1830
lacquered wood
39 x 34½ x 21⅞, 99 x 87.5 x 55.5
Collection Peabody Museum of Salem

(right)
Festival of *shishimae* (lion's dance) in
Kanazawa, Ishikawa Prefecture.

(opposite)
Festival at Yasukuni Jinja, Tokyo.

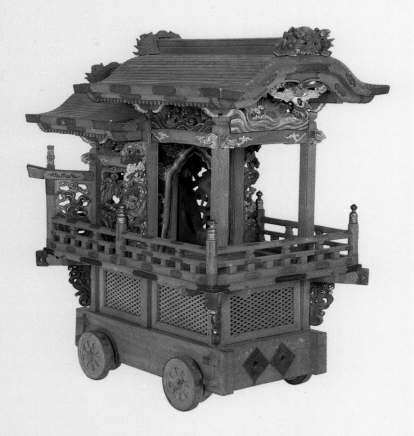

Festivals

In Japan, *matsuri* (festivals) are
inextricably linked to Shinto. Viewed as
a joining of man and nature through
ritual, *matsuri* represent the central act
of worship that renews ties with the
spiritual world. They are occasions for
reverence as well as celebration, and
through their enactment the continued
protection of the community by the *kami*
(deity) is acknowledged and appreciated.
Matsuri still hold a predominate place in
rural Japan and have also aided in
shaping public festivities and traditional
parades in modern urban society. Based
on the traditional Japanese calendar
year, beginning with New Year
observances, *matsuri* are often marked
by seasonal holidays. Traditionally,
matsuri were closely tied to agricultural
cycles—summer *matsuri* assured against
pestilence and insects, spring *matsuri*
were to ensure favorable conditions for
planting. Now, however, festivals and

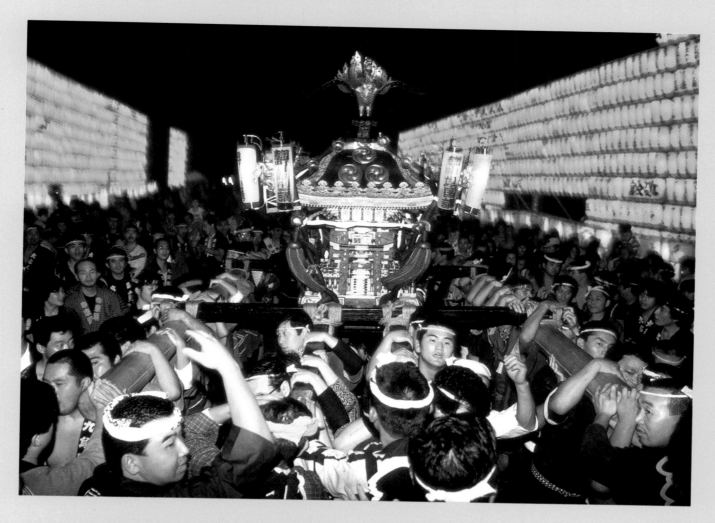

rituals underlie a variety of events—the dedication of a skyscraper, for example.

The idea of *matsuri* encompasses private observances as well as the more widely known public celebrations; the first is associated with individual practice emphasizing the offerings and prayers to the *kamidana* (small household shrine) or to small exterior shrines *(yashiki-gami)*. Public *matsuri* center around the community shrine which, at a designated time, undertakes major festivals in the honor of their patron *kami*. While these *matsuri* do involve the sober perform-ance of rites by priests, parishioners and household representatives in obeisance to the *kami*, they invariably assume a spectacular character during the symbolic tour of the *kami* around the parish and in the colorful festivities that, in many cases, accompany the tour.

The tour of the *kami* is directed along an established path. In some *matsuri* such as the Kanda Matsuri in downtown Tokyo (15 May) the *kami* is enshrined in a *mikoshi* (portable processional shrine) that was derived from ancient imperial corteges. Borne by a team of young men festively bedecked in half-length *happi* coats and twisted-cloth headbands, the procession marches around the neighborhood. By doing so, the ceremonial meeting between *kami* and men at the places where they work and live is completed. The parish will be, as a result, purified and protected. Whether *matsuri* take a more somber approach, such as the nine-hour Aoi Matsuri (15 May) in Kyoto, or more vigorous, as the Nachi Fire Matsuri (14 July) in Wakayama Prefecture, all *matsuri* share a respect for the *kami,* and participation by the community, establishing a sense of solidarity in the act of ritual worship.

Performance—particularly music and dance—are essential elements of a *matsuri*. As with many Shinto elements, performance has sacred links with the Sun Goddess Amaterasu who, while secluded in her cave, was drawn out by merrymaking and music. *Matsuri* performance over the centuries has continued this heritage, the jingling of bells and the beating of drums, the metaphorical heartbeat of Shinto.

Amy Reigle Newland

Tadanori Yokoo and Arata Isozaki: Walking

When I walk through the streets of Tokyo, it is not unusual for me to weave back and forth as if I were recovering from an illness—I have the sensation of losing my balance. If city dwellers do not distance themselves from city life, the ability to recognize themselves as individuals (rather than to be consumed by the city) is weakened.

Tokyo is extremely crowded with people and things. The shops overflow with products and the streets are filled with multifarious neon lights and traffic signs. This visual information overwhelms the population of the city. The residents of Tokyo survive in the city, not by rejecting the abundant services that the city has to offer, but rather by meeting the demands made by city life.

My work for *Tokyo: Form and Spirit* consists of seven ceramic wall murals and, reflecting the idea of a Walking space, they are intended to represent the passage through Tokyo from the past to the present.

The murals are grouped into seven periods: Edo, Edo to Meiji, Taisho, Postwar, the 1960s, the Present and the Near Future.

The Near Future of Tokyo is the last of this series. It begins with the attack of the monster Godzilla and ends with the second coming of the Amida Buddha rising above the burning skyscrapers. Tokyo's fate is continuance, despite the repeated destruction caused by catastrophic fires, earthquakes and large-scale bombings.

Technically, ceramics cannot be easily controlled, and therefore are a very difficult medium; however, completion of these works was aided by the five natural elements—earth, fire, water, wind and ether.

Like human beings, Tokyo has its own cycles of life and death. With continued destruction and creation, cities grow, prosper and deteriorate. The spirit of the city continues to live and this spirit is contained in the ideas of its creators and builders. Ideas bring eternal evolution to the city, more directly, they bring about a karmic cycle.

T.Y.

Design
Tadanori Yokoo
Arata Isozaki

Production
Otsuka Ohmi Ceramic Co., Ltd.
Japan Heuga Carpet Co., Ltd.

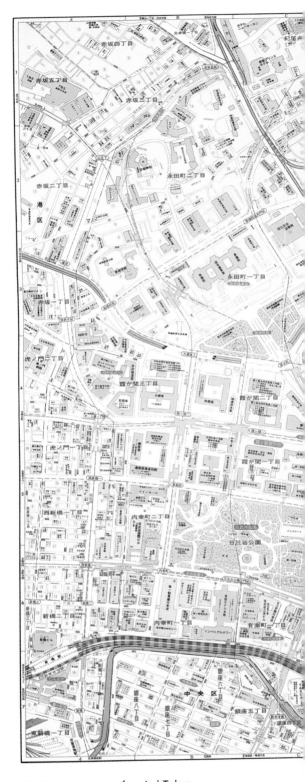

Contemporary map of central Tokyo indicating the void of the palace grounds and its water-filled moat, the sole remaining vestige of the complex helical canal system that surrounded the Imperial Palace during the Tokugawa era. Enormously diverse and vast, Tokyo is a city in which walking is exciting, always surprising and blissfully safe, day and night.

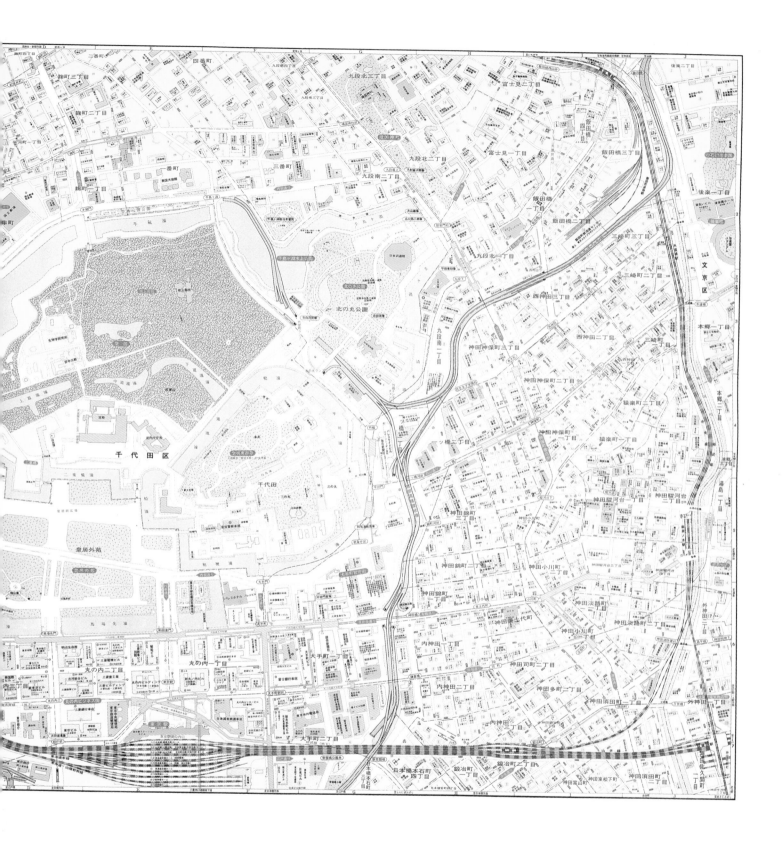

(above)
The Walking space in the exhibition is defined
by a linear structure that acts as support for
Yokoo's ceramic tile murals. The framework
designed by Isozaki will contain three-
dimensional elements representing aspects of
the themes of the seven murals. The
framework will form passageways leading
from one exhibition space to another.

(left, from top)
Tadanori Yokoo's sketches for the ceramic tile
murals *Edo* and the *Near Future.*

(opposite)
Tadanori Yokoo
Edo to Meiji, 1986
silkscreen on ceramic tile
96 x 96, 243.84 x 243.84
Collection the artist

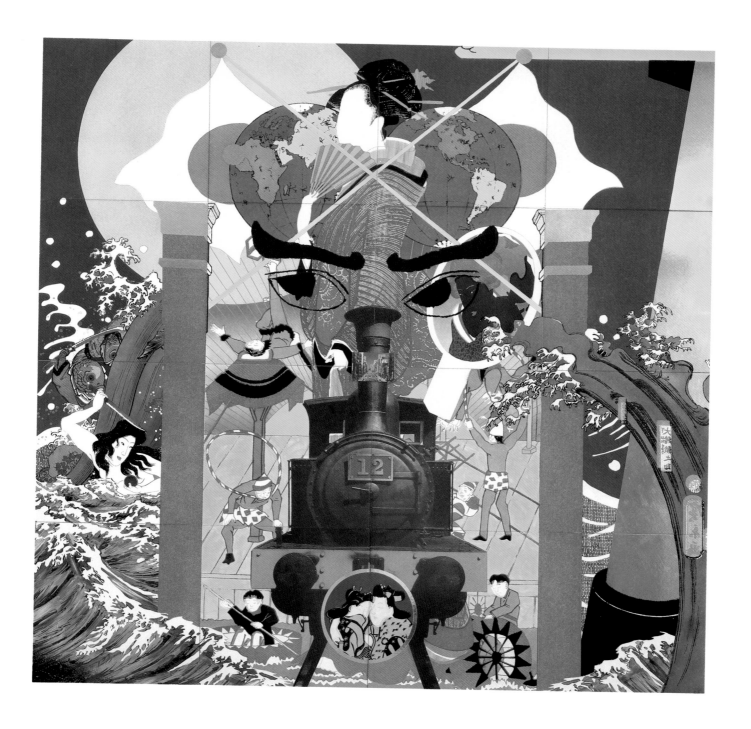

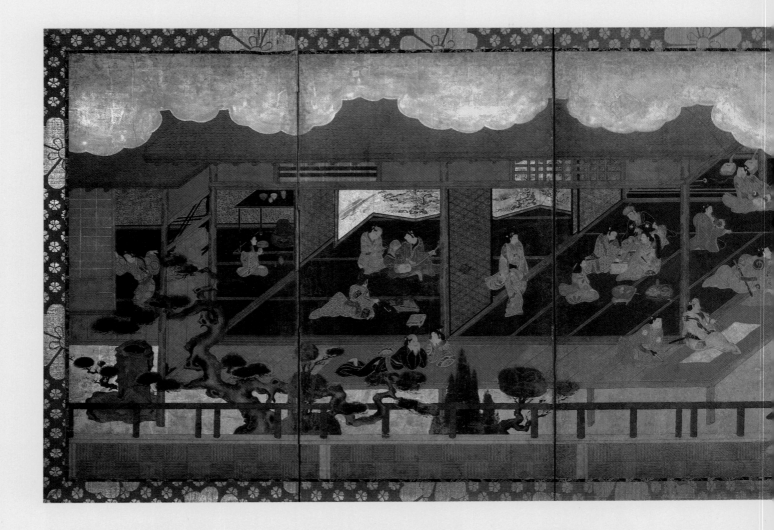

Artist unknown
Women Merrymaking, seventeenth century
six-fold screen; color, gold on paper
29³⁄₈ x 79⁷⁄₈, 74.5 x 202.6
Tiger Collection

A large residence, open on two sides, dominates the left half of this screen. A lattice-woven fence that runs along the bottom of the screen and turns in the center to follow the shape of the house shields it from public view. The line of the fence leads the eye to a fully-blossomed cherry tree, which indicates the season depicted is spring. The figures of two samurai seated at a corner of the veranda, a couple lying on a red spread on the veranda, a couple leaning out of the house, and three women in the courtyard watch seven young samurai warriors in a lively dance.

In the large room of the house facing the courtyard, a group of two women and a man are engaged in a game of *go.* A young servant sits before

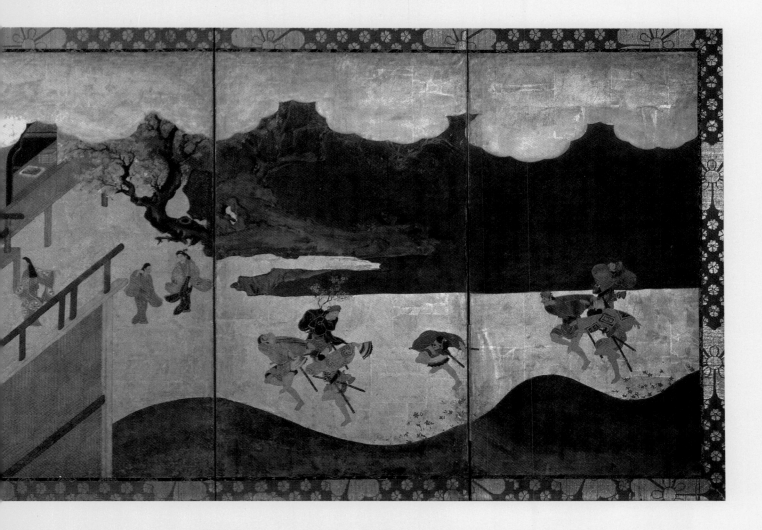

them with refreshments while a woman stands watching their game with amusement. At the rear of this room, a man who sits with his back to the *go* game is apparently conversing with a second man, who leans on the edge of the alcove where two *shamisen* (three-stringed musical instrument) have been placed. To the left, two men, seated in front of a large six-fold screen are being served food. The room at the extreme left has a young girl preparing ceremonial tea, her panoply of utensils arrayed on a lacquer shelf, while a woman dressed in red stands at the edge of the veranda, gazing into the garden.

The manner of depicting the figures, with careful attention to gesture and to textile patterns in clothing, is typical of genre painting in the early Edo period. The removal of walls to permit a view into the interior of residences is a method that was developed in the Late Heian period (897-1185) and remained in use throughout the Edo period. The male dancers are notable in this screen for the free form of their dance, which is unlike the more formal dances frequently seen in other screens with a large number of people forming a circle. Other notable details are the writing alcove at the rear of the first large room where an inkstone rests on the top of a pile of papers (a reference to writing letters and poetry), along with a pile of books (a reference to reading). The large six-panel screen at the back of the middle room is painted with a monochrome ink landscape.

This screen is typical of any number of genre screens that depict activities in a domestic interior. While some of these appear to be residences of the wealthy elite, others clearly depict large mansions, euphemistically called "teahouses," in the pleasure quarters. In this screen, the group of young samurai and the visual references to the Four Accomplishments—reading, writing poetry, music and games—are more suggestive of a family, in this case a *daimyō* family, relaxing and enjoying amusements characteristic of a festive, springtime mood.

Emily Sano

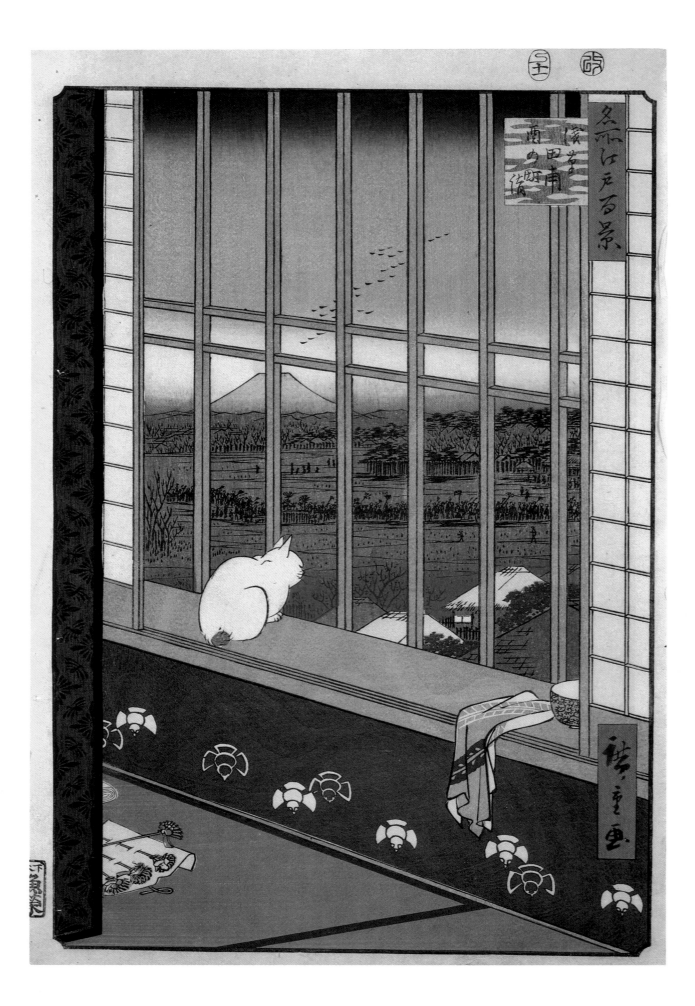

The Dichotomies of Dwelling: Edo/Tokyo

Marc Treib

Joining systems (*tsute-shikuchi*) from a Japanese carpenters' manual, *Nihon kenchiku no kakusareta chi-e (Hidden Knowledge of Japanese Architecture)*.

(opposite)
Andō Hiroshige
Asakusa Ricefields During the Cock Festival from the series *One Hundred Famous Views of Edo*, 1857
color woodblock print
19 x 15, 48.3 x 38.1
Collection Elvehjem Museum of Art,
E.B. Van Vleck Collection,
Bequest of John Hasbrouck Van Vleck,
University of Wisconsin, Madison

Over the centuries, the Japanese dwelling has risen from the surface of the earth to become a platform hovering above it. The peoples of Japanese prehistory lived directly upon the ground in a shallowly excavated pit enclosed by a structural framework of wood roofed with grass, reed or leaves. By the end of the second century A.D., a distinction between structures for dwelling and those for storage had developed. To protect its contents (often rice) from flood, insects and vermin, the floor of the storehouse (*kura*) was lifted high above the ground. The concept, in time, transferred to the house, leading to a form that combined a thatched roof with an elevated wooden platform.

While the thick grass mat, predecessor of the true *tatami*, already existed in the Heian period (794-1185), the use of the *tatami* floor in the residences of the higher social strata was not widespread until the fifteenth century, and in the common house not before the Edo period (1603-1868). Wood remained the principal flooring material until that time. The dwelling thus stood as the collective memory of its making, encompassing an earthen area (*doma*), sections of wooden planks in the higher use areas, and finally an expanse of the true grass *tatami*, all capped by a massive straw roof. Each of these floor areas reflects a stage in the development of the house and their persistence, even today, illustrates the reluctance to discard traditional forms that is characteristically Japanese. In the past, new forms evolved through a process of addition or adaptation, rather than through the wholesale introduction of radically new forms and construction techniques into the existing building vocabulary.

Until the modern era, wood continued as the most common structural material. Abundant and easily worked, wood was not used as in the load-bearing diaphragm wall of the West, but as an exposed structural frame. Japanese buildings are organized on the modular grid of the *tatami* (approximately three by six feet) and rely on seemingly simple perpendicular intersections. Structural members appear to intersect effortlessly, but these clean intersections, in fact, depend on elaborate joinery to function effectively. Rarely rigid, these joints acquire their strength through the tightening of wooden wedges and the dead weight of the roof. Certainly, mud-shear walls increase the stability of the structure, although as infill panels they lack the carrying capacity of true bearing walls. The frame's structural flexibility actually helps withstand seismic shocks, which are transmitted through the frame rather than resisted by it. To the forces of fire, however, the wooden house offers little resistance, and fire periodically destroyed sections of Edo.

Hasegawa Settan
View of an Edo theater district, from the 1928 reprint of *Edo meisho zue,* nineteenth century black and white album plate

The majority of the buildings are *machiya* (residences of the townspeople); *kura* (storehouses) line the river.

Storehouses accompanied the better dwellings in the country and in the city. Although the *kura* used the same wooden construction as the house, its walls and ceilings were packed with a mud and clay mixture to a thickness of eighteen inches or more, effectively rendering the structure a fireproof vault. In times of conflagration, the step-profiled windows and doors were sealed with wet clay to prevent the infiltration of oxygen.[1]

Two principal types of sliding panels filled the house's wooden frame, and used the same module as the *tatami* flooring. The *shoji* was a joined wooden frame covered with rice paper or other translucent material. The *fusuma,* an opaque composite paper panel, was used when greater visual or acoustic privacy was required. To these must be added the heavy wooden rain shutters (*amado*) that closed the house at night or in inclement weather. Unlike the *shoji* and *fusuma,* the *amado* occupied the very edge of the veranda, and was not used internally. While not panels in the strict sense of the word, the folding screen (*byōbu*) and the hanging bamboo curtain (*sudare*) functioned in a parallel manner, completing the system of spatial dividers.

In place of the fixed rooms of Western dwellings, the spaces of the traditional Japanese house flow into one another, barely subdivided from the whole; fluid spaces that change over time. Variability in spatial configuration is perhaps the most important characteristic of the Japanese residence, and therefore the ossification of spaces into rooms in the twentieth century has been one of the most radical changes to have taken place under the influence of Western architecture. The typical Japanese house lacked fixed rooms—such as the parlor or the drawing room or the living room—for specific functions. The act of dwelling embued meaning. A single space could serve activities as wide ranging as conversation, dining or sleeping. Though there was relative spatial flexibility, certain sets of functions were assigned to specific zones within the house: the earthen floor area might be used for heavy cooking, storage, or—in certain districts in the rural north—even the housing of animals. The wooden-floored areas usually accommodated the greatest traffic and mundane use, while the finer *tatami*-covered spaces were reserved for the most honored guests, special occasions, or those places that housed the family's Buddhist altar or Shinto shrine. In spite of variations in specific forms, these generic solutions to the making of a house—its construction, its zoning in floor levels, its disposition in plan, and the use of the roof as a symbol—pervaded most residential architecture.

Edo Period Dwellings

Prior to the Meiji Restoration of 1868, Japanese society comprised four main classes: the nobility, followed by the military, the farmer and artisan, and finally the merchant.[2] By the end of the Tokugawa era, in part the product of centuries of relative peace, and a money rather than a barter economy, considerable financial power lay in the hands of the merchant class—in spite of the social prohibitions. The sumptuary laws instigated by the shogunate to maintain authority and social position regulated almost all aspects of life, including that of dwelling. Structures for society's lower classes were limited in size and quality of materials, and their location was rigidly· circumscribed.[3] The elimination of such restrictions at the close of the century allowed the merchant class larger houses of better materials.

1. See Marc Treib, "The Japanese Storehouse," *Journal of the Society of Architectural Historians,* vol. XXXV, no. 2, May 1976, pp. 124-137. Teiji Itoh, *Kura: Design and Tradition of the Japanese Storehouse* (Tokyo: Kodansha International, 1973). Ever astute, Morse notes that a candle would be placed within the *kura* as the doors and windows were sealed against an approaching fire, expending the oxygen and further reducing the chance of combustion. Edward S. Morse, *Japanese Homes and Their Surroundings* (New York: Dover Publications, Inc., 1961 [1886]), pp. 35, 76.
2. This four-part structure discounts the *eta* (untouchables), who stood below the lowest level of the rankings.
3. See William H. Coaldrake, "Edo Architecture and Tokugawa Law," *Monumenta Nipponica,* vol. XXXVI, no. 3, Autumn 1981, pp. 235-284, for edicts proscribing building materials and finishes.

110

Nineteenth-century *machiya* with a typical entryway slotted *noren*.

(below)
In the interior of the Yoshijima house, Takayama (1908), wooden beams pile up solidly from the ground to the skylights.

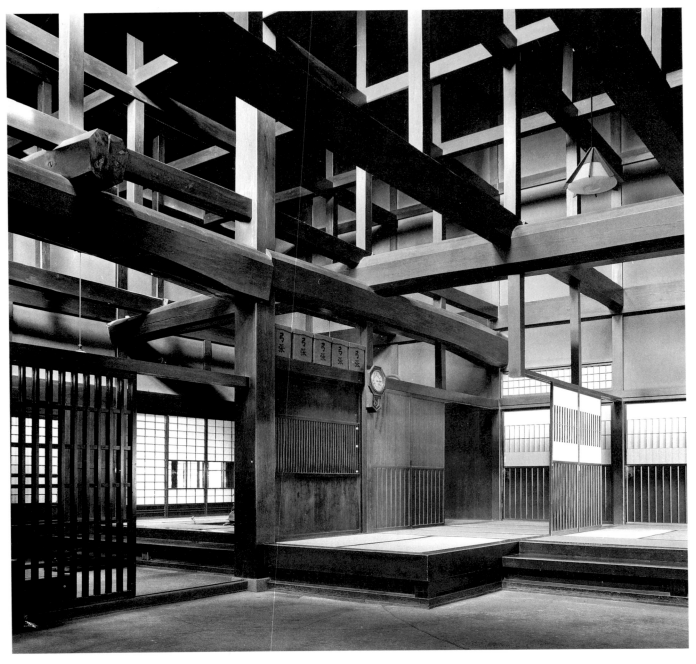

While residential architecture itself continued to follow traditional patterns, the range of class and taste of those who built the houses, and those who lived within them, broadened.

Three types of structures dominated the housing stock: the *machiya*, the *nagaya* and the *yashiki*. Of the three, the *machiya* was perhaps the most colorful and provided the greatest variety of activities for urban life. The *machiya* (literally, townhouse) typically included a shop as well as a residence. Business transactions, well into the modern era, were personal interactions and the architectural distinctions between a shop and an urban residence could be difficult to discern. A facade of clay, wooden planks, or grillwork greeted the street, its massing defining the void of the shop's entry. When open, the *noren* bearing the crest of the owner draped the opening. One entered on an earthen floor as in a rural house.

In Europe, living over one's shop was a common pattern; in Japan the shop lay to the rear or to the side of the dwelling. Business and residence shared common architectural features and utilized similar materials and building technology. Unfortunately, World War II erased many of the historic examples of the Edo *machiya*, although the pattern still survives in countless small business districts around Tokyo.

For period representatives one may turn to *machiya* in the towns of Kawagoe, north of Tokyo, or Takayama in Gifu prefecture. The structures of the latter mountain village are certainly the more splendid, illustrating how excessively and ostentatiously the Japanese patron and carpenter could build while remaining within the limits of the accepted social and architectural canons.

With the promulgation of the modern constitution in the Meiji period (1868-1912), Tokugawa building restrictions were lifted, allowing the wealthy merchant class overt access to the architecture of luxury. The Takayama district was known as a "Little Kyoto," its fortunes made in sake brewing and money lending. The great houses of Takayama, like the Kusakabe or Yoshijima residences (both from the very beginning of this century), are elaborate constructions of beams and posts piled one upon the other, growing solidly upwards from the ground to the skylights that bring light deep into the usual darkness of the dwelling. Entry is once again upon an earthen floor. The raised floor level of the reception, sales, or production areas that greeted the client or visitor, opened to those parts of the dwelling on the side and to the rear of the site. Arranged on the *ken* grid, the residence gracefully meandered through pocket courtyard gardens to the storehouses in the rear. As a generalization, we could say that the most important spaces lay deep in the interior (*oku*) of the dwelling.[4] In these houses we see the highpoint of the tradition, where the manipulation of space and light, the use of materials, and the detailing of the *shoji* intersect in an architecture of complex richness.

The *nagaya* (longhouse) was the dwelling of the people of lesser means, a unit arranged in compounds along streets, or in the rear yards of the *machiya*, in the manner of a row house or tenement. Here lived the worker, or perhaps the artisan, affiliated in some way with the shop in front. The square footage of the *nagaya* was considerably smaller than the combined floor areas of the shop and dwelling of the *machiya*, and its building materials were of lesser quality. A prime distinction between types was that the inhabitant usually rented the *nagaya* while the *machiya* was owned, or built under an extended land lease. In all, the *nagaya* was a serviceable, though minimal, habitat in which the working population

4. *Oku* has been explained by architect Fumihiko Maki as "the hidden core of Japanese space," revealed through progression. It is not an inner sanctum in the Western sense of the word, but more a concept of "interiority." Fumihiko Maki, "Japanese City Spaces and the Concept of *oku*." *The Japan Architect*, vol. 54, no. 265, May 1979, pp. 50-62.

lived. Packed in districts or subdistricts, its intimacy forced lively social interchange—or miserably crowded conditions—upon an expanding population.

The *yashiki* stood at the top of the dwelling pyramid. In some ways suburban, in others urban, these mansions of the aristocracy occupied districts apart from the intensity of the *shitamachi* (downtown), which was the center of plebeian life in Edo. Like much Japanese housing stock, little of the *yashiki* complex was visible from the street. Over the outer wall the roof of the residence might be seen, though with sufficient land no part of the principal dwelling was visible from the outside. Instead one saw the tile-capped plaster surfaces of the circumferential wall, the barracks of the lower ranking retainers and, at times, an ornate entry gate. In addition to the Tokugawa laws that required *daimyō* to reside in Edo during alternate years, other edicts explicitly dictated the construction of residential compounds that communicated the social status of their owners. The elaborate building forms, such as the entry gate, not only expressed wealth and social rank—thereby reinforcing the Tokugawa hierarchy—but also drained the economic resources of the *daimyō*, diverting funds that might have been directed to military purposes.[5]

Within the walled enclosure was a green world that recalled life in the estates and gardens of Kyoto.[6] The estate structure retained a resemblance to the humble farmhouse. Its garden was equal in importance to its house, and in some instances the garden surpassed the residence in prominence.

Edo Period Gardens

During the Edo period a fundamental change occurred in the conception of the garden, or let us say, a reinterpretation of the garden ideas of past ages. The upper classes continued to admire the artistic and cultural accomplishments of certain historical periods, such as the Heian. In the intervening centuries, political power had been consolidated in the hands of the shogunate, and the lavishness of the imperial life style—and available land for development—was seriously diminished. In many ways the Heian period had contributed the first polished versions of truly Japanese art, even taking into consideration the Chinese influences upon which many of its art forms were based (literary allusions within the garden, for one).[7]

The Heian garden was essentially a pleasure garden in which one appreciated the passing of the seasons and the subtleties of nature, entertained other members of one's class, and engaged in the refined aesthetic pursuits of the era. Poetry writing parties were popular, with nature serving as an obvious subject. As poetry reflected nature, so too the designed vegetation of the garden recalled and heightened the experience of the natural world.

But first under the influence of Zen Buddhism and subsequently that of the tea ceremony, the notion of landscape gardening changed. Within the setting of the Zen compound, the garden served as a contemplative vehicle towards the achievement of *satori* (enlightenment). The garden occupied the zone between the roofed structure and the wall, converting what might be considered a residual or negative space into a positive one. The dry garden at Ryōan-ji illustrates how the simplest of building palettes—rock, gravel and moss—can be converted into a landscape of

5. See Coaldrake, *op. cit.,* "Edo Architecture and Tokugawa Law," for an extended discussion of the gateway and its role in the architecture of the *daimyō*.
6. The distinction between the *rikyū*, and the *yashiki* as building type is perhaps more a question of scale and elaboration than a strong distinction in form.
7. In the Heian period novel, *The Tale of Genji*, nature, and nature in the garden, play a key role in the setting of mood: "Akikonomu's garden was full of such trees as in autumn turn to the deepest hue. The stream above the waterfall was cleared out and deepened to a considerable distance; and that the noise of the cascade might carry further, he set great boulders in mid-stream, against which the current crashed and broke. It so happened that the season being far advanced, it was this part of the garden that was now seen at its best; here indeed was such beauty as far eclipsed the autumn splendor even of the forests near Oi, so famous for their autumn outings." Lady Shikibu Murasaki, *The Tale of Genji (Genji monogatari)*, trans. Edward Seidensticker (Rutland, Vermont: Charles E. Tuttle Co., Inc., 1976 [written between 1001 and 1020]). See also Ivan Morris, *The World of the Shining Prince* (Baltimore: Peregrine, 1964).

The staggered plan of Katsura Detached Palace in Kyoto is the primary example of diagonal incremental growth in Edo-period architecture.

considerable visual richness, if one possesses the proper frame of mind to discover the sources.[8]

In Japan, one looks not upon but within a work of art. The extraction of significance lies with the perceiver, not within the object perceived. The historic house or temple within its walled setting was not itself the subject of view. It articulated space, orchestrated movement through it and functionally withstood the sun, snow, or rain—but it was not an architectural entity to be approached and confronted in the tradition of formal Western architecture. The objects of contemplation, instead, were the incidents within the space: the folded screen, the transom carving, the ceramic vessel or the flower arrangement—and, after time, the garden. The dwelling thus served as a species of roofed bridge between exterior spaces.

Contemplative gardens were not meant to be walked in; one visited them through the eye and the mind.[9] The tea garden (*roji*), on the other hand, was conceived as a progression that led from the tumult and formality of the daily world, to the calm and focused repose of the cult of tea. The ceremony itself is today prescribed and codified, though even within its formalities and standardization variations still occur. As in the martial arts, one learns by repeating the *kata* (forms), and with their assimilation true learning occurs.[10]

The garden form itself reflects this concept of tradition. When the tea ceremony was new and still open to development in the late sixteenth and early seventeenth centuries, it was pervaded by wild notions of experimentation. For one, the emerging tea masters eschewed the complex refinements of the Chinese style of architecture for a model based on the rural farmhouse. The simple, the honest were revered—*wabi* characterized the tea style.[11] In contrast to the formalized symmetries of the older palatial style, the contrived, picturesque massing of the teahouse reflected organic patterns of growth, to formulate an architecture in accord with nature.

An organism, these aesthetes believed, should be regarded as an entity in any stage of its development. From birth through growth, personal fruition, decay and even death, each stage was taken as equally viable

8. See Teiji Itoh, *The Japanese Garden* (New Haven: Yale University Press, 1972); Jon C. Covell, *Zen at Daitoku-ji* (New York: Kodansha International, 1974); and Marc Treib and Ron Herman, *A Guide to the Gardens of Kyoto* (Tokyo: Shufunotomo Co. Ltd., 1980).
9. There is some evidence, however, that the purity of the stone and gravel garden at Ryōan-ji actually dates from the Edo period, and that prior to that time there were trees within the walled enclosure.
10. "Therefore the sage . . . learns to be without learning." Lao Tzu, *Tao Te Ching*, trans. D.C. Lau (Baltimore: Penguin Books, 1963), pp. 125, 126.
11. *Wabi* is a Zen aesthetic incorporating simplicity and humility, developed by tea master Senno Rikyū, which sought inner beauty hidden under a wretched surface. It is commonly defined as "refined poverty."

In present-day Tokyo, Koraku-en retains its Edo reference to China's Mount Lu (Lushan) in this grass-covered hillock.

and equally complete. Symmetry requires repetition to create a sense of aesthetic balance. Asymmetry, on the other hand, diagrammed the irregular processes of life more directly. The familiar plan of Katsura Rikyū (Katsura Detached Palace) in Kyoto was developed on the "v" pattern of geese in flight, and constructed along an implied diagonal. The palace was built over a period of more than a century in three distinct phases. The entirety is ordered by the *ken* system, and the staggering of the pavilions and the studied relationships of the building elements create a unified composition. Even in its earlier stages of construction the palace appeared cohesive and complete.[12]

Four principal concepts informed the Edo garden: the use of unfinished materials, asymmetrical planning, the presence of water, and experience directed by a controlled path—perhaps the most important element borrowed from the tea garden. The relative stability of the times and the detachment of direct governance from the imperial family left the court aristocracy with sufficient time but limited resources to develop an architectural setting of refinement. Recalling the pleasure gardens of the Heian period, they distilled their ideas of landscape in the *kaiyūshiki teien* (stroll garden).

In the stroll garden, movement was essential for appreciation and comprehension. Building and landscape were taken as complementary, the one the setting for the other, with the edges between the two blurred through contrived design and ritual use. In imperial gardens, such as Katsura Rikyū or Sento Gosho, a pond occupied the focal position with directed movement along a path that kept the water to one's right. The orchestrated traversing of the garden revealed the sequence of its events, blocking vision with plants and trees, or opening a view to distant vistas and special features.[13] As in the gardens of the twelfth century, literary allusions recalled foreign places or previous times whose auras hovered over the contemporary vegetation.

Kyoto was a city of rising and falling land, situated within a gently inclined valley, fed by rivers and surrounded by hills and mountains. The major gardens occupied the junctures between flat and sloping land and utilized changes in topography to assure the flow of water or the presence of surrounding landscape as part of one's own garden.[14]

Most of Edo offered few of these natural advantages. The land surrounding the bay was primarily flat, in places marshy, watered by the Sumida and Kanda Rivers. In contrast to the hilly topography of the Yamanote district, the Edo lowland offered little to the garden maker. If the halcyon days of the Heian period provided the model for the gardens of Kyoto, then Kyoto later served as the model for the gardens of Edo. The stroll garden featured pointed references to famous Japanese or Chinese landscapes, as well as to the landscapes of Buddhism or myth. The plants and hills of the gardens in Edo, on the other hand, recalled many of the noted sights in and around Kyoto, and in some cases even replicated the features of its gardens. The best-known of the Edo estates are the Hama Rikyū, Koraku-en, and Rikugi-en; their past glories, though greatly diminished, are still visible today.

Hama Rikyū, originally duck hunting grounds for the shogunate, had a rather uninteresting, flat marshy site that ultimately was used to advantage. Canals needed for drainage linked the estate to the bay, and inte-

12. Although Katsura is planned on the rectilinear module of the *tatami*, a diagonal organization is implied by the zigzag of the corridors. See Treib and Herman, *op. cit., A Guide to the Gardens of Kyoto*, pp. 28, 29.
13. *Ibid.*, pp. 27, 28.
14. This concept, known as *shakkei* in Japanese, incorporated features of the background landscape into the garden principally by masking distracting elements in the middleground and using the foreground to frame the distance. *Ibid.*, pp. 30, 31, and Teiji Itoh, *Space & Illusion in the Japanese Garden*, trans. Ralph Friedrich and Masajiro Shimamura (Tokyo: Weatherhill/Tankosha, 1973), pp. 28-58.

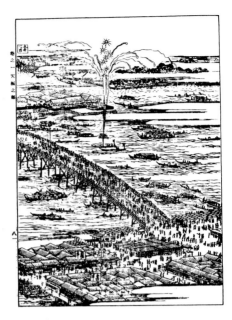

grated the rise and fall of the tides into the cycle of the garden's ponds and streams. Today a public park, its outer zone exhibits little of its earlier detail, but within the central compound, the pond and waterways, the meandering *yatsuhashi* (zigzag bridge) and the reconstructed architectural features provide insights into its Edo beginnings.

Koraku-en was commenced in 1629 by Tokugawa Yorifusa (1603-1661), and further developed by his son Tokugawa Mitsukuni (1628-1700). Today most of its structures are gone, but certain features of the garden, such as its reference to the Chinese Mount Lu (Lushan), remain both noteworthy and illustrative of the period's taste. The path weaves along the main stream, through wooded areas, across yielding rice fields, and finally skirts the pond. The wisteria trellises that link shore to water and a miniature dike that references Lake Xi Hu at Hangzhou exemplify the blending of historical origins with formal harmony. Though the site originally included small hills and trees, most of its landscape features have been augmented or completely constructed. At times, metaphorical reference to mountains was the best that one could do, although in this instance the Lushan hillock was built from earth excavated to create the garden's water features.[15]

If Edo was a green city, most of that greenery was privately owned or leased. And while Japan had little public open space tradition beyond the residential or commercial street, there were almost always publicly accessible green areas. Shrine and temple compounds offered needed open space in the densest areas of the city, and their grounds often accepted social uses, such as children's noisy play, that would be out of keeping with churchyards in the West. In many ways, these must be grouped with parks as public open space. Street trees, a Meiji development, graced certain districts of the city and at times even became a symbol for them, as for example, the willows of the Ginza.

The riverbanks, however, were among the few places of true escape within the urban limits. Often planted to cherry, flowering with delicate pink blossoms in the spring, the banks were points of recreation and rejuvenation. In July the Sumida River officially opened, crowded with boats of all kinds, illuminated by brilliant pyrotechnic displays.[16] Many of the riverbanks have since been lined with concrete for flood control and water management and their effect has been seriously diminished. Although lacking aesthetically, they remain the site of ball fields and promenades. With the imperial restoration, public utilization of open space shifted to reflect the change in land ownership and use. The major urban parks in Meiji Tokyo were a result of these changes. Ueno Park, established in 1837 as the city's first, incorporated the grounds of Kan'ei-ji, one of the two main familial temples of the Tokugawa family. Today's Meiji Jinja had been relatively undeveloped imperial land surrounding a local Shinto precinct, re-formed between 1915-1927 as a fitting memorial to the emperor.[17]

In the last two decades Tokyo has seen the development of skyscraper towers at a new scale, principally in a small pocket surrounding the Shinjuku Station complex. Accompanying the tower—in the Western mode—is the plaza, a form virtually unknown in Japan before the modern era. The Mitsui Plaza, designed by Nihon Architects and built in 1974, is both typical and among the best of its genre, a plaza frontispiece to the tower behind it. Focused on a masonry waterfall and pond, the space is enlivened

15. Mark Holborn, *The Ocean in the Sand: Japan from Landscape to Garden* (Boulder, Colorado: Shambhala, 1978), pp. 88-94.
16. Edward Seidensticker, *Low City, High City: Tokyo from Edo to the Earthquake* (New York: Alfred A. Knopf, 1983), pp. 136, 137.
17. *Ibid.*, pp. 254-256.

(above)
The *eki-mae* (open space fronting a railroad station), with its bustling activity, is the contemporary successor to the Edo street.

Mitsui Plaza, among the best of Tokyo's Western-style urban spaces, is enlivened by a waterfall and pond.

(opposite)
Hasegawa Settan
July Opening of the Sumida River, from the 1928 reprint of *Edo meisho zue,* nineteenth century
black and white album plate

This depiction celebrates the annual boating parties and fireworks at the *Ryōgokubashi.*

by the presence of water and the activity of the small shops and cafés that open onto it. But unlike the classic Italian piazza such as the Campo in Siena or the Piazza San Marco in Venice, Mitsui Plaza—and the others of its type—has no tie with the dense urban tissue of Shinjuku or Tokyo.

For that integration of open space and public life one must turn to the *eki-mae,* the open space fronting railroad stations. This, too, is a modern invention, the product of the railroad and the transportation modes that carry passengers and freight to and from it. While rarely given the architectural treatment of corporate or commercial plazas, these spaces teem with activity, mixing people, cars, buses and taxis in structured chaos. In this sense it is the *eki-mae,* and not the corporate plaza, that is the successor to the Edo street.

A turn of the century Western-style house in Kobe, with the period's characteristic balconies and verandas.

Housing in Tokyo

Japanese culture, on more than one occasion, has evidenced its ability to embrace simultaneously the foreign and the indigenous, rooting the new and exotic firmly within traditional patterns. The images of Meiji-period prints project what to the modern viewer are rather improbable cultural juxtapositions: kimono, top hats and laced shoes, trains and *jinrikisha*, and unlikely concoctions of Western architecture adapted from storehouse construction by native builders. And yet a common sensibility pervades each of these scenes, a sensibility that conveys an appropriateness in contrast to the formal disparity of the individual elements. Architecture also felt the force of Western importations. Kobe provides several representative examples of early Western domestic architecture, though much of what remains was built by foreign designers for foreign residents. The period's most characteristic feature was the ornate veranda attached to the projecting bay. Though the veranda (*engawa*) was known in Japan, its traditional function as a transition space contrasted with its use as a separate room in the new Western-style house.

The early monumental buildings of Meiji were designed by imported architects and smack of an English, French or heavy Germanic style. The great residences of the period from the Restoration into the 1930s exemplify an almost exact antithesis to the lightness, delicacy, and sense of impermanency that characterized—and graced—so many imperial building projects in the Edo period. The Akasaka Detached Palace, built in 1909 by Otokuma Katayama along the lines of the great baroque palaces of Europe, is perhaps the most severe representative of this architectural predilection, a building that acquires in dignity what it loses in finesse and refinement. Obviously structures like these used little of the Japanese dwelling tradition and it was common practice to include a Japanese section in a Western-style dwelling (or vice versa), which could be used for receptions and to impress foreigners, but hardly to live in.[18] Technical improvements, on the other hand, were probably welcomed, but their acceptance took time. Central heating systems, extensive use of glass in place of translucent paper, and later electricity had their impact on the house. But each innovation required a period of acceptance—and in certain quarters, or in certain strata, they were not assimilated for decades.

Palaces were hardly the norm, however. For the great mass of people living in Tokyo, or streaming into the capital to serve and be served by

18. The original treaties between Japan and the United States, Russia, France and Great Britain, among others, included the opening of Yokohama, Kobe, Osaka, Nagasaki, Niigata and Hakodate to foreign trade; establishing a passport-free zone of about a twenty-five-mile radius; low import tariffs; and extraterritoriality—the most upsetting of the articles. Much of Japan's striving for political and cultural recognition in the late nineteenth century was aimed at improving its status in these treaties. See Basil Hall Chamberlain, *Things Japanese* (London: John Murray, 1905), pp. 488-497 for a 1905 account, and Seidensticker, *op. cit., Low City, High City,* pp. 68-70 for their impact on architecture, specifically the Rokumeikan.

the emerging metropolis, house meant housing. The position of the lowly *nagaya* was superseded by the *mokuchin jūtaku* (low-cost wooden rental units). Of one or two stories, these at first resembled large houses arranged into apartments, but over time they assumed the form of apartment blocks as we know them.

On 1 September 1923, the Great Kantō Earthquake demolished two-thirds of the city. What the shocks commenced, the fires completed. While only one of Tokyo's fifteen wards remained untouched, the city pulled itself out of the ashes and rubble and rebuilt. New buildings on the Western order continued to increase in number but the fabric of the city remained true to its traditional mold: a low profile of extremely high density, even though the development of mass transit—the subways, the suburban lines and the bus system—allowed the population to live farther and farther from the workplace.

If the Great Earthquake signaled a new architecture within historical lines, World War II ended traditional Tokyo. From the devastation of 1945 emerged a more Westernized city with fireproof structures capable of withstanding greater seismic shocks. Due to housing demands and the financial climate, however, the pattern of the single family house continued to thrive in the immediate postwar period. But by the early 1960s apartment blocks began to overtake the house as the typical dwelling, although "My Home" still remains the dream of the middle class. Few areas of the city today retain their prewar face and many of those that appear traditional were, in fact, constructed during the past three decades. Architect-designed houses in Japan today remain isolated exercises, detached from the general flow of contractor or public housing in both form and values.

Postwar Architecture

Japanese architecture, like the Japanese nation itself, sought an appropriate identity during the 1950s, trying to balance the essences of tradition with the innovations of foreign ideas. If the credo of some Meiji enthusiasts had been "Western learning, Japanese spirit," the new style—termed "Japonica"—blended a native attitude, tempered by the spirit and materials of Western Modernism. The style was at once a fusion and a search.

Kenzo Tange's own house, built in Tokyo in 1953, illustrates the architect's return to the tried forms of the frame and the *tatami*. The principal living spaces are raised fully to the second floor, supported on a columnar structure of elegant proportions. The shape of the house in plan is a rectangle that is subdivided spatially into four principal zones. In a manner defying tradition, the axis of the house is subtly exaggerated by the alignment of the *tatami* along the longitudinal axis, replacing the balanced symmetry or purer arrangements of the older mat plans. Tange, in fact, advances tradition by refining the building elements into a distilled clarity. The plan shares certain parallels with Mies van der Rohe's Farnsworth house in Plano, Illinois (1950), using the stair or bathroom core to define the principal zones within the encompassing perimeter of the walls. Each segment aligns and complements the next. The adjustment of piece to piece and the astute manipulation of the rhythm of panels creates a house balanced and yet charged with a visual drive, showing us that refinement need not necessarily yield a static effect.[19]

19. Robin Boyd, *Kenzo Tange* (New York: George Braziller, 1962), pp. 27, 28. Udo Kultermann, ed., *Kenzo Tange: 1946-69 Architecture and Urban Design* (New York: Praeger Publishers, 1970), pp. 28-31.

By the end of the 1950s the Japonica trend exhausted itself, after having produced some buildings of astonishing power and beauty. The resurgence of national identity after the defeat of World War II involved a reevaluation of Japanese roots, and the adaptation of traditional building systems to the materials and urban demands of the twentieth century. The path led into an aesthetic dead end, although it took more than two decades for the movement to dissipate.

In 1960 an international architectural congress was held in Tokyo that served as the official debut of the new Japanese architecture. The conference introduced a loosely confederated movement entitled Metabolism, whose participants included such architects as Fumihiko Maki, Kiyonori Kikutake, Arata Isozaki, Kisho Kurokawa, and the critic Noboru Kawazoe, with Kenzo Tange as a sort of spiritual mentor. Metabolism argued that construction should echo in some ways the metabolic process of life, recalling the additive qualities of *sukiya* architecture, albeit at a vastly enlarged scale.[20] Ironically, many of the buildings that eventually issued from this theoretical attitude toward context threatened the very neighborhoods whose life they were meant to emulate. The biological metaphor was soon depleted and little metabolist architecture was actually built in a pure form, the most prominent representative being Kenzo Tange and URTEC's Yamanashi Communications Building in Kofu (1966). Built as a system of circulation and service towers with work spaces infilled between, the structure was intended to facilitate addition while expressing the presence of time in its construction. Having the look of growth with little actual growth exposed the hollowness of this effort.

Metaphor and the Urban Environment

Perhaps the greatest legacy left contemporary Japanese architecture by Metabolism was the use of metaphor in architectural design. In reaction to the functionalist tradition, which sought its significance in the accommodation of program and its expression in construction method, architects began to design by basing architectural concepts on philosophical or social ideas. By the 1970s, the houses published in the trade journals were often treated thematically rather than as the house of Mr. So-and-So. A book of Kazuo Shinohara's work lists the Incomplete House, a House of Earth, and a Prism House, among others.[21] In other publications, we can find the Nirvana House, House like a Die, Stepped Pyramid House, and Mondrian House by Takefumi Aida. References to other architects, artists, themes, and formal parallels ran rampant in residential design as architecture sought substantiation through related reference.

The search for significance is a common thread that defines architecture worldwide in this postmodern period.[22] While Japanese culture rarely has discarded any aspect of its building tradition, certain features have been buried for a time, only to reappear later on in a similar or grossly distorted manner. The forms of historical architecture returned to the architecture of the 1950s and 1960s in concrete instead of wood, replaced the single-story house of the past with multi-story buildings. The modernist idiom overlaid Japanese architecture, deflecting the course of construction without subsuming it completely. Like most foreign movements adopted by Japanese architects, it was essentially an excursion.

20. "Let us say that the *sukiya* style is one of the two chief traditional styles surviving in Japanese residential architecture today (the other being the *minka* or folk-house style), that it represents a refinement of elements and techniques borrowed mainly from the earlier teahouse and *minka* as well, and that it is characterized by a freedom of planning and construction and an individuality of treatment that set it apart from all other styles." Teiji Itoh, *The Elegant Japanese House: Traditional Sukiya Architecture* (Tokyo: John Weatherhill, Inc., 1969), p. 8.
21. See Institute for Architecture and Urban Studies, *Kazuo Shinohara* (New York: Rizzoli International Publications, 1982).
22. Postmodernism in architecture still eludes precise definition, some seeing it as a stylistic development while others regard it as primarily a question of chronology. To many—and this is unfortunate—postmodernism implies a return to classical idiom, however distorted.

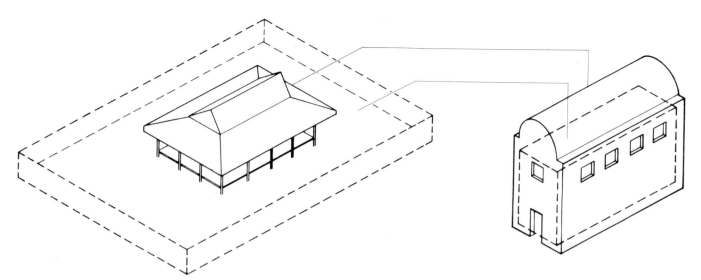

A diagrammatic depiction of an Edo house in a garden and a Tokyo house merged with a garden.

The new Japanese urban dwelling has changed from a haven within a naturalized environment to a haven from the natural environment. The Tokyo dwelling has been reduced to a living machine in which the external perimeter battles the elements as might a space capsule, keeping noise, pollution, dirt and the other negative forces of life at bay. Its perimeter is constantly imploding. As the size of the building lot is reduced, the stature of the average Japanese continues to increase, as do the number of possessions with which urban dwellers live out their lives.

In Edo, we have noted, a circumferential wall held the city at bay like a retaining wall against a hillside. By establishing the controlled zone within the walls, the minimal closure of the structure and roof afforded the house an Edenic existence within the garden. The *machiya* type was less fortunate, but even here, the dwelling retracted its openings from the noisy street and turned them inward toward the internal court or garden.

In the modern era, land values soared and the luxuries of the garden were accessible to few. The walls that once encircled the site far beyond the limits of the house were first pushed into coincidence with it. But the modern city impinges further. In a house in the Tokyo district of Musashi, Kazuo Shinohara has constructed a residence that precisely diagrams the relationship between architecture and its environment, the membrane of the house distorted by invisible forces surrounding it. Located below a run of high voltage lines, the set-back radius from the wires deemed safe by building codes determined the contour of the building envelope. Rather than addressing the legal prescriptions by pulling back parts of the house from the power lines, Shinohara modeled the roof shape to accommodate the precise zone of electric power.[23]

The pessimist could read this as an act of obeisance in which the roof plane has bowed to the invisible powers of public utilities. Those more optimistic, however, could think of Shinohara's design as an act of defiance in which architecture does not retreat, but presses its face against the unseen force—though deformed by it in the process. The architecture of the Tokyo house is thus both a weapon and a shield. No longer within the benign environment secured by a simple circumferential wall, the dwelling must once again assert itself to establish the human position in an urban world.

23. Institute for Architecture and Urban Studies, *op. cit., Kazuo Shinohara,* pp. 110-113, and "Two Shinohara Houses," *The Japan Architect,* September 1981, pp. 18-27.

The Dichotomies of Dwelling

To understand the changes in the dwellings and gardens of Tokyo during the last century, one must look beyond architectural style. In Japan, as elsewhere, architecture exists as a response to social, economic and political forces. Therefore I have outlined the flow of these forces and their impact on the city's dwellings and gardens as Edo became Tokyo, and Tokyo became a metropolis.

Beyond this, however, lies what I term "the dichotomies of dwelling," four sets of characteristics in seeming conflict. These characteristics are less a rigid standard of judgment than the poles between which comprehension might lie; less a finite answer than a structure for posing the question.

Dichotomy 1: The Grid and the Incident

The modular planning of traditional Japanese architecture produced not only a rational, prefabricated system of construction to be modified and even transported with relative ease, but also a conceptual terrain upon which to build—like a chessboard in three dimensions. The employment of consistent angles in both plan and section created an ordered field in which the position of all elements and their relationship to one another is easily established. The three-dimensional framework structured the shifting configurations of infill panels, yielding an interior landscape of changing spaces.[24]

Formally, the frame was nearly neutral, composed of square columns into which the beams and transoms were fitted. The resulting field of view was quiet and calm—the diagonal, necessary for structural rigidity, appeared but rarely, usually in the roofline where functional necessity overcame aesthetic preference.

One principle of Japanese aesthetics is based on the pairing of contrasting properties. Our perceptions of places are prompted as much by what they are not as what they are. The roughness and patina of natural materials, for example, are experienced more noticeably when contrasted with smooth, visually cool, highly polished surfaces. Within the architectonic order of the dwelling, the exception to the grid has a more pronounced effect than a similar incident within an unstructured visual field. The ceiling of evenly spaced wooden planks appears as a neutral surface, as does the floor of beige *tatami*. Against the order of the grid, the painted folding screen, the ornate *fusuma,* or the post of the *tokonoma* contrast significantly, and its aesthetic effect is correspondingly increased.[25]

The *tokobashira* (wood post of the *tokonoma*) best exemplifies the "power of the incident." In the teahouse, where all parts exist within a state of repose, a sense of harmony governs the choice of materials, the colors, the textures and overall character of the room. The *tokobashira* is the exception. The post is selected for its departure from the worked materials of the teahouse; the visual incident in its natural form bears witness to the process of its growth. Memory condenses in a single pillar that shares the sensibility of the flower arrangement or the hanging scroll in the alcove adjacent to it. The Japanese have learned that one intensifies by selection, and heightens an effect by its isolation rather than through the restatement so often used in the West.

24. Engel distinguishes two groups of standards, the *kyoma,* based on an average dimension of 6.5 *shaku,* and the *inaka ma,* based on 6 *shaku,* in his discussion of the modular *ken* system. Heinrich Engel, *The Japanese House: A Tradition for Contemporary Architecture* (Rutland, Vermont: Charles E. Tuttle Co., Inc., 1970 [1964]), pp. 77-100. Masuda describes the application of measurement to construction and their relationship to building tools. Tomoya Masuda, *Living Architecture: Japanese* (New York: Grosset & Dunlap, 1970), pp. 100, 138.
25. The *tokonoma* is the central feature of the tearoom, but by no means centrally positioned. Against the simplicity and earthy roughness of the interior is contrasted this alcove for the display of a flower arrangement, ceramic object or scroll. "The 'Abode of the Unsymmetrical' suggests another phase of our decorative scheme . . . a result of a working out through Zenism or Taoists ideals . . . The dynamic nature of their [Zen and Daoism] philosophy laid more stress upon the process through which perfection was sought than upon perfection itself. True beauty could be discovered only by one who mentally completed the incomplete . . . the art of the extreme Orient has purposely avoided the symmetrical as expressing not only completion, but repetition. Uniformity of design was considered as fatal to the freshness of imagination." Kakuzo Okakura, *Book of Tea* (Rutland, Vermont: Charles E. Tuttle Co., Inc., 1956 [1906]), pp. 69-71.

Tadao Ando
Horiuchi Residence, Osaka 1978

An interior view of the house illustrates Ando's idiosyncratic placement of light wells and windows, designed to take advantage of selected urban views and to regulate natural light.

(opposite)
With its unpolished, natural appearance, the *tokobashira* (wood post of the *tokonoma*) in the Urasenke Society's contemporary teahouse exemplifies the "power of the incident" carried out in the traditional manner of Japanese architecture.

Dichotomy 2: Open Versus Closed

Through the Edo period the house remained a simple frame containing a diversity of social spaces. It was more a lens for focusing upon the activities and objects of the domestic landscape than the subject of view in itself. In many ways the spatial continuum through the house terminated in the outdoors. With the possible exception of the garden or certain entry courts, attention progressed from the building to the garden rather than vice versa. The "walls" of the house were blown out to the limits of the site, precluding physical and visual intrusion, while the dwelling served as a modulator between its inhabitants and nature.

Nature played a critical role in Japanese existence and served as its most noted marker of time. The seasonal varieties of plants and trees, the changes in color and the prominence of plant materials, played important roles in the lives of the people, a role raised to excruciating refinement by the upper classes. Within the house, the choice of flowers for the vase in the *tokonoma* or the selection of subject matter for the scroll—or even the colors or motifs of one's kimono—all derived to some degree from the current season.

Takefumi Aida
Toy Block House #4, 1980-1982

Aida refers to his toy block houses (a ten-year obsession) as "animated architecture," in which cubic elements are fitted together in a complex intellectual game of construction.

(opposite)
Team Zoo
Domo Celakanto, 1972-1975

The wandering irregularity of this house interior belies the strong grid pattern of its plan.

Of course, in today's Tokyo this is hardly the case. The forces of the environment have reduced the size of the site, and forced an internalization of many of the functions traditionally rooted in the garden. In houses such as Tadao Ando's Ishihara house (1978) in Osaka, simple and bare in concrete and glass, all vestiges of nature seem to be absent. Yet Ando believes in the importance of nature within the confines of the house, and he pursues it in a startling manner. He believes that fabricating a tie with nature through traditional means is no longer possible in an urban setting; only through a view of the sky and the presence of light within the house can the dweller link with the world beyond the city.

Dichotomy 3: Architectonic Versus Thematic

The Edo house presented itself to the street as a series of wooden grills, a cloth *noren* in the doorway, or perhaps an earthen clay wall. Its treasures were internalized. The house provided the frame for examining living rather than portraying the subject of that life per se.

From the late 1960s on, Japanese architects have furthered the concept of the house as a subject. Partially due, no doubt, to the disappearance of sufficient open land, the garden and the house have been pushed into one another, merging the subject with the traditional vehicle for its observation. If the external garden has disappeared in recent construction, it has become embedded into the form of the house itself.

Metaphors or formal themes become the starting points for the design. The work of Takefumi Aida exemplifies this predilection, although it is an approach shared by architects with as seemingly diverse styles as Tadao Ando, Shin Takamatsu, Kazumasa Yamashita and Arata Isozaki. Their use of subject varies, of course, certain of them selecting architectonic motifs such as the vault (for example, Isozaki's houses of the 1970s); others use artistic borrowings or philosophical ideas.

For a period of almost ten years, Aida has been playing with the theme of the "toy block." His ideas derive not only from his own childhood but also the more direct formal reference to the childhood education of Frank Lloyd Wright, whose mother exposed him to the Froebel System of block play early in his life. Aida's interest in the system also builds upon the formal complexities prevalent internationally in today's architecture, such as the return to color, and the increase of texture and ornament. This Toy Block theme has now been applied to ten projects that contain a number of subthemes. Toy Block House #4 plays with a white and gray color scheme and an asymmetrical entrance which recall the De Stijl architecture of Gerrit Rietveld. The blocks now recall as well a stylized version of classical architecture, and comparison to the work of Michael Graves is inescapable.

Dichotomy 4: *Shibui* Versus *Hade*

Most architectural traditions are characterized by stylistic polarities. The first embodies restraint, quiet and balance, with an emphasis on the sophistication of its forms rather than on the invention of new ones. The second stresses independence and exuberance, and is far more dynamic in its relationships of form and color. One could also measure the architecture of Japan against this dual organization, well exemplified in the terms *shibui* and *hade*.

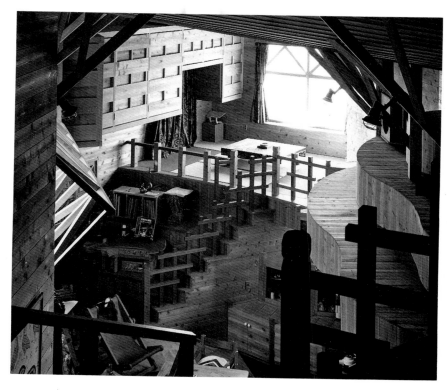

26. "In the tea-room the fear of repetition is a constant presence. The various objects for the decoration of a room should be so selected that no colour or design shall be repeated. If you have a living flower, a painting of flowers is not allowable. If you are using a round kettle, the water pitcher should be angular. A cup with a black glaze should not be associated with a tea caddy of black lacquer. In placing a vase or an incense burner on the tokonoma, care should be taken not to put it in the exact centre, lest it divide the space in equal halves. The pillar of the tokonoma should be a different kind of wood from the other pillars, in order to break any suggestion of monotony in the room." Okakura, *op. cit., Book of Tea*, pp. 71, 72. The monotony, or absolute harmony, is termed *jimi*. While acceptable, it is regarded as a lesser order than true *shibui*. For a simplified treatment see *House Beautiful*, August 1960, which popularized the concept of *shibui* in the United States.

I wish to thank the following colleagues for their valuable comments in discussion or review of the manuscript: Chris Fawcett, Ron Herman, Riichi Miyake, Henry Smith and David Stewart. I remain grateful to the following architects for sharing insights into their work and the work of others: Takefumi Aida, Tadao Ando, Hiroshi Hara, Arata Isozaki, Tsunekata Naito, and Fumihiko Maki.

Both could be loosely translated into English as beautiful, but a simple definition is insufficient. More specifically, each term connotes a particular kind of beauty, two varieties that seem in opposition and yet overlap to a certain degree. *Shibui* develops from the root word for astringent, signifying a type of beauty through reduction, through simplicity and refinement, through the combination of resonant and dissonant elements. In color it might be a series of hues in the earthen range set against a deep husky purple. A monochromatic palette might create harmony, but that lack of the missing dissonance would undermine its ultimate perfection.[26]

As might be expected, the term is associated with the tea ceremony. Within the tearoom the world should be serene and in repose. But like the visual dissonance of the naturally curving *tokobashira* within the consistency of the gridded field, the color scheme was far from a mute harmony. The restraint of tea architecture and the related *sukiya* style constitute one of the primary strains of Japanese aesthetics. It is the school of thought that is commonly sold to the West as the true Japanese mentality, perhaps because it can be applied best to Japan. It is a school that still pervades many aspects of contemporary aesthetics, but it is only one of the several sensibilities of beauty.

Like yin-yang, the male-female dichotomy of the forces that govern the world, the refinement of *shibui* is complemented by the exuberance of *hade*. *Hade* also expresses beauty, but it is a beauty of brilliance. *Hade* is the beauty of gold embroidery on flaming vermilion silk, the beauty of polished stainless steel against brilliant enameled yellow. It is the beauty of the architecture of expressionism or collage, the polychromy of the shrines at Nikkō, the elaborate carvings, the extravagant materials and ornament. While it would be convenient to advance the *shibui* faction as the genuine Japanese, and the *hade* as a more continental import, this is not the case. Both coexist as two sides of a single coin, and both are saved—the *shibui* from deadliness, the *hade* from over-exaggeration—by the presence of the other, expressed or implied.

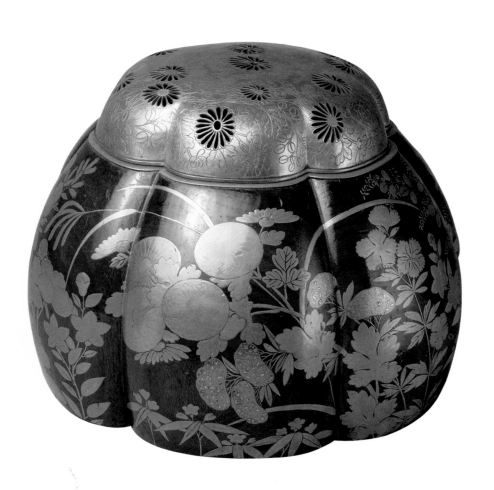

Ko-ashiya kettle, Muromachi period,
sixteenth century
cast iron, bronze
6⅞ x 5¼, 18 x 13.2
Collection Richard and Peggy Danziger

This kettle, intended for winter use, has a
graduated hailstone pattern, two rondels with
designs of bamboo, plum and pine—the
"Three Gentlemen" of Chinese scholarly
tradition.

(opposite, top)
Te-ro (handwarmer) in shape of Akoda melon,
Edo period
lacquered wood, *hiramaki-e,* gilt copper,
metal alloy
9 x 11¾, 18.1 x 29.8
Collection Richard and Peggy Danziger

(opposite, bottom)
Kogo in shape of plum blossom, Edo period
red lacquer over basketry core, wood,
gold leaf, silver *hiramaki-e*
1½ x 3½, 4 x 8.5
Collection Richard and Peggy Danziger

The five-lobed plum blossom shape is
appropriate for use in February when the plum
trees are in bloom.

(gatefold)
Designed under the supervision of Tea
Master, Sen Soshitsu XV, head of Urasenke
School of Tea
Contemporary Teahouse
Japanese cedar, plaster, rice paper,
rush matting
90 x 117 x 152, 228.6 x 297.2 x 386.1
Collection Urasenke Tea Ceremony Society

This three-*tatami* room dismantles for
shipment. For demonstration purposes, two
walls have been removed.

Axonometric drawing of the Living space for
Tokyo: Form and Spirit

(opposite)
Tadao Ando
Conceptual drawing for Living space, 1985
graphite on paper
15⅛ x 21⅛, 38.6 x 53.84
Collection the architect

Tadao Ando and Shiro Kuramata: Living

The Japanese people have opposing terms, *hare* and *ke,* symbolic words that express Japanese living space in two ways: *hare* means a public place and formal occasions, such as the marriage or funeral ceremony; *ke* means everyday life and its space. But, in reality, it is difficult to make sharp distinctions between *hare* and *ke.* Because of that, the line of the pillars in the Living space we have designed for this exhibition, for example, may be associated with the traditional Japanese formal living room without the requisite *shoji* or *fusuma.* But, alternatively, the pillars may evoke an informal room in summer. Thus, we recognize the change of value possible in a single space traditional to Japanese living.

We must think of Japanese space in terms of its actual as well as its traditional meaning. We plan ambiguities that will play on the uncertainties of human perception. The elements:

1. Seven wood pillars painted red and white are obliquely illuminated, making shadows on the floor.

2. White cloth, which looks very soft on the wall and floor, is, in fact, very hard, stiffened with FRP polymer.
3. The illusion of a three-dimensional object is projected on a wall by means of a hologram.
4. A television monitor shows a clock with no face ticking away the time.
5. *Tatami*-like rectangles of cracked glass float over a metallic floor.

T.A. and S.K.

Design
Tadao Ando
Shiro Kuramata

Design Associates
Kazuo Hamana
Akira Katoh

Production
Ishimaru Co.
Mihoya Glass Co.
Miyake Kogei Co.
Sansyu Kogei Co.
Mitsuya Kogei Co.
Asahi Kenso Co.
Inuzuka Seisakusho Co.
Shiba Toso Co.
Nihon Keikinzoku Co.

The Living space under construction, Tokyo, 1985. Stainless steel bars create a framework for a translucent expanded metal screen that recalls the *shoji* of Edo-period architecture. Draped fabric surrounding the space is seen here before the stiffening coat of FRP polymer has been applied.

(opposite)
Under construction in Tokyo, the Living space takes shape with a row of lacquer-red and white columns; Kuramata's glass chair is in place on the aluminum-paneled floor.

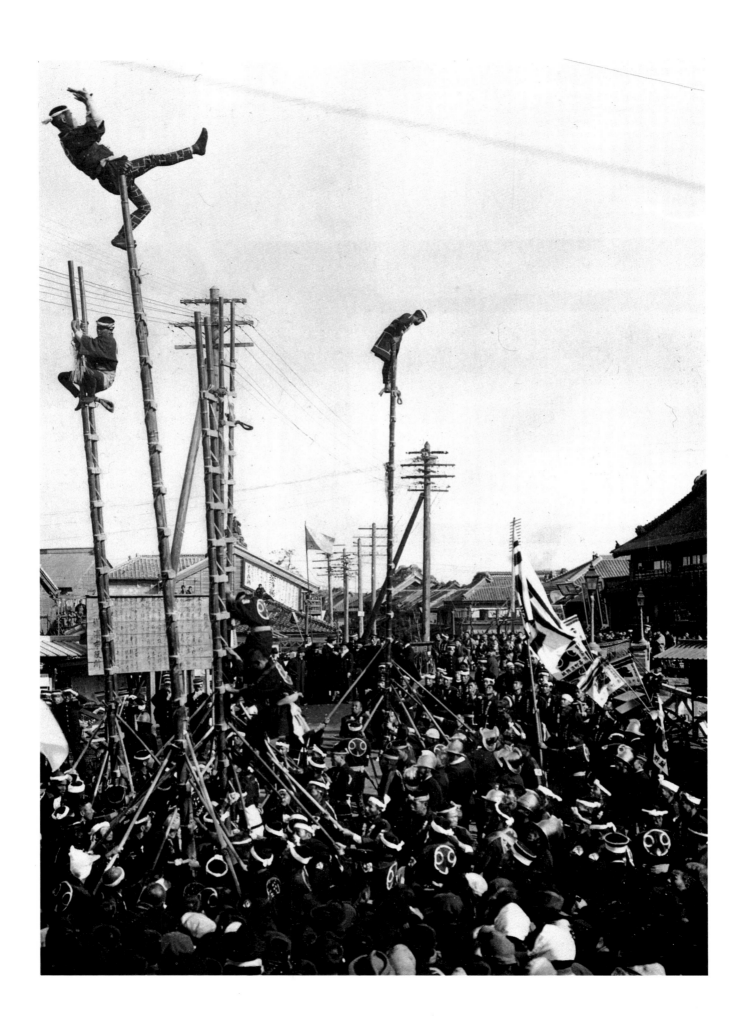

Work as a Form of Beauty

Ian Buruma

Do the Japanese really work harder than everybody else? They, as well as most experts trying to explain the Japanese phenomenon, certainly think so. Myself, I sometimes wonder. The Japanese do have a work ethic, not unlike the Protestant one, expressed in such clichés as: we Japanese don't work to live, we live to work, unlike foreigners who But ethics in Japan can seldom—if ever—be separated from aesthetics. Work is a form of beauty, in the sense that it matters less what one does than how one is seen to do it. Japanese, more than any other people I know, have made work into a spectacle, if not a fine art.

There is a yearly festival that clearly illustrates this. Among the most celebrated heroes of the common man in Edo were the firemen. Flamboyantly tattooed with dragons—a beast associated with water in Japan and thus with firefighting—these noble tough guys were sent to put out the "Flowers of Edo" by displays of derring-do. They would climb to impossible heights on bamboo ladders, passing heavy buckets of water along a human chain with great acrobatic skill. These once indispensable skills have since been replaced by more modern methods, but they are still practiced every year at the firemen's festival in Tokyo. The ladder-climbing, bucket-juggling, death-defying acts are literally a circus of work.

The aesthetic approach to work, exemplified by the brave firemen, is still a feature of the factory floor, too. Factory—and office—walls are usually festooned with gracefully written Chinese characters poetically expressing the company philosophy. Typical would be something like: Work is the essence of the human spirit; spirit is the essence of harmony. But such slogans aside, it is in the ways of the workers themselves that a traditional aesthetic can be seen.

The president of a Japanese ball bearing company once said in an interview that in his factory it took exactly four seconds to grind a ball bearing fifteen millimeters in diameter. He was not joking: watching a Japanese assembly line is like watching a ballet performance: every body movement has been worked out to achieve utmost efficiency; every tool can be reached with minimum effort. Not just that: everything is calculated to allow the worker to accomplish the maximum amount of work in one continuous movement. (Anyone who has seen a sushi chef in action, putting rice and fish together with the utmost speed, grace and economy of movement, will know what I mean. It is a perfect illustration of how function and beauty merge in Japan, to become indistinguishable.)

This does not mean that the Japanese work harder than other people. Despite the often rather theatrical insistence on working overtime—to show dedication rather than for any practical reason—time wasting is endemic to Japan's vastly overmanned companies. People will spend hours reading comic books rather than break the taboo of leaving before the boss. But there does seem to be an attention to detail and good workmanship, which is often lost in the West. While nineteenth-century methods and a remarkable degree of inefficiency still persist in such institutions as banks or the construction business, industries geared to export are models of productivity. So, while on one hand it takes an army of carpenters and roof builders an endless amount of time to build an ordinary house, motorcycles, TV sets and cameras roll off assembly lines at almost unbelievable speeds. What is more, they are likely to have fewer flaws than similar products elsewhere.

Traditional approaches to work partly explain why. Company loyalty, discipline and, that magic word, consensus—all these qualities have been fostered in Japan for centuries. Military discipline and loyalty were part of the samurai ethic; the necessity for consultation and consensus-forming was part of village life.

Some of these attitudes can be seen in modern companies, often under a Western guise. Perhaps the most celebrated attitude toward the Japanese working system—seen especially in such books on the "economic miracle" as Ezra Vogel's *Japan as Number One*—is "quality control," actually based on an American idea, imported in the 1950s. Workers are encouraged to participate in the process, not just by checking, but through constantly improving the quality of products and the efficiency with which they are produced. A type of letterbox is to be found at the end of all assembly lines, in which workers are asked to deposit suggestions and criticisms, which are discussed weekly at "quality control meetings." Bright ideas do sometimes make their way to the top and are even occasionally implemented. During the early 1970s it was still common to find slips of paper attached to Japanese products with the names of the workers and

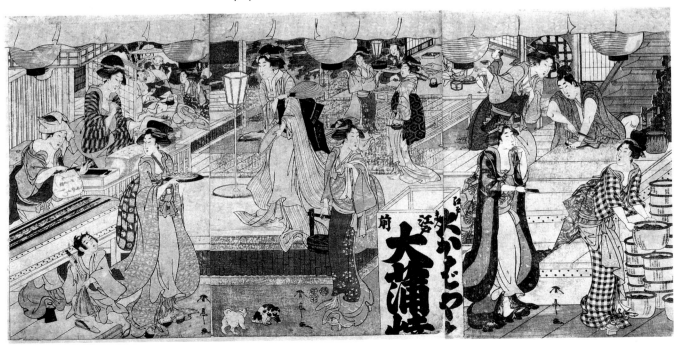

(detail)
Katsushika Hokusai
Shell Gathering, Edo period
color on silk
Collection Osaka Municipal Museum

(opposite)
Katsukawa Shuntei
Eel Shop, 1807
color woodblock print
triptych, 14½ x 30⅛, 37.1 x 76.7 each
Collection Musées royaux d'Art et d'Histoire, Brussels

controllers responsible for that particular camera or gadget. Thus, a note of humanity was introduced in an otherwise rather faceless production process.

The advantage of such participation is that it makes a dull job more interesting; instead of a sulky work force agitating for longer teabreaks, Japanese workers, ideally, feel that they are involved in the achievements of their companies and take pride in them. There is a tradition in Japan—and in China—of mass-production craftsmen, not on the scale of modern factories, of course, but of large potteries, printing firms or kimono makers. Japanese have always excelled at highly skilled crafts aimed at a huge market.

Worker participation also appeals to the traditional ideal of consensus: decisions are not made by one man at the top, but as a result of long consultations in which everybody's voice is heard. Of course it does not always work this way in reality, especially in so-called "one-man" companies led by tough self-made entrepreneurs. But the important thing is that people have the feeling they are not just nuts, bolts or, more to the point these days, digits.

The Japanese love for uniforms is another aspect of the aesthetic work ethic. Uniforms help to foster a collective identity. But apart from that, the work one does ought to be visibly identifiable. Filmmakers wear sunglasses; artists wear berets—the sort of thing painters sported in Montmartre; salarymen wear suits. Even leisure—so often a form of work—has its uniforms: Sunday afternoon hikers wear alpine gear; photo enthusiasts wear safari jackets. All this, so there can be no mistake about what people are up to; it is also an expression of the Japanese belief that once form has been established, substance will follow. The best, most extreme, and thus not entirely typical example of this aesthetic approach in industry is Fanuc Ltd., the world's largest maker of digital machine tools. Company management has the idea that yellow is the color most conducive to high performance. Consequently, everything in the factory, from the machines to the workers' uniforms, is bright yellow.

This aesthetic approach to work is the strongest continuous tradition linking old Japan and the world of high technology. A crucial element is the way work aesthetics is taught. The most common Japanese methods are both old and surprisingly uniform. They are based on a Zen-like ideal of cultivated intuition, honed by endless repetition. This ideal is most romantically expressed in the example of Zen archery. To master the "Way of Archery," said the monks of the Edo period (1603-1868), one had to become one with one's bow. The arrow thus shot would automatically hit the target. What was meant is that the discursive mind, rambling and random, gets in the way of total concentration. To reach the ideal state of readiness one must empty the mind: in other words, stop thinking and you shall find.

The process of acquiring this intuitive technique is based upon a special relationship between master and pupil, a relationship Westerners—and many modern Japanese—like to call "feudal." Whether this is apt or not, such relationships are still very common in Japan, especially in arts and crafts.

Rather than theory, however, I would like to offer some examples. They are imaginary examples and so, to put the ideas across, somewhat caricatural. But each in its own way represents the aesthetic ideal. I shall start with a modern craftsman: a photographer.

Since childhood, Kazuo Ito had wanted to be a photographer. Through a friend's introduction he was taken on as a second assistant by a famous fashion photographer, whom Ito calls *sensei* (master). Professional photographers, like painters, writers or anybody else successful enough to have apprentices (*deshi*) are usually called *sensei.*

Ito lives in a small room at the master's studio. As an apprentice, his duties are without limit. The first thing he does in the morning is make coffee for the first assistant, who comes in at eight. He then polishes lenses, gets the equipment ready, tests the light batteries, anything, as long as he looks busy when the master comes in. Like the daughter-in-law in a traditional household, Ito gets up before everyone else and goes to bed after everybody is asleep.

The assistant is rarely told directly what to do. He has to anticipate the wishes of his superiors. If an order has to be given, it means Ito is already too late. If he guesses wrongly, he is yelled at, not by the master himself, but by the first assistant. This is part of the learning process. Nothing is explained, nothing is explicit. Ito is taught the ropes like a circus monkey, by watching his trainer carefully: right merits a pat on the head (if he's lucky), wrong elicits a humiliating scolding. A slight shake of the head means he has to light the photographer's cigarette; a short grunt means adjust the umbrella on the top light.

Ito is paid the equivalent of one hundred dollars a month, but stays at the studio rent free. His meals, wolfed down during work, are also paid for by the master. His own money goes toward drinking on Saturday nights with other photographers' assistants. He has been known to get into scrapes, but the master always takes care of the damage. The master has taken the place of Ito's father, in a way, and his indulgence has to be paid for by total obedience during working hours. Ito does not enjoy himself especially, but realizes that his present hardship is a necessary initiation into the life of a photographer. He is proud of his capacity to suffer through it, and consoles himself with the idea that one day he will be called master too.

Such methods do not foster the kind of individual initiative thought to be indispensable to creative work in the West. Indeed, the Japanese have a reputation for being imitators, technically polished imitators, but copycats nonetheless. Of course, mimicry is the essence of learning everywhere, but Japanese appear to carry it to extremes. Leaving the romantic matter of unique individuality aside, this stereotypical view of the Japanese is not entirely accurate. A wise Japanese—I forget who—once put it this way: only when everybody wears exactly the same kimono can one detect true individual differences. Acting in the Kabuki theater comes about as close as one can get to this aesthetic.

Becoming an actor of female roles (*onnagata*) in Kabuki had not been a matter of choice for Ayame. He was born into a Kabuki actor's family, and he learned the rudimentary steps of traditional dance as soon as he could walk. His grandfather would move his hands and feet for him, over and over again, until he could do it himself. In his early teens his slender build, graceful movement and high-pitched voice made the specialization in female roles an obvious choice. The only male roles he subsequently played were those of effeminate young lovers, the type Japanese matrons, for some reason, have always idolized.

Ayame was preparing for his grand entrance as an Edo-period courtesan. He had applied his makeup in a style unchanged since the play was

written. While waiting for his cue, he sipped from a cup of green tea, supplied by one of his apprentices, who watched his every move. As with the photographer's assistant, a Kabuki apprentice is rarely told anything directly. He must learn intuitively, as it were. To get it wrong, in the olden days, meant a severe beating.

When he stepped onto the stage, the audience applauded loudly and members of a professional claque, seated in various parts of the auditorium, called out his stage name. His gracefully stylized walk and the coquettish movement of the eyes reminded connoisseurs of his grandfather, also a famous *onnagata,* who acted in the style of his father, a celebrated nineteenth-century actor.

Ayame's disciples were looking at him intently from backstage. One day the best of them might, with luck and hard work, emulate his master's technique to perfection. He would have to be so much like him that he could wear his style like a skin. That would not be enough, however. True mastery lies in the way one's own skin comes almost imperceptibly peeping through the master's. Only then can one be said to control the style and not vice versa. There are only a few people left who could recognize the new skin, but that does not in any way diminish its greatness.

The repetitive zeal with which Japanese go about honing their skills makes them seem obsessed with form, with mechanics rather than content. A rather touching example of this is the first reaction of Japanese audiences to moving pictures: they turned round their chairs to watch the projector, a source of much more fascination than the images flickering on the screen. Added to their reputation as copycats is their image as robots. This, too, is missing the point. The preoccupation with style does not necessarily mean the lack of a soul; just as Japanese do not feel that good manners make a human being less "real," "himself," "natural" or what-ever term one wishes to use for that elusive inner core of man. Style, in the post-romantic West, is largely an extension of man's ego; traditional style in Japan—and China, for that matter—is more a transformation of the ego: to acquire a perfect technique, one eliminates, as it were, one's individuality, only to regain it by transcending the skill. This new individu-ality is not the expression of one's real private life, but an individual interpretation of something already there and thus in the public domain.

Private life in Japan is just that: private. An artist or, for that matter, a waitress, is not expected to reveal his—or her—private "self," but his public one. The borderline between public and private worlds is much clearer in Japan than it is in the West (as in China, many Japanese houses have walls around them). Thus, the public self is not seen as a humiliating infringement on the "real" self. Of course, in certain periods, Japanese artists have rebelled against this division and the rigidity of style by going to the opposite extreme: writers of the "natural" school saw it as their vocation to burden the reader with the minutest details of their private lives. One key, I think, to the public aesthetic is the skill of an elevator girl.

Yoko Sato is nineteen and she is being trained to be an elevator girl in a department store. She lives at home with her parents but needs the extra money she earns to buy clothes and go to discos on Saturday nights. It's hard being an elevator girl for, as Yoko is ceaselessly told, she is the face of the store. If she does something wrong or displeases a customer, the company loses face.

Yoko does not much enjoy the lectures on company loyalty or philosophy written in fussy Chinese characters by the owner of the store,

Department store elevator girl, Tokyo, 1970.

who likes to expound at length on the uniqueness of his firm. Still, Yoko learned all the lines by heart and recites them every morning with her colleagues. It may be a lot of boring nonsense, but this is the way things are done, and Yoko wants to do a good job.

The voice and bowing lessons are a little more interesting. Yoko always prides herself on being a good mimic—her imitations of the pompous section chief make her friends laugh. The perfect elevator girl's voice is high-pitched, on the verge of falsetto, and seeming to bubble over into merry laughter, without actually doing so. This is not an easy effect to achieve and it takes hours of drilling. Yoko's name was called out by the teacher, asking her to come forward. She was told to speak the following lines: this lift is going up, this lift is going down; and again: this lift is going up . . . and again. Her pitch was too low and her delivery not quite sprightly enough. The teacher told her to practice at home.

Bowing lessons are a more mechanical exercise. An inventive young engineer in the design department devised a bowing machine. It is a steel contraption a bit like those metal detectors through which one must pass at international airports. An electronic eye, built into the machine, registers exactly the angle of the bow and lights flicker on at fifteen degrees, thirty degrees and forty-five degrees. The teacher of the bowing class explained that the "fifteen bow" was for an informal greeting to colleagues. The "thirty bow" was appropriate for meeting senior members of the store, and the deepest bow essential when welcoming clients, shoppers and other visitors. Much of the average day of an elevator girl is spent at a perfect forty-five degree angle.

Yoko does not find this in the least humiliating, or even dull. Learning a skill like this is a challenge, and she is eager to get it just right. The girls were lined up in front of the machine and one by one, like pupils at a gymnastics class, they walked up to make three bows. Yoko missed the first one by several degrees; the disapproving noise of an electronic buzzer told her so. She blushed. The second, thirty degrees, she got wrong again, by inches. Determined to get it right the next time, she bent down, back straight, fingers together and eyes trained on the floor about three feet from her toes—the light flashed, she did it, a smile of contentment spread across her face.

This is an extreme—though in Japan by no means despised—example of the insistence on form and of the way it is taught. The training of elevator girls also points to another constant factor in Japanese attitudes to work: form in human relations. The importance of etiquette and ritual in Japanese work is vital. When male bosses tell their female staff that serving tea, bowing to clients and other such ceremonial functions are as necessary as the jobs usually reserved for men, they are only being partly hypocritical. To be sure, many men would feel threatened if too many women encroached on their traditional domains. It is much safer to insist that women should stick to the home after marriage or, in the case of unmarried "office ladies" (OLs), stick to making tea or other ceremonies. But, at the same time, Japanese do attach far more importance to such decorative functions than Westerners tend to do; and they genuinely feel that women do them best. Although some Western tourists might find the artificial ways of elevator girls grating, humiliating or, at best, quaint, Japanese feel comfortable with them and indeed miss such service when it is not provided.

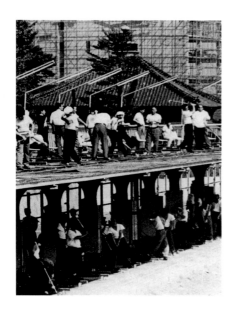

Nigiwau Golf Practice, 1965.

Men, too, spend much of their time on the rites of human relations. Although Japanese have a strong sense of hierarchy, decisions are based upon at least a show of consensus. This makes it difficult to take individual initiatives, and passing the buck is therefore a national sport. Consensus, as indeed all forms of Japanese business, is built on personal relations. These relations are based on mutual obligations: if I do this for you, you do that for me. Such favors are rarely expressed directly and relations take much time and effort to cement. This is where most salarymen—the middle-ranking samurai of today—come in. Because there are so many salarymen and so many relations to cement, many hours are spent in coffee shops during the day and bars and restaurants at night. This may seem inconsequential or even parasitic to the Western mind. It certainly does not make for efficiency. But just as the trade of rugs in the Middle East cannot proceed without endless cups of tea, the coffee shop workers are the backbone of the Japanese miracle. Let us turn again to an example.

Every table at the Café L'Etoile, a coffee shop in the Ginza, was occupied. Through the thick screen of cigarette smoke one could just discern Kazuo Sasaki, a young employee of one of the largest advertising companies. He was exchanging *meishi* (name cards) with three men from a small public relations firm. All four of them studied the cards carefully, made polite hissing noises and sat down. Sasaki ordered his tenth cup of coffee and lit his thirteenth filter-tipped cigarette.

His order was taken by a uniformed young waiter who yelled out the command to another waiter, who shouted it to another link in the chain. The effect was highly theatrical—a spectacle of work, as it were. This particular gimmick was unique to L'Etoile and new waiters were drilled endlessly until they got it just right.

So much of Sasaki's day was spent meeting people in coffee shops that it was easier to reach him at Café L'Etoile than at his office. He has been working for his company for four years. His main job is to delegate commissions taken by his company to smaller companies, who then often delegate them to even smaller firms.

Business was not much discussed at Café L'Etoile. It would be indelicate to come directly to the point. Instead, Sasaki had become expert at discussing golf handicaps—the nearest he got to a golf course himself was one of those practicing ranges where one spent hours hitting balls into a giant net. He also had an endless supply of jokes about last night's hangover, or jocular comments on his client's sexual prowess. He always knew the latest baseball results and could talk for hours about television programs. On those rare occasions when an eccentric client insisted on talking about politics or books, Sasaki was at least a good listener. He has, in short, the social graces of a very superior barber.

In a country where so much depends on social graces, this is not to be despised. It is, I think rightly, argued that human relationships in Japan transcend abstract ideals of right and wrong. This is not true, for instance, in the Judeo-Christian tradition, where God is the final arbiter, in whose eyes we shall be judged. To commit perjury in a Japanese court, to protect one's boss, is the moral thing to do. Loyalty transcends a mere law. (This was proven several times during the long case against former Prime Minister Kakuei Tanaka.)

This principle permeates working relationships at every level of Japanese society. It explains, for example, the workings of the Japanese underworld. The underworld in Japan, though not necessarily respectable,

is in many ways an overworld. Gangsters have their jobs to do, just like milkmen or prime ministers. Their roles in society, though, again, not respectable, are acknowledged. An often told story is about a man who woke up one night to find a *dorobō* (thief) going through his wallet. According to this tale, the man let him be, for a thief has to make a living too.

Tetsu Yamazaki is a *yakuza* (gangster). He prefers another term for his trade, however: *ninkyōdō* (The Way of Chivalry). This sounds more traditional, more in keeping with Yamazaki's image of himself. Like many of his colleagues, Yamazaki likes to dissociate himself from the common criminal who, alas, has begun to predominate in the Japanese underworld.

Yamazaki, *oyabun* (boss, or literally father figure) of his gang, Yamazakigumi, was expecting the local police chief for tea. This official had a habit of dropping in at the Yamazakigumi headquarters for afternoon chats. He kept abreast this way of the latest underworld gossip and in exchange for a good tip, he let Yamazaki carry on with his operations—within traditionally and mutually understood limits, of course. Extortion, protection rackets, prostitution were all right (somebody had to do those jobs), but physical violence against innocent people was not. Extortion, to name one occupation, does not always work without at least the threat of violence; but that fine line could always be worked out between gangster boss and policeman. The police chief was a reasonable man and Yamazaki, when necessary, a generous one.

Yakuza; his trade is often referred to as *ninkyōdō* (The Way of Chivalry).

(below)
Tattooed *yakuza,* circa 1980.

The policeman arrived. He took his shoes off at the door and was loudly greeted by bowing young mobsters with crew cuts. He was ushered into the main room, where he made an informal bow to Yamazaki who bowed in return. The boss, dressed in a green, pin-striped suit, a yellow shirt, red tie and diamond clip, barked an order. A young mobster bowed, and slipped noiselessly into the kitchen, from where he emerged five minutes later with two cups of tea.

The police chief, after discussing the weather and inquiring after Yamazaki's golf handicap, asked a question about a recent murder case. He knew which gang was involved. He also knew that the boss of that gang was in debt to Yamazaki. Yamazaki himself was in some trouble over an amphetamine bust. So the police chief asked if perhaps Yamazaki could persuade his fellow boss to hand over the murderer, and then the amphetamine case could be forgotten.

Yamazaki thought this was a reasonable proposition and called up his friend. He told him what was up and asked him to hand over the man as a personal favor. Now, the "murderer" did not have to be the man who actually did it. It is an old Japanese—and Chinese—tradition that underlings take the full rap for crimes committed by their superiors. Unlike plea bargaining in the United States, where offenders get lesser punishments for cooperating, the Japanese system actually allows innocent people to substitute for the real culprits. These "innocents" are obliged to do this out of loyalty to their bosses. It is, in short, their duty.

There is something in it for the substitute, however, for after he gets out of jail there will be certain promotion waiting for him. The man will be happy, the murderer—a senior in the gang hierarchy—even happier. The police will have done their duty and Yamazaki will be off the amphetamine hook.

Their work concluded, the two men promised to meet again soon and the police chief took his leave. Next, Yamazaki received a magazine

reporter who wanted to know about traditional customs of the *yakuza* world. The boss was in his element here, as he liked to hold forth on the noble traditions he upheld. He was the heir of Kunisada Chuji (a legendary nineteenth-century Robin Hood type of gangster). If it weren't for men like him, who took care of their boys and taught them the ways of chivalry, the streets of Japan would no longer be safe. The good *yakuza* still understood the Japanese code of honor, forgotten by the young who were corrupted by communist schoolteachers and foreign fashions. Leftists were selling Japan out to the foreigners and it was his duty, as a *yakuza* of the old school, to stop this from happening. When asked about the nobility of extortion, violence and amphetamine trafficking, Yamazaki got quite indignant: only bad mobsters engage in such practices; good *yakuza* had nothing to do with it; he was a protector of the poor, just like Kunisada Chuji; why, if the reporter wanted to have proof of this, he could call the local police chief: he knew all about it.

Human relations based on hierarchy are a comfort to many, especially in a highly competitive world. In most Japanese companies seniority counts for more than competence and, ideally, one's job is forever assured. This works best for mediocrity—which, for face-saving reasons, is rarely exposed—and worst for talented mavericks.

Talent, being highly individualistic and thus socially troublesome, is not always highly regarded in Japan. Hard work and skill, especially in the sense of dexterity (*kiyō*), are the two qualities Japanese pride themselves on as a people. The traditional Japanese stress on refining and miniaturizing everything—the Korean critic Yi O Ryong argues that this is the key to Japanese culture—may explain the modern success in transistor, microchip or camera making. But although manual dexterity, the appearance of consensus and the discipline—not to say docility—of the Japanese rank and file account for some of Japan's success story, no country can succeed without talented mavericks. Despite the Japanese saying that nails that stick out must be hammered in, there are those odd, talented exceptions, even in Japan, who refuse to be hammered in. Though sometimes respected, such people are rarely liked. The great Japanese filmmaker Akira Kurosawa, known in Japan as The Emperor, is a case in point. He is undoubtedly one of the greatest artists of the century, but Japanese critics have consistently tried to pull him off his pedestal, often in snide personal attacks. He has consistently refused to toe the social line; he has neither masters nor pupils; the ritual of human relations is less important to him than his talent. He is, in short, a loner, as is almost every truly gifted man or woman in this collectivist society.

But the creative force in Japan comes from these loners. They tend to come to the fore mostly in periods of social instability. The immediate aftermath of World War II seems to have been especially congenial to nonconformist entrepreneurs. Akio Morita, founder of Sony, Konosuke Matsushita of Matsushita and Soichirō Honda, the grand old man behind the motor cars, immediately come to mind. The interesting thing about such creative oddballs is that once they make it to the top, they almost invariably become traditional masters, laying down the rules for the young to follow. They are more than teachers of technical skills or business methods, in the manner of such figures as Lee Iacocca. In fact, they conform more closely to the image of the classical Confucian sage, concerned with ethics and moral philosophy rather than technique.

Portrait of Konosuke Matsushita, founder of Matsushita.

(below)
Portrait of Akio Morita, founder of Sony.

Matsushita wrote a kind of bible, expounding his philosophy; and Honda's autobiography has an equally lofty tone.

Recently the enormous success of high technology industries has spurned a new generation of mavericks—whiz kids, laying the paths to Japanese versions of Silicon Valley. Such people are especially interesting as they combine the old Japanese penchant for miniature refinement and uncommon individualism. They often get their start in research and development departments of large companies, but proceed to break with the time-honored tradition of company loyalty to start their own firms. According to an official at the Ministry of International Trade and Industry there are now about five thousand "highly innovative" small companies with the potential to emerge as future Sonys or Hondas. No doubt their leaders, too, will one day write their books and become masters.

Although the difference between artists and craftsmen has never been as clear in Japan as in the post-romantic West, there have always been mavericks in the arts as well. But those who do not follow masters often pay a heavy price. The number of suicides among Japanese writers in this century cannot be a mere romantic aberration. Such artists, like the gung-ho entrepreneurs, also thrive in times of unrest. The turbulent early nineteenth century produced such highly eccentric playwrights as Tsuruya Namboku and artists such as Ekin, who rejected every traditional school and persisted in a highly individualistic style. Two famous eccentric geniuses of our own time are Kurosawa and the author Yukio Mishima (1925-1970), Japan's most celebrated twentieth-century novelist, who ended his life at forty-five in a dramatic suicide.

Creative loners are by no means limited to men. In some periods of Japanese history women had more freedom to express themselves than men, paradoxically because they had less freedom to engage in other public pursuits. Perhaps the greatest period for Japanese literature was the Heian (794-1185), particularly the tenth century, when the *kana* syllabary, a truly indigenous script, was developed. While educated men—virtually restricted to the aristocracy—still wrote in literary Chinese, talented women expressed themselves in the vernacular; the obvious example being Murasaki Shikibu (978-1015/31?), the author of *Genji monogatari (The Tale of Genji)*. One of the greatest writers of modern Japan was also a woman: Higuchi Ichiyō (1872-1896), who lived and died—very young—at the end of the nineteenth century. Both women wrote mostly about loneliness—a common theme in literature and a usual fate of writers anywhere, to be sure, but especially in Japan, where isolation from the common herd is particularly keenly felt.

So originality and creativity do exist in Japan. But they are all too often stifled by the pressure to conform. It takes tremendous courage to continue on in one's individual course. Let us be thankful for those few who do. But while such gifted eccentrics are rarer than in countries where individualism is fostered, there is an advantage to the Japanese preference for skill over originality. In places where everyone wants to be a star, but mediocrity necessarily prevails, there is a disturbing lack of pride in an ordinary job well done. In Western Europe there is even a perverse tendency to be proud of sloppiness. Japan may have fewer Nobel Prize winners than, say, Britain, but to see a shop girl wrap a package or a factoryworker assemble a bike is to see routine work developed to a fine art. This, the lack of Nobel Prizes not withstanding, may be Japan's grandest tradition.

Artist unknown
Scenes of Craftsmen at Work, Momoyama
period, seventeenth century
pair of six-fold screens; color on gold
ground paper
22⅞ x 14¾, 57.8 x 37.5 each panel
Collection Wadsworth Atheneum,
The Ella Gallup Sumner and Mary Catlin
Sumner Collection

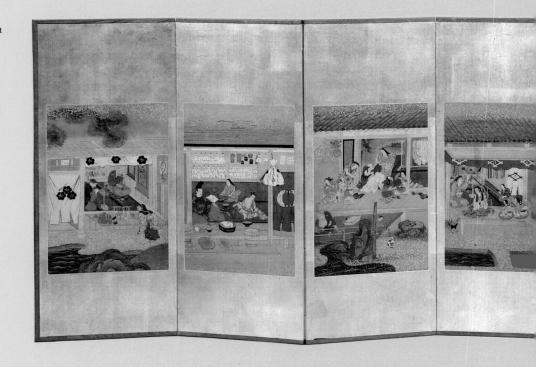

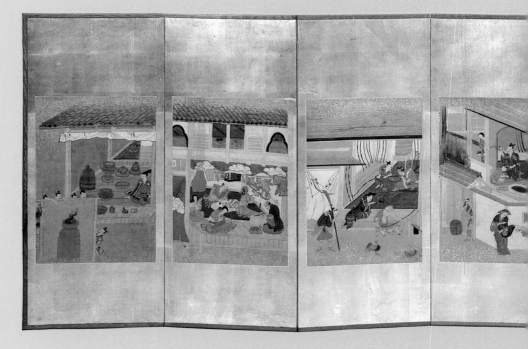

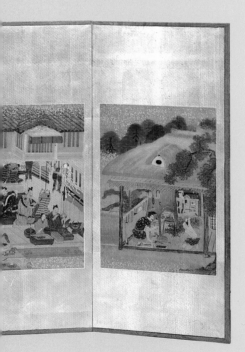

Twelve separate paintings of craftsmen at work are mounted on the individual gold leaf panels of this pair of screens. On the top screen, reading from right to left, the craftsmen depicted are: a brushmaker, a lacquerer, a thread maker, a dyer, a pharmacist and a Buddhist rosary maker. On the bottom screen there are a swordsmith, a helmet and armor maker, a sword polisher, a bow maker, a maker of leather leggings and coverings and a metal caster. Each craftsman is shown in his shop engaged in his occupation with family and assistants. The crafts represented on the top screen produce goods for general, daily use. The crafts on the bottom, however, are quite specifically related to military arts and activities. It is possible that this screen pair consciously intended to contrast the *bunbu* (literary and military arts), a dichotomy that emphasized the difference between a life of contemplation and intellectual pursuit with the military life of action and warfare. Together they reveal some of the types of goods and services that were available to the Japanese elite during the Edo period.

Edo, the seat of the feudal Tokugawa government, grew as a city of support services for the military lords and their clans. Craftsmen who produced daily use and luxury goods for their clients—first the military elite and then wealthy merchants—played an important role in the economy of the city.

Scenes of craftsmen at work have long had a role in Japanese genre painting, particularly in the *Rakuchū-Rakugai* type (views inside and outside the capital) where they appeared as small vignettes of street life within large compositions of the city of Kyoto. The emergence of these craftsmen as isolated figures in screens of the late sixteenth and early seventeenth centuries is not so different from the emergence of the ubiquitous *bijin* (standing beauty) from the large context of genre painting to that isolated figure that has become one of the hallmarks of Edo-period Japanese art.

The Wadsworth Atheneum screen pair is a work that follows the composition and subject matter of a pair of craftsmen screens by Kanō Shigenobu (1552-1640). Stylistically, however, this work is thought to be closer to the Tosa school than the Kanō, and the date of production is put at the middle of the seventeenth century.

Emily Sano

Photograph of a section of acrylic paneling, in process, Tokyo, 1985.

(opposite, top)
Professor Hara's laboratory at the University of Tokyo is shown filled with the research materials and equipment used by the design team in the creation of the Working space for *Tokyo: Form and Spirit.*

(opposite, bottom)
Hiroshi Hara
Conceptual drawing for the
Working space, 1985
graphite, colored pencil on paper
17⅜ x 23¾, 43.94 x 60.32
Collection the architect

In this pencil sketch for the robot images Hara indicates the manner in which the acrylic sheets will overlap and the etched forms will be seen through each other.

Hiroshi Hara: Working

In the future, the boundary between the extent to which work will be carried out by humans, and the extent to which it will be carried out by machines will be unclear. In Buddhist thought, various elements in diverse phenomena are fused and their boundaries become vague, creating the possibility of coexistence. It is this way of thinking that underlies work and production in modern-day Japan.

The robot silhouettes in the exhibition attempt to express a situation that fuses humans and machines. The robots are seen against a row of plexiglass treelike forms containing diodes of moving colored light. The trees demonstrate ideas about time and space expressive of Japanese life. Originally developed as *A Message from Eastasia*, part of the Austrian exhibition, *Architekturvision 1984*, organized in celebration of George Orwell's visionary novel *1984*, the trees are now an element in the Working space of *Tokyo: Form and Spirit*. The robotic elements designed for this exhibition carry further some of the ideas developed earlier in Graz.

Working on programmed light changes, the robots illustrate aspects of our consciousness. Earlier machines were an imitation of the human body; today's machines have come to resemble the human mind. Architecture that now conforms to the body will, in future, become an architecture of the mind.

Mediating a new image in the production system, the robots attempt to present the overlay of the body on the universe. (The way of thinking that views the body and universe as one and the same is based in Eastern tradition.) The Japanese people like to work because, by working, we catch a glimpse of the universe within ourselves.

H.H.

Design
Hiroshi Hara

Design Collaborators
Kazuhiro Kojima
Hidekuni Magaribuchi
Kumi Nagai
Yasuyuki Itoh
Maho Hiiro
Hiroshi Horiba
Roh Kanao
Yukio Kawase
Kazumi Kudo

Lighting Consultant
Kaoru Mende of T.L. Yamagiwa Laboratory, Inc.

Lighting Collaborators
Yukio Onoda
Yuriko Hanagaki

Production
Sichiro Furuya
Masami Usuki
Sijoji Nakabayashi

These drawings diagram a man (left) and a woman as they will be etched into acrylic sheets. Each humanoid will have a distinct set of characteristics, created by the patterns of etched lines and lighted diodes.

(opposite, top)
One of the six trees and the moon that will form an environment for the robotic elements of the Working composition. In these fanlike shapes, diodes of moving color will create changing patterns against the silver surrounding walls.

(opposite, bottom)
Hiroshi Hara
Explanation of color placement for acrylic panels in the Working space, 1985
photostat with color film overlays
16¼ x 23⅜, 41.91 x 59.18
Collection the architect

Hara indicates the way in which programmed lines of color will activate the darkened space of the Working section in this drawing.

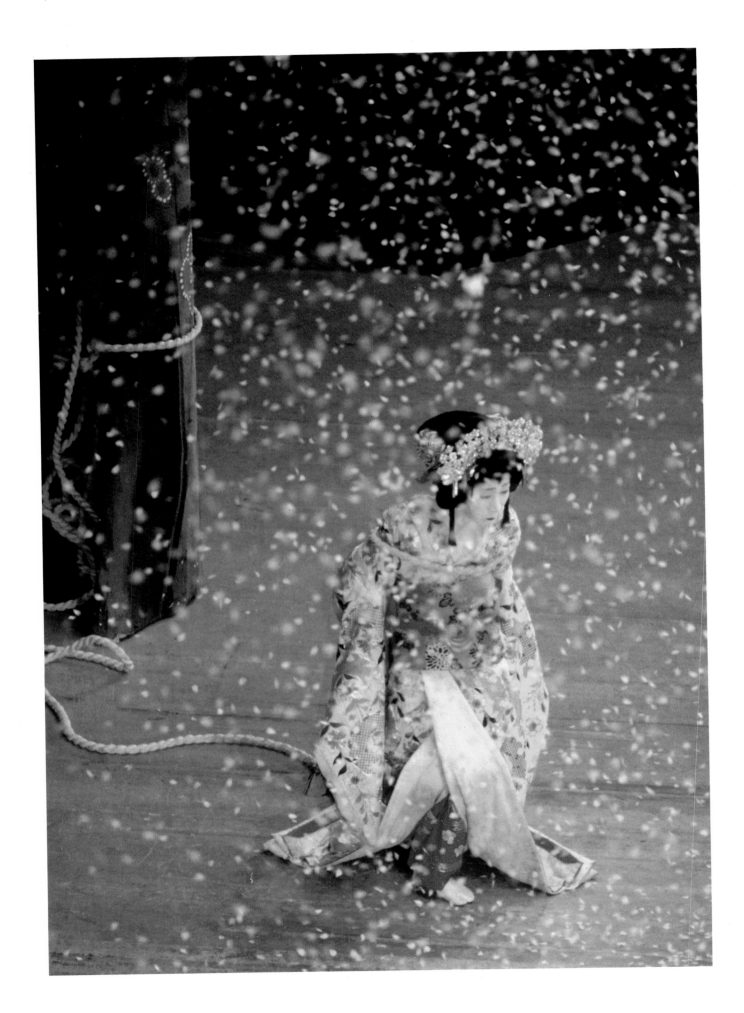

Performance: Edo/Tokyo

James R. Brandon

Nakamura Utaemon as Yukihime (Snow Queen) in *Kinkaku-ji,* Kabuki-za, Tokyo.

A contemporary observer of the Tokyo scene, Edward Seidensticker, reminds us that the typical son of Edo, the bumptious *Edokko*, was inordinately fond of "looking at things," and that of the performances "central to Edo culture . . . at the top of the hierarchy, the focus of Edo connoisseurship, was the Kabuki theater."[1] Because Kabuki has been bound inextricably to life in the Eastern Capital for so many centuries it deserves exploration here. Classical Nō and Bunraku puppet theater are imports from the Kamigata region (Kyoto and Osaka) and, although performed in Edo/Tokyo, they do not have Kabuki's deep associations with the city. These, as well as less celebrated theatrical forms spanning Edo to Tokyo, will be dealt with here.

Kabuki (and the licensed quarters) dominated the city's consciousness in far from ideal circumstances. Edo was the seat of an imperious Tokugawa Shogunate, a government that despised plebeian Kabuki theater and that ranked its performers among social outcasts. The actresses and boy actors who had originated Kabuki in the first decades of the seventeenth century had performed on temporary stages set up on unclaimed land in riverbeds, earning them the disparaging name "wanderers of the riverbed" (*kawara kojiki).* They were landless, classless vagabonds in a society where land and hierarchy meant everything. Yet they brought entertainment and, like wandering artists from medieval times, through them the voice of the deity might speak during performance. In Edo, even after theaters had become a permanent part of urban life and leading actors were adored by the general populace, Kabuki remained in the eyes of authorities a debased art of "wanderers of the riverbed" until nearly the beginning of this century.

Tokugawa officials tried numerous stratagems to curb Kabuki's appeal. They banned women and young boys from acting on the professional stage in 1629 and 1652 respectively, and from this edict grew the remarkable art of the *onnagata* (adult male performer of female roles). They forced theaters to move into special areas distant from Edo Castle and from residences of the samurai. In a final attempt to eliminate Kabuki altogether, theater owners were called into the City Magistrate's office in 1841 and ordered to relocate outside of city limits. Theaters, attached teahouses, stalls and actors' homes were relocated in open fields in Saruwaka-chō, a ward near Sensō-ji. The edict, written by no less a person than the Shogun's Chief Minister Mizuno Tadakuni, read in part:

1. Edward Seidensticker, *Low City, High City: Tokyo from Edo to the Earthquake* (New York: Alfred A. Knopf, 1983), pp. 144, 145.

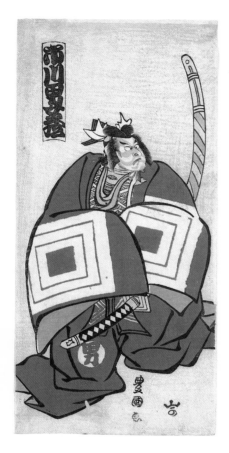

Utagawa Toyokuni
Actor Ichikawa Omezo in Shibaraku Role,
1795-1800
color woodblock print
12½ x 5⅞, 31.5 x 14.6
Collection The Brooklyn Museum,
(16.539)

2. Natsunosuke Nishiyama, *Ichikawa Danjūrō*
(Tokyo: Yoshikawa kobunkan, 1960), p. 199.
3. See Donald Keene, *Chūshingura: The
Treasury of Loyal Retainers* (New York:
Columbia University Press, 1971).
4. Nishiyama, *op. cit. Ichikawa Danjūrō*,
p. 199.

Because the Three Theaters are exceedingly licentious and they corrupt public morality, they may no longer be located within the castle-town limits. Also, because actors do not respect the division of social classes, all households connected to theaters in any way must vacate.[2]

The order was part of the government's draconian Tempō Reforms (1841-1843) that were aimed at bringing about fundamental changes in social and economic conditions. It was reasoned that if Kabuki could be separated from its audience, income would fall and the form would wither away. This did not happen. Saruwaka-chō flourished as a new entertainment quarter. That Kabuki theaters were now close to the prostitution quarter of Yoshiwara gave male spectators a double motive for making a trip out of the city: now they could go to the theater during the day and to the licensed quarter at night.

Officials strictly censored the subject matter of plays that were staged in Kabuki. Plays could not portray the samurai class or its activities—a rule Kabuki playwrights circumvented by altering characters' names to those of historical figures and by placing the events in the past. The Akō Vendetta of 1702, for example, is one of the famous incidents that reached the stage by this means. (Its best-known dramatization is the puppet play, *The Forty-Seven Loyal Retainers*.)[3] Government edicts also set out the maximum size and height of theater buildings, the type of boxes and curtains that could be used, and whether roofs could be tiled or not. The frequent reissuing of these regulations suggests the difficulty in their enforcement. As a popular saying had it, "the law lasts three days." For example, when actors were forbidden to dress ostentatiously on and off stage, they took to wearing plain cotton kimono lined with gorgeous silks thereby setting a new fashion. Because Kabuki actors were neither samurai, artisan, merchant, nor farmer—the four recognized classes of society—they were ordered to live apart from other citizens, yet we know they often did not. Theaters were constantly burning down—records kept over a 185-year period indicate that Edo's Kabuki theaters were destroyed by fire thirty-two times.[4] When a theater burned, officials would use the occasion to delay rebuilding.

The harsh treatment of Kabuki by the Tokugawa *bakufu* is clearly shown in two famous incidents. In 1842 the government decided to make an example of the exceptionally popular actor Ichikawa Danjūrō VII for living in a style they considered too luxurious for a performer. He was exiled from Edo for seven years and his career destroyed. His son, Danjūrō VIII, felt the disgrace so keenly he committed suicide. In an earlier incident in 1714, the Yamamura-za was razed to the ground and permanently closed when it was discovered that Ejima, chief lady-in-waiting of the shogun's retinue, was meeting secretly with a leading actor of the theater, Ikushima Shingorō. Ejima and Shingorō were sent into exile on remote islands, sixty-seven accomplices were arrested, and the lady's eldest brother was executed. Yet none of these official rebukes could suppress Kabuki. The appeal of Kabuki to the *Edokko* was too fundamental to be denied by edict.

What was the basis of that appeal? Edo was a new city, filled with country samurai, merchants and workers newly arrived from small villages. Kabuki was a new art, born the same year the city of Edo was founded. Simply stated, Kabuki put onto the stage the vibrant life of the times. The *Edokko* went to Kabuki to hear the erotic new music of the *shamisen*, a Chinese instrument brought to Edo from Okinawa a few years before the

(detail)
Utagawa Toyoharu
View of a Kabuki Theater, 1755-1814
color woodblock print
10¾ x 16⁹⁄₁₆, 27.3 x 42.1
Collection Henry Art Gallery,
University of Washington,
Gift of Mr. and Mrs. Matsutaro Kawaguchi

(gatefold)
Ichimura Uzaemon as Kamakura Gongorō
(center), with Nakamura Tomijuro as Kiyohara
Takehira, Bando Kamezo as Shinsai and
Sawamura Sojuro as Teruka in the Kabuki play
Shibaraku, Kabuki-za, Tokyo.

first Kabuki dance (*Kabuki odori*) was performed in 1603. He also came to see staged versions of popular street dances (*furyū*). Even in Edo, people knew of the brilliantly costumed processions of hundreds of *furyū* dancers that had thronged the main streets of Kyoto in 1607, honoring the ninth anniversary of the death of Toyotomi Hideyoshi. As Kabuki became established, costume and hairstyles of popular actors set new fashions of dress for dandies and courtesans in the town. Beginning in the Genroku era (1688-1704), actors in the Ichikawa Danjūrō family line thrilled Edo audiences with unusual portrayals of superman heroes. They created a grandiose acting style known as *aragoto* that became the pride of Edo. The bold red and black makeup, wildly exaggerated costumes, fierce *mie* (poses), and rhetorical vocal displays of *aragoto* acting appeared absurd to audiences in sophisticated Kyoto and the somewhat more provincial Osaka, but they struck a chord in the heart of the *Edokko* Kabuki fan.

For most of the Edo period (1603-1868) three large theaters were licensed by the magistrates of Edo to perform Kabuki (four before the Yamamura-za was banned). They were known as Edo *sanza* (Edo's Three Theaters), the oldest being the venerable Nakamura-za, opened by the actor-manager Nakamura (Saruwaka) Kanzaburō I (1598-1658) in 1624. The Morita-za opened its doors in 1660, and the Ichimura-za received its Kabuki license in 1663. Half a dozen small unlicensed theaters (*koshibai*) also staged Kabuki plays. It was cheaper to go to a small theater, but it was much more exciting to go to one of the Three Theaters with a banner-draped drum tower (indicating its license to perform), high over the theater entrance. Inside, spectators could watch scenes magically change before their eyes on a revolving stage. They could see leading actors make stunning entrances from the back of the house, strutting down the *hanamichi* (runway), through the audience and onto the stage. They could listen to the sharp clacks of the hardwood clappers as the Kabuki draw curtain of broad rust, black and green stripes was opened or closed by a black-robed stage assistant (*kōken*). These exciting staging devices were denied the smaller, unlicensed theaters by government order. In the event one of the Three Theaters wasn't operating, its license was transferred to designated smaller theaters—the Miyako-za, Kiri-za, or Kawarazaki-za.[5]

We know a great deal about performances and spectators at the licensed theaters during the Edo period because Kabuki fascinated *ukiyo-e* artists. In hundreds of woodblock prints, they recorded lively scenes in front of, inside and backstage at the Three Theaters. Prints show that the theater was an open, oblong box with flat groundfloor seating and two tiers of boxes on each side. Light came from sliding windows located just under the eaves (performance was permitted only during daylight hours) and candles arranged along the front of the stage. The stage opening stretched nearly the full width of the theater building. A replica of a Nō painted set stood stage center until around 1800; after that it was gradually eliminated to allow room for scenery, often a raised platform for an interior scene. Even so, scenery was not used to enclose the stage, but rather to indicate a locale. In Kabuki, the actor stood on an open stage and played directly to an audience of a thousand or fifteen-hundred spectators. When an actor entered on the *hanamichi,* he would stride to the *shichisan* ("seven-three" position, three-tenths of the distance toward the stage), where he would announce his character's name in an extended, fanciful speech. Broadsheets were published so that the audience would know

5. Shotarō Koike, *Kōshō Edo Kabuki* (*An Investigation of Edo Kabuki*) (Tokyo: Miki shobō, 1979), p. 17.

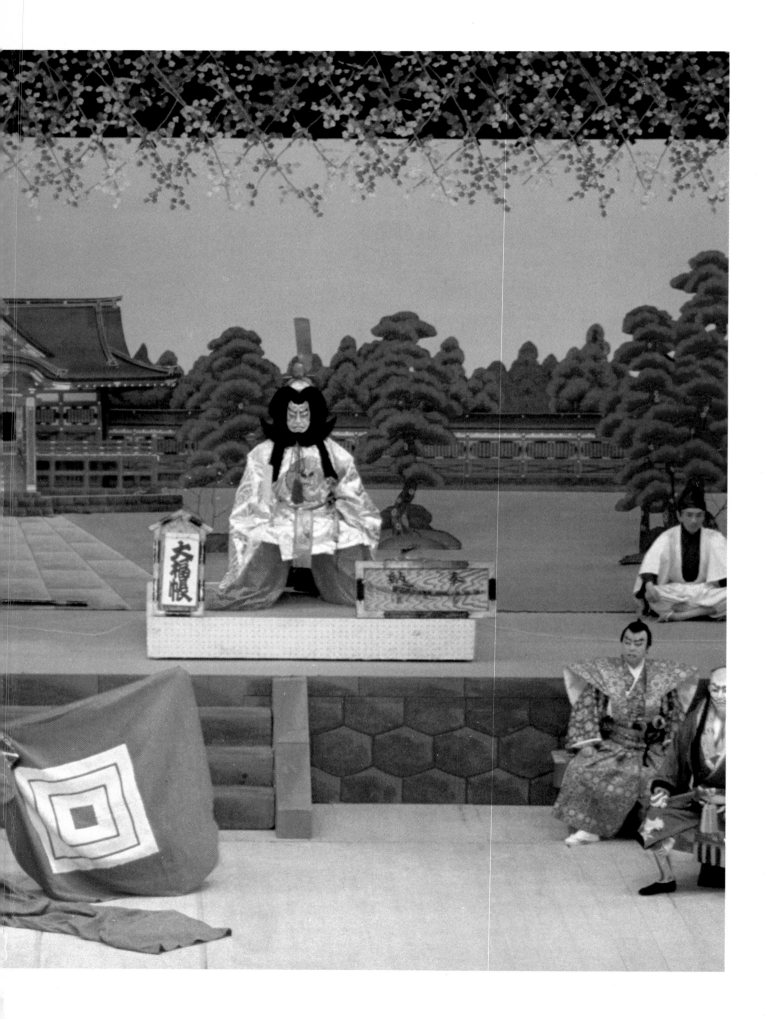

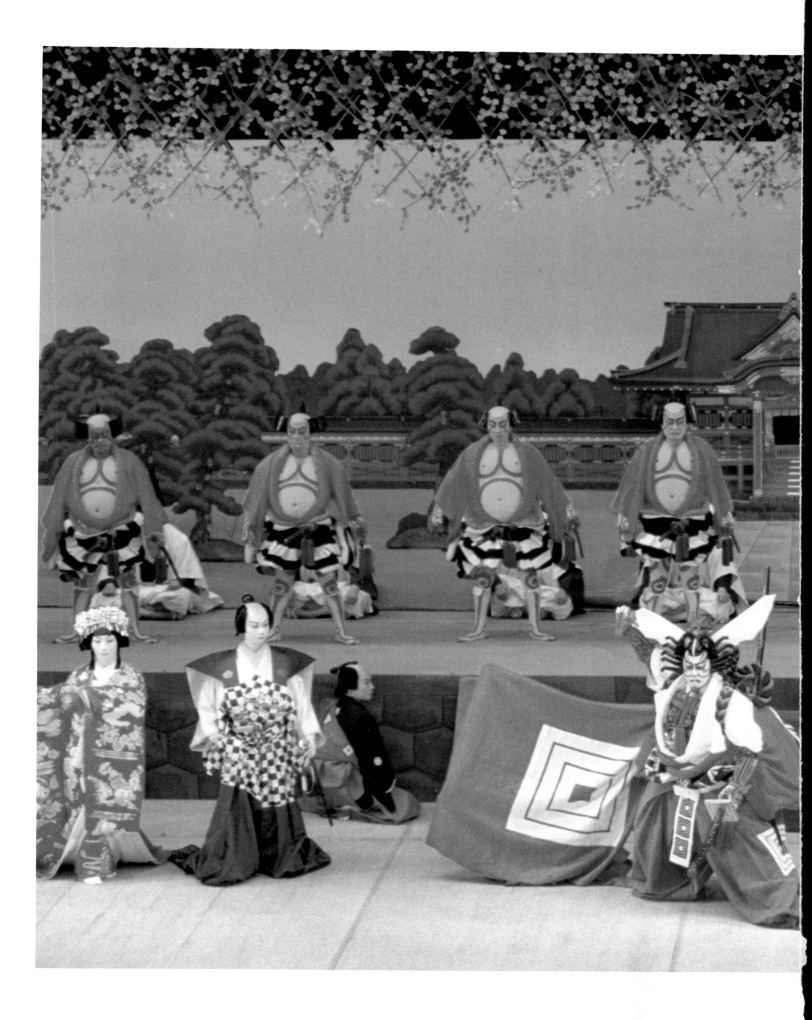

the speech before coming to the theater. This pun-filled, rhymed and metrical passage was delivered in a musical style called *tsurane,* derived, it seems, from Buddhist chanting. Fans cheered the actor and shouted his "shop name" (*yago*)—"Naritaya!" if it was Danjūrō, for example—during these exciting entrance scenes, a practice that continues in Kabuki today. These speeches, especially in the Ichikawa family's patented bravura-style plays, such as *Wait a Moment! (Shibaraku)* and *Sukeroku,* became famous.

The relation between audience and actor was extremely close in Edo Kabuki. The physical theater reinforced the psychological bond: actor and spectator were enclosed within the same physical space. The actor was not seen behind a forbidding proscenium arch or through a "peep hole" in a fourth wall, as was the actor in Western theater. Audience and acting area intermingled. Sitting on *tatami,* spectators could face in any direction. When an actor appeared at the far end of the *hanamichi,* or crossed through the spectators at the rear of the theater on a crosswalk (*watari*), or made a complete circuit through the auditorium via a second *hanamichi* set up on the opposite side of the theater, the actor and spectators shared the same space. The actor was close enough to the audience to be touched. When the actor moved, spectators easily changed their own bodily positions to match the actor's progress. The genuine intimacy of this physical relationship no longer exists. (Floor-bolted, unidirectional seats in Kabuki theaters today unfortunately prevent natural turning.)

Kabuki was a major commercial enterprise in Edo times. The physical theater building was owned by a proprietor and the company was backed by financiers. Productions were expected to earn them a profit, and theater owners offered star performers extravagant annual contracts in the hopes of assuring good houses. A play was chosen to appeal to the largest possible audience. The happiest sight in Kabuki was the "full house" sign raised over the stage when a theater was sold out; a run ended only when the audience stopped coming. Expensive box seats were sold by teahouses that were built along the two sides and the back of the theater. A licensed theater might have twenty to thirty teahouses serving it. Customers with box seats entered the teahouse and from there were ushered to their seats along a private passage. Off-the-street customers bought tickets at the front entrance to the theater; these tickets allowed you to sit on the ground floor level, either in the pit or jammed knee to buttock in a boxed-in square with five or six other people. If you were really poor, you could buy standing room for mere pennies on the second floor above the stage in an area called "Mount Yoshino," named after a famed cherry-blossom viewing area. It was so named because you couldn't see much more than cherry blossoms hanging above the stage, or perhaps the actors' backsides.

Perhaps the most damning aspect of Kabuki in the eyes of *bakufu* officials was that it was an egalitarian art. Kabuki was in fact, as well as in theory, subversive in the rigidly stratified society that shogunal rulers maintained throughout the long Edo period. Thus, samurai were forbidden to attend Kabuki; nonetheless they did so, hiding behind disguises and sitting in second tier boxes with the blinds discreetly closed. The theaters were as irresistible to women of high station as they were to serving maids, as the Ejima affair shows. Prostitutes, merchants' wives, priests, dandies, workers, artisans, former samurai (*rōnin*), and outcasts are all seen in the woodblock prints of Edo's Three Theaters. In a social system based on exclusion, no one was denied admission to Kabuki if he or she had a copper.

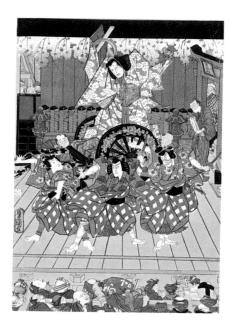

(detail)
Utagawa Toyokuni III
Great Draw at the Kabuki Theater, 1859
color woodblock print
Courtesy Tokyo Metropolitan Central Library

6. Yukio Hattori, *Kabuki no kōzō* (*The Structure of Kabuki*) (Tokyo: Chūo koronsha, 1970), p. 31.

The commercial success of Kabuki is clearly shown by the huge service staff—as many as 230—a theater maintained to cater to its audience.[6] In front of the theater, barkers urged passersby to purchase tickets and professional mimics imitated star actors in excerpts from the play being shown. Two entrances at the front of the theater leading to the pit were manned by ticket sellers, cashiers, doorkeepers, guards and ushers. More than a hundred functionaries roamed the house itself: bouncers to control drunks and break up fights, cushion sellers, men selling programs and play synopses, and vendors selling food and drink of all kinds. Servants from the theater teahouses were constantly on the run, bringing hot sake, broiled fish, fruit, sweets and tea to patrons in their boxes. There was even a guard who knelt on the forestage throughout a performance to keep people from climbing onto it and interfering with the play. Backstage, actors rehearsed and ate, playwrights and assistants read scripts, musicians tuned instruments, and costumers, hairdressers and property men plied their trades. Prints show these backstage dressing rooms packed to overflowing.

A Kabuki performance lasted from before dawn until dusk. In this twelve-hour period, actors and audience settled in for a marathon session of performing-spectating. On the stage and in the house everyone knew how a performance of this magnitude was organized. They could expect in the early hours to see the ritual *sanbasō* dance, a short comic house play (*waki kyōgen*), and two short introductory pieces (*jobiriki* and *futatateme*) designed to give young performers experience. Then came the long feature play (*hon kyōgen*) lasting perhaps ten hours and containing, in order: a brilliant history section (*jidaimono*); a beautiful dance section—often a romantic travel dance (*michiyuki*); and an emotional contemporary section about commoners (*sewamono*). The day's program would conclude with a joyous dance by the entire company (*ōgiri*). Spectators came to watch the plays, of course, but the day was long and what was going on in the auditorium was also interesting. People were drawn to Kabuki for the pleasure of leisurely eating and drinking, the delight of meeting and conversing with friends, the excitement of arranging an assignation with a lover, or the simple fun of gawking at those around them. The gathering of the audience was itself an attraction that competed with the performers.

In modern times, Kabuki was the art par excellence of the "Low City" (Shitamachi). The Low City was the area of Edo, largely to the east and west of the shogun's palace, inhabited by merchants and workers. Although merchants were low on the social scale, some were wealthy. This group organized the actor fan clubs, *renjū*, who sat in special sections of the theater, cheered their favorites, and tried to jeer rival actors from the stage. As noted, most residents of the Low City were recent arrivals. In their new homes in the city they maintained a number of agricultural customs of their native villages. Of prime importance was the celebration of the five annual festivals (*gosekku*). So it is not strange that Kabuki matched its five annual productions to the five calendrical festivals: the lunar New Year, Girl's Day in April, Boy's Day in June, the *Bon* (All Souls) season in mid-summer and Chrysanthemum Day in autumn. Plays with appropriate themes were chosen for each seasonal presentation.

More than that, many aspects of Kabuki performance can only be understood by a reference to the performance of Shinto festivals. A Shinto festival (*matsuri*) renews the bond between the farmer and his protective

deities (*kami*). Festivals everywhere in Japan share the same three-part structure: a protective deity is entreated to leave the other world and journey to earth; the deity is entertained; and the deity is seen off on his return journey to the sacred other world. In the second section of the ritual, villagers would be called on to entertain the deity with a performance. Further, it was a villager who would portray, and on occasion be possessed by, the visiting deity. Because it was acknowledged that the deity made a journey through time and space, festival performances established the immutable practice of delineating a special passage through the spectators for this journey. The *hanamichi* in Kabuki and the bridgeway (*hashigakari*) of Nō are direct descendants of this religious practice. These passageways led to a designated sacred space within which dances, songs or plays were enacted.

In many village festivals only a young boy could play the role of the visiting deity; similarly, many boy actors were stars in Edo Kabuki, especially actors in the Ichikawa Danjūrō family line. It is recorded that the seven-year-old Danjūrō VII played Kamakura Gongorō Kagemasa, the superman hero of *Wait a Moment!*, to great acclaim. The play shows a powerful hero subduing evil enemies, culminating in a strong stamp and a fierce *mie*. Japanese scholars point out that the Kabuki actor's action of stamping on the ground to drive demons away is precisely the action of the Shinto deity protecting a village from evil. In the popular mind Gongorō was an *arahitogami*, a "revealed human-deity," a man who became a god after death and who could reveal himself when called upon by the living. Thus, on the Kabuki stage the child actor was simultaneously playing a dramatic role within a fictional play and performing a public ritual of exorcism.[7] Through the annual enactment of this ritual-play—it was the New Year production at the Three Theaters for more than two hundred years—the attending audience was blessed and protected for the coming year.

The *mie* itself, so characteristic of the Edo *aragoto* acting style, can be traced to religious models. Arms and legs of the actor are held tensed, one eye is crossed over the other, and the musculature of a fiercely glaring face is accented by bold makeup. All of these features are present in the statues of guardian deities that stand at the gates of Buddhist temples. It is not surprising to find that the central guardian deity, Fudō Myōo, is the Ichikawa Danjūrō family god and that they have worshipped Fudō Myōo at the Shinsō-ji in Narita (hence the "shop name" Naritaya) for twelve generations. The present Ichikawa Danjūrō XII succeeded to his name in 1985 only after he made a pilgrimage to Narita to solicit Fudō's protection and support.

Annual shrine festivals provided the *Edokko* with religious and secular entertainment in an environment entirely apart from the fashionable, commercial world of Kabuki. Shinto shrines and their protective deities were associated with each neighborhood of the city. The simplest festival stage was a square of earth in a shrine precinct, marked at each corner by sprigs of sacred bamboo. Believing that a deity would more readily inhabit a raised earthen spot, the area might be built up to make a god's seat (*kami-za*) or mountain (*yama*). Kagura, Shinto dances of worship, were and are performed in the open air. In Edo times important shrines had a special Kagura hall (*kagura den*). Significantly the Kagura stage was without walls, and it was located in the broad, open outer precincts of a shrine. It was constructed of fine polished wood, and the dance floor was raised

7. Haruo Misumi, *Geinōshi no minzokuteki kenkyū* (*A Study of Folkloric History of the Performing Arts*) (Tokyo: Tokyodō, 1976), pp. 250-252.

Bunraku performance showing chief puppeteer with two "invisible" assistants.

(below)
Female *bunraku* puppet in dance pose.

several feet off the ground. Four pillars supporting a roof marked out the stage area in the same way the sacred bamboo had done. Worshippers and passersby could watch from any side of the performance space, but the audience remained outside the sacred space.

A festival that began in a shrine (or Buddhist temple) might continue into the streets as well. One of the purposes of a festival street procession was to exorcise evil spirits (*goryō*). Portable shrines (*mikoshi*), serving as temporary homes for the deities, were carried through the streets, assuring protection to the homes and businesses they passed in the course of their journey. Hundreds of street festivals occurred each year in Edo and the largest, most famous—the Three Shrines, the Kanda, and the Sannō festivals—continue today. Collectively they are known as the Three Great Festivals (*sandai matsuri*) of Edo. Street festivals are significant because they are occasions for residents of a community to join together in a religious celebration that will assure the health and prosperity of the group. They also provide those outside the group an opportunity to share in the religious protection generated by the festival and to enjoy the spectacle. The continuous movement, music, singing and dancing, brilliant massing of colorful costumes, floats, regalia, drinking, eating, and the interplay of performers and audience produce a highly theatrical "performance." In the street, the distinction between performer and spectator grows fuzzy. Members of neighborhood groups, who are the official participants, work as a unit and are identifiable by their uniform costumes, yet no one objects when a spectator temporarily enters a festival procession. For example, in the midsummer *Bon* festival, the boundary between doing and watching is completely broken. Anyone may be a participant, and crossing back and forth between the roles of performer and spectator is an enjoyable part of this otherwise serious festival.

Kabuki was the most important but not the only commercial theater enjoyed by residents of the Low City. Puppet troupes had played in Edo alongside Kabuki ever since Satsuma Jōun and others brought their knockabout puppet plays from Osaka to the Eastern Capital in the 1660s. Bunraku, as puppet theater came to be called, was performed on a stage very much like Kabuki, equipped with revolves, sometimes a *hanamichi* and elaborate sets. The mid-eighteenth century was a time of unparalleled prosperity for puppet theater: great dramas were written for realistic, lifelike dolls, each complexly manipulated by three men. Audiences were similar to Kabuki's, though reputed to be somewhat more intellectual.

It is instructive to compare the aesthetics of Kabuki and Bunraku performance. The two forms grew up at the same time. Both were plebeian arts. Each borrowed plays from the other. Yet each had its distinct artistic appeal, based on different conceptions of organizing time, space and energy on stage. Each Kabuki actor occupied his own separate space. Other actors did not encroach on that space. Movements were few and were deliberate, spare and forceful. Even when not moving, the actor filled the space around him with a constant flow of energy. Traditional Kabuki did not use a narrator, so the full attention of the spectator was on the figure of the actor, sharply etched in space. The Bunraku doll created a semblance of life through small and continuous movements of head, neck, chest, arms and hands and even eyebrows, eyes and mouth. The spectator saw each doll figure as part of a larger ensemble, surrounded by three human manipulators. The voice of the puppet character came from a chanter (*tayū*), twenty to thirty feet away from the puppet, but

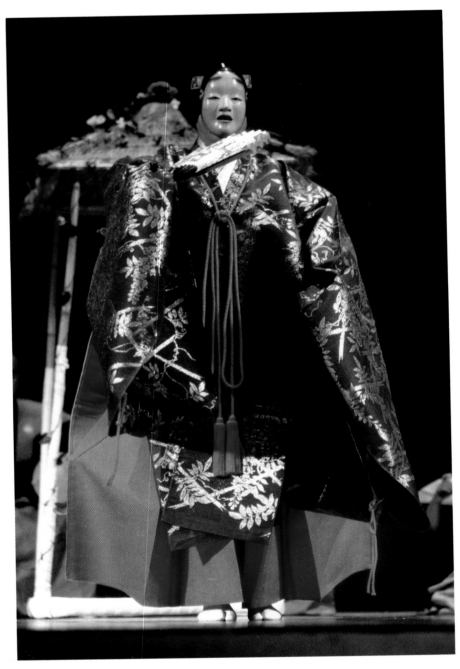

visible to the audience at stage right. The basic energy, moving the play forward, came from the chanted and sung text. Bunraku was a vocal, narrative art. The Bunraku spectator's attention moved from chanter, to puppet, to manipulator, and back to chanter. In spite of the separation of performance elements and the technical nature of the doll-puppet medium, Bunraku is an art of "fusion," which, at its most dramatic, conveys intense emotion. Paradoxically, the theater of living actors is "cool" in comparison.

The theater edict of 1841 applied to puppet troupes in Edo as well as to Kabuki. The two puppet theaters licensed to perform in Edo were forced to move outside the city. In Saruwaka-chō, two Bunraku theaters were located on one side of a street and the Kabuki Nakamura-za and the Ichimura-za faced them on the other side.

Kanze Motomasa in the Nō play
Yugao, 1979.

Other theaters, not affected by the 1841 regulation, were perhaps a hundred variety halls (*yose*). Scattered throughout the city, the houses were small, seating two or three-hundred spectators, and admission was much cheaper than at Kabuki or Bunraku. Going to a neighborhood *yose* was a matter as casual as going to a movie today. A typical four or five hour program was made up of a dozen short acts—comic storytelling (Rakugo), telling of romantic tales (Kōdan), comic vaudeville (Mazai), as well as paper cutting, mimicking, juggling, singing and dancing.

The entertainments of the *Edokko* of the Low City have been the subject of this essay thus far, but Edo also included the "High City" (Yamanote). It encompassed the shogun's palace and the pleasant hilly areas surrounding it, especially to the northwest. The shogun and his retinue lived in the center of the High City, surrounded by thousands of samurai officials and scores of provincial rulers (*daimyō*), each with their supporting retainers. The "official entertainment" (*shikigaku*) of this vast samurai establishment was Nō, a dance-drama refined into a noble art in the fifteenth century by the actor Zeami Motokiyo (1362/63-1443). Following the lead of the shogunate, troupes of Nō actors had been patronized by lords in various regions of the country for two centuries before the city of Edo existed. Under Tokugawa rulers, Nō actors were awarded samurai status. In Edo, stages for Nō were built in the palace and in important officials' mansions. The structures were freestanding and were erected in a garden or other open area. A Nō stage was a raised, square dance platform connected to a dressing room by a bridgeway. Stage and bridgeway were roofed, the roof being supported by wooden posts. Ideally, if not always in practice, the wood was fragrant, gleaming cyprus. An important function of the roof over the stage was to define the vertical dimensions of the stage space. It prevented the eye of the spectator from roaming about the otherwise unlimited space of open-air surroundings. Honored spectators watched from a nearby sitting room facing, but not connected with, the stage. Lesser functionaries might sit on mats spread upon the grass.[8] Each performance was a command affair, ordered by a patron to celebrate a special occasion, and spectators were the patron's invited guests.

The orthodox shape of the Nō stage described above is that of Japan's oldest extant stage, built at Toyotomi Hideyoshi's command in 1581 and now preserved in the northern garden of the Nishihongan-ji in Kyoto. Unlike the standard form, earlier stage configurations seem to have been suited to a particular site. There are sketches showing Nō stages without roofs or pillars, with the bridgeway joining the stage at the back, with two bridgeways, and with no bridgeway at all. It should also be remembered that before the Tokugawa era, Nō was commonly performed in temples and shrines at festival times and therefore access to Nō was open to the general public. But by the time the city of Edo was built, attendance at Nō was deliberately restricted to members of the samurai class. The main exception to this was "Subscription Nō" (*kanjin Nō*). A subscription stage would be built in a large open area accessible to the public, with boxes around it and the area fronting it marked out for cheap seats. Subscription Nō was rarely allowed in Edo, and perhaps for this reason performances were exceedingly popular when they occurred. The fortunate master of a Nō school who obtained the shogun's permission to stage these performances over a ten-day or two-week period could expect to earn a huge sum from the sale or "subscription" of the seats.

8. One of the oldest words for a play is *shiba-i* (being on the grass). Naorō Adachi, *Kabuki gekijō onnagata fūzoku saiken* (*A Study of the Customs of the Kabuki Stage and the Female Impersonator*) (Tokyo: Tenbōsha, 1976), p. 28.

The oldest extant Nō stage at Nishihongan-ji, Kyoto, built at Toyotomi Hideyoshi's command in 1581.

(below)
Interior of contemporary Nō theater, performance of the play *Dōjōji*.

A Nō program consisted of three to five elegant plays interspersed with shorter Kyōgen comedies. The interpenetration of time and space, characteristic of Japanese theater, is clearly apparent in the structure of Nō plays: the past is brought forward into the present and space is dissolved by dreams and memory. In a typical play a spirit (or deity) manifests itself on earth, drawn by emotional ties (a Buddhist concept) or invited by a shamanlike traveling priest to journey to this world. In *Matsukaze* for example, a wife laments the death of her beloved husband, causing his ghost to manifest itself on stage. Thus, the past comes to exist in the present—both times commingle. The play shows spirit possession as well, for the ghost of the husband possesses the living. The spectator sees and hears the husband through the body and the voice of the wife.

As with certain other Japanese arts, direct expression is not the aim of Nō. One is struck by the number of obstacles placed in the way of the actor's ability to be expressive. The tempo of performance is slow, the range of gesture restricted, the amount of action slight. How can an actor "act" when his most expressive feature, his face, is hidden behind a mask, when his body is encased in a rigid robe that conceals postures and movements, when even his hands are scarcely seen inside enfolding sleeves? The actor seems locked inside an elegant prison of form, but in the Zen world view, silence and stillness (*ma* or *mu*) are potentially filled with meaning. In an extreme case the central scene of a Nō play will not be acted, and the audience will be expected to imagine in its mind the dance of a motionless performer. Freshness and uniqueness in performance—*hana* (flower)—were the Nō ideal in Zeami's time. *Yūgen* (restrained beauty) was the aesthetic aim most prized by elite Tokugawa audiences. On rare occasions, when a great performer breaks through the Nō barriers of form, the essence of a character will radiate from the stage with impelling force and the spectator is led to share an intuitive sense of beauty.

In 1868 Edo became modern Tokyo and the performing arts of the city entered a radically new era. The Meiji (1868-1912) and Taishō (1912-1926) periods ushered in profound alterations in traditional patterns of theatergoing and in the theater's social role. Initially it seemed that Nō would not survive when its actors lost their positions as samurai. There are many sad tales of once mighty artists selling baskets by the roadside. But soon it was realized that Nō might be compared to Western ballet and opera, and hence be of value, and in 1881 members of the new Meiji nobility built a Nō theater in Shiba Park for public use. Following this, four of the Nō schools, lead by the Kanze and Kita families, built public theaters in Tokyo. Actors turned to teaching amateurs and gradually Nō came to be supported, not by the new government, but by large, committed groups of performer-students. Student tuition and royalty fees to teachers—as much as two thousand dollars for a student to perform a major role in a recital—provide the bulk of Nō's very substantial income today.

The new theaters built after the turn of the century for Nō and Kyōgen performance were unusual in that the traditional stage and bridgeway were placed within a multi-story brick or frame building influenced by Western tradition. In time, folding seats in the Western manner were introduced as well. Why were previously separate stage and seating spaces brought together under a single roof? Certainly one motive was to protect the fragile stage from inclement weather and to keep out vulgar city noises. But Nō stages had been rained on for centuries and the streets of

Edo had always been noisy. The new theaters were enclosed, like Kabuki theaters, to limit attendance to those who had bought tickets. The manner in which Nō telescoped 250 years of Kabuki theater development—from freestanding stages in 1600 to specialized buildings housing the multiple functions of seating, playing, rehearsing, box office and management—into a mere two decades illustrates the urgency that was felt in Meiji times. Tokyo today boasts of many modern Nō theaters. The elegantly simple National Nō Theater that opened in Tokyo in 1983 exemplifies the modern theater: a traditional roofed stage with a wonderfully long bridge-way, modeled after Hideyoshi's 1581 Nō stage, is encapsulated and embalmed within a striking reinforced concrete building fitted with plush seats, electronic lighting and other modern conveniences.

Kabuki theaters suffered directly from fighting between Tokugawa and imperial soldiers at the time of the Meiji Restoration. For a time, theaters were shut down because of disorders in the city. In 1867 samurai occupied the *hanamichi* of the Morita-za during a performance, and in the first year of Meiji, the actor-manager Kawarazaki Gonnosuke was assaulted and killed by a band of thieves in his own theater.[9] During the Meiji and Taishō periods, performers and managers of the Three Theaters moved to elite "uptown" addresses as soon as they were able. They also deliberately abandoned their Low City audiences in the move to gain social respectability. Revised government regulations allowed more theaters to be constructed and five new Kabuki theaters were built in 1873 alone, mostly in High City areas.[10] The Kabuki-za, which opened in fashionable East Ginza in 1889, aimed at an elite audience. In an effort to prove that riverbed wanderers deserved respect in the new era, a Society for Theater Reform outlined a plan to "improve" Kabuki by doing away with traditional *shamisen* music, *aragoto* acting style, the *onnagata* and the *hanamichi*—everything that was not Western and modern. Some years earlier Ichikawa Danjūrō IX had worn a swallow-tailed coat at the opening of the new and "modern" Shintomi-za to announce from the stage his pledge that:

> The theater [Kabuki] of recent years has drunk up filth and has smelled of the coarse and the mean. . . . I, Danjūrō, am deeply grieved . . . and in consultation with my colleagues, I have resolved to clean away the decay.[11]

As if to set the seal on Kabuki's new social standing, the Meiji Emperor himself witnessed a Kabuki performance in 1887. Kabuki was becoming sedate and its audiences reserved. Even the meaning of the word Kabuki was "reformed" during the Meiji period: Kabuki, meaning song-dance-prostitute, was sanitized into Kabuki, meaning song-dance-skill. Today, "Grand Kabuki" (*dai-kabuki*) is the favored term for the former art of riverbed wanderers.

In fact none of the specific reforms advocated by the Society were realized. The stultifying Victorian attitude that prompted the reform crusade, however, afflicts Kabuki to this day. Guided by my good friend Onoe Kuroemon, a noted Kabuki actor, I was privileged to have seen the Katabami Kabuki Company, the last of the small, traveling Kabuki troupes, play several times in Asakusa in 1959 just before it disbanded. Although coarse compared to Grand Kabuki, the acting was wonderfully vibrant and exciting, suggesting the vitality of Kabuki in Edo times. Love scenes in particular were both artistic and remarkably erotic. The *onnagata* used the cross-gender ambivalence of a man being a woman to arouse strong reactions from the audience that are never seen in classic Kabuki theaters

9. Toshirō Ihara, ed., *Kabuki nenpyō* (*A Chronology of Kabuki*) (Tokyo: Iwanami shoten, 1962), vol. 7, pp. 147, 148, 151.
10. Earle Ernst, *The Kabuki Theater* (Honolulu: University of Hawaii Press, 1974 [1956]), p. 58.
11. Toyotaka Komiya, ed., *Japanese Music and Drama in the Meiji Era*, trans. Edward Seidensticker and Donald Keene (Tokyo: Ōbunsha, 1956), pp. 191, 192.

today. Overall, Grand Kabuki has not changed in its acting techniques very much over the past century, but a sea change has occurred in its spirit. It is now a genteel art.

The European opera house was taken as a model for many new commercial theaters. The Imperial Theater, built in 1911 in Marunouchi in the style of a Renaissance palace, was the first of many theaters designed in European monumental style. Adjacent teahouses were eliminated. Evening performances replaced all-day programs. Audiences sat in Western-style seats. The changes were not necessarily felicitous. Stages in commercial theaters reached widths approaching one hundred feet, so vast that even Kabuki actors found it hard to fill a stage effectively. Large stages required acres of painted canvas scenery that dwarfed performers. Western-style overhanging balconies blocked many spectators' views of the *hanamichi,* and back rows of seats were too far from the stage. The current Imperial Theater, Nissei Theater, and even the Kabuki-za suffer from the Meiji spirit of gigantism. Traditional Japanese performing arts are suited to medium or small performing spaces; even today their accommodation to Western theater design proves difficult to achieve.

The meeting of Japan and the West spawned new theater forms unimagined in Japan before the twentieth century. Actresses were brought back to the stage after a lapse of three hundred years. Shinpa (New School) began at the turn of the century as a rejection of "old style" Kabuki. Relatively natural acting and plays about current events were daring innovations at the time. Today Shinpa is performed by one troupe in a sentimental style redolent of the atmosphere of Meiji-Taishō times in which it was born. Neither old nor new, it nonetheless forms a tenuous theatrical link between Kabuki and modern theater.

The performance of Western realistic drama began in Tokyo in the second decade of the twentieth century. It was previously unheard of for an actor to stand and merely talk on stage (music, dance and drama being fused in traditional performance), so the foreign drama was appropriately called Shingeki (New Drama). Large theaters were inappropriate to the modest scale of the new plays. Beginning with the Yuraku-za that was built in 1908 with a seating capacity of nine hundred, numerous small theaters were designed to meet the requirements of Western realistic plays. In 1924 Kaoru Osanai, returning from a study trip to Germany and Russia, built the Tsukiji Little Theater a few blocks from the Kabuki-za, where he produced the plays of Ibsen, Chekhov, Shaw and other serious Western playwrights. Osanai attracted a very small (the theater seated 497), very young, and very High City audience of intellectuals and students to his model performing space. Today a similar type of audience attends productions of *Death of A Salesman* and *Equus.*

By the end of World War II Shingeki had become a well-established genre. Playwrights wrote dramas that were literary, realistic, high-minded. Directors and actors formed companies dedicated to the performance of "spoken drama." But its critics said it was already bogged down in old-fashioned and, what is worse, foreign traditions. A reaction to Shingeki began in the 1960s. Young people in theater, especially playwright-directors, embarked on a search for contemporary yet wholly Japanese styles of performance. Jūrō Kara, Tadashi Suzuki and the late Shūji Terayama are well known for creating new plays within experimental, intensely theatrical performing styles. Working with small acting com-

panies, they have rejected Western realism totally and have returned to earlier Japanese customs and performing styles—Nō, Kabuki, Kyōgen, Bunraku—for inspiration. Lighting, costuming and music are important to their work, and occasionally they all direct in formal theaters. But it is characteristic of their approach that performing spaces be flexible. Suzuki's favorite acting area is a refurbished farmhouse in the mountains of Toyama Prefecture; Kara plays in a tent set up in a Shinjuku shrine compound; Terayama staged plays in a loft, a barge, a warehouse and in the street.

Today, 120 years after the end of the Edo period, "popular" theaters still cluster in the Low City. In Ueno and Asakusa you find *yose*, striptease shows, movie houses and theaters featuring Tabishibai, scruffy little troupes on permanent tour like a midwestern Toby show. The Suehiro *yose* in raunchy Shinjuku has old style *tatami* seating along the side and a mood that goes back to prewar days. Larger theaters located on the fringes of the Low City, like the Meiji Theater, Koma Theater and Shinbashi Music Hall, present popular historical dramas and musicals that have great appeal for Low City audiences. The best place I know to taste and smell the atmosphere of Low City performance is the family-run Shinohara Theater, two subway stations north of Ikebukuro, where Tabishibai troupes stage pseudo-Kabuki programs made up of history, dance and contemporary sections. Thirty or forty older people from the neighborhood, sitting on rented cushions scattered on the floor of a matted room, eat, drink and gossip as they watch a three to four-hour performance. After ten days the troupe moves on and another troupe takes its place.

Most of Tokyo's theaters in 1986 are not in the Low City, however. Tokyo is wealthy, cosmopolitan, high fashion, high tech. It has perhaps the largest concentration of superbly equipped modern theaters, including four national theaters, of any city in the world. Every two weeks the play guide magazine *Pia* lists some three hundred theater, dance and music events that take place in over eighty High City theaters. Nō and Kyōgen are performed on eight stages. Most months Kabuki is seen at the Kabuki-za and the National Theater and less often at the Shinbashi Music Hall and the new Asakusa Hall. Public performances of Bunraku from Osaka and Bugaku dances from the Imperial Palace are given at the National Theater four times and twice a year respectively. Shingeki companies rent out the rebuilt Actors' Theater, Kinokuniya Hall, and the Mitsukoshi Theater for one to three-week runs. Ōta Shōgo's theater of silence, in which characters move with glacial stillness and power, shows a concern in the twentieth century for the concepts of open space and time first explored in the fourteenth century by actors of Nō drama. Primitive demonic forces exorcised in village rituals transform into the modern agonies of tortured, white-bodied Butō dancers of the Sankaijuku and Dairakudakan troupes. The list could go on, for Tokyo's performance spaces are open to theater of all kinds, from the traditional to the as yet undiscovered avant-garde.

Artist unknown
Nō Performance of Funa Benkei,
circa 1660
six-fold screen; color, gold on paper
40 x 103½, 101.6 x 262.8
Tiger Collection

The spacious courtyard of a large enclosed residence is the setting for an animated theatrical performance that dominates this colorful screen. On the far left, a large house is depicted with all its shutters open, revealing a group of several men, including a *daimyō* and two Buddhist priests. They are comfortably seated to watch a play in progress on a stage that projects into the courtyard. Seven musicians and chanters who accompany the performance are seated at the rear of the stage. The scene of a demon, who is attacking four men enclosed in a light, boat-shaped frame,

suggests that the play is *Funa Benkei (Benkei in the Boat).* Numerous spectators, all male, are seated at the base of the stage. Also part of the audience, but conspicuously separated from the men, are numerous women who occupy several rooms that extend across the bottom of the screen. With the walls of the house removed, they can be observed watching the play, engaged in conversation and playing *go.* Three women, seated in a room on the far right of the compound, are watching the play from behind *sudare* (reed blinds). They are probably members of the host's family.

The gate of the fence enclosing the courtyard is open on the right side. The scene outside the gate fairly bustles with

activity. The most conspicuous group of figures is eight men seated on a red cloth on the edge of a stream. They are laughing, conversing and drinking from small red lacquered wine cups that are being filled upstream by two young servants and floated down to the men on flat, round lotus leaves. The manner in which these men are drinking is reminiscent of the famous "Gathering at the Orchid Pavilion," an event that took place in 353 A.D. in China, when the host, Wang Xizhi (321-379), invited forty-two scholars to celebrate the advent of spring on his estate, on the third day of the third month. The scholars conversed, sang, wrote poetry and drank wine from small cups floated downstream. The event was memorialized in Chinese literature by the host who gathered the poems, transcribed the names of the participants, the titles of their poems and the number of cups of wine consumed, and it became a favorite subject for both Chinese and Japanese literati paintings for centuries thereafter. A similar event, *Kyokusui no en,* celebrated on the third day of the third month, became established in ancient Japan as one of the observances of the twelve months of the year. Like the Chinese tradition, cups of wine were floated down a stream to guests who, before they could take one to drink, had to recite a poem. This vignette, then, is both a literary allusion and an indication of season, identifying the day of this party as the third day of the third month of the year.

Funa Benkei, renowned as a masterpiece in the Nō repertory of demon plays, closes a Nō program with a lively tempo and cheerful impact. The scene depicted on this screen is the dramatic moment when Tomomori, the vengeful ghost of a defeated Heike warrior, rises out of the water to menace the boat ferrying Benkei and the youthful Yoshitsune across the Inland Sea.

Emily Sano

Arata Isozaki and Eiko Ishioka: Performing

The Performing space for *Tokyo: Form and Spirit* includes a *himorogi* (sacred rectangle), a stage, and several auxiliary objects. The traditions represented by the *himorogi* and the stage are universal: sacred dances offered to the gods on the clay stages of the Shinto shrines in Japan were similar to the plays and dances performed in rotundas located beneath the sanctuaries of the Acropolis in Greece. Our Performing space is a modern adaptation of these ancient sacred stages, in which television creates compelling images that symbolize entertainment in modern Tokyo.

The *himorogi* consists of a seven-foot-high wall of rice straw that surrounds a rectangle on three sides. This wall is painted pitch-black. A pure white *shimenawa* (twisted rope used to demarcate a sacred area) is stretched across the open side of the *himorogi*. Smooth, round black stones *(tamaishi)* are spread on the floor. Vertical totemlike poles made of a number of video tubes are placed in the center of the rectangle. They represent the modern god.

In contrast to the *himorogi*, the square stage is in the form of a large Japanese lunchbox *(bentō)*; fifty-three video tubes of various sizes, nestled within it, tilt in a number of directions. A reinforced transparent glass stage floor rests on top of the *bentō,* covering the video screens whose colorful images will light up the stage. From the stage floor and the *himorogi*, video monitors broadcast Japanese television commercials that date from 1983 and 1984. Each monitor is programmed to broadcast a number of images. Located around the stage area are ladders made of black wooden poles. Climbing to the top of these, viewers may watch live and video performances on the stage. Several ladders are covered with large squares of brightly-colored fabric that may provide dressing rooms for the performers or storage areas for the video controls. For live performances, the stage is covered with a wood floor similar to that in a Kabuki theater.

A myriad of visual and aural forms will be created by the live performances of vocal and instrumental music on one hand, and the shower of sounds and images of the television commercials on the other. Together, they symbolically express the source of Tokyo's intricate energy—a mixture of tradition and modernity.

A.I. and E.I.

Design
Arata Isozaki
Eiko Ishioka

Design Associates
Kenji Sato
Hajime Kumakura
Tessei Matsushita

Production
SONY
SONY/PCL
Sanei Television Co.
Maki Kensetsu Co.
Kato Seisakusho Co.
Art Directors Club
A.C.C.
C.M. Land
Yasushi Ohno
Tohkoen Co., Ltd./
Kazuyoshi Matsuda
Manufactures Ltd.

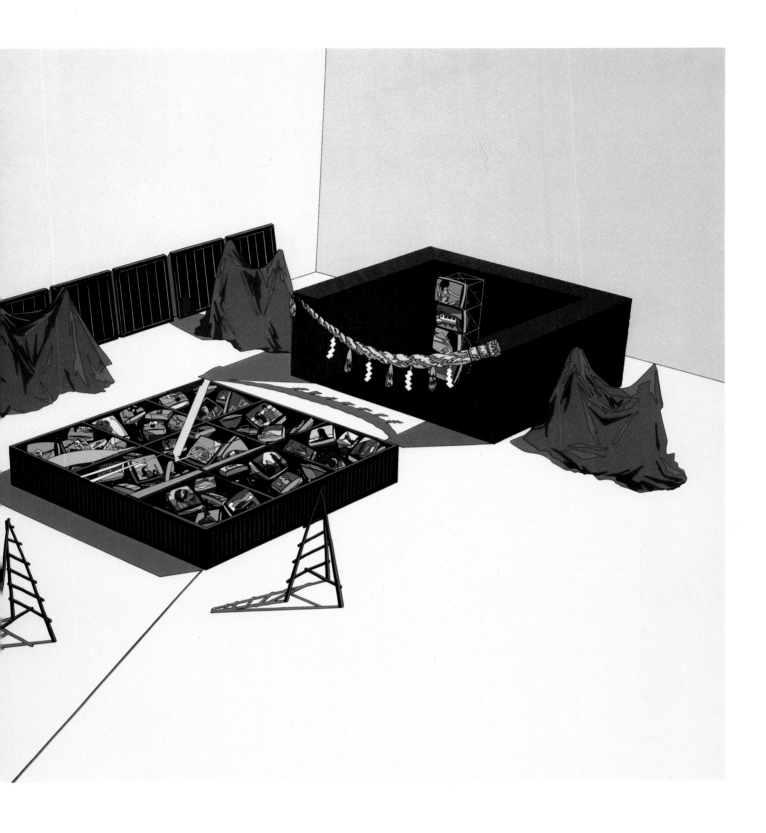

174

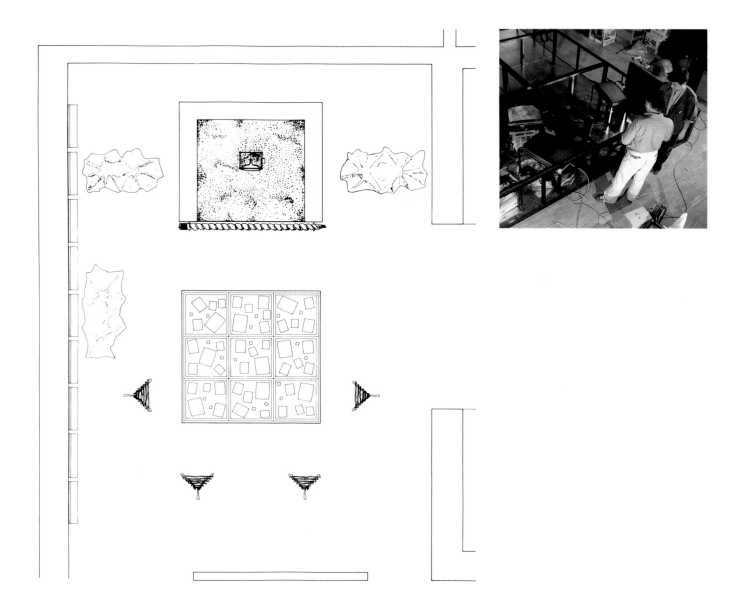

(above, left)
Floor plan, Performing space,
Tokyo: Form and Spirit, 1986

(above, right and opposite)
Photographs of the *bentō*-like stage under
construction in Tokyo. The fifteen-foot-square
platform contains video monitors
programmed with Japanese television
commercials. Small-scale live performances
will also take place on this stage, which will
then be covered with a wood floor.

(overleaf)
Eijin Suzuki
Illustration of the Performing space,
Tokyo: Form and Spirit, 1986

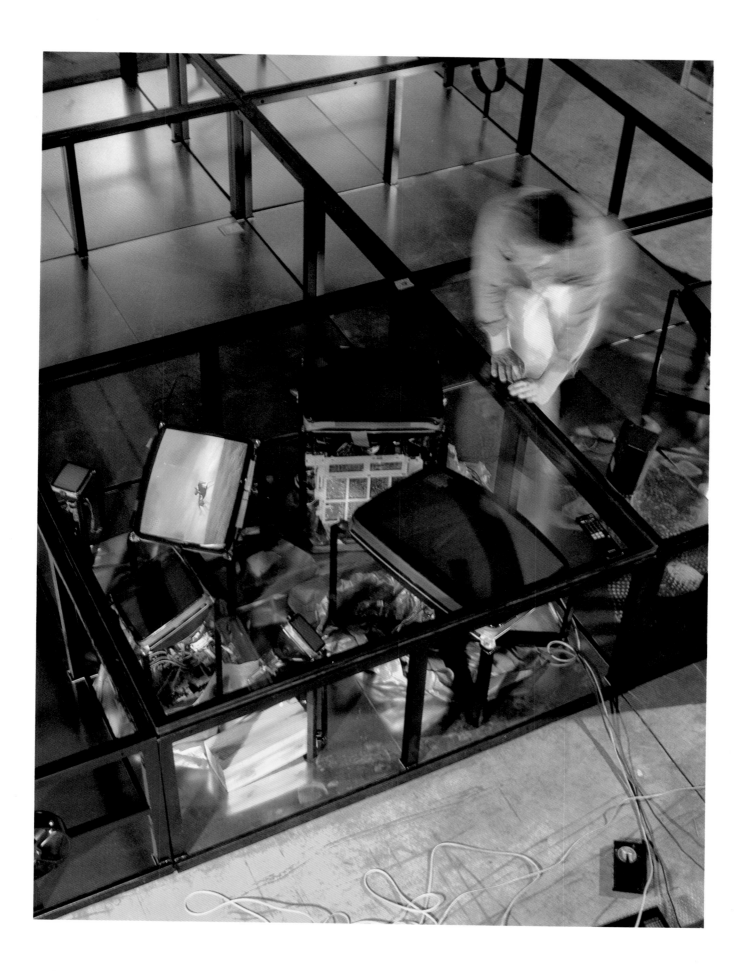

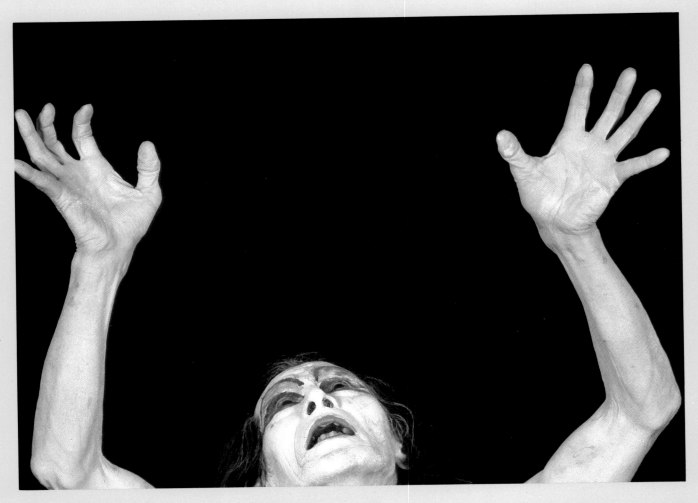

Kazuo Ohno in a performance of *Admiring La Argentina*, 1985.

(opposite, left)
Byakkosha, a new Kyoto group, in the finale of *Skylark and the Lying Buddha*, 1985.

(opposite, right)
Excerpt from *Daytime Moon*, choreographed by Min Tanaka, 1985.

Butō

The seasonal cycle that pervades Japanese aesthetics is expressed through a myth. The Sun Goddess, Amaterasu Omikami, from whom the Emperor is descended, once retreated to a cave and the world was plunged into darkness. She was enticed out of the cave by the sound of revelry as a wild and bawdy dance was performed at the cave's entrance. Amaterasu's reappearance heralded the return of warmth and light, and the onset of spring, so important to the agricultural cycle.

Myth occupies a significant position in the Japanese imagination, and is sustained through institutions such as Shinto, the native religion. The technological and commercial facades of contemporary Japan have foundations nurtured in mythology. An imagination that can still perceive the world in terms of symbol and archetypal imagery constitutes an essential part of the Japanese identity. In the course of the rapid postwar redevelopment of Japan, and the rise of her international status and economic power, the need to

preserve that peculiar sense of national identity has become more important. From the late 1950s to the present day, artists, writers and performers in Japan have been searching for a style that confirms their identity, and reflects their assimilation—and ultimate rejection of—Western influence. National prosperity has created a revitalizing sense of confidence as Japanese style and design have flourished outside Japan, reinforcing the potency of native cultural roots.

The phenomenon of Butō, an avant-garde form of dance theater, is an exemplary assertion of Japanese identity. Butō refers to the dance of a primary agricultural society: *Bu* means dance and *tō* means to stamp the ground. By its audacity and lyricism, Butō challenges the restraints and social conventions of contemporary Japan; it is as divorced from Western modern dance as it is from Nō and Kabuki. The images and gestures of Butō provide a link to myth and the subconscious, yet also reflect the modern Japanese experience born out of the nuclear age. Originating as an element

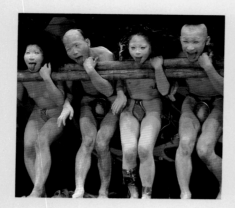

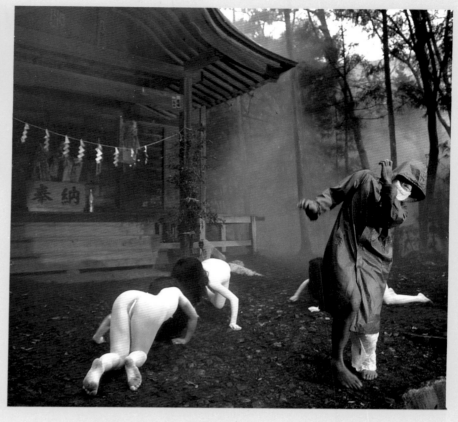

of 1960s Tokyo subculture, the vitality and integrity of Butō is maintained by its remaining on the very periphery of the established arts. Although it has received considerable attention outside Japan, Butō is potentially subversive and innovative; it is in the tradition of the sensual, provocative dance that initially drew Amaterasu from her cave.

In the immediate postwar years Western modern dance was performed in Japan and influenced Kazuo Ohno and Tatsumi Hijikata, who were to become the progenitors of Butō. In 1959 Hijikata performed his adaptation of Yukio Mishima's novel *Kinjiki (Forbidden Colors)* in Tokyo before a small audience of about two hundred people. It was an historic performance during which he slaughtered a chicken on stage, causing members of the audience to faint. He was officially outlawed as a "dangerous" performer by the Japanese dance institutions. Mishima supported Hijikata's experimental dance theater during the 1960s, providing the calligraphy for the emblematic banners of Hijikata's *Ankoku Butoh-Ha (Black Dance Theater)*. Butō flourished in the fertile climate of Tokyo in the late 1960s,

at a time when *Tenjo Sajiki (A Laboratory of Theater Play)* also developed a new surreal and erotic form of theater under the direction of the recently deceased poet Shūji Terayama.

In 1968, Hijikata created *Kamaitachi* with the photographer Eikoh Hosoe in the far north of Honshu. It was a dance-drama of possession by a demonic spirit, set against the backdrop of the memory of the year 1945. Hijikata's performances reached a climax in 1968 with *Revolt of the Flesh,* in which he finally turned his back on Western dance.

In the 1970s and 1980s, as many as twenty different Butō groups have developed. They refer back to the work of Hijikata, who continues to choreograph and direct. Kazuo Ohno still dances. His notable recent performance was an homage to the Spanish dancer, La Argentina. Despite its essential Japanese characteristics, Butō forms a link between the Japanese avant-garde and the West. Hijikata cites the influence of Antonin Artaud's *Theater of Cruelty;*

and Min Tanaka, the most significant of a later generation of dancers, recently performed his adaptation of *Viola, A Homage to Kandinsky,* in Europe and Japan.

The Butō group most widely seen outside Japan is Sankaijuku, under the leadership of Ushio Amagatsu, who also acknowledges the influences of Ohno and Hijikata. Sankaijuku's performance *Jomon-sho* referred to the early Jomon culture of Japan. It involved the descent of the dancers from the roof to the stage, suspended head-first by ropes tied around their ankles. Their motion represented a birth rite, an enactment of the origins of Japanese culture.

Butō has no orthodox vocabulary of gesture. It is both highly fluid and expressive, as well as almost static and sculptural. It involves a body language derived from great discipline, and in true Japanese style it is both an art of the body and an art of the mind. When asked by a Western theater director to describe the philosophy behind Butō, Hijikata replied, "There is no philosophy before Butō. It is only possible that a philosophy may come out of Butō."

Mark Holborn

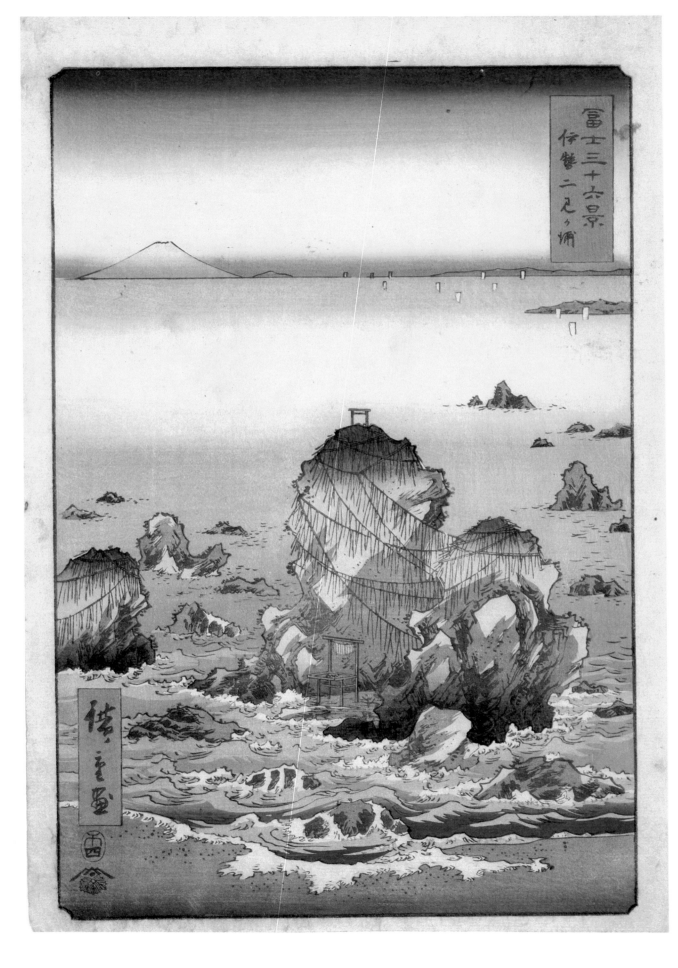

Tokyo's Silent Space

Chris Fawcett

The familiar symbol of a sacred Shinto sanctuary—the red-orange *torii*.

(opposite)
Andō Hiroshige
Mount Fuji from Futami, Ise, from
the series *Thirty-six Views of Fuji,* 1831
color woodblock print
13⅝ x 8¹¹⁄₁₆, 34.9 x 22.2
Collection The Minneapolis Institute of Arts,
Gift of anonymous St. Paul Friends

The best language is that which is not spoken,
the best form of action is without deeds.
Xuang Zi

Those who know do not speak; those who speak do not know.
Laozi

So still
Into rocks it pierces
The locust shrill.
Matsuo Bashō

Sitting quietly, doing nothing
Spring comes and the grass grows by itself.
Zenrin

To the music of the reaper's flute
No song is sung
But the sighing of winds in the fields.
Zeami

What is the sound of one hand clapping?
Zen koan

Has the Garden of Silence already been lost?
Then birds must arm themselves.
Harayuchi Tōzō

Japanese music is above all a music of reticence, of
atmosphere. When recorded, or amplified by loudspeaker,
the greater part of its charm is lost. In conversation, too,
we prefer the soft voice, the understatement.
Jun'ichirō Tanizaki

Vimalakīrti was silent when Mañjuśrī asked him as to the doctrine
of non-duality, and his silence was later commented upon . . . as
'deafening like thunder.'
Daisetz T. Suzuki

The Many-Voiced Silence

From a thousand and one Tokyo orifices Muzak grabs at our sensibilities when they are dozing. In department stores a leaden-yet-light music plays on our consciousness, inducing a comfortable stupor wherein the purchasing embryo can be born and grow into habit. Muzak descends on players in countless pinball parlors, urging them on to win (or lose) all the more heroically (or tragically). It calms us in lifts, restaurants, banks, waiting rooms, shopping malls. It assaults us in chic Ginza or Roppongi, in Shinjuku's pleasurescape, in downtrodden Akasaka as well as in Tokyo's electronic nerve center, Akihabara. In hotel lounges it eases the restless traveler into a quietude essential in the hyperactive space, otherwise known as Japan City.

Tokyo's Muzak seems to come from nowhere. The speakers are usually high up (heavenly). It mysteriously corporealizes out of nothing, an entrancing ethereality of tiny charged particles landing in the eardrum with scarcely a reverberation. It is a near-subliminal communication mode, which is why it is so successful in its opiating job, dulling and enhancing.

Tokyo is a million and one sounds. The call of sweet potato hawkers, the scream of police and factory sirens, the thunderous uproar of round-the-clock construction work, the terrible rhythm of pile drivers, the quirk, quirk, quirk sound of vehicles reversing, the beep, beep, beep warning at level crossings, politicians on vans broadcasting megaphone messages, the buzz of portable generators. Muzak is a domesticated version of that out-world mayhem, refined and enslaved.[1]

On the evidence of early Western travelers, Edo was just as cacophonous and many Edo sounds persist. For instance, the sounds of insects and natural life are aural stimuli recorded and gloried in haiku. Festivals are explosively noisy (as well as totally silent). At the New Year, temple bells are struck 108 times. Masked monsters (*namahage*)—annually invited into houses—shout fiercely, searching for any hidden children. There are even percussive rites. When a corpse is carried out of the family house for cremation, the deceased's rice bowl, symbolizing his soul, is smashed the moment the coffin crosses the threshold. Simultaneously, a Buddhist monk strikes a gong.[2]

1. Decibel count machines have been set up in Tokyo's public spaces—they attract kids who shout and encourage the monitor to record the highest count. A Japanese hard rock group is called Loudness.
2. In a funeral I observed, with the coffin positioned in the hearse, the bereaved husband, mike in one hand, thanked the guests through a loudspeaker. *Otozure*, meaning "visitor" or "guest," literally reads "bringing a sound." L. Lionni and Seigow Matsuoka, *Ma no hon (The Book of Ma)* (Tokyo: Kosakusha, 1980), pp. 20, 21.

The Silence of Timber

Flight of steps leading to Hie Jinja, built on its present site in 1659.

(bottom)
The entranceway to Hie Jinja is flanked by two statues of holy monkeys.

(opposite)
Upon entering Hie Jinja, worshippers may summon the spirit of the *kami* by ringing the brass bell; coins are tossed into the offering box behind the bell.

Alongside the Capital Tokyu Hotel, encircled by woods and by a belt of offices and apartments, on the border of Akasaka's dominion of embassies and executive expectancy, and Kasumigaseki (Tokyo's first skyscraper, 1968), Whitehall-like corridors of power (leading to the Diet Building, seat of the Japanese Parliament), is Hie Jinja. Built in 1478 it served as the guardian shrine of Edo Castle until 1607. It was then removed to Kōjimachi, destroyed, and then rebuilt on its present site in 1659.[3] The Shinto precincts are approached through *torii* (gates) and steep flights of steps to an almost symmetrical ensemble of traditionally formed shrine elements, such as the *heiden* (offertory hall) and the *haiden* (oratory), gathered around a graveled courtyard. Glass cases on either side of the intermediate entrance contain representations of holy monkeys, liaisons between the shrine's deity and the local community.

Cameras clicking and popping. The shrine bell being rung to summon the deity. Couples giggling. Feet on gravel. The musical calling of ritual instruments. Babies crying. The sawing of timber by the shrine carpenter. These variations in aural focus notwithstanding, the shrine is dignity, solemnity. A silence of history. Though numbers of hotels and office buildings are visible and nearby traffic is audible, the shrine is a blissful space apart, a serenity countering Tokyo's crowds of silence.

An inner realm is offered at Hie Jinja, an in-space available to all comers, a magnetic no-where, no-sound, no-thing, no-body. The sweeping cosmopolis of densities and intensities barely pertains. Of course, there are sounds, things and bodies, but without their normal credentials. While I write this a helicopter is flying overhead and the shrine carpenter is hammering, but the no-where, no-sound, no-thing, no-body continues, still supplying the shrine with its centralized, elevated order, its established *basho* (locus), handed down from a meditative constituency in which the quintessential idea was to build and not to build, to space and not to space, to sound and not to sound.

It's a tricky silence. However one might want to confine it, say, to a tree, it moves off to a cupreous roof, and as soon as you think you have it, it is likely to leap off onto the graveled court or one of the ramped approaches. Should you try too hard, it is conceivable that the silence will become vehicular noise. So however much the *hare* (sacredness) is disturbed, a reflecting space will always be present, persistent in the face of the chauffeurs polishing cars parked at the rear of the wedding hall, wedding guests' riotous departures, or visitors kick-starting their motorbikes.

The Slow Silence

Architecture is human insofar as it eludes categorization, and so is silence. Specific historical buildings in Tokyo lead to a realization of silence—they tend to resound to the quietness of rock, raked sand, nature. Although the bulk of this old space was de-realized in the wake of the last war, there is enough remaining (and sufficient rebuilt, or else brand new-old) to warrant study. Meiji Jinja, near Tokyo's Olympic gymnasiums in Yoyogi Park, is a comparatively recent case (first constructed in 1921, rebuilt in 1958), a typical Shinto sanctum dedicated to the Meiji Emperor. Northeast

3. Hie Jinja was obliterated during World War II; it was finally rebuilt in 1967. Japanese temples and shrines have histories of destruction and renewal, while Western churches have histories of stable, additive growth.

of the Imperial Palace is Yasukuni Jinja; ultranationalistic connotations and controversy still hold sway there among the shrine's twenty-four million pillars commemorating Japan's war dead.[4]

Northeast Tokyo is packed with sanctuaries. The year 1627 saw the foundation of the Buddhist Kan'ei-ji, in what is now Ueno Park. According to geomantic practice, the *kimon* (literally demon's gate, also refers to the northeastern or unlucky quarter) was the most vulnerable position, and the function of Kan'ei-ji was to defend the entire Tokyo area against the hostile out-world and its evil beings.[5] Others followed in the same strategic zone, and lesser ones sprang up in the south, so that ultimately Edo came to be encompassed by a silent network of spiritualized protective screens. Much in the same way as religious built-constructs, gardens (such as Koraku-en and Rikugi-en) and parks (such as Hibiya and Shinjuku Gyoen) provide ancient machinery for the slow enhancement of silence.

Chinmoku is the Japanese for "silence." *Chinmoku wa kin yūben wa gin* is a common adage meaning: "Speech is silver, silence is golden."[6] *Chinmoku* comprises two Sino-Japanese characters: *chin* is related to water; *chinsai* designates a Chinese rite in which an animal was submerged in water. One half of the *moku* character represents a dog following a person without barking, and the other was first defined as "dark."[7] *Moku* then acquired the meaning of "not saying." The compound *chinmoku* connotes being submerged in silence. Calmness, peace, composure, meditation are obvious states of *chinmoku*, without comprehensively describing it. That is because the preconditions for stimulating a space of silence involve either an insulating or a distancing from the sound source. Both instances, or combinations of the two, give ideal cover for intrigue and crimes of passion, which are vividly depicted in Heian period (794-1185) literature, and are pertinent today.

The novelist Angō Sakaguchi (1906-1955) suggests that even the muffled space under a cherry tree is less than safe. ". . . at times, all could be silent . . . the calm disturbed only by one's own form and one's own footsteps muffled by the cold and unmoving wind. As petals flutter to the ground one sees his own ghost scatter among the trees, his own life slowly wither and decay."[8]

The Artifactual Silence

Architecture is the outcome of countless imponderables, a collective emotional knowledge, a communal designator. A temple is especially so—structure and faith in a sacred object. Such is Chūta Itō's Buddhist Tsukiji Hongan-ji (1931-1935), near Tsukiji Fish Market and Tokyo Bay. Imprisoned within a high tension symbolic field, the temple is a funky arcanum if ever there was one. Asakusa Mido-ji (1658) had occupied the site, but nothing survived the Great Kantō Earthquake of 1923.[9]

If we ignore its visual archaisms, what we find is a structure of comparatively recent resonance. The approach is less than generous, across a bare parking lot, but the object is generosity itself. Its linear composition is marked at either extremity by smallish stupalike towers and a huge emblematic banner festoons the centralized hall of worship. We enter through a flourish of steps, confirmed by a portico blessed with an onion-shaped cutout negative globe. As a whole, it is a transplanted *hare*, bombastic silence if you will, meditation on an enlarged, urban scale, yet still

4. Yasukuni Jinja, originally a monument to the dead of the Meiji Restoration, was built in 1870; it was then called Tokyo Shōkonsha. The present shrine was realized in 1873 and was a national symbol during World War II.
5. F. Maraini, *Tokyo* (Amsterdam: Time/Life, 1977), p. 127. The Ueno area is now a composite of religious, cultural and institutional buildings. Le Corbusier's National Museum of Western Art (1959) is there, so is Kunio Maekawa's Metropolitan Festival Hall (1961).
6. *Nihon kokugo daijiten (A Dictionary of Japanese)* (Tokyo: Shogakkan, 1980), p. 604.
7. Akiyasu Tōdō, ed., *Kanji gogen jiten (An Etymological Dictionary of Sino-Japanese Characters)* (Tokyo: Gakutōsha, 1974), pp. 164, 793. Darkness is an important ingredient in the Japanese architectural aesthetic, and spaces of shadowy twilight highly valued. Isozaki's Aoki house, Tokyo (1977-1979), is an expressly dark homage to Jun'ichirō Tanizaki's *In Praise of Shadows* (New Haven: Leete's Island Books, Inc., 1977).
8. Angō Sakaguchi, "In the Woods Below the Cherry Blossoms in Full Bloom," trans. R. Pulvers, *Mainichi News*, 11/12/84, p. 9. Poet-sculptor Kōtarō Takamura described war thus: "A very deep silence attacked." An army song has one line: "Our canon which made the enemy silent." *Nihon kokugo daijiten, op. cit.*, p. 604. (In Yasunari Kawabata's *Yama no oto [The Sound of the Mountain]* it is the mountain's rumbling that intimated the hero's death.)
9. Formerly the Asakusa Mido-ji had been in Tokohama-chō, but was destroyed by fire in 1657. The Edo Shogunate granted the temple a lot in Tokyo Bay provided it would reclaim the land. The "Tsukiji" component of the current temple name reads "built land."

Chūta Itō
Tsukiji Hongan-ji, 1931-1935.

(opposite)
Meiji Jinja, first built in 1921 and rebuilt in 1958, is dedicated to the Meiji Emperor.

quiet. In going out of his way to avoid importing "alien" (Western) temple types, Itō Asianized the silence, producing an object as alien to Tokyo as a replica of Japan's Shinto heart-space, Ise Jingū, would be to New Delhi.

Shades of Indian and Chinese architectural canons stalk Tsukiji Hongan-ji. But calmly, unhastily, building and rebuilding its vision of silent monumentality, meditation is grandly transposed in an axial symmetry of effects and approaches. A contemplative and reflective stillness is maintained in spite of the building remodeling underway at both ends, in spite of the white commercial buildings around the site about to close in on the glorious about-turns in the name of Buddhism. Moorish windows, Chinese lions, Japanese TV aerials. British colonial governors' residences in India are suggested, and the eighth-century Pattadakal, an early Chālukya coronation site, although Tsukiji Hongan-ji is less surfacescaped than strictly Hindu temples.[10] Some take to this noisy, babbling *chinmoku*, a virtuoso demonstration of faith remodeled for an age when radios, stereos and TVs are turned full on. (The apotheosis of macabre-as-style.)

Ryōan-ji in Kyoto is the epitome of minimalism, a stone and sand miracle of silent contraction. Paradoxically, it attracts so many visitors that the Zen temple broadcasts tape loops explaining for the crowds the nature of "the soul-space-of-silence" Ryōan-ji is purported to be. Tsukiji, on the other hand, appears loud, there is a busy air, things seem to be being made and done artifactually. Consequently it is not sought out by the tourist, and, in effect, Tsukiji Hongan-ji is the quieter of the two.

The interior of Tsukiji Hongan-ji is East Indian Buddhist temple in form, if we ignore the tip-up cinema seating, auto-tea-dispenser and church organ. Inside is quietness, a receptive in-silence, stiller than the out-silence. The in-silence of the spaces of contemplation is withdrawn from the out-silence. The in-silence is darker, more profound, deeper and more austere, even should a monk chant a sutra, for its resonance sounds out the in-silence in the same way the traffic noise makes the out-silence. Here the architect has gone to the edge, coming up with a temple that in some manner is a religious precipice.

10. The nearest equivalent to Tsukiji is a hilltop mausoleum in Himeji, in western Japan, rivaling the castle for dominance of the skyline. The Great Sacred Hall of the new religious group Risho Koseikai, north Tokyo, designed by the sect's founder, has a spire on the dome modeled after a tower in India where Sākyamuni attained Buddhahood. See my "Ideology and Epiphany: The Air Conditioned Sanctuaries of Japan's New Religions," *Architectural Association Quarterly*, vol. 10, no. 4, 1978, p. 54.

The Fast Silence

Not far from the Yaesu exit of Tokyo Station, squeezed beside Shingofukubashi (1984), a multi-rise commercial center in a street of offices and banks immediately opposite the Royal Theater and Mitsukoshi Cultural Center, is a diminutive three-story Sōtō Zen temple, Eimmei Jizō-san. Built in 1977, replacing one realized in 1718, this Buddhist temple is precariously perched over the concrete ramp to an underground parking lot. Roofs, walls, structure are entirely metal. Its aluminum windows are the type used in very cheap houses. Lightweight metal panels are painted in imitation of timber, and the finial on top is painted to pass as gold. A rough steel replica of an Indian temple.

A thin and tinny, contemporary *chinmoku*, yes, but useful in a business district where people like to feel they belong to something other than just their company. Tokyo, rife with rival realities and contending truths, maintains the sacred essentiality alongside its scene-switchings, its multi-form temples alongside its various existences. South of Ochanomizu Station is the Eastern Orthodox cathedral (Nikolaidō), an onion-domed resolution, designed by the Russian Father Nikolai (1891); it's not as marvelous, however, as the ice version of Moscow's St. Basil's, sculpted during Sapporo's annual Snow Festival in 1983. Tange's St. Mary's Catholic Cathedral, Bunkyo-ku (1964), has a buckling and twisting aluminum cross plan, reflecting and puzzling the god-light. Yoshirō Taniguchi's Josen-ji, Shibuya (1965), is a horizontally regular and rationalized solidification of immanence. Susumu Takasuga's Sanctuary and Zen Hall of the Ryuun-in (1978) ventures a massively amplified temple, internally timbered and organized in convulsions of *hare*. Tokyo boasts an unknown destination, nonetheless there are sacred stations along its axis.[11]

Architecture must be a passion through which the architect engages with streets and cities. Now Tokyo-based Monta (Kikō) Mozuna, self-styled "cosmic architect," must make the most consistent attempt at sacralizing the environment. His projects, whether modestly scaled like Neko-dera, or intemperate proposals for new religious movements, are all prefigurations of an architectural afterlife in the world-city.[12]

Zen Eishō-ji, near Shimo Kitazawa Station in a Tokyo suburb, is silence incarnate—peeled domes, pyramids and timber frames under a simple pitched roof—a creeping crypto-functionalism has smothered the primal box of Zen. Mozuna has stated the premise for this building:

> 'Sohmon' (the first gate), 'Sandoh' (the approach), 'Sanmon' (the third gate or gate of the mountain), 'Kairoh' (the corridor), 'Kyo no niwa' (the garden of the void), 'Kidan' (the base), 'Shumidan-Horizon' (the main idol). The latter is the system of scenes such as columns, the pyramids of ying and yang, the inside and outside of the sliced dome, the magic square, the giant 'Shumidan' and the double mirror image of the Buddha statue. . . .[13]

The Silence of the Object

Sweeping past two lion figures (mimesis of those guarding Nelson's Column in London), one is greeted by the sound of an organ being played on the ground floor (not Muzak). A 10.91 meter-high statue of Tennyo Magokoro (Goddess of Sincerity) dominates—Gengen Satō spent ten years carving it from a five-hundred-year-old Japanese cypress selected from woods surrounding Kyoto's Kibune Jinja. The figure represents the cloud-

11. New temples and shrines are not restricted to Tokyo: Kikutake's office building for the Izumo Taisha (Izumo Great Shrine) (1962), concrete reconstitution of the timber tradition; Murano's fabulizing Takarazuka Catholic Church (1967), wherein the architect's last rites were enacted 11/27/84; Mozuna's Takatsuki Church (1970), like a badly parked Romanesque bus; and Shin Takamatsu's Zen Temple in Gifu (1982), a somber, Shinohara-like exterior masking a 3-D carpentered saturnalia.

12. Mozuna's Neko-dera (Cat Temple) is a paper project only, but on the grounds of west Tokyo's Jikei-in is the actual Tama Dog and Cat Cemetery, Japan's largest. See K. Cherry, "Japanese and Animals Have Purr-Growl Relationship," *Mainichi News*, 11/23/84, p. 9.

13. Jonathan Glancey, "Zen temple, Eisho-Ji, Tokyo, Architect: Monta Mozuna," *Architectural Review*, August 1981, p. 122.

swathed Goddess of Sincerity descending lightly to earth, accompanied by a phoenix bearing an offering for her tray of heavenly flowers.

Where are we? Without doubt, the centerpiece is the deafening power of the statue, polychromatic visualization and enrapturing of a swaying verticality, although the radiance of the hymn being played on the organ comes a close second. The six-story void around the figure implying a high-rise temple is like a halo above the Goddess. The statue is spotlit—in a real temple it would be hidden in a dark spot. In its entirety the complex is varying states of highlight, from the underbalcony lighting to the artificially illumined stained-glass ceiling.

Where are we? In this instance the silent space of reflection is agitated by economic disturbances, sales campaigns, broadcast messages, bartering. It is a quiet that might just make it—at least the Muzak is on hold, and customers speak only in hushed tones. The scene combines like a jigsaw puzzle with a piece missing. Despite the frustration we can still get a picture of the silent object. An ethereal, suspended mood, somber as important negotiations have to be, differentiates the scene from the violent detonations of mah-jongg parlors or street demonstrations.

Where are we? There is a theater, too, bonsai corner, portrait studio, maternity shop, art galleries, tearooms, boutiques, restaurants. The roof is Shangri-La: outdoor stage and seating, artificial cliff, fast-food outlets, pet shops, and a modest Shinto shrine, timber and ceramic-tiled, complete with *shimenawa* (sacred rope). When visited at the end of October 1984, it was sheathed in the same protective metal panels enveloping the neighboring rooftop plot, where construction work was in progress. Box plants had been set around the metal sheets to alleviate the visual shock. The silent potency of the rooftop shrine had been encaged, its meditation throttled. No go zone. Noise.

Where are we? At least the sky, its openness, its insistence on being there and divulging something faintly numinous and silent absorbs the metropolitan white noise. High-rise and other buildings in Tokyo utilize their roofs to the fullest—gardens, tennis courts, playgrounds, mini-golf courses, bars; and because of their relatively mountainous elevation, they provide the sky, clouds, birds, aurora, rainbows, a kind of silent hemisphere over the city. Sitting on the *tatami* floor, the Japanese horizon and point of view is low compared to that of the chair-sitting Occidental. Guests invited to a tea ceremony are proscribed from standing up; if they want to move they must crawl. So the silence of the tea ceremony is at earth level, and that of the city on the roof—the sky.[14]

The Silence Transfigured

The legendary virginity of Japan's *hare* is now uncertain (if not lost altogether). Its "god-stuff" has been stormed and possibly breached for good. Tokyo's culture of anarchy, where Shinto, Buddhist, Daoist, Confucian, Zen, Christian, and more unorthodoxies stew in a great cauldron, where little traditions and big traditions meet in visualized violations, where ritual and future worship and cavort together in a death-defying urban *ontos*, where rulelessness rules—anything can happen within its supernature of mystico-symbolism, arcane referents and quasi-religious gestures, ordered, perhaps, according to the odd lumps and conglomerates of Japanese gardens. The transfiguration of silence.

14. Where are we? The main Mitsukoshi Department Store, Nihonbashi, the Japanese Harrods or Macy's. Shrines devoted to the deity of commerce are often placed on top of large stores and office buildings. (In Hong Kong and Bangkok, small shrines are even atop apartment blocks and single houses.) In space-starved Tokyo, the flat roof is a useful resource, provided with facilities easily reached by the public.

A 10.91-meter-high statue of
Tennyo Magokoro (Goddess of Sincerity)
greets shoppers in Tokyo's Mitsukoshi
Department Store.

Some while back I photographed a Japanese "salaryman" at the Shinto shrine of Ise Jingū—his obligatory carrier bag was emblazoned with a conspicuous photo of Macao's ruined seventeenth-century cathedral. Once regular shops and businesses along Tokyo's main streets close for the night, palmist-astrologers set up booths in front of the dormant commercial premises. Shinjuku Station features a raucous representation of Tengu, a folk deity whose distended nose has distinctly phallic ramifications.[15] Torii, symbolic entry ways to Shinto shrines, are now made of concrete. Facing Shibuya Station is a fifties-style aluminum arabesque super-torii designating the entrance to a shopping street. Architext (a group including Takefumi Aida, Takamitsu Azuma and Minoru Takeyama) even proposed a Metabolist parody with their gigantesque torii-as-housing project. Certain hare are being updated even faster. Department stores offer computer palmistry. Taped sutras are selling well. Intended for domestic Buddhist rites, the producers were surprised to learn youths listened to them in their cars. In a city whose time is as scarce as its space, some shrines have automated and miniaturized proceedings. On inserting a coin into a glass box, a Shinto priest doll rotates, blessing the visitor, and ejects a paper fortune slip. Toy versions of kamidana (small shrines set up within the house) are available. The shrine doors open at the clap of a hand and one of the seven deities of good luck emerges. Nam June Paik's "TV Buddha," exhibited in Tokyo's Metropolitan Museum of Art in 1984, must be the perfect comment on the technologizing of hare. He has a Buddha meditating on its own image as it appears on a TV monitor. One sacralizer contemplating another.[16]

On top of changes in its nature, there is a coincident metamorphosis in its abode. The status of temples at present is more that of cultural venues, repositories of ancient life forms; they may be utilized for theatrical events such as those of Jūrō Kara, staged at a Shinjuku shrine. Tokyo's silence is currently encountered elsewhere, in museums, galleries, banks, restaurants, kissaten (coffee houses). Individual houses—reinforced refuges like those by Hiromi Fujii, Tadao Ando, Kazuo Shinohara, Toyo Ito, or Hiroshi Hara's internal cities, are a further locale. Hotels—their stolen gardens, secret spaces and air of eventlessness are another. Tange's new Akasaka Prince Hotel (1983) has a white, silent lobby, internationalized around the glorious anonymity of sculpted white marble walls, white seats, stairs, piano. Marbletown Square, the tea lounge, is fitted out with white tables and ashtrays. (Even the shadows are white.) The sole colors are those of the guests. A stainless, unmuddied beauty is there for the taking. The gentlest of Muzak does not distract, like the soothing sound of a fountain in an Indian garden.

The Liminal Silence

Sensō-ji (popularly known as Asakusa Kannon Temple), in what was Edo's Shitamachi (Low City), the equivalent of London's East End, is a temple besieged. It was founded in 1360, when three fishermen brought up a Kannon (the Bodhisattva of Mercy) from the Sumida River, and determined to build a temple. Demolished in World War II, the present complex arose in 1958. An onrush of "busitors" is accompanied by the hammering of a toy drum by a toy monkey in a toy shop next to the police station, next

15. Sensō-ji, Tokyo, holds an annual flower fair; during one visit a mini-floral temple was included. By the sides of streets and alleys are miniature shrines. They are so small that they resemble models, but in fact function as dwellings for yashikigami, protective deities who preside over the locality.
16. The shock horror mutations of sacred images are an endless list: "stained-glass" transfers on pachinko parlor doors; fronting a Tokyo cinema is a replica of Elvis Presley's tomb; large, illuminated ads for graveyards in underground shopping cities; in Kyoto a temple is planning to install a nuclear shelter!

to the paper-lantern-englamored Kaminarimon. Asakusa Nakamise Street, lined with busy stores, is the temple's main approach. A festiveness gushes out from the gate, transforming the surroundings, giving templelike roofs to shops and restaurants, and a templelike entrance to the Ginza underground line.

Two guardian demons, stationed at the gate, endeavor to protect the inner sanctum from the out-world. The first impression is of figures from a silent Buddhist movie shot in Tokyo Disneyland. But they are made of sterner stuff. They indicate the temple's presence to the street, their lethal bodies almost twisting, almost buckling in fiercesome poses of destabilization, which is their archetypal form given that their function is defensive. Since that function demands that they remain at the threshold dividing the temple's inspirational geometry from the cellular commercial grid of Shitamachi, constrained in space-time, improbably the guardians have acquired a jewel-like stillness, suggestive of the ultimate Tokyo silence, the totality of noise and rubbish blown away. What about the giant paper lantern in the gate, struggling to carry the mighty ideogram of the temple; isn't it too fragile to withstand such a blast? However, there it is, proof of its persistence in the eyes of any threat.

The temple, covering a considerable portion of Asakusa in an embrace of a pagoda, a main hall, lesser halls, pools, gardens, is served by a meshed crisscrossing. The tissue is narrow streets and tight alleys, cheap shops crammed with cheap shoes, kimono, souvenirs, pickles. As the Nakamise Street is an acknowledged fact of the temple, we can deduce that its in-dwelling sacrality is fast losing ground to the objects industry is piling up around it.

Drunks cavort within the precincts, dossers camp there, fights break out. The cyclist's noise, while meeting the silence of an absence halfway, then reengages with the voiced. Shoppers taking shortcuts, giggling and gossiping, obtain a quasi-tranquility, nevertheless recoiling into sound. The space of gangster types hatching plans drifts into non-space, but after a spell reaffirms the rule of the sounded. Still, one must not be too hasty in judging—after all, there are those demons, their muscular, sinewy presence a real compositional chance for the utterly silent architecture of contemplation.

Almost Silence

The way Tokyo is lived now; an unholy alliance. The monumentally miniature. Recondite urban schemes that narrate opaque and elliptical reality games. Quantum leaps. Ordinary people in extraordinary situations. Silence, we have observed, is virtually an excremental affair, worthy of analysis by scatologists and architectural historians alike. The traditional abode of silence has been undone pretty much too—mimicked and borrowed in unprecedented settings, its revised *habitus* ought to be recognized.

Take the Shinto shrinelike public toilet near the Olympic gymnasiums, or the shrine roof dangling from the interior of the shed roof of the Sumo Stadium of Kuramae Kokugikan.[17] Hearses have Buddhist temple roofs and Cadillac-style bodies. Public baths, garages, houses, love hotels can assume temple guise. The entrance to the YMCA Hotel, Kanda (1929), is a mini-pagoda. (Its Christian chapel is in subdued Gothic style.)

The approach to Asakusa Kannon Temple (Sensō-ji); the temple was begun in 1360 and reconstructed in 1958.

17. Takefumi Aida's Toy Block House in Hōfu, Yamaguchi Prefecture, is a stylized version of Ise Jingū. Teahouselike forms proliferate. They occur under the Renaissance domed 1½ House by Toyokazu Watanabe, Osaka; in Yasuo Yoshida's Photo Studio, Osaka; and inside Kikō Mozuna's projected Metabolesque hotel in Hokkaido. The generational form of the total hotel was a *mikoshi*, a mobile shrine carried in festive processions. Isozaki's *Ma* exhibition featured a teahouse entrance, and he designed a teahouse folly for an exhibition at the Leo Castelli Gallery, New York, 1983.
18. In Nagoya City there is a *hanko* (personal stamp) shop, which has a perfect pagoda for the street elevation's right half, the other half perfectly ordinary.
19. Demolished in 1964, the lobby of Frank Lloyd Wright's Imperial Hotel has been resurrected at Meiji Mura, an open-air architectural museum north of Nagoya.
20. Rarely is institutional Gothic employed for actual churches—such is the Tokyo architect's disdain for stylistic actuality as reckoned in the West. Ochanomizu Church is exceptional. Rusticated base, tiled four-story symmetrical order, it is more Islamic than Gothic perhaps, or more Plateresque, like Santiago de Compostella, or maybe Mexican? At least it is more successful in its admix of Gothicisms than the average Turkish bath.
21. Lately Tokyo Tower's future was found to be wanting and the cluster of towers in Shinjuku has claimed the public eye. See Inuhiko Yomota, "Eizōka sareta Tōkyō: Tōkyō to nano tsukerareta eiga" ("Tokyo Filmic Visualization: Films with Tokyo in the Title"), *Book Review*, Summer 1982, pp. 68-71.
22. The roof of Shakaden is related to the *gasshō-zukuri* style of farmhouse, with a timber structure and a massive, steeply-sloped straw roof, which resembles hands clasped in prayer, hence, the name, literally glossing "praying hands."

Sendagaya has a concrete pagoda operating as a crematorium.[18] Mamoru Yamada's octagonal Nippon Budōkan (1964), a martial arts gymnasium near the Imperial Palace, is derived from the seventh-century Yumedono, Hōryū-ji. Ginza's Kabuki-za (1889) is drawn from the agitated style on display in some sections of the seventeenth-century Nikkō Mausoleum (Nikkō Tōshō-gū), and Takenaka Kōmuten's National Theater (1964) is in turn a transcription of the more severe form of the Treasury of Nikkō.

The "prime objects" referred to need not be indigenous. Frank Lloyd Wright's Imperial Hotel was a reproduction of the Tibetan holy city of Lhasa.[19] Tōgo Murano's New Takanawa Prince Hotel (1982) has an Islamic banquet hall. Greek temple forms resound to the function of supermarket, station, jewelers, anything save an actual temple. Churchlike neo-Gothic institutional buildings reverberate, like those specimens at Tokyo and Waseda Universities, as well as ward offices, hospitals, public libraries.[20] Adjoining Meiji University, the Hilltop Hotel, Surugadai, Kanda, is an example of this genre in a stripped down, unburdened version, recently remodeled. Erected in 1937, it was called Satō Seikatsukan, an idealized version of the future, which its owner, Satō, wished to bestow on Tokyo. It was not until 1954 that its use changed to a hotel. Even now it barely dares to state its function—one reads it as a silent church, as though that had been its role in some former life. Symmetry is at work here and rules over the generality of institutionalized sanctuaries. The Kanda district, formerly an agglomeration of Buddhist temples, has now been invaded, appropriately enough, by neo-Gothicisms. The building of the Shufunotomo publishing company is a case in point, although the Plateresque wins out over the Gothic at the end of the day.

The Silence of Steel

Given that sumptuary laws restricted the urban fabric to a one to two-story horizontality until 1868, Edo's readily identifiable landmarks were its temples and shrines. Now they are hard to find, blurred by Shinjuku's towering megaliths, by TV broadcasting stations, pylons, column buildings. Neither quite in Roppongi nor quite in Hamamatsu-chō, of all the steel and glass totem poles by Shiba Park, three are noted competitors for vertical supremacy—Tokyo Tower, NOA Building, Shakaden. Tokyo Tower, a strident meta-echo of the Eiffel Tower, invoking the "superstition of technology," has defiantly made itself the popular symbol of Tokyo's sacred future. An engineered externality of the voiced.[21] Seiichi Shirai's NOA Building (1973-1975) is a refined, slender ovoid techno-tower (deliberately non-reflective, non-graphic), standing on top of a crumbling brick archaism. It recalls the new vertical Tokyo, reborn phoenixlike out of the old horizontality. The building does not emit a single sound—threatened by Tokyo Tower's Muscle Beach macho, it withdraws into a dark meditation, absorbing the sound of the locality, exchanging it for silence. No Muzak inside. Black lifts. Visual silence, if anything. A baffling rite-of-entry, an in-realm and an in-stillness eyeball to eyeball.

The latest to claim its vertical rights, and by far the oddest, is Shakaden. From certain angles its distorted pyramid roof (representing two hands in prayer) and a double-ring motif (emblem of harmony) humbles even the soaring Tokyo Tower.[22] Consuming more than twice as much steel as the Tower, Shakaden (1973-1975) is the main sanctuary of Reiyukai, a new

Buddhist sect. Its major hall has a statue of Sākyamuni Buddha; the other spaces are the Kotani Hall and the Inner-Trip Hall.

To Shakaden's rear is Hachiman-gū, a traditional Shinto shrine reached via a rising concrete *torii*-framed approach. Its timber main building and subsidiary shrines are surrounded by a nicely earthed baffle of trees, all hard up against the back of Shakaden. The two religious constructs attempt stillness from antithetical world views—Hachiman-gū giving us a subtle, naturalizing space, like a sanatorium-as-garden, Shakaden evoking a Buddhist laboratory.[23]

Hachiman-gū, according to the gardener, has one thousand years of history—Shakaden a decade. Old thoughts and new thoughts. Old silence. New silence. Shakaden does incline towards an abstract representation of a traditional Buddhist temple, particularly the front elevation, and so both share a communal religio-architectural stock, yet they are one thousand years out of sync. Neither the silence of the rocks nor that of the trees is broken by the gardener at work, the announcements relayed from the nearby station, the view of Tokyo Tower and NOA Building. Stillness, calm, a fresh tranquility in the very shadow of Shakaden's superspaced-superreal-superfreakism.

Shakaden itself is divided in two—an administrative wing in regular office mode and the dark red aluminum-clad main sanctuary. The sanctuary, looking like the casualty of an aborted renaissance of some former temple, shouts and exclaims loudly, a staggering and cantilevered *hare* that must astonish villagers up for the day. Less simplistic than other buildings for new religions in Tokyo—for example, Seicho no ie's circular sanctuary conceived by the sect's founder. Shakaden is a supermarket of stolen Buddhist elements, maybe, an over-pregnant symbol, granted, a competitive consciousness, agreed, narcissistic, since it wants to put its beholder into the best light possible. My interpretation is that deep down in the soul engineering of the "vision company" there is something present, a manufactured-yet-supportive rapture of religiosity, meditation and so-lace slowed down to a very old time. No, it doesn't possess NOA's silent calculus, and it would have yielded better results in the hands of a Hiroshi Hara, say, or a Kikō Mozuna, but when we realize it was by Takenaka Kōmuten, Japan's largest design group, then what quiet reasoning there is, is to be applauded. (Where Takenaka fails is in the resemblance of its building to those of architects who erect chapels to the empiricist cult of data.)

Architects on Silence

Ando's and Shinohara's work is silent. In my Reflective Houses I have set up an architecture of absorption, bastions against sound, related to an inner reflective space of echoes. Reflection of light as well as sound.
Hiroshi Hara

The Nō mask is silence.
Hiromi Fujii

Silence is negative will.
Toyo Ito

23. It is sheer coincidence that Shakaden and Hachiman-gū should sit side by side. Historically there is no connection. Nor is there between Shakaden and the lower, ruined pilgrimage shrine at the front.

A stone Buddha, located on a windowsill, offers a place of worship to the passerby.

(opposite)
Seiichi Shirai
NOA Building, Tokyo, 1973-1975.

Architecture of silence must be pure. Within pure forms there must be multiplicity of meaning Architecture of silence is especially conspicuous within noisy cities The range of the architect is limited—it is as if he were in the hand of the Buddha from which he can see only the smallest part of what is clear to the Buddha's eye. Therefore I can only answer questions with silence.
Takefumi Aida

Silence in Japanese space is quintessential. Its depth varies from individual to individual. You cannot see the depth of silence. In the West you can actually see space, but in Japan, architectural space has tried to create a non-visual depth of silence. Imagine the two-*tatami*-mat teahouse in Kyoto's Nijo having its light blocked for a second by a passing cloud—that is what I mean by depth. And as the mind changes so the architecture changes. When you look at Japanese architecture it expands and shrinks. Rather than considering silent architecture, is not depth a better subject? Modern architecture has cut away the depth of silence, and my own space tentatively expresses a rich and silent content. In that sense it is postmodern.[24]
Tadao Ando

24. Hara, Ito, Fujii, Aida are Tokyo-based; Ando is Osaka. Quotes are from discussions with the author, except Aida's. See his "Silence," *The Japan Architect,* October/November 1977, p. 52.
 Architecture has no presence, music has no presence. I mean . . . the spirit of architecture . . . and music. What does exist in a work of architecture or a work of music which the artist offers to his art in the sanctuary of all expression, which I like to call the Treasure of Shadows, laying in the ambience, light to silence, silence to light.
 Louis Kahn, in "Silence and Light," *A + U,* January 1973, p. 24.

So where is Tokyo's silence? Is *samadhi*, the ultimate intent of yoga, to be found there? I think it is for those who dare claim it. Let Tokyo be a globe, divided into segments: noisy city, dense city, machine city, messy city, post-industrial city, everything city, turmoil city, compulsive city. Then the globe's in-world is the silent city, timber city, immortal city, mandala city, meditative city, essential city, transcendental city, absolute city, soul city, reflective city.

Artist Unknown
Chiko Mandala, Edo period,
seventeenth century
color on silk
29½ x 22¾, 74.9 x 57.7
Collection Dr. and Mrs. Robert Dickes

(opposite)
The forty-nine-foot-high bronze Amida
Buddha in Kamakura was erected in 1252.

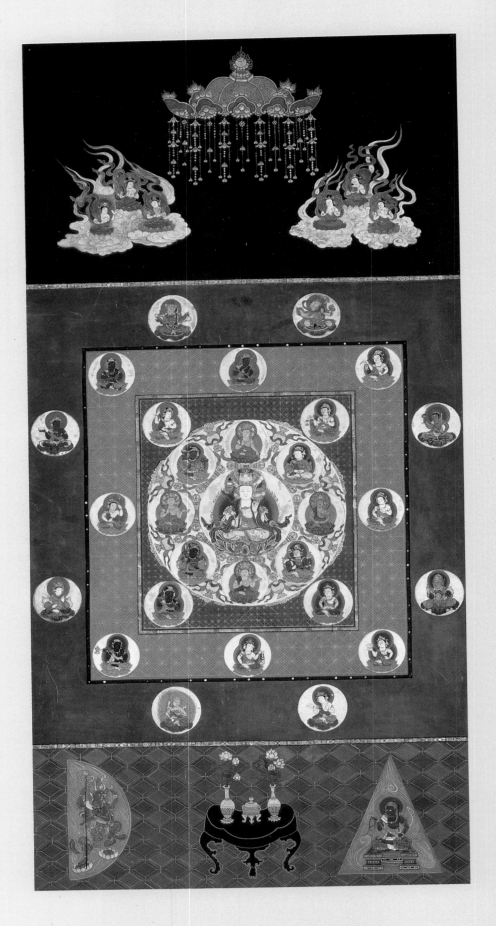

Buddhist Art in Japan

The Japanese are a pragmatic, sensitive and intensely emotional people. Throughout their history they have responded to the force of natural phenomena with awe and respect, and to imported religious philosophies, most notably Buddhism, with a fervent zeal. After the introduction of Buddhism from Korea to Japan in the sixth century, supporters of the religion overcame an initial struggle with those dedicated to preserving the primacy of the native religion, Shinto. Buddhism flourished, developing over time strong traditions in a number of different Buddhist theologies—exoteric and esoteric, the Pure Land faith of easy salvation, and the meditative sect, Zen. There was even a formal alliance between Buddhism and Shinto that led the Japanese to develop an amalgamation of the two systems in the ninth century. This dual character was to become integral to Japanese life throughout the Edo period. Homes had both Buddhist and Shinto altars; temples had shrines on their premises, and the *shimenawa* (twisted rope), borrowed from shrines, was hung on the New Year. The Japanese tendency was to take whatever appealed to them from each system without too much concern for inconsistency.

During the Edo period Japanese temples functioned much as they had in the seventh century. They were impressive complexes that served as centers of community activity. Samuel Morse described the scene at Sensō-ji in Edo in the late nineteenth century as the site of festival vendors and special events. Religious concerns for the ordinary citizen ranged from funerals and memorial rites to weddings, exorcisms, consultations for the sick and advice for those with special hopes and wishes. The temples were frequently spacious, and afforded a parklike atmosphere for strolling and relaxing.

Beneath their apparent conviviality, the Japanese maintained a deep-seated sense of life as insecure and transitory. They were intensely aware of change and of crisis.

The Buddha was everywhere a clear symbolic image, recognizable throughout Asia by the characteristics of its form established in the second or third centuries in India. The Buddha was created to manifest the idea of a "great man," and as such is said to have thirty-two identifiable marks that were not all visible. The Buddha either sat or stood. The head, which may be covered with tight curls of hair, featured a cranial protuberance on the top called an *ushnisha*. This bump, which was derived from a hairstyle with a topknot, has come to be regarded as a physical sign of the Buddha's supra-human intelligence and supernatural powers. Through misinterpretation, its form became an essential identifying mark of divinity. The Buddha wore a simple monks' robe but was devoid of the earrings and necklaces that may adorn lesser Buddhist divinities. The hands, which were held in pronounced gestures, or mystical signs called *mudra,* may have helped identify a specific Buddha. However, *mudra* were not derived from iconic law, but evolved through generations of use.

The first Buddha, Sākyamuni, was the deified form of a man who lived and died in India in the sixth century B.C. As the faith grew, spread and developed, Buddhism acquired a multitude of images, including variations on the theme of the "great man" himself. Buddhas of the past numbered not just one, or seven, but into the thousands. Buddhas became identified with the four quadrants of the heavens (such as Amida, Lord of the Western Paradise), with healing (Yakushi), and finally, with the idea of a totally supreme being so powerful, so ineffably strong, right and just, as to constitute a Buddha who towered over the rest (Roshanna).

The Buddha was installed with accoutrements that honored him. A gong was used to beseech his attention and it was struck as chants were recited in his presence. A *vajra* (thunderbolt) was symbolic of the immense powers of an esoteric divinity. The lotus was one of the earliest representations of the faith. Lotuses, which grew in muddy ponds, rose out of the water on long, thin stems and produced large, beautiful blossoms of the purest white and palest pink. To the Buddhist mind the pond was likened to the dirty mundane world out of which is born the soul blessed with the purity of salvation. As single blossoms in vases, as the decoration of a map stand, on the hanging decorations about the altar, the lotus reinforced the message of hope in this life for the next life beyond.

Visual images of the worlds of the Buddha aided the faithful in devotion. A mandala, a schematic diagram of the universe, laid out the correct relationship of divinities one to another. It was a creation of esoteric Buddhists who focused on the complex interrelationships of forces and phenomena. The strict esoteric mandala consists of groups of figures arranged in circles around a central image, or on a grid. The classic prototypes are the so-called "Mandala of the Two Worlds," or "the Womb World" and "the Diamond World." These two forms, introduced to Japan in the ninth century, were the source of a number of variations that continued to be painted throughout the Edo period.

The term mandala was also used generally to describe diagrammatic paintings of other Buddhist and, even, Shinto sects. The Pure Land Buddhists, for example, who are promised rebirth in a heavenly Western paradise through faith and good works, revere the *Chiko Mandala,* which correctly depicted paradise as described in the scriptures. It showed Amida Buddha flanked by his Bodhisattva attendants in a setting of an elegant palace courtyard where trees sparkled with jewel-like blossoms, and music and dancing abounded. The painting presented an image for the individual to meditate upon in order to ensure his rebirth.

Emily Sano

Ema, wooden prayer tablets.

(below)
Inner sanctuary, Nishina Shinmei-gū,
Nagano Prefecture.

(opposite)
View of entranceway, Nishina Shinmei-gū.

The Forms of Shinto

In one of the oldest written documents recording the legends and myths of Japanese history, the *Nihonshoki* (compiled circa 720), it is said of the Japanese archipelago: "In that Land there were numerous deities (or spirits) that shone with a luster like that of fireflies, and evil deities that buzzed like flies. There were also trees and herbs that could speak." This passage reflects the spirit of Shinto, which centered around the presence of *kami* and their life-giving powers. Intrinsic to Shinto ideology is the belief that all sentient beings are the common offspring of *kami,* and therefore are endowed with their spiritual force and presence. Shinto, considered uniquely Japanese, is not so much a religion as a complex of beliefs and observances that has remained relatively unaltered through time. With the observance of proper rites and celebrations, a spiritual harmony is maintained that assures the human community of a secure existence. The individual, as a result, becomes but one link in an infinitely larger chain of life.

Shinto, "The Way of the Gods," was so named in contradistinction to the imported religion of Buddhism after the latter's introduction in the sixth century A.D. Shinto, however, predated Buddhism's introduction to Japan; its roots can be traced to the early Japanese agricultural population. They were in awe and fear of the mysteries of nature—these were explained by the existence of *kami. Kami* also served to explain the creation of the world: ". . . in the beginning men and animals were gods, and plants and rocks had speech." *Kami* existed in the service of the community too, and each clan associated itself with a particular deity *(ujigami).* Gradually, with the organization and institutionalization of Shinto over the course of several centuries, national unity came to be symbolized by the worship of the supreme *kami,* Amaterasu Ōmikami, the Sun Goddess and agricultural protector. The rulers legitimized their ascendancy to the throne by proclaiming their relationship to her. Therefore, Shinto existed on a community level and it became a national religion, glorifying the unity of the nation under the rule of an emperor who claimed divine right. Politics and religion were synonymous in a theocracy that persisted until the end of World War II.

In the early stages of Shinto worship, prayers and the expression of gratitude on the part of the living were addressed directly to nature and none of the symbolic repositories of the spirit, such as shrines, that are associated with Shinto today, were needed. *Kami* were believed to live in remote places and only visited human society on select occasions. Prior to important festivals or rites, a *himorogi* (a symbolic square demarcated with straw ropes hung between four posts) or the more permanent *iwasaka* (a sacred area marked off by a boulder) was erected for the *kami* to inhabit. The desire to capture and contain the numinous power of the deity was a primary impetus to the beginnings of shrine construction. Temporary structures gave way to permanent ones that were built in the shape of a house. Thus, a shrine was, in effect, the house of the *kami.*

The Shinto ideals of simplicity, purity and harmony with nature extend to shrine architecture. The Shinto shrine characteristically has little or no decoration.[1] The grand shrines of Ise and Izumo are exemplary in their austerity, and majestic simplicity—unpainted wood pillars and thatched roofs—creating an atmosphere of *kami-sabi* (divine serenity).

The building of Shinto shrines began at a relatively late date (sixth century). The evolution of permanent sanctuary architecture was influenced by the Buddhist temple complexes, for Shinto was, in a way, competing for Japanese allegiance. A sanctuary included the shrine buildings—generally the main hall (*honden*); the oratory (*haiden*); as well as subsidiary halls and the portals (*torii*). Initially made of unpainted tree trunks, *torii* were subsequently painted red-orange; they have since been made in a variety of forms and colors.

Other familiar Shinto elements are the *shimenawa, gohei (nusa)* and *ema*. The *shimenawa*, is hung on rocks, trees, *torii*, shrine structures, and in private residences in order to expel evil spirits and to protect against religious impurity. Straw strips are hung at intervals along the *shimenawa*, and between these, *yū-shide*, divine offerings made of white paper, are attached.

The *gohei* consists of a small pole of wood or bamboo in which is inserted a pure white piece of paper or cloth, cut so that the two parts hang down on either side of the pole. The *gohei* indicates the presence of the *kami* in the sanctuary. More colorful are the wooden prayer tablets *(ema)* that are hung on trees or found on small buildings especially erected for them at the shrine. The presentation of *ema* is an informal way of asking the favor of the *kami* and generally corresponds to the important stages of life. For example, the shrine of Yushima Tenjin in Tokyo, where the *kami* of learning is enshrined, receives many *ema* during February each year, beseeching the favor of the *kami* for success in examinations. Originally decorated with only horses, *ema* are now illustrated with a variety of anthropomorphic or zoomorphic motifs.

Amy Reigle Newland

1. Although, under Chinese influence, ornate shrines such as the Nikkō Tōshō-gū were built.

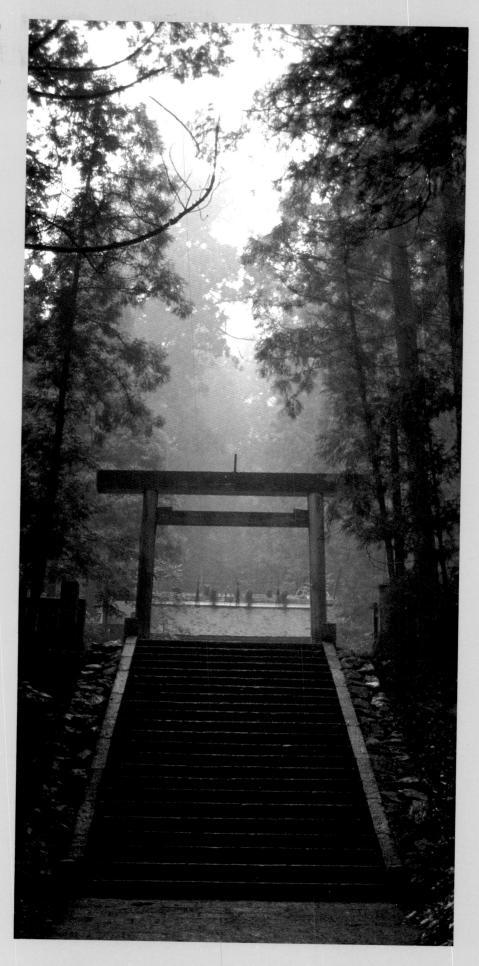

196

Kohei Sugiura
Conceptual sketch for the Reflecting space,
Tokyo: Form and Spirit, 1985
Collection the designer

(right)
Toyo Ito and Kohei Sugiura
Axonometric drawing of the plan
for the Reflecting space, *Tokyo:
Form and Spirit,* 1985
ink on mylar with film overlay
13 x 16¼, 33 x 41.27
Collection the designers

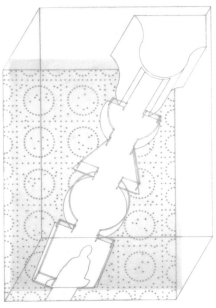

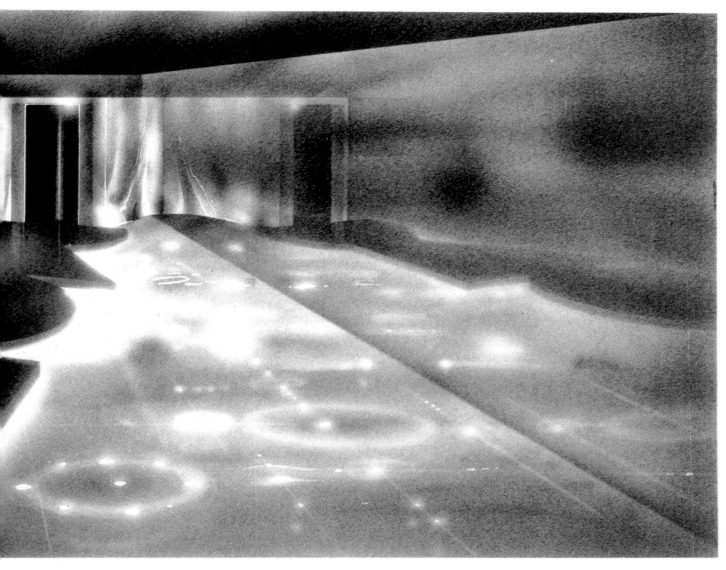

Toyo Ito and Kohei Sugiura: Reflecting

In Buddhism, the relationships of the divinities to each other and to the world are made visible in mandalas. These complex images are schematic diagrams of the universe, which in ancient times were seen as a means toward a deeper understanding of the Buddhist religion.

Although many contemporary Japanese have lost some of the original concepts of Buddhist belief and worship, many still accept Buddhism as essential to their everyday lives.

The Buddhist "universe" can be seen from the summit of the sacred mountain at the entrance to the Reflecting space. Walking through the entryway—a void in the shape of a seated Buddha—the visitor steps onto a series of panels that form a bridge over a sea of flickering lights. These geometric panels represent the four natural elements as a square of earth, a circle of water, a triangle of wind and a half-circle of ether. While crossing the bridge, one hears the synthesized music of the composer Sōmei Satō coming from an enclosure at the far side of the room. Images projected from an 8 mm camera pour down, like a waterfall, over this oval form through which one passes to the universe beyond.

T.I. and K.S.

Design
Toyo Ito
Kohei Sugiura
Keijiro Sato

Music
Sōmei Satō

Textile
Junichi Arai

Design Associates
Masakazu Akazaki
Kazumichi Iimura
Tatsuro Kuwahara
Reiko Sudo
Satoru Suzuki
Fujio Watanabe
Hiroishi Yamazaki
Masahiro Kobayashi
Kazuo Omata
Takashi Iwakura
Michiaki Shiranezawa

Production
Tanseisha Co., Ltd.
T.L. Yamagiwa Laboratory, Inc.
Mitsubishi Chemical Industries Ltd.
Kyokko Electric Co., Ltd.

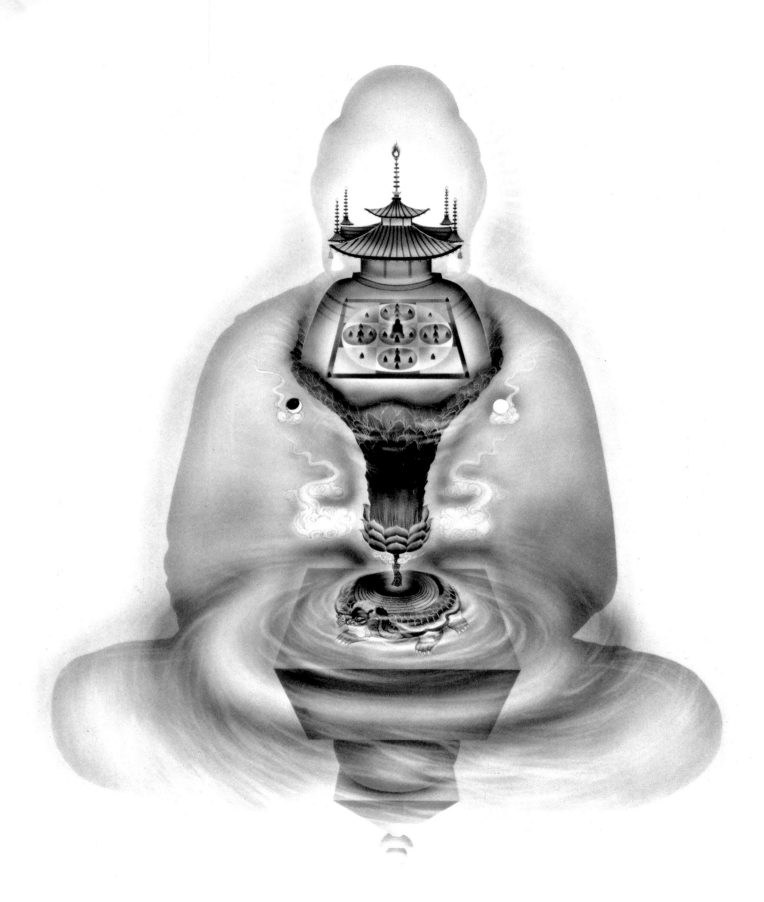

The Reflecting space under construction,
Tokyo, 1985

(opposite)
Kohei Sugiura
Study for seated Buddha, 1985
Collection the designer

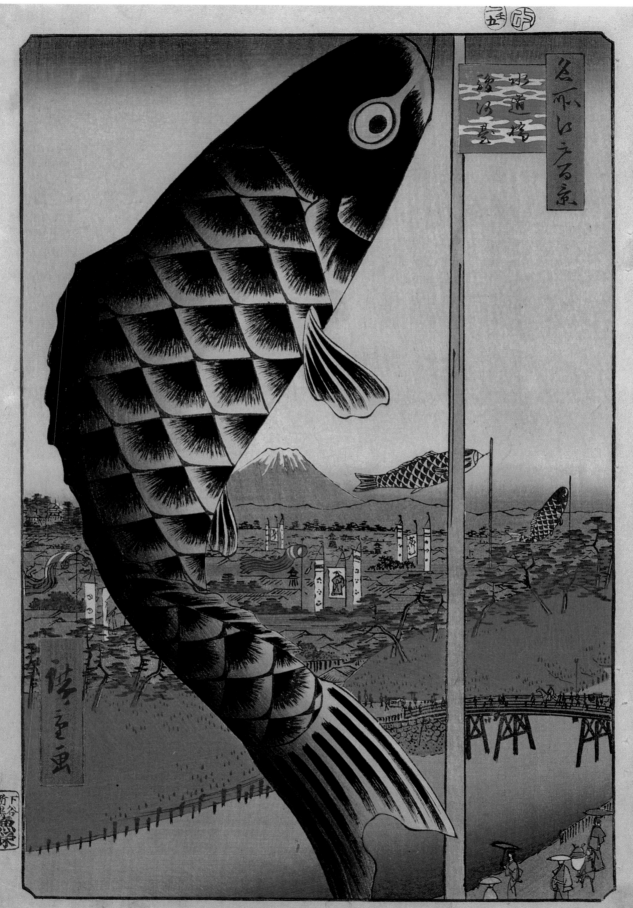

suburban home's backyard. Its purpose is simply as space that can be run around on—a luxury for a Tokyo city child.

Fish, pets and bonsai also dwell in this children's heaven. Puppies, rabbits, chipmunks and parakeets are all for sale, although most children seem to think of this area more as a miniature zoo than a pet store. The fish display is by far the largest, with a selection that ranges from fifty-cent goldfish in bowls to fifty-dollar carp for the garden pond. It is here that one can observe the quintessential Japanese children's *asobi: kingyō-sukui* (scooping goldfish). For one hundred yen, a child gets a small aluminum bowl and a circular wire scooper with paper stretched flat across the diameter. The point is to dip out as many fish as possible before the paper dissolves. Catch five, and one is yours to keep. Mothers rarely worry about finding a place to put the prize goldfish, for it is very difficult to catch more than a couple before the scooper splits down the middle.

Platforms of miniature trees—fruiting and flowering—tiny stands of bamboo and groves of six-inch-tall pine and maple are displayed in the bonsai section. They contribute to the sense of having wandered into a land where everything is child scale. The kids themselves hardly notice the trees; they are too enthralled with the sound and movement of the games and rides. In any case, the cultivation of bonsai is grandpa's *asobi*.

Play Comes of Age

"Work hard, play hard" is the motto of the self-confident young American, Ivy League graduate. For his Japanese counterpart it may well be, "work hard, play later." This is certainly true for the teenage high school student, who is obliged to defer many a gratification until passing the college entrance exams. University acceptance, however, is the gold card to four years of *asobi* for many. Some critics view college as primarily an extended period of rest and relaxation for the individual burned out from intense academic competition in high school. The college years may well be a person's last chance to dally and play for a very long time.

The attainment of maturity is officially celebrated on 15 January of the year in which one turns twenty. Practically, however, adulthood begins when one takes his first job upon graduation. Marriage, especially for women, underscores it. By the time Japanese reach their mid-thirties, the years of responsibility are upon them in earnest, and play is pursued in forms different from that appropriate for children.

Japanese businessmen find it necessary to cultivate certain kinds of *asobi*—golf, drinking, a familiarity with geisha—as part of their executive image. Indeed, many of them complain that playing is one of the hardest parts of their work. The ability to pursue one's individual interests at a leisurely pace may well have to wait until retirement. Women experience an even sharper falling off of opportunities for play during the years they are raising children.

Yet no matter how heavy the responsibilities of adulthood may weigh, certain diversions will never be displaced. Sex, festivals and the occasional pilgrimage or journey were probably the primary categories of enjoyment for the common man and woman in both town and country in prewar Japan. Sex may be the most mundane form of play for adults, but it is also the most engaging. Certainly it colored the enjoyment of festival and travel as well.

Adult Play

Just as the innocuous term "adult" becomes a euphemism for sex when coupled with "bookstore," so does the innocence of *asobi* evaporate as soon as it is no longer applied to children. Not that there aren't many things that men and women can do together to have fun, but sex is undoubtedly the *asobi* par excellence for grown-ups.

The Dictionary of Asobi, a fairly thick book available at any large Tokyo bookstore, turns out to be none other than a detailed guide to massage parlors and other de facto sex establishments throughout the country. This facet of *asobi* reflects the meaning of play as in playboy, a concept that has its historical counterpart, with gender reversed, in the Japanese term *asobime* (playgirl, in effect, a prostitute).

As long ago as the sixteenth century when St. Francis Xavier introduced Christianity to this island country, foreign visitors have commented on the absence of a sense of sin or guilt regarding sexual matters in Japan. Whether deploring this attitude or reveling in it, foreigners have been struck by a certain casual frankness that pertains to pleasures of the flesh.

Licensed prostitution, a fact of life in Japan until the 1950s, evoked much horror and amazement (and surreptitious interest) on the part of foreign dignitaries. Government regulation confined prostitution to certain areas of the cities, sections set apart from ordinary society by physical walls as well as metaphysical rules. Yoshiwara in Edo was the most famous example of these areas, which were generically known as *yūkaku* (literally, "playpen;" in English idiom, the red-light district).

Essentially created by the merchant class, the *yūkaku* was a refuge from the Confucian strictness of samurai culture. This is where the urban sophisticate of Edo went to relax, to compose poetry, to eat and drink and amuse himself with clever women whose profession it was to create a world of play. The *asobime* was, literally, the mistress of *asobi*, and the higher her rank within the quarter, the more skills she was supposed to have had.

The composition of linked verse, and the calligraphic ability to record those poems in a fluid hand, were essential attributes of an accomplished mistress of *asobi*. Song and dance and witty repartee were as important as the knowledge of the *asobime* of *toko no higi* (secrets of the bedroom).

Still, undeniably, the central aspect of an excursion to the *yūkaku* was the consummation of an evening of *asobi* by playing under the quilts. The *yūjo* prostitute kept a number of adult toys in her pleasure chest for this purpose. The nubbly tubiform body of the sea slug, for example, was dried, then reconstituted with water as the Japanese equivalent of a French tickler. Dildoes came in one basic shape, but various sizes—from improbably large (used as a decoration no doubt) to miniature "finger dildoes." There is a school of thought that holds that the uncluttered, simple *kokeshi* doll, beloved as representative of Japanese folk craft, is in fact simply a decorated dildo.

Duty and propriety seem to have been the overriding principles of the lives of women of the samurai class. They were taught to eschew the frivolous in the call of moral uprightness. The refined types of *asobi* permitted to these women (incense sniffing, arranging flowers, making ceremonial tea) seem pale in comparison to the pleasures available to the wealthy male merchants and samurai of Edo.

Certain temples become the site for instruction in *ikebana* (flower arranging).

(opposite)
Ushizo Sato
Kokeshi, Togata type, 1976
wood, color
9½, 24
Collection Boston Children's Museum

The peasants and the urban poor were little concerned with either the exquisite amusements of the *yūkaku* or the stiff virtues of the samurai class. According to Ella Lury Wiswell's monograph of village life in prewar Japan, ribald joking and lewd song and dance seem to have been the sine qua non of any informal gathering.[1] Not only was sex itself recognized as one of the main ways adults have fun, but talking about it seems to have provided unflagging amusement as well.

More refined urban taste found this countrified humor grossly offensive, and today the more explicitly lewd aspects of sexual humor have been tidied up as middle-class sensibilities spread to the hinterlands. Yet an undercurrent of appreciation of the bawdy still remains, a muddy underground rivulet that will burst the dam of respectability if only enough liquor is consumed.

Drinking has always been an indispensable part of adults' *asobi* in Japan. Liquor is the solvent for the rigid rules governing proper behavior between individuals in this hierarchically self-conscious society. The bar, club, or "snack"—a recent term meaning an elegant little place serving liquor and bites of exquisite this and that—are the arenas of the after hours world of modern adult play.

Social drinking per se is by and large an activity of men. The women found cozily sitting at their sides are not wives, or even girlfriends, but rather bar hostesses: women hired by the clubs to provide feminine presence and companionship. In Edo, these women would have been geisha, unmarried entertainers skilled in the arts of singing and dancing. Geisha are still available for wealthy executives with a nostalgic bent, but there is little room in the crammed schedules of modern Tokyo to develop the knack of geisha *asobi*—the art of passing time elegantly with soigné companions.

Hobbies

Most Japanese cultivate some kind of hobby in their leisure time. There are some truly idiosyncratic avocations such as keeping bush warblers, but most hobbies have long traditions: associated clubs, regular get-togethers for enthusiasts, and group-sponsored publications. Most popular hobbies contain a strong element of self-improvement. Simply killing time, as in playing pachinko or video games, does not count as a proper hobby— even though more and more people are listing these as leisure time activities when they respond to questionnaires.

Ideally, a hobby is something a person does over a long period of time, deepening his or her appreciation for its content, bending the ego to its demands. If a woman works at the tea ceremony, for example, the idea is to gain practical knowledge of the ritual, the utensils and the philosophy over the course of her life. But even if a person's interest lies in something as prosaic as the raising of Coturnix quails, he can learn discipline by the regular care and feeding the birds require.

Young women often study one or several of the arts before they marry. A certain amateur's proficiency in classical Japanese dance, piano, *koto*, tea ceremony, or English, is thought to give girls a genteel polish that a prospective husband (or his family, at least) will find attractive. Almost without exception, these arts, practiced as hobbies in high school and college, are set aside during the first decade or so of a woman's married life. The care and feeding of children, followed by the responsibility

1. Robert J. Smith and Ella Lury Wiswell, *The Women of Suye Mura* (Chicago: University of Chicago Press, 1982).

of getting them through the fiery gates of entrance examination hell, is a totally demanding activity. Motherhood allows for no hobbies that do not have some immediate and practical relevance for the family.

But when the intensive mothering stage of life is past, women who are not constrained by economic necessity to find a job, can look forward to filling their newly found leisure hours with elegant hobbies. Quite frequently they will revive one of the interests from their teen years—Japanese dance, perhaps—and pursue it with renewed and deepened vigor.

When responding to the curiously great number of national opinion polls, Japanese list among their favorite hobbies such things as: golf (mostly men, but some bourgeois ladies too); swimming (younger people, men and women); reading (all Japanese are insatiable readers, even if it's only comic books for some); listening to music; having tea with their friends (ladies); and watching television.

Middle age often awakens an interest in native arts and traditions among both men and women in Japan, and they enter the hierarchical world of lessons given by the traditional masters. For women in particular, this becomes a reason to cultivate an associated hobby: the wearing of kimono. Somewhat unusual in Tokyo, yet attaining its interest by that very fact, the kimono has become an expensive avocation for ladies of the upper middle class.

A great number of the artistic hobbies everyone thinks of as being haute Japonaise come straight from the feudal samurai tradition. The schools of tea, flower arranging, dance and music thrive in the climate of culturally upward aspirations of the middle class—which means almost everybody now. Yet this does not affect the less pretentious means of enjoyment such as playing mah-jongg. There also seems to be a certain underlying continuity between the Edo inhabitant's relish for a boating excursion on the Sumida and his Tokyo counterpart's urge to take a companion for a drive on a Sunday afternoon.

Travel

The journey (*tabi*) has a long history of being a favorite way of escape from the cares of everyday life in Japan. For the man and woman of Edo, the main form of travel was the religious pilgrimage. The people of feudal Japan were not permitted to wander far from home on a whim or without a travel permit, so the occasion of a pilgrimage to famous temples and shrines also afforded a rare opportunity to see other parts of the country. The well-worn pilgrimage routes were lined with shops for refreshment and amusement, and it is no accident that many of the famous geisha communities originally sprang up in areas near the major shrines in order to cater to travelers with their hearts set on enjoyment of one sort or another.

According to proverb, the traveler knows no shame.[2] For the man of Edo, the occasions when the regulations of everyday life were lifted—as on festival and travel days—must have produced a euphoric feeling that is hard to imagine in our modern world where individual freedom of choice seems to reign supreme. A perennial favorite object of travel is a trip to a mountain or seaside resort featuring a natural sulphurous hot spring. The baths are considered restorative of body and soul, and the atmosphere

2. In Japanese, *tabi no haji wa kakisutete.*

Pachinko, the Japanese-style pinball game, is a popular pastime of the urban Japanese.

(opposite)
The wearing of kimono and *obi* in today's Japan is a form of recreation.

of the resort towns is entirely geared toward relaxation and *asobi*.

Few Japanese, then and now, choose to travel by themselves. Even Bashō, the seventeenth-century ascetic haiku poet, had an entourage for his journey along the "Narrow Road to the Far North." The denizens of major European and American cities have long since become accustomed to groups of Japanese tourists following their standard-bearing tour leader on their Jalpak-arranged journeys abroad.

These group trips are first experienced when sixth-grade school children take their class trip to one of the famous tourist spots in the country. Trips for junior high and high school generally move farther and farther afield, and college-aged groups of friends often save their money to make a trip abroad together.

More than fifty percent of Japanese newlyweds travel abroad for their honeymoons today, with places like Guam and Hawaii ranking first in popularity. One hardly thinks of a honeymoon as an example of group travel, but so many couples choose the same tour packages that, in effect, it amounts to almost the same thing.

Japanese touring their own islands is a highly promoted industry within Japan, with regional specialties being preserved and touted in order to draw tourists. High on the list of regional attractions are the many folk festivals that occur at local shrines around the country. Combining the enjoyment of travel with the excitement implied by a festival seems like a double dose of *asobi* for many modern Japanese.

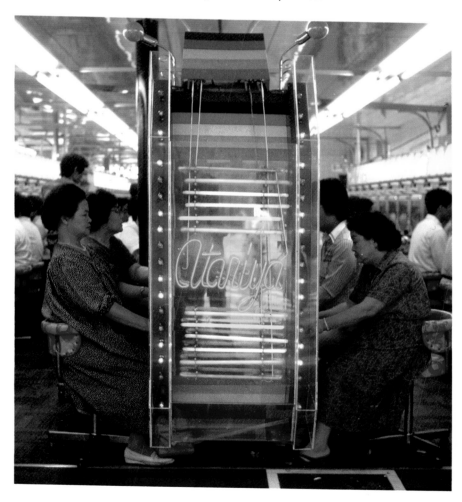

Festival

There were two kinds of time in traditional Japan: ordinary time and festive time. Folklorist Kunio Yanagida maintained that this distinction was a primary aspect of peoples' attitudes toward life. In addition to an individual's special days (first shrine event, coming of age, marriage, etc.), the main occasions for celebration were the festivals. Work was the mainstay of ordinary time, so naturally resting or playing became the hallmark of festival time.

Festivals strongly punctuated the rhythm of life in Edo. They have not lost much of their vigor in the neighborhoods of modern Tokyo, either. Every neighborhood has its Shinto shrine, and practically every shrine has its festival, celebrated locally and noisily by its parishioners. The "Son of Edo" (*Edokko*), it was said, would happily pawn his wife to raise funds for these festivals where portable shrines are borne through the streets on the shoulders of enthusiastically chanting people of the neighborhood.

Annual markets take place at some of the larger shrines and temples, and these have a decided festival flavor, too. The shopkeepers' fairs may have used the agricultural symbols of heavily laden fronds of rice, but the prosperity they invoked had more to do with bountiful customers than crops. Still, a festival is a festival, businesses and government offices close down, and people devote themselves to enjoying the time set apart from routine.

National holidays are often based on traditional festivals too, but to the extent that they are widely observed their content has become somewhat homogenized. Yet it is no accident that even the urban *matsuri* occur in a regular order based on the seasonal progress through the year. The rhythms of nature, agriculture and human life come together in a certain natural periodicity that results in a major festival almost every other month.

The New Year's holiday is preeminent among the ancient five big

Children carry a *mikoshi* in a neighborhood *matsuri*.

(opposite)
Men dressed in *happi* coats parade an enormous cloth *shishigashira* (lion-headed mask).

festivals of the year, and it is celebrated by young and old in city and village alike. The observances associated with *shōgatsu* retain more of their original religious import than almost any other of the multifarious festivals of Japan. The remaining national-level *matsuri*, especially those that happen not to have been made into official holidays, may be more or less matters of indifference, especially to the childless. Children have always held a special place in the traditional celebration of festivals, and have long since come to dominate certain ones.

March third is the day of the *Hinamatsuri* (Doll's Festival), also known as Girls' Day. This is not an official holiday (the government "combined" it with Boys' Day to become Children's Day on 5 May) but it is one with magical roots that go deeper than the expensive displays of dolls representing the imperial court would lead one to believe.

Long ago, the third day of the third month was an occasion for the performance of purificatory rites. Originally the "dolls" (*hina*) were effigies of paper, wood, or straw meant to absorb a person's evil inclinations. They were henceforth burned, sent down a river, or similarly destroyed in order to complete the purification. At some point long ago the dolls became more splendid and, far from being disposed of, were treasured by the little girls who owned them. The many-tiered display of dolls representing a prince, princess and their retinue, is the centerpiece of this holiday the way a crêche is to Christmas. For the last several centuries, this holiday has been celebrated by combining the aspect of conspicuous display with the proclivities of little girls for playing house.

The late Boys' Festival (also known as *Tango no sekku*, or the Feast of Irises), now Children's Day, has its roots in ancient rituals of fecundity. It is now almost entirely dominated by the militantly boyish symbols: carp swimming determinedly upstream, phallic budding iris with swordlike leaves, and displays of armor, bows and arrows, and other toy samurai paraphernalia. Miniature helmets, spears and martial banners are set out on a green cloth where a sister's display of dolls had been arrayed on red two months before.

But it is hard to erect the carp banners (*koinobori*) when you live in a Tokyo apartment, and fewer families are buying the expensive accoutrements of the old *Tango no sekku* display for their sons. No doubt the kids think of Children's Day as a day off from school when they can play with their friends and perhaps have a party that includes a heavily iced cake with decorations of intrepid carp, if not the real thing.

Many of the observances of seasonal change that were aspects of traditional festivals celebrated in Edo have not survived the change to Tokyo. Who listens to the warblers of Koishikawa in the spring, or goes to view lotus at Shinobazu Pond in summer, or views the snow from the far bank of the Sumida River in winter?

Asobi may be as much a part of Tokyo society as it was of Edo, but clearly it has a harder edge now. Modern schedules are ostensibly geared for efficiency, which means that certain things are to be done just at certain times—of life, of the year, or of the day. The Edo spirit of *asobi* has lost some of its languid character in Tokyo.

In 1952, 1 October was declared Tokyo Citizens' Day by the Metropolitan Government. A new festival was decreed including various events such as a Miss Tokyo pageant. The admission fee to all parks and gardens is waived, and public schools are let out. Thus, bureaucratized perhaps, is the spirit of the *matsuri* carried on.

Inu hariko (papier-mâché dog), circa 1920
paper, rice paste, whitewash, applied color
9 x 9, 22.9 x 22.9
Collection The Brooklyn Museum,
On loan from Dr. John Lyden,
(TL1984.35.5)

(opposite, left)
Haru koma (hobby horse), late Edo period
wood, bamboo, silk, animal hair
32½ x 10, 82.5 x 24.4
Collection Richard R. Silverman

(opposite, right)
Kubi-furi ningyō (bobbing-headed doll),
early twentieth century
clay, whitewash, gold leaf, applied color
6½ x 4 x 3½, 16.5 x 10.1 x 8.8
Collection Mrs. Hans Conried

(p. 213, top)
Inuyama tsuchiningyō (Inuyama clay doll)
of a woman traveler, Meiji period
clay, whitewash, applied color
10, 25.4
Collection Richard R. Silverman

(p. 213, bottom)
Anesama ningyō (elder-sister dolls),
late Meiji, early Taishō period
paper, cornhusk, cloth, clay, applied color
4½ to 12¼, 11.4 to 31.1
Collection Honolulu Academy of Arts,
Frederick Starr Collection,
Gift of Ruth Knudsen Hanner, 1951

(p. 214)
Tondari hanetari (jumping dolls), late Meiji,
early Taishō period
paper, rice paste, whitewash, applied color,
bamboo, resin
1¼ to 2, 3.2 to 5
Collection Honolulu Academy of Arts,
Frederick Starr Collection,
Gift of Ruth Knudsen Hanner, 1951

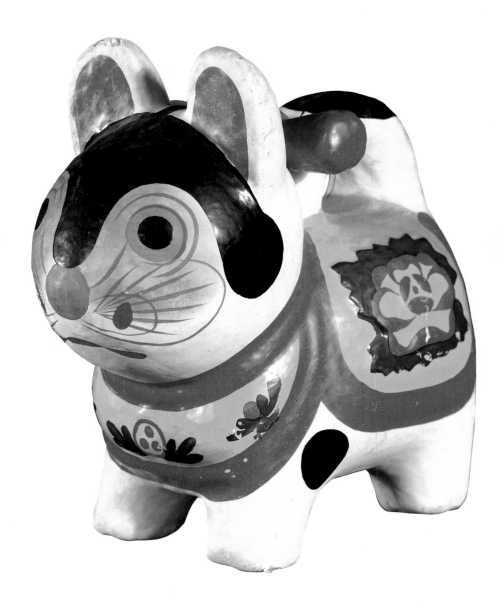

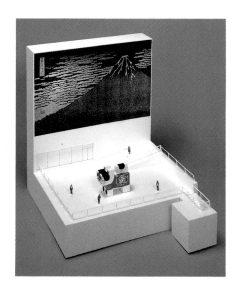

Shigeo Fukuda
Model for the Playing space,
Tokyo: Form and Spirit, 1985
Collection the designer

Walker Art Center's roof terrace, directly off the gallery containing the Edo-period toys, will be the site for Fukuda's *inu hariko*. The wall overlooking the terrace will be covered with the banner of Mount Fuji.

(opposite)
Shigeo Fukuda
Sketches for the Playing space, 1985
Magic Marker on paper
Collection the designer

The earliest conception for the terrace included a number of elements in addition to the *inu hariko*. These were eliminated as the dog grew in scale. The hanging kite in the upper drawing was later replaced by the Mount Fuji banner.

Shigeo Fukuda: Playing

In Japan, parents traditionally visit Shinto shrines to pray for the happiness and health of their children. The *inu hariko* (papier-mâché dog) was created for this purpose and offered on behalf of the children. The word *inu* has several meanings: a reminder never to forget one's obligations to the master; to lessen difficulties in childbirth; or, to encourage the healthy development of children. Working within the theme "Edo to Tokyo," I have chosen this representative folk toy of the Edo period as the central image of the Playing space.

As the name implies, the original *inu hariko* was made of papier-mâché, however, due to its placement in the exhibition on an exterior terrace, I have used a steel-framed structure overlaid with an impermeable skin, painted in the manner of the traditional animal form. Taken directly from the shape of an *inu hariko*, the piece is meant to express a contemporary feeling while retaining its connection to the Edo period.

Spectators will be able to look into the *inu hariko* through peepholes. In it they will see visual references to children's *asobi* from Edo to Tokyo. The motifs of these pictures of play include *karuta* (poetry cards), *sugoroku* (Japanese pachisi), *fukuwarai* (children's paper masks), *hagoita* (battledores), *takeuma* (bamboo horse), and *tako* (kites).

The motif of the wall banner is a detail taken from the color woodblock print *Mount Fuji on a Fine Day with Breeze* from the series *Thirty-six Views of Mount Fuji* completed in 1833 by the consummate Edo-period artist, Katsushika Hokusai.

Mount Fuji is illustrated through the use of 11,088 masks: *okame*, also called *otafuku,* a moon-faced woman mask with a prominent forehead and plum cheeks, which appeared in the performances of Edo-period *sato-kagura* (local shrine pantomimes), emits a charming, happy, comical and warm feeling; the male faces are represented by the *hyottoko* (clown jester).

With the use of historical symbols in the banner of Mount Fuji and the *inu hariko,* in combination with contemporary visual attitudes, I believe this work connects the essence of Edo to the lifeblood of contemporary Tokyo.

S.F.

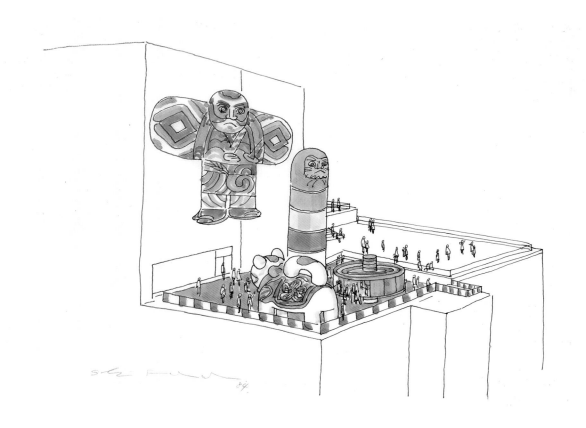

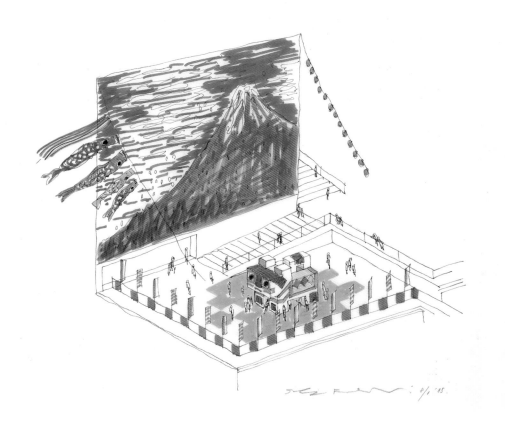

Shigeo Fukuda
Model of the *inu hariko,* 1985
watercolor on cardboard
Collection the designer

Shigeo Fukuda
Diagram of the elevation for the *inu hariko*
indicating the peepholes through which
visitors will see various *asobi* from Edo
to Tokyo.

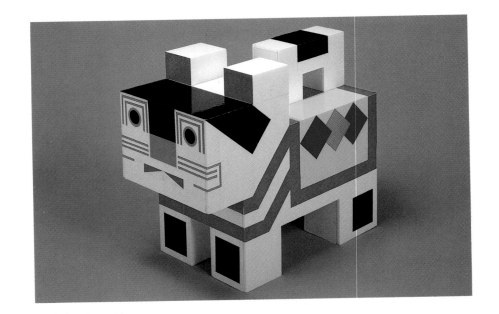

(top)
Shigeo Fukuda
Sketch for Mount Fuji banner for the
Playing space, *Tokyo: Form and Spirit,* 1985
Magic Marker on graph paper
Collection the designer

Segment of the banner depicting Mount Fuji,
to be made of plastic masks in various colors,
organized on the net support to create the
image shown in the sketch above.

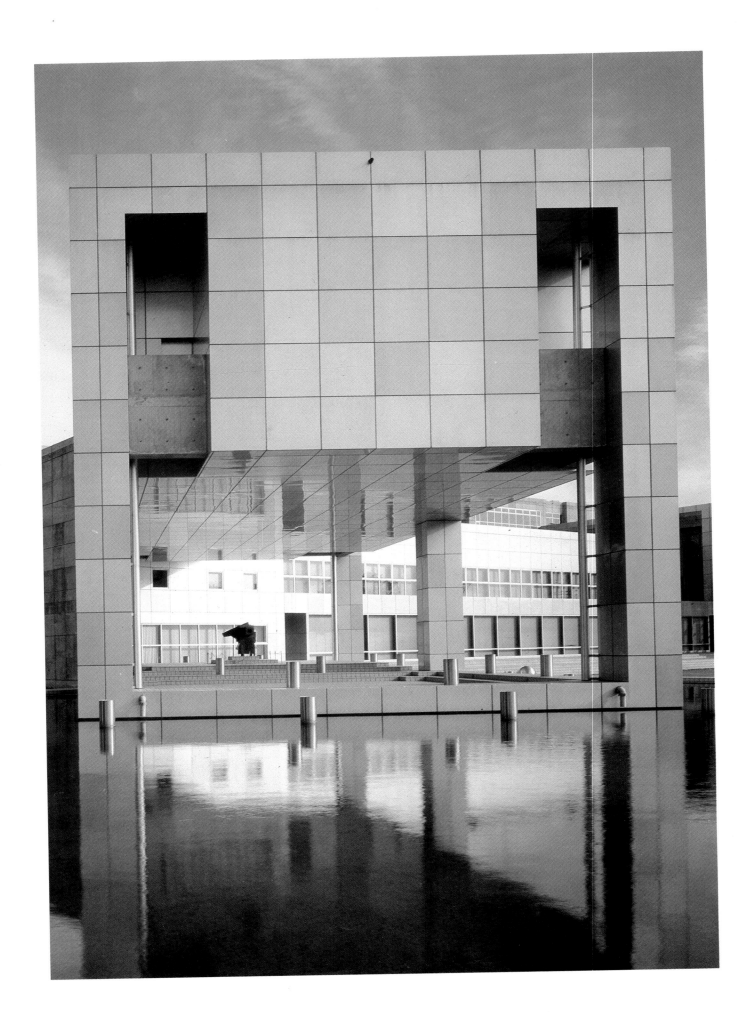

Twilight Gloom to Self-Enclosed Modernity: Five Japanese Architects

Kenneth Frampton

Arata Isozaki
Gunma Prefectural Museum of Fine Arts,
Takasaki, 1971-1974

The architect used a cubic framework to enclose space designed to permit continuous redefinition of the areas for changing exhibitions.

Born within three years of each other in 1931 and 1928 respectively, Arata Isozaki and Fumihiko Maki are today among Japan's main public architects. Together with Kisho Kurokawa, who is of the same generation, they have been independently responsible for some of the finest public works carried out in Japan over the last twenty years. Significantly, all three are graduates of the elite Tokyo University and protégés of the post-World War II master, Kenzo Tange.

Here, however, resemblances end and significant differences begin, notably with the politically well-connected Kurokawa, who stepped into the limelight with the Metabolism movement in the early 1960s and never looked back—passing from enfant terrible to establishment architect overnight—while Isozaki and Maki were separately to experience a much slower pace of development. Irrespective of their enjoying a period of prolonged maturation, both Isozaki and Maki had quite different experiences after leaving Tokyo University, and those formative years of apprenticeship left distinguishing marks on their subsequent practices. Thus, while Isozaki remained in Tange's office from his graduation in 1954 to the establishment of his own practice in 1963, Maki moved to the United States in 1953, studying first at the Cranbrook Academy and then under José Luis Sert at the Graduate School of Design, Harvard University. Therefore, Maki's post-graduate master was Sert rather than Tange, and he completed this extended tutelage by working for Sert, Jackson and Associates until 1956.

Even more fundamental differences, turning on background and temperament, have served to distinguish the highly independent careers of these two men. Today, Isozaki remains the quixotic "outsider" from the island of Kyushu, while Maki has always operated within the "classic" boundaries of the Tokyo establishment into which he was born. Thus, while Maki, after ten years of teaching in the United States, was to become the natural successor to a much coveted chair in architecture at Tokyo University, Isozaki was to assume the role of the bohemian intellectual who would, with his charismatically brilliant critical discourse and his irrepressible creativity, command a wide following among the intellectual architects of the next generation, including such brilliant young radicals as Hiroshi Hara, Toyo Ito and Tadao Ando.

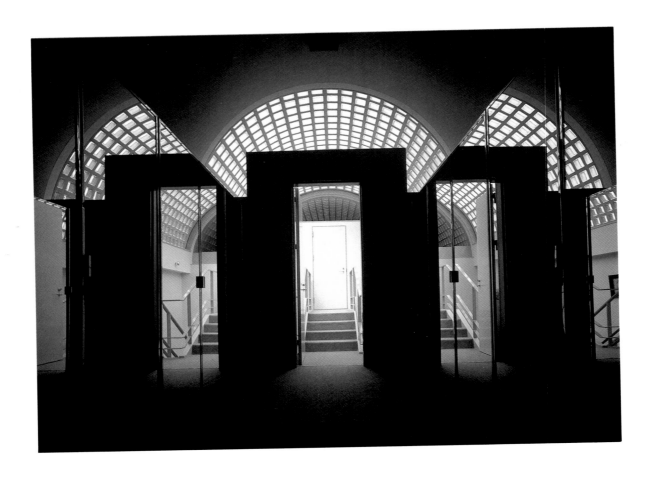

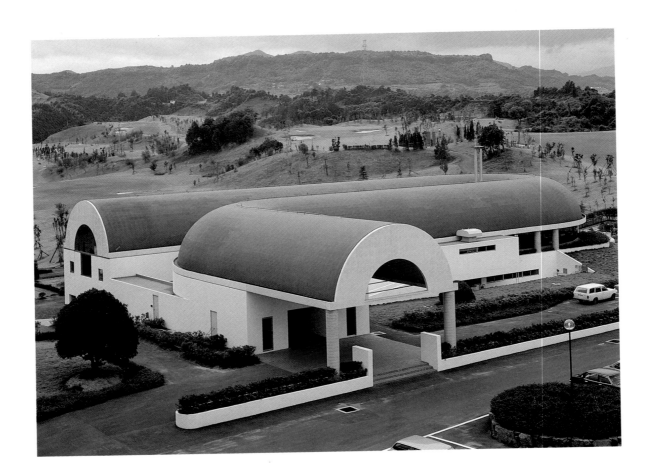

(opposite, top)
Arata Isozaki
Hayashi House, 1978

Illusion and spatial ambiguity characterize this house, as in this example, in which the glass-block vault of the hallway is reflected in mirrored closet doorways.

(opposite, bottom)
Arata Isozaki
Fujimi Country Clubhouse, Oita, 1972-1974

The clubhouse footprint is in the shape of a "question mark;" a continuous thin-shell concrete barrel vault forms its roof.

Arata Isozaki

Isozaki's seminal essay of 1964, "Yami no leukan" ("Space of Darkness"), written a year after founding his own independent practice, formulates for the first time the critical stance that his work would adopt during the next decade. Assuming as his point of departure Jun'ichirō Tanizaki's 1933 essay *In Praise of Shadows*,[1] Isozaki nevertheless found himself compelled to renounce not only Tanizaki's nostalgia but also the simple-minded positivism of the *wakonyōsai* (Western influenced) reinforced concrete frame, which had become the received style of Japanese modern architecture in the immediate postwar years.[2] Where Tanizaki's *In Praise of Shadows* was to contrast the technical brittleness of the modernization of Japan—electric light, chromium plate, white tile—with the shadowy, delicate and even oppressive earthiness of the Japanese domestic tradition, Isozaki's concept of the "space of darkness" lies suspended between two poles: there is the consciousness that the megalopolis has been brought into being as a chaotic and illusionary Luna Park, and yet, Isozaki remains aware that Tanizaki's "shadows" are not only the ghosts of the traditional Japanese house, but also the ultimate repository of the nation's spirit.

In his early work Isozaki is to posit two alternative subversive strategies as complementary modes for the creation of a critical modern architecture. The first of these appropriates the Western arational tradition as this extends from the anamorphic perspective of the Renaissance to the disjunctive Modernism of Adolf Loos and Marcel Duchamp. The second projects a highly speculative, iridescent and ambiguous space. Isozaki conceives of this illusory "twilight-gloom" space as being the modern equivalent of Tanizaki's "shadows," as something that is absent yet latent within the Japanese tradition. Isozaki will eventually conceive of this illusory space as a substitute for the Japanese sense of darkness and approach it by combining two different kinds of light: Western chiarascuro, and an Eastern, more filtered form of illumination.

With the four Fukuoka Sogo Home Bank branches designed between 1968 and 1971 Isozaki began to evolve his strategy for creating an illusory "twilight gloom" as a kind of latter-day Japanese Suprematism. With the Nagasumi branch of the Home Bank (1971), a totally fresh aesthetic suddenly takes form in Isozaki's work. We are confronted with the hallucinating effect of a ruthlessly reiterated 1.25 meter square grid imposed on every available surface, be it transparent, translucent or opaque. The effect of this space has been well characterized by Isozaki himself:

> This building has almost no form; it is merely a gray expanse. The multi-level grid guides one's lines of sight but does not focus them on anything in particular. At first encounter, the vague gray expanse seems impossible to decipher and utterly odd. The multi-level lattice disperses vision throughout the space much as various images might be thrown around an area from a central projector. It absorbs all individual spaces that establish strict order. It conceals them, and when that concealment process is over, only the gray expanse remains. The process itself has an order of sanctity, like a brilliant crime committed in the midst of dusty daily life.[3]

The Gunma Prefectural Museum of Fine Arts, under construction in the town of Takasaki from 1971 to 1974, resolves the syntactical problem of the "twilight" manner through four interrelated operations: first, by controlling the mass of the building through the imposition of neo-platonic cubes; second, by inflecting some of these cubes diagonally against the main orthogonal composition; third, by using self-closing pieces for all

1. Jun'ichirō Tanizaki, *In Praise of Shadows* (New Haven: Leete's Island Books, Inc., 1977).
2. The term *wakonyōsai* refers to such works as Kenzo Tange's Kagawa Prefectural Office (1955-1958), on which Isozaki worked as an assistant. It typifies those Japanese works of the 1950s where an attempt was made to simulate traditional Japanese timber sections and proportions in terms of the reinforced concrete frame. See T. Muramatsu, "The Course of Modern Japanese Architecture," *The Japan Architect,* June 1965, p. 45.
3. Arata Isozaki, "Fukuoka Sogo Bank, Nagasumi Branch," *The Japan Architect,* vol. 47, no. 188, August 1972, p. 53.

the corner conditions of the gridded aluminum revetment; and fourth, by simply allowing the in situ concrete frame to depart from the iridescent universality of the hermetic skin, thereby serving as a foil to the principal facing element. As Isozaki was to put it in his essay "Cubes on the Lawn" of 1974:

> Cubic frames and membranous coverings are not however coordinated. Though the frames seem to be totally covered, in fact, the membrane only extends as far as it is actually needed. No strain was exerted to install it where it is not wanted and its homogeneity breaks down from place to place, providing glimpses of the skeleton (cubes) beneath the surface. (The glimpses suggest flashings of the lining of a kimono brought to light as the person wearing it walks.) This method effectively transforms the frame into a suggestive background element.[4]

Between 1972 and 1975 Isozaki moves away from his preoccupation with dematerialization toward an architecture predicated on tectonic form, in which shallow shell vaults appear as roofs for cubic volumes. The semi-cylindrical vault emerges in full in the roof structure of Isozaki's Kitakyushu Municipal Central Library (1972-1975). Here the character of the vaulted space derives directly from the rhythmic articulation of the ribs of a precast vault. Tectonic and sculptural at the same time, this civic monument seems to present two faces: the first of these alludes to the archaic Japanese past, above all perhaps to third-century burial mounds; the second opens up toward the city by exposing its spinal ramp toward an esplanade, stepping down to the town. Where the first is a copper covered tumulus closing about itself, the second evokes the agora of a European hilltown.

The Fujimi Country Clubhouse (1972-1974) refines and condenses the semi-cylindrical tectonic of the Kitakyushu Library. Its in situ reinforced concrete shell is handled as a seamless tube, as though it were an extrusion. Isozaki's transferral operation (what Koji Taki refers to as his anagrammatic approach) here simultaneously establishes both the composition and the structure, and from this tectonic initiation everything else follows. While the arbitrary "question-mark" configuration of the cylindrical vault cannot be read from the ground, it nonetheless assures the fluid continuity of the internal volume, which otherwise stems directly from the manipulation of certain typically modern elements: the raising of the vault on cylindrical piloti and restraining of the outer thrust through horizontal chromium-steel tie rods and the use of seamless plate glass, sweeping graciously about a central semi-cylindrical fireplace.

Like the Gunma Museum, the Kitakyushu Library and the Fujimi Country Clubhouse assert themselves as representative works, comparable in their civic deportment to the finest public buildings of Kenzo Tange. The fact that Isozaki has been able to achieve this with his so-called "anagrammatic" approach is remarkable since, with the exception of the Palladian references made in the Fujimi Country Clubhouse, these monuments owe little to traditional typology and iconography.

Isozaki's "rhetoric of the cylinder" culminates in the 1970s and the early 1980s in a sequence of vaulted houses in which the semi-cylindrical vault is seen as being symbolic of the concept "house;" that is to say, the vault not only presupposes the occidental megaron but also the archaic Japanese burial casket (*haniwa*).

With the Waseda Sho-gekijo Toga Sanbo Theater, and the IBA Tegelhafen competition entry, both dating from 1980, overtly historicist fragments begin to appear in Isozaki's work for the first time. In the first instance historicism appears in the more or less direct simulation of

4. Arata Isozaki, "Cubes on the Lawn," 1974. Translation of an as yet unpublished essay by Isozaki. See also "Arata Isozaki: Square, Cube and Rectangle," *The Japan Architect,* vol. 51, no. 229, March 1976, pp. 21-78.

Arata Isozaki
Tsukuba Civic Center, Tsukuba Science City,
Ibaragi Prefecture, 1983

This interior view looks back at the entrance
of the hotel, which is on the eastern edge of
the Tsukuba complex. Its striped marble walls
are punctuated with hundreds of small
incandescent lights.

(below)
Partial view of the oval-shaped sunken plaza
and the entrance to the lobby of the concert
hall at Tsukuba.

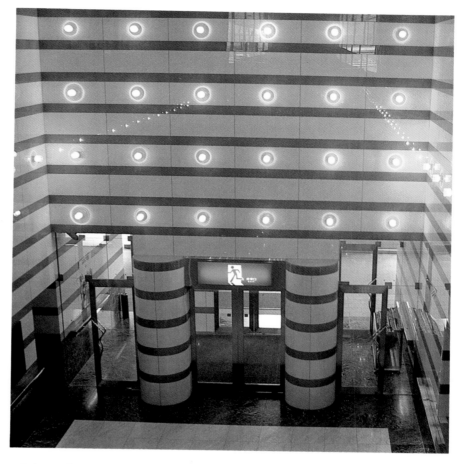

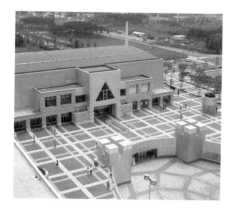

minka-style construction; in the second, it emerges as a full-size replica in the form of a ruined version of Schinkel's Schloss Tegel.

Tsukuba Civic Center, completed in 1983, is no less vagrant in its cannibalistic procedure of quotation and metaphor and while a strictly historicist citation is hard to identify, it is obvious that certain profiles and proportions have been drawn from Claude Nicolas Ledoux's unrealized Ville de Chaux (1780). Moreover, these rusticated fragments find themselves mixed up with the gleaming silver "twilight-gloom" manner of Isozaki's Gunma Museum. While this quasi-historical collage controls the exterior of the building, it is not maintained within, where its equivalent, in banded crystallized glass, breaks up the internal walls and columns into a kaleidoscopic assembly of luminous illusion. This disjunctive interior is highly episodic, so that one passes, in a state of excited bewilderment, from one set piece to the next, as light and geometry exercise their mutual permutational effects on the illusory quality of the space. Finally, there is the Tsukuba Plaza itself, which aside from incidental cannibalized parts taken from Gunma and the historical parody of Michelangelo's Campidoglio, it posits itself as the center of a symbolic void: literally, as the central drain down which all surface water finally disappears and to which all pedestrian activity is inevitably drawn. In place of his ironic but nonetheless intellectually challenging and sensuous "twilight" manner and the tectonic rigor of his "anagrammatic" vaulted forms, Isozaki finds himself reduced at Tsukuba to historicist disjunction and syntactical suturing. These are the only operations now capable of sustaining the composition without falling into kitsch on the one hand, or total chaos on the other.

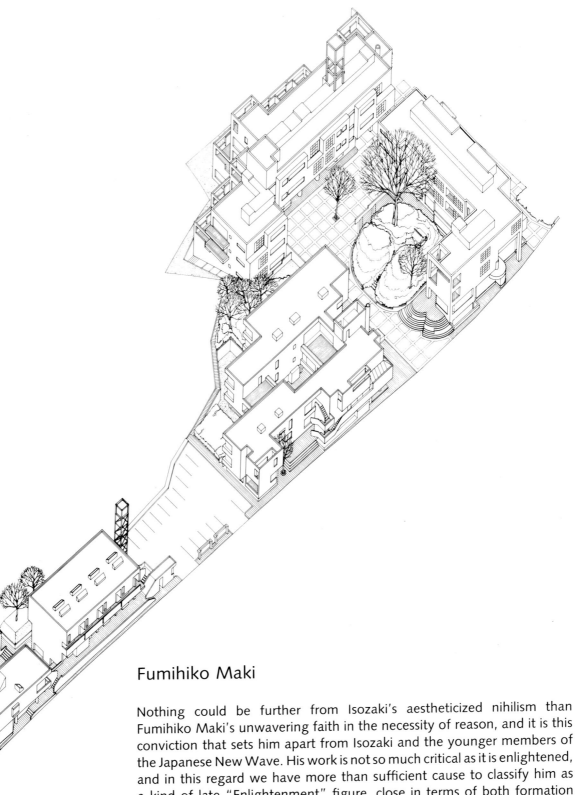

Fumihiko Maki

Nothing could be further from Isozaki's aestheticized nihilism than Fumihiko Maki's unwavering faith in the necessity of reason, and it is this conviction that sets him apart from Isozaki and the younger members of the Japanese New Wave. His work is not so much critical as it is enlightened, and in this regard we have more than sufficient cause to classify him as a kind of late "Enlightenment" figure, close in terms of both formation and commitment to the tradition of the Harvard Graduate School of Design line, stemming from Gropius and running as a continuum through Breuer and Sert, to culminate today in the delicately rational work of his own practice.

In his continually evolving commitment to the possibility of realizing a rational urban practice, Maki is unique among the Japanese architects of his generation. From his earliest concepts of "collective form," worked out in collaboration with Masato Ohtaka in 1960, to the staged realization of his Hillside Terrace Apartments, built as a settlement in Tokyo in three phases over an eleven year period, it is clear that this theory and practice stands in strong contrast to the "negative" thought of Isozaki and the

Fumihiko Maki
Hillside Terrace Apartments, Tokyo, 1976

Japanese New Wave. His work in this regard is all the more challenging for its refusal to become enslaved in the master planning illusions of the Western modern movement with which he could be otherwise so easily affiliated. For while Maki designed megastructural urban projects in the late 1960s and early 1970s, such as his international competition entries for Vienna (1969) and Santiago (1972), there has always been a certain realistic restraint in his urban thought.

Maki's urbanism is closely linked to recent developments in his own general theory, most notably his 1978 elaboration of the esoteric concept of *oku*. In their research, Maki and a team from the Toray Science Foundation conclude that the archetypal concept *oku* accounts for the peculiarly Japanese capacity for creating precisely articulated, layered worlds within very restricted domains, irrespective of whether these mini-ature realms occur at a private or generalized urban level. The idea of *oku* is closely linked to the concept of depth as this recedes in a given field toward the unseen and the sacred. As Maki concedes, it is unclear to what degree or in what way *oku* may be consciously cultivated in the present, but nonetheless he goes on to state that: "The history of Japanese cities eloquently teaches us that the desirable qualities of space are to be found not only in its expanse but also in the creation of depth."[5]

Whether it reflects the ethos of *oku* or not, the Daikayama residential settlement of 1978 is certainly a realization of the strategy of "group form" as Maki had conceived this together with Masato Ohtaka in his 1964 *Investigation in Collective Form,* and this relatively organic concept of urban composition was to prevail in his practice throughout the late sixties and seventies, perhaps most notably in a series of micro-urban realms which he was fortunate enough to be commissioned to build.

Maki's personal maturity as an architect seems to come with two related works of exceptional refinement dating from the late 1970s. These are his own house, built in Tokyo in 1978, and the Iwasaki Art Museum completed at Ibusenki, Kyushu in the following year. Both of these struc-tures display, perhaps more decisively than other buildings by Maki, the underlying tension in his work between symbolic form, monumental by definition, and a long-standing preference for organic irregularity and for the informal expressiveness of free-style functionalism. The absence of any traditionally understood symbol in modern society creates a void for Maki, as for any other contemporary architect. It is a dilemma no more readily resolved by Isozaki's *maniera* than it is assured by Maki's repeated assertion of two simple ideogrammatic figures—the stepped pyramid profile, supposedly signifying dwelling, which first appeared somewhat cryptically inscribed into the otherwise glass-lensed facade of the Central Physical Education Building, Tsukuba University (1974), and the "horizon-tal" cross, rendered in freestanding welded steel, which Maki first used symbolically in the Iwasaki Museum. This last had apparently no further intentional significance than the indication of a forbidding cage. This museum was also the first occasion on which Maki would employ the non-load bearing, freestanding, single symbolic column as an *axis mundi* immediately evocative of Shinto culture.

Apart from the recently completed Fujisawa Municipal Gymnasium, few works from Maki's late career can compare with the diminutive light-ness and elegance of his own house, a work in which convenient elisions introduced into an otherwise symmetrical plan are re-stabilized, as it were, by the superimposition of a centering device. As in the Iwasaki Museum,

5. Fumihiko Maki, "Japanese City Spaces and the Concept of *oku*," *The Japan Architect,* vol. 54, no. 265, May 1979, pp. 50-62.

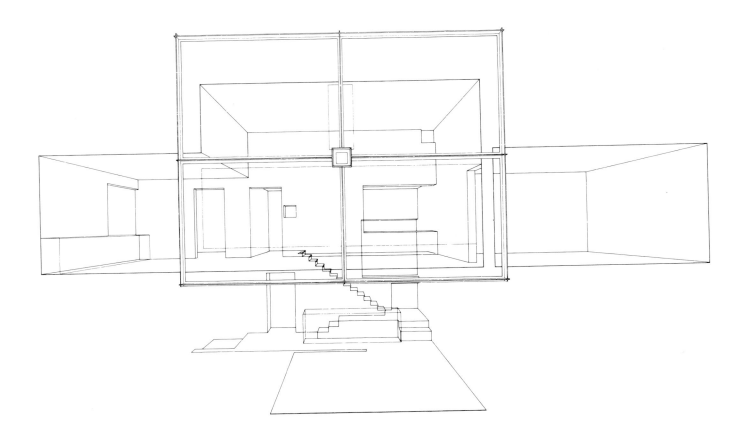

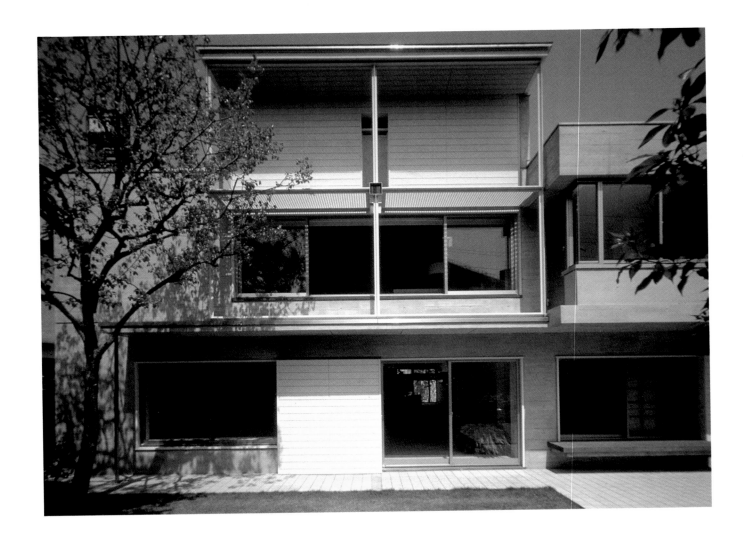

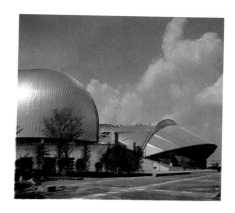

Fumihiko Maki
Fujisawa Municipal Gymnasium, Kanagawa
Prefecture, 1984

The main entrance to the complex is a
concrete podium that forms a link between
the two buildings whose thin stainless steel
skins reflect the Fujisawa sky.

(opposite)
Fumihiko Maki
Maki House, Tokyo, 1978

The cruciform sunscreen and balcony of the
house are defined in the section drawing
above.

this assumes the form of a symbolic cruciform executed in welded steel
and, in this instance, suspended, as a sun-screen, from the front of the
one-and-a-half-story-high living volume, situated on the second floor.
The most memorable qualities of this house, however, do not stem from
this "applied" monumentality, but rather derive from the simple spatial
fluidity of its plan and section, from the precision of its detailing and,
above all, from the limpid, changing quality of the light that permeates
its airy volumes. If there is a moral to be drawn from this achievement,
it is that Maki's work is at its best where the monumental, not to say the
symmetrical, remains subservient to the organic. This is indeed the case
in the spatially and plastically dynamic Fujisawa Gymnasium completed
in Kanagawa Prefecture in 1984.

Like Isozaki's Sports Hall for the 1992 Olympics, under construction
in Barcelona, Maki's Fujisawa Gymnasium represents something of a return
to the high tectonic manner of Kenzo Tange in his prime: that is, to the
structurally expressive manner of his Olympic buildings completed in Tokyo
in 1964. Like Tange's suspended catenary structures, Maki's gymnasium
is a tectonic tour de force. The return to Tange is also evident in the
rooted cultural associations evoked by the complex elliptical profiles
adopted for the stressed-skin metal shells covering the large and small
sports arenas. Of these brooding shapes, faced throughout in glistening
stainless steel, Maki has written:

> Seen from the stage end, the main-arena building has a form reminiscent of the
> kinds of helmets Japanese warriors wore in times past. Seen from the spectator-
> gallery end, it looks like the kind of wooden gong (mokugyo) used in Buddhist
> ceremonies. The double-height space in the sub-arena building recalls the form
> of a fencing mask, while the staircase in the rear recalls the Einstein Observatory
> in Potsdam by Erich Mendelsohn.[6]

Irrespective of the general accessibility of these associations—the well-
known dilemma of an *architecture parlante*—two things certainly can be
claimed for this work, aside from the astonishing sculptural energy of the
composition as a whole. The first is the presence of something that is
becoming increasingly rare, above all in the United States: namely, an
evident capacity to continue with the evolution of tectonic culture on a
grand scale, comparable to the most heroic achievement of nineteenth-
century engineering; that is to say, the articulate pursuit of collective space
as the primary touchstone of a great civilization. Where today are the
American architects and engineers, let alone clients, who can rise to such
a challenge? The second is the hermetic silver finish of the building's
stainless steel exterior that imparts to the work an aura of hallucinatory
brilliance, as though the structure is a vast sculptural mirage, changing
under light; a form which is never perceptually stable. In this respect it is
possible to claim that Maki has been influenced by Isozaki and that his
recent work makes use of certain finishes and effects that were pioneered
in the "twilight-gloom" manner.

Maki's response to the moral and cultural predicament of the late
twentieth century is rationalist rather than metaphysical, even if his
rationalism is strongly tempered by a concern and respect for regional
culture and form. However, Maki's "regionalist rationalism" has rather
precisely defined boundaries. He refuses, in his delicately refined forms,
to indulge in an unduly direct reinterpretation of the traditional *sukiya*
manner, so evident in some of the works of the Japanese New Wave. He
insists instead on a regional expression that arises primarily out of the
manner of occupying space, and above all, out of a way of building in
urban space.

6. Fumihiko Maki, "Fujisawa Municipal
Gymnasium," *The Japan Architect*, vol. 58,
no. 3, March 1983, pp. 55-59.

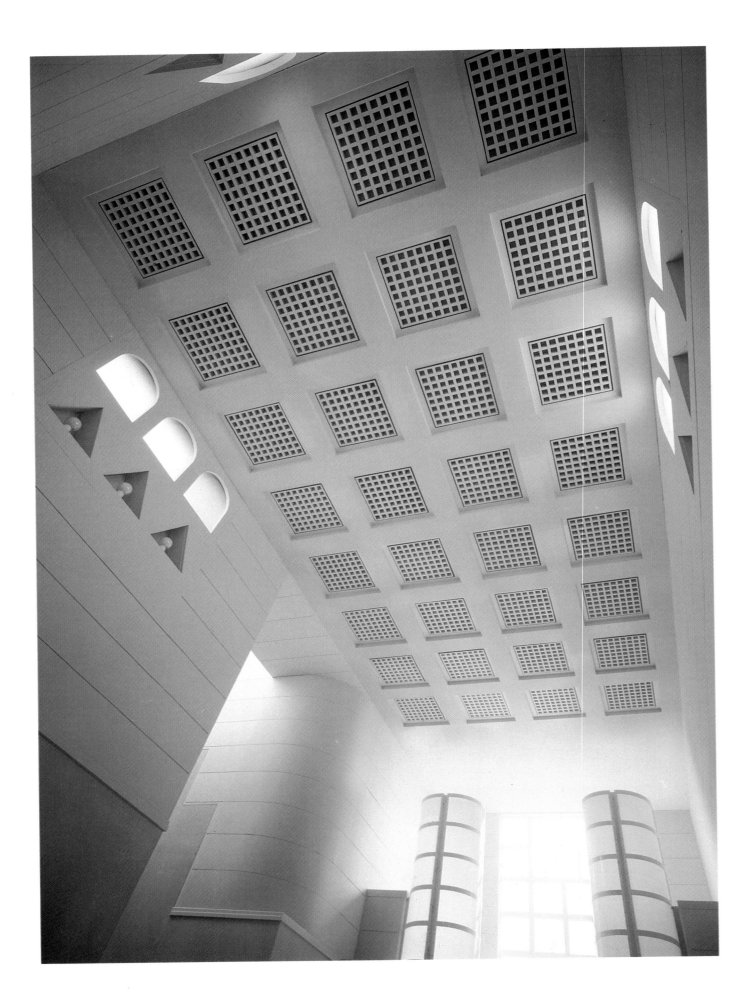

Hiroshi Hara
Shokyodo Museum, Toyoda, Aichi Prefecture, 1979

View of a gallery space in a museum entirely devoted to a collection of *ukiyo-e* woodblock prints. A private collection became public with the construction of this museum, which attached to one side of an existing private house.

Hiroshi Hara

Born in 1937 and educated at Tokyo University, Hiroshi Hara is the eldest of the three "radical" architects who will be treated in this essay, and the one who has been perhaps the least influenced by the Isozaki-Maki generation. While he has been as committed to an architecture of "resistance" as Toyo Ito and Tadao Ando, the singularity of his theoretical approach is a sign of his independence. Indeed, if there are any discernible influences on Hara's work and thought they seem to lie outside Japan in the critical-anthropological approach advanced by Aldo van Eyck and his immediate followers, Herman Hertzberger, Piet Blom and Jan van Stigt. Even then, the influence is on the level of thought rather than in terms of specific architectural form, as is clear from Hara's work and from his seminal statement of 1978, "Anti-Traditional Architectural Contrivance," in which he wrote:

> Modernization has made it difficult to maintain architectural openness, firstly because population increase, urban migration, and the centralization of cities have resulted in higher densities and an acute shortage of land. Given that the existence of a common environment is a prerequisite for the condition of 'openness,' architectural extension has become virtually impossible. Secondly, modernization has also brought about a change in human relationships themselves. The traditional neighborhood atmosphere has been destroyed.
>
> To design an open·architectural environment today, it would necessarily have unsatisfactory qualities because it would be too 'interactive.' Aspects such as 'noise' necessarily increase the degree of control which has to be exercised in such an environment. . . .
>
> Scope for cultural reconstruction, therefore, lies in countering the openness of traditional architecture. The image of a closed architecture is favored by the discontinuous layouts, as opposed to the continuous ones of open-architecture.[7]

While Hara's trans-historical analysis of the socio-cultural connotations of "open" versus "closed" architecture serves to justify his own introspective preferences, particularly with regard to the design of domestic environments, it also supports his conception of the dwelling as having a reciprocal, almost compensatory relationship with the chaotic vastness of the modern city. And while his earliest works—the Ito house of 1967 and the Keisho kindergarten of 1968—are quasi-expressionistic exercises displaying close affinities with a self-consciously evoked "universal" vernacular, his Awazu house of 1972 and his own Hara house of 1974 were each treated as Lilliputian micro-urban realms.

These houses are emblematic, so to speak, of his strong interest in a kind of anthropological-structuralist architecture, although their centralized axial and layered interiors suggested, through the subsidiary forms and spaces they proliferate, a strong personal affinity for Islamic culture. It is this, perhaps, together with the totally top-lit introverted nature of the space, which gives these houses the feeling of being "cities in miniature." Looking down the repeated tiers of radial glass and the paired domes that flank the central axis on both sides, one has the sense that one has stumbled into a science-fiction, Islamic image of the future, where somehow or another one is never the correct size.

Strangely enough, Hara has only been able to transfer this manner successfully to a public building on one occasion, in the Shokyodo Museum for Woodblock Prints completed in Toyoda, Aichi Prefecture, in the middle of 1979. Like his own house in Tokyo and the earlier Ito house, this timber-framed building is faced on its largely blank exterior with black, tongue and groove boarding. The Toyoda Museum is an ambiguous

7. Hiroshi Hara, "Anti-Traditional Contrivance," in *A New Wave of Japanese Architecture*, ed. Kenneth Frampton (New York: Institute for Architecture and Urban Studies, 1978), p. 59.

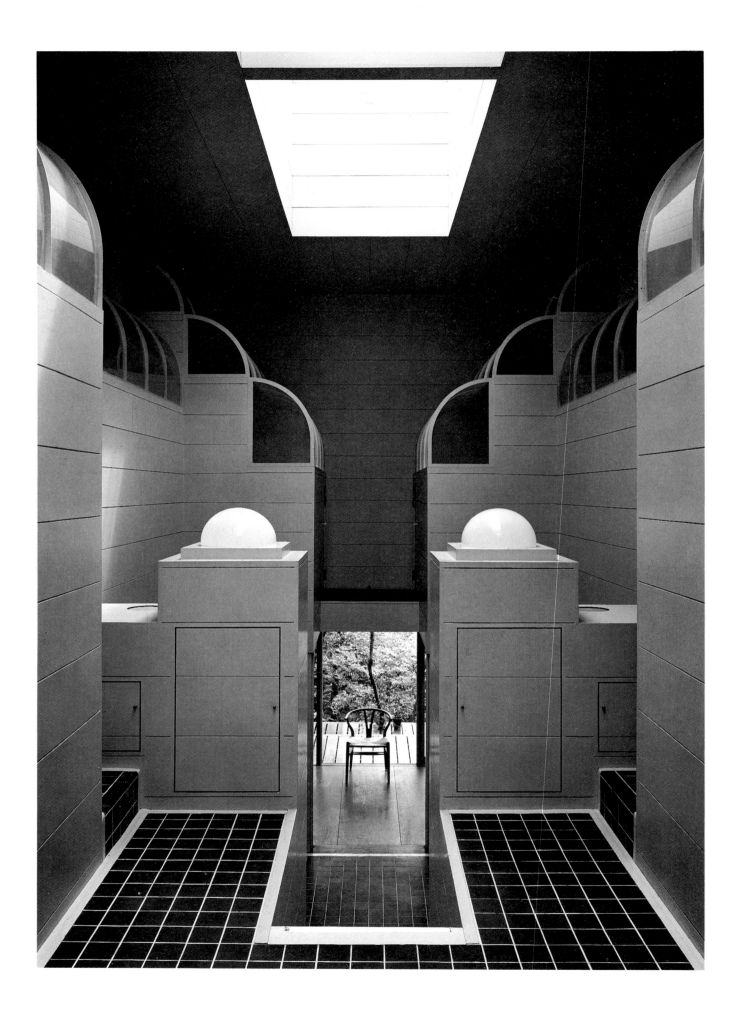

Hiroshi Hara
Hara House, 1974

In his own house, the architect has created a
micro-urban realm.

commission since not only did it mark the moment of a private collection
going public, but it was the occasion of adding an ample public gallery
space to the side of an existing private house. In writing of this ambiguous
program in 1980, Hara revealed more clearly than elsewhere the way in
which he had conceived of his domestic dwellings in the past:

> In my travels through many of the villages of the world, I have learned that the
> houses of old were complete worlds in themselves. They contained all kinds of
> functional elements including places of production, places of amusement, places
> to worship the gods, places for friendly intercourse, places of prisonlike surveil-
> lance, and places that served as a hospital. Though, of course, not all houses
> were perfectly equipped with all these elements, there is nothing wrong with
> drawing up this kind of basic image.[8]

While Hara is as critical of megalopolitan post-industrial society as
Toyo Ito and Tadao Ando, he entertains, at the same time, romantic
utopian views that are ultimately unacceptable to his slightly younger
peers. This much is perhaps most evident in the way he concludes his
1979 article on the museum. After expressing doubts about the universal
modern museums, he writes of the museum as a potential "social con-
denser" for a new society:

> But, if the place is pleasant, it becomes a regional nucleus. Independent groups
> of such pleasant places in various regions, joined by means of the desire for
> artistic expression and the powers of the imagination, can contribute to the
> creation of a new culture and new kinds of relations among human beings.[9]

Toyo Ito

It is perhaps no accident that a leading Japanese architect should seek to
predicate his work on an aestheticized screening of the urban environment,
for the Japanese New Wave architects have long since manifested a hyper-
consciousness about the contradictions in which they operate. Aside from
having to work within a constantly expanding megalopolis, Japanese ar-
chitects have been subjected to apocalyptic change for more than a cen-
tury. Unlike their Western counterparts, today's Japanese architects have
invariably sought to compensate for the constantly escalating pace of
modernization through subtle forms of introverted sublimation. Removed
from the ethos of American postmodernists, who oscillate between a form
of bricollage employing random, iconic material and a reactionary impulse
toward the simulation of traditional form—often passing from one to the
other in the same work—the Japanese late "avant-garde" has elected to
play with a more restricted, more abstract palette. Toyo Ito, for example,
has opted for what might be described as a membranous containment of
the body, and for the simultaneous partial rupture of this membrane so
as to reveal, either through light or disjunctive form, the spiritual abyss
that surrounds us.

This much was never more evident than in what is possibly Ito's most
comprehensive theoretical statement, his 1978, "Collage and Superficiality
in Architecture," in which he wrote:

> . . . most Japanese cities are not structured according to clear physical patterns
> such as grids or radiating networks. Therefore, we do not comprehend urban
> space through pattern but rather through collage or the empirical composition
> of symbols discontinuously scattered about. The architectural *mélange* of the
> typical Japanese city consists of traditional wooden architecture, stylistic architec-
> ture imported from Europe, and modern architecture brought from the United
> States. Big cities such as Tokyo have been growing as a complex of architectural
> symbols derived from various periodicals and places. When we walk about these
> bustling streets, we are wrapped in a membrane consisting of these icons. The

8. Hiroshi Hara, "Shokyodo: Minimal
Museum for Woodblock Prints," *The Japan
Architect,* vol. 55, no. 5, May 1980, pp. 23-30.
9. *Ibid.*

Toyo Ito
House in Nakano, Tokyo, 1976

In this house for his sister, the architect responds to the urban site with a central courtyard and a closed facade to the street.

(opposite)
In the Nakano house, Ito has created smooth white curved surfaces on which he projects patterns of daylight and shadow.

10. See Toyo Ito, "Collage and Superficiality in Architecture," in *A New Wave of Japanese Architecture*, ed. Kenneth Frampton (New York: Institute for Architecture and Urban Studies, New York, 1978), p. 68.

incessant change and rapid development through which Japanese cities have passed, have favored lightness, superficiality and disorder. The heavy and ordered harmony to be found in European cities is entirely absent. Surface richness in a Japanese city does not consist of a historical accumulation of buildings but rather arises out of a nostalgia for our lost architectural past which is indiscriminately mixed with the superficial icons of the present. Behind an endless desire for nostalgic satisfaction there resides a void without any substance. What I wish to attain in my architecture is not another nostalgic object, but rather a certain superficiality of expression in order to reveal the nature of the void hidden beneath.[10]

Possibly nothing characterizes this superficial intention better than Ito's hard-line renderings of his earliest works that are able to suggest the unreal notion of a paper-thin architecture, one even more insubstantial, in feeling at least, than the traditional lightweight vernacular of the country. The all but totally uninflected line-weights used in the projected plans of the Nakano house (1976) or the so-called Hotel D (1977), built in Sugadaira, either totally flatten the image of the projected space or, alternately, encourage that familiar illusion of an axonometric representation turning "inside out." This phenomenon is complemented in the case of the Nakano and Kamiwada houses by hieroglyphic plans drawn in an unvaried heavy line, without details and omitting all doors and windows. These drawings are intended to serve as didactic diagrams. They are supposed to convey in one image, the singular spatial/formal configurations about which these houses are organized.

Like those of every other member of the so-called New Wave, Ito's early houses were built of reinforced concrete, although even at this stage he took particular pains to dematerialize these masses as much as possible. This he was able to achieve largely through the way in which light was introduced; that is, the light, instead of being admitted frontally, would enter through hidden slots usually situated to the side of the volume, thereby casting a graduated pattern of illumination on the primary flanking planes.

Of all of Ito's early works, the Nakano house, built in a suburb of Tokyo for his sister, is by far the most spatially iconic, since the continuously curving living room volume creates a kind of cycloramic "stage." In it, both people and objects acquire a curiously heightened presence owing, in part, to their mysterious appearance and disappearance within a seemingly infinite "flow-zone" or cyclorama; appearing as objects or disappearing as people according to the movement of the subject. Thus, the subject is either perceived as entering the flow-zone like an actor entering a stage (except there are no wings and there is no proscenium) or the object is perceived as disappearing due to the recession of the observer within the space. All in all, the Nakano house is close to the concept of *chashitsu* (teahouse): it is an "enclosure brought to life by concentrating on the performance." This dramatic effect evokes the illusory changes suffered by the protagonists of Lewis Carroll's famous tale, with the rabbit disappearing into the darkness and Alice continually experiencing a marked instability with regard to her size. This last seems to be induced in the Nakano house by a conscious distortion of our normal perspectival perception, arising out of an interaction between the inclined ceiling plane and the continuous curve. The spatial result, when furnished with unusual objects such as Mackintosh's highly distorted ladder-back chair or the intrinsic scalelessness of a small lamp when situated on the floor, induces in the observer a feeling of dimensional instability coupled with a sense of phenomenological awe.

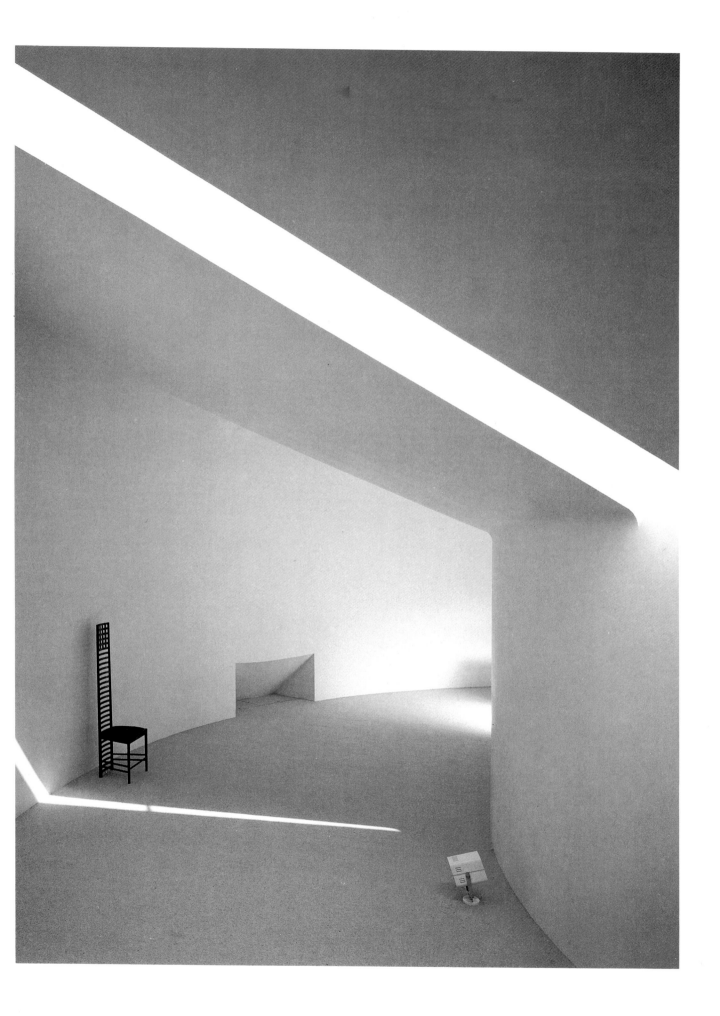

There is, finally, another dynamic element that has to be accounted for in the Nakano house, aside from our own movement in relation to its furnishing. This is the top light that enters the volume through a narrow slot cut across the inclined roof. This unstable light source is constantly transforming itself in terms of both profile and intensity as it moves across the "cyclorama."

The PMT Building, completed in Nagoya in 1978, is an important transitional work for Ito inasmuch as it follows Isozaki's "twilight gloom" manner as it was evolved in his 1974 Gunma Prefectural Museum. Like the Gunma Museum, the PMT Building is predicated on the idea of a regularly trabeated frame which is then clad with a scintillating metal skin. This skin is at variance with the underlying order, at times revealing it, at times concealing it. In certain respects, the PMT Building is a free interpretation of Isozaki's manner, for its frontal facade is contradictory of its own order. Ito chose to arrange the lower, middle and upper sections of the PMT facade according to different systems of axiality, reflecting a wide range of modern influences from Mackintosh to Le Corbusier and Adolf Loos. At the same time, the lower and upper sections of this facade appear to allude to the "higher" and "lower" ranges of the semiotic operation; that is, to the syntactical rigor, say, of the ground floor fenestration of Ludwig Wittgenstein's Stoneborough house (1929) and to the popular semantic ploy of Robert Venturi's "decorated shed," this last being evident in the PMT billboard facade bearing the logo of the German printing-machine company. Nevertheless, as Botond Bognar has recently remarked, Ito could hardly be more removed from Venturi's aesthetic opportunism:

> . . . The reason behind Ito's purpose of creating ambiguous and unclear forms, that is to say non-forms, is that they are less likely to degenerate into another of the countless consumerist codes in the city. When the communications industry, hand-in-hand with the strictly profit-oriented advertising industry, floods the market and practically every segment of contemporary life with mass-produced consumable images and with ruthlessly manipulated meanings, then a break in the line, a black-out or 'silence,' may be a welcome alternative, an initial step toward checking the process of overall devaluation. The PMT Building is a direct rejection of the instrumental sign and in this sense it points beyond Isozaki's undulating "Marilyn Monroe" metal skin facades like those of Kamioka Town Hall. It brings Ito closer to the Japanese syntax of space, with a result that it differs even more radically from the American Post-modernists' stage-set architecture and Venturi's propagation of the 'main street (as) almost all right.'[11]

The 1980 Koganei house is a unique work in Ito's career, suspended as it is between the "superficiality" of the PMT Building and the "constructivist" quality of Ito's own residence, his so-called Silver Hut. In the Koganei house Ito patently intended a level of generalized production that is at once evident in the straightforward orthogonal planning throughout and in the exposed standard steel framework and neon strip lighting with which an otherwise neutral gray interior is vigorously articulated. The ambiguous intention here was to posit a house type that would be as universally available as the nineteenth-century Japanese woodblock print. Something of this egalitarian drive is suggested by the chrome-yellow enamel employed as a finishing coat for all the exposed steel. All in all, the tradition of the *ukiyo-e* is an underlying theme in all of Ito's work. [12]

11. Botond Bognar, *Contemporary Japanese Architecture* (Academy Editions England, 1982).
12. I have employed the term *ukiyo-e* in relation to Ito's architecture for two reasons; first, because the Japanese woodblock print (*ukiyo-e*) was a middle-class art created for a middle class throughout the Tokugawa era (1603-1868) and in that sense it was quintessentially an art for the people and by the people; second, because such prints project a floating, transient world redolent in many respects with the same spiritual stoicism and energy that Ito displays toward the megalopolis.

Toyo Ito
Silver Hut, 1984

The architect's own house in Nakano uses
a system of lightweight metal construction.
This view of the kitchen illustrates the
structural grid and the triangular skylights that
punctuate its vaulted ceiling.

The culmination of his output to date is unquestionably his own house, the so-called Silver Hut completed in 1984 in the Nakano suburb of Tokyo, next to his sister's house of a decade earlier. This house embraces the lightweight, machine-tool capacity of modern society in order to project itself as a prototype for "guerilla warfare." Taking his cue from Kazuo Shinohara's part ironic, part serious appraisal of the U.S. moon landing vehicle in his essay "Towards Architecture" of 1981, Ito has returned to the earlier anarchic attitudes of his own generation: he has, above all, found his new point of departure in the sewer-pipe architecture of Osamu Ishiyama. This much is obvious not only from the stressed-skin, "vaulted" strategy adopted for the main spatial enclosures, but also from the lightweight, metal detailing employed for many of the subsidiary elements.

Ito's Silver Hut is predicated on a highly economical procedure in which once the initial concrete columns have been cast, the system of assembly is largely dry. This is dramatically apparent in the roof vault made of prefabricated diamond sections. When bolted together these elements constitute the structural segments of a flexible faceted latticework structure that can be assembled in the form of three different spans, incrementally increasing from 3.6 to 6.0 meters, with the final vault covering the atrium having a span of 7.2 meters. Where the smaller spans accommodating the principal rooms of the house are covered with built-up composite roofing, the largest vault is partly enclosed with canvas and partly left open, according to the season of the year and the time of day. In full sunlight this atrium may be further screened below the latticework by the application of a pleated canvas blind. The fitting-out of the house follows a similar logic. Thus, just as the columns form the primary supports for the vaults, so do they also constitute the basic framework for different kinds of infill: for the metal-framed, glass-lensed panels that screen the private wing of the house, and the plate-glass, sliding aluminum doors that separate the living/dining volume from the outside space.

The Silver Hut is a general proposition combining methods and concepts drawn from the Japanese vernacular with late twentieth-century productive means and iconography. Ito sees the necessity of positing a new lightweight Japanese domestic architecture that, while remaining rigorously modern, is critically linked to the Japanese past on two levels. In the first place, it categorically rejects the techniques of anti-seismic reinforced concrete construction that continue to condition so much of contemporary domestic architecture in Japan; in the second place, it reinterprets the modular Japanese timber building tradition in an anarchically relevant way. Indeed, were it not for the ideogrammatic delicacy that is the irreducible hallmark of his style, one might even think of the Silver Hut as Ito's "white bicycle"—as a kind of neo-situationist architecture *après la lettre.*

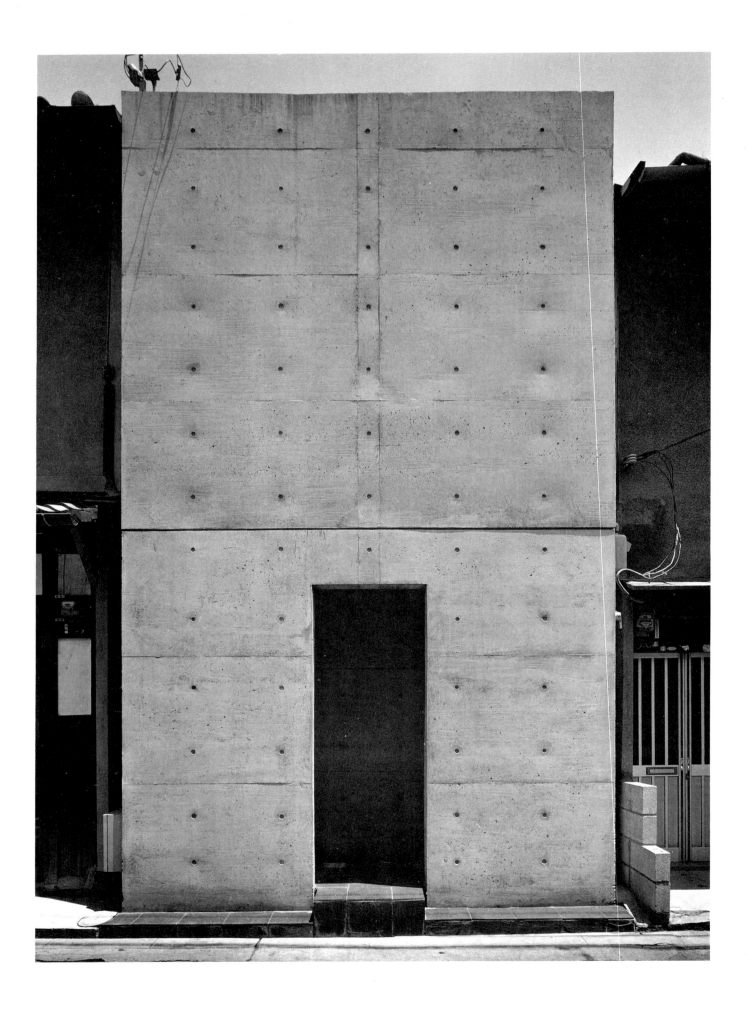

Tadao Ando
Azuma House, Osaka, 1976

On the east facade of this row house, Ando
defines the separation of house and street
with a poured-in-place concrete plane.

Tadao Ando

Like the Tokyo wing of the so-called Japanese New Wave, Osaka-based
Tadao Ando's architecture is critical in the sense that it resists being ab-
sorbed into the ever-escalating consumerism of the modern city. And
while this resistance may seem futile in view of the fact that such architects
are unlikely to receive large-scale commissions, it nonetheless retains its
value as a rejection of consensus opinion. In Ando's case, moreover, the
scope of his practice has widened considerably in recent years to include
a number of extensive realizations, such as his ten-story Rokko housing
(1983) completed on a hillside near Kobe, and his eight-story Festival
commercial complex in Naha, Okinawa (1984). It is, in fact, the prime
paradox of Ando's career that while he has maintained a rigorously critical
approach, he has nonetheless received a number of large-scale commis-
sions. Despite this worldly success, Ando has retained his commitment to
a "resistant" domestic architecture, a concept that, as in the case of Hara's
private houses, turns on the notion of creating an introspective domain
within which the client may be granted sufficient "ground" with which
to withstand the alienating no-man's land of the contemporary city.

At the same time, Ando remains aware that this pervasive modern
predicament cannot be resolved by any kind of fictitious "homecoming,"
by the mere simulation of traditional Japanese timber construction or the
use of evocative domestic components, such as the *shoji* or the *tatami*.
And while such components are still available despite the industrialization
of Japan, Ando steadfastly refuses the nostalgic ethos that such vernacular
elements imply. He has, in fact, consistently rejected the current vogue
for evoking another more benign period of history, remote from the harsh
facts of post-industrial society. The material conditions of modern society
are always indirectly present in Ando's architecture, as implicit in its rein-
forced concrete walls as in the flood tide of development they may serve,
however partially, to check. These walls reflect, through their surprising
weight, not only the seismic conditions of the country, but also the "storm
of progress" that rages in the Tōkaidō megalopolis.

Ando uses walls not only to establish, as he puts it, "a human zone
where the individual will can develop in the midst of the standardization
of the surrounding society," but also as a means of countering the ubiqui-
tous monotony of commercial architecture: the use of walls, as he expresses
it, to control walls. And yet, while the wall on the exterior acts to delimit
and reflect the surrounding urban chaos, on the interior it serves to encap-
sulate a "primitive" space that for Ando is able to symbolize the relationship
between man and nature as this may be mediated by the interaction of
material with light, wind and water. Ando's concept of nature is as removed
from specific forms of the Japanese landscape tradition as his architecture
is distanced from the specific details of the *sukiya* style, by which at the
same time it has been influenced.

As far as architecture is concerned Ando has evidenced his breadth
of critical understanding by remarking on the comparable devaluations
suffered by the post and the colonnade as a consequence of the invention
of the reinforced concrete frame. In his important essay "The Wall as
Territorial Delineation," Ando argues that the fundamental tropes of ar-
chitecture in both the East and the West have been effectively nullified
by the advent of the universal rigid frame. He cites the salient role played

Tadao Ando
Rokko Housing, 1983

Residents of this ten-story apartment complex
on a hillside near Kobe have a superb view of
Osaka Bay. In the detail above, Ando's
concrete walls and turretlike elevator core
create beautiful patterns of shadow and light.

(right)
Tadao Ando
Times Building, Kyoto, 1985

In this extraordinarily elegant commercial
complex, Ando relates his brick and glass
structure to the gentle curve of the Kyoto
canal that is its front yard.

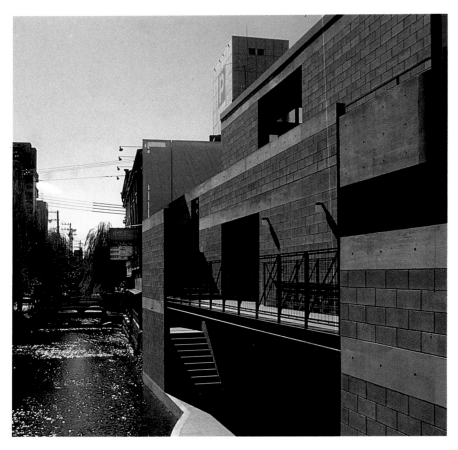

by the symbolic, non-structural post in traditional Japanese architecture,
and he goes on to point out how the rhythm of the Western colonnade
has been rendered equally obsolete and hence culturally inaccessible by
the infinitely greater spanning capacity of the reinforced concrete frame.

Ando engages in a form of cross-cultural criticism that attempts to
compensate for the generic devaluations architecture has suffered at the
hands of technology. In this respect, his criticism is as valid for the West
as for the East. But it is equally clear, as has been recently demonstrated,
that Ando's work is at its most subversive in the Japanese context, where
the deeper significance of the allusions to *sukiya* may be readily ap-
preciated. Teahouse style originally comprised certain fundamental charac-
teristics that are consciously reinterpreted in Ando's work. Of the basic
(non-stylistic) features that Ando's work and the *sukiya* style have in
common, Kiyoshi Takeyama cites calmness and purity, gentleness and
clarity of mood. Ando follows the *sukiya* manner in his preference for dim
lighting broken by shafts of light unexpectedly entering the darkness.
Likewise, he attempts to create a feeling of spiritual expansiveness within
a small domain. And while both expressions are patently artificial they
succeed nonetheless in evoking a feeling for nature as an ineffable, all-
pervasive presence. Thus, even in the midst of a highly congested urban
fabric, Ando's constant reference to *sukiya* is ultimately rural.

And yet, as far as Ando is concerned, architecture must accommodate
daily life while remaining open to the symbolic. To this end his work has
always been structured about absolutes: wall versus columns, square versus
circle, concrete versus glass, dark versus light, materiality versus immate-
riality. The essential character of his work resides finally in the interaction
between these last four terms, in the way that light transforms both

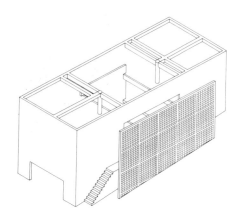

Tadao Ando
Horiuchi Residence, Osaka, 1978

A glass block wall screens the house's atrium
from the street, while permitting filtered light
to enter.

volume and mass; the way in which it changes the volume of the building, according to the hour, transforming dark into light and ponderous mass into scintillating surface. It is for this reason that Ando, unlike his peers, insists on the paradoxical rendering of concrete as though it were a light material, like a paper screen, where all the energy is concentrated on the surface. For Ando, concrete "is the most suitable material for realizing surfaces created by rays of sunlight . . . [wherein] walls become abstract, are negated, and approach the ultimate limit of space. Their actuality is lost, and only the space they enclose gives a sense of really existing."

Of the sixteen-odd residences realized by Ando since 1977, a number emerge as achieving a unique reinterpretation of the *sukiya* paradigm. Among these is the Ishihara residence, built in downtown Osaka in 1978, which happened to be the first occasion on which Ando was to make extensive use of glass block. This house, modeled in certain respects after Pierre Chareau's Maison de Verre in Paris, takes the concept of the introspective domestic realm to extreme ends, for the Ishihara house is bounded by blank concrete walls on all four sides, and thereafter organized as parallel wings facing each other across a glass-block-faced court. The Ishihara house exemplifies Ando's determination to recover something of the lost *sukiya* sensibility under unpropitious conditions.

In his seminal essay of 1981 entitled "From Self-Enclosed Modern Architecture Toward Universality," Ando makes the concept of "enclosure" the touchstone of his entire practice. Thus he writes:

> . . . what I refer to as an enclosed Modern Architecture is a restoration of the unity between house and nature that Japanese houses have lost in the process of modernization.

For Ando, this enclosed form of architecture is capable of developing a peculiarly regional character while at the same time remaining open to the advantages of universal technique and method. He writes:

> Architecture of this kind is likely to alter with the region in which it sends out roots and to grow in various distinctive individual ways. Still, though closed, I feel convinced that as a methodology it is open in the direction of universality.

What Ando has in mind is the development of an architecture where the tactility of the work goes beyond any initial impression we may have of its visual order. Precision and density of detail are thus both crucial to the experiential qualities of his forms and spaces. As he was to write of his masterly Koshino house, built in Ashiya, near Osaka in 1981:

> Light changes expression with time. I believe that the architectural materials do not end with wood and concrete that have tangible forms, but go beyond to include light and wind, which appeal to our senses.

I have chosen to write on Ando's theory at the expense of analyzing his work in order to afford a clearer idea of the very different sensibilities involved in the work of these five architects, some of whose creations might otherwise appear to the uninitiated as being superficially similar. As one can see, the ideological range runs from one extreme to the other; from the aestheticized negativity of Isozaki to the ontological, existential position assumed by Ando. Somewhere throughout the intervening spectrum one would have to situate both the liberal rationalism of Maki and the anthropological structuralism of Hara. In all this, Ito emerges as the unique synthesizer, as the critical poet who combines certain aspects that can be found, to varying degrees, in the work of the other four. His Silver Hut is "negative," one might say, inasmuch as it distances itself, playfully, from Ando's somber existentialism and Maki's liberalism. On the other hand it is "positive" in its inexpensive, erector-set functionalism and its maintenance of a strict enclosure.

(detail)
Masami Teraoka
Study for a pair of six-fold screens
on a Tokyo theme, 1985
watercolor on paper
15 x 90, 38.1 x 228.5
Collection the artist

The completed screens, ironic commentaries
on contemporary Tokyo life, are painted in
a quasi-*ukiyo-e* style. One screen depicts
joggers at Nihonbashi, with a samurai at one
end and a geisha at the other. The second
screen includes a bathhouse scene showing
two women in conversation; cherry blossoms
float in the water as a springtime image.

Lenders to the Exhibition

Art Gallery of Greater Victoria, Victoria, British Columbia
Boston Children's Museum, Boston, Massachusetts
Mr. and Mrs. Peter Brest
The Brooklyn Museum, Brooklyn, New York
The Cleveland Museum of Art, Cleveland, Ohio
Janet Francine Cobert
Mrs. Hans Conried
Craft and Folk Art Museum, Los Angeles, California
Richard and Peggy Danziger
Dr. and Mrs. Robert Dickes
Elvehjem Museum of Art, University of Wisconsin,
Madison, Wisconsin
Field Museum of Natural History, Chicago, Illinois
Henry Art Gallery, University of Washington,
Seattle, Washington
Honolulu Academy of Arts, Honolulu, Hawaii
Isseido Bookstore, Tokyo, Japan
Alan Kennedy
Richard and Mary Lanier
Mr. and Mrs. Leighton R. Longhi
Marilyn and James Marinaccio, Naga Antiques, Ltd.,
New York, New York
McMullen's Japanese Antiques, Los Angeles, California
The Metropolitan Museum of Art, New York, New York
The Minneapolis Institute of Arts, Minneapolis, Minnesota
The Morikami Museum of Japanese Culture,
Delray Beach, Florida
Museum of Oriental Cultures, Corpus Christi, Texas
The Nelson-Atkins Museum of Art, Kansas City, Missouri
Gail Y. Okawa
Pacific Asia Museum, Pasadena, California
Peabody Museum of Salem, Salem, Massachusetts
Ravicz Collection
Seattle Art Museum, Seattle, Washington
Richard R. Silverman
Tacoma Art Museum, Tacoma, Washington
Takenaka Museum of Carpentry, Kobe, Japan
Tiger Collection
Urasenke Tea Ceremony Society, New York, New York
Virginia Museum of Fine Arts, Richmond, Virginia
Wadsworth Atheneum, Hartford, Connecticut
Shigehiko Yanagi
Takashi Yanagi
Private Collections

Acknowledgments

This publication, *Tokyo: Form and Spirit*, like the exhibition that inspired it, began taking form several years ago. In 1982, under the auspices of the International House of Japan, Mildred Friedman, Design Curator at Walker Art Center, and I spent a month in Japan and began our acquaintance with its traditional and contemporary arts. During our first weeks in Tokyo and Kyoto, Rand Castile, Director of Japan House Gallery in New York and Lily Auchincloss, then Japan House Gallery's Chairman, traveled with us and introduced us to many of the artistic wonders of old Japan.

Particularly fascinating to us was the harmonious coexistence of old and new art forms, especially in Tokyo, and we began thinking about organizing an exhibition that would illuminate this phenomenon. While many exhibitions in the United States and Europe have focused on Japan's great historical art forms and some have stressed its recent artistic production, another possibility suggested itself: a large-scale presentation that would examine the relationship of long-established aesthetic attitudes to current artistic activity there.

During successive trips to Japan, we gradually familiarized ourselves with the work of many highly creative individuals associated with new directions in the visual and performing arts who readily acknowledged the influence of tradi- tional Japanese forms and attitudes in their production. It was during our second trip that Rand Castile and Alexandra Munroe, his assistant at Japan House Gallery, and we discussed various themes for such an exhibition. We were especially impressed with the vitality of new architecture and design we had encountered and our goal became a large-scale design exhibition that would include important historical and contemporary examples. The historical manifestations of Japanese design are many, and include architecture, furniture, painted screens, woodblock prints, ceramics, textiles and lacquer. Because of Tokyo's increasing importance as an international center of artistic creativity, it was evident that Japan's capital city should be the context for this exhibition. In order to focus on recent evidences of the Japanese creative spirit, we decided to select artists, designers and architects who live and work there. We were able to pursue this approach with one exception: the architect Tadao Ando, who is based in Osaka. As he has designed a number of buildings in central Tokyo, his inclusion in the exhibition is appropriate.

Our next step was to invite teams of architects and designers to think about a number of architectural themes, each representative of some aspect of city life. These included: the street, the house, the workplace, the theater, the temple and space for recreation. Those invited to participate understood they were to deal with these themes conceptually and that their contributions would not be proposals for "practical" structures. Rather, they were asked to design spaces that would deal with their respective topics in philosophical terms.

In order to develop an exhibition of such scale and complexity, it was evident that we would need a coordinator in

Tokyo to maintain close contact with the architects, artists and designers we had selected to produce works for this exhibition, which by now had its title, *Tokyo: Form and Spirit*. Riichi Miyake, Assistant Professor of the History of Architecture at Shibaura Institute of Technology, assumed this awesome task. He monitored the development and construction of the design projects in Tokyo, and throughout the evolution of the exhibition provided invaluable assistance as strategist and resourceful diplomatic problem-solver. He was ably assisted by Mitsuru Fukumoto and Katsumi Tanabe.

Once designs for the respective thematic spaces were completed, arrangements were made to build them in workshops throughout the city. Fortunately, the Sapporo warehouse in Tokyo's Ebisu district was made available for several months in fall of 1985 for construction of the exhibition's elements.

Major financial support as well as contributions of materials and services were provided by a number of sponsors in the United States and Japan. Without such broad support, this exhibition could not have been realized; these generous contributions are gratefully acknowledged on page 4 of this publication.

Counsel and support were given throughout the development of the exhibition by Richard Lanier, Director of the Asian Cultural Council in New York. In Japan, important assistance came from Mikio Kato, Associate Managing Director of International House of Japan and Tatsuya Tanami, that institution's Liaison Secretary. Warren Obluck, Acting Counselor of Embassy for Public Affairs at the American Embassy in Tokyo, provided useful information about the contemporary art scene in Japan. Donald Richie, the Tokyo-based American who has written so eloquently about the art and culture of Japan,

was a constant source of advice and encouragement, and contributed a major essay to this book. Assisting us with photo research in Japan was Uchiri Ujikawa. We are especially grateful to Takashi Yanagi, whose counsel and assistance with loans for the exhibition were of major importance. Judith Connor, whose guidebook to Tokyo proved invaluable to our research, spent considerable time assisting us in finding traditional Japanese crafts material and other objects. From the initial stages of this project we had the consistent, unflagging support of Arata Isozaki; not only did he participate in his capacity as a major Japanese architect, but he also served as advisor to the project.

On behalf of Walker Art Center and the Japan House Gallery, it is a privilege to thank the many artists, architects and designers who gave so much of their time and talent to create works for this exhibition. Descriptions, drawings and photographs made while the works were in preparation in Japan are included in this book and biographies of the architects and designers appear on page 246. In Japan, the role of the craftsman in realizing design projects is especially important. We want to acknowledge the valuable assistance provided by the many individuals whose technical skills have contributed so significantly to the creation of the thematic spaces in the exhibition. In particular, master carpenter Fumio Tanaka constructed a

superb *torii* for the exhibition, and working with Sony engineers, he created the stage for the Performing space.

We are grateful to the many distinguished scholars and curators in Japan and the United States who wrote articles for this book on a wide range of topics that parallel the exhibition's themes. Bibliographical data appears on page 249. Translators for articles by Yūichiro Kōjiro and Jōhei Sasaki are listed at the close of their essays.

Selections of many of the Edo objects in the United States were made by Emily Sano, Assistant Director for Programs and Academic Services and Curator of Asian Art, Kimbell Art Museum. *Ukiyo-e* woodblock prints were selected by Amy Reigle Newland, who was a curatorial intern at the Art Center from September 1984 to August 1985, and served as exhibition assistant until December 1985. Important loans of Edo material came from many museums, individuals and institutions in the United States and Japan. Grateful acknowledgment of these loans appears on page 243.

Many Walker Art Center staff members were involved in the organization and presentation of the *Tokyo: Form and Spirit* exhibition and book. They are listed, as is the Japan House Gallery staff, on page 256.

Finally, on behalf of its Board of Directors, I extend the Walker Art Center's sincere gratitude to the extraordinary number of people in Japan and the United States who have contributed their expertise and goodwill to this book and to the exhibition.

Martin Friedman
Director, Walker Art Center

Biographies

Architects and Designers

Tadao Ando (b. 1941),
a self-taught architect, traveled abroad, studying architecture in Europe and the United States, from 1960-1969. He was awarded the fifth Alvar Aalto medal in 1985. The majority of his work has been private residences and housing projects in the Osaka-Kobe region. With exhibitions in France, Finland and the United States, Ando is one of a small number of Japanese architects whose influence is becoming international. His eclectic, non-academic training lends his work a particular strength and originality. Ando's major buildings include: Sumiyoshi Row Houses (1976), Koshino Residence (1981), and Rokko Housing (1982).

Kiyoshi Awazu (b. 1929),
graphic designer, art director and author, has been producing significant work in a variety of media since the early 1950s. Awazu has been an influential teacher and is the author of a number of books, including: *The Discovery of Design* (1964), *Thinking Eye* (1975) and *Gaudi Sanka* (1981).

Shigeo Fukuda (b. 1932),
a graduate of Tokyo University of Arts and Music, is a pioneer in Japan of three-dimensional graphics, sophisticated puzzles and toys that are works of high design and artistry; he explores concepts of space in his work, such as geometric paradox, visual puns, metamorphosis. Fukuda has exhibited at the IBM Gallery, New York (1967) and at numerous galleries in Tokyo.

Hiroshi Hara (b. 1937)
received his Masters degree in architecture at Tokyo University. He is Assistant Professor, Tokyo University, and in 1970 he established his own architectural firm, Hiroshi Hara and Atelier. Hara's buildings draw on eclectic classical sources both Eastern and Western. Major buildings include Sueda Art Gallery, Oita (1972-1973), Shinohara Residence (1973-1974), Kudo Second House (1973-1976), Shokyodo,

A Museum for Woodblock Prints, Toyoda (1979). His recent work displays a combination of sheet metal elements with low-relief wood details that push the vernacular image toward Surrealism.

Eiko Ishioka
is Japan's most widely known art director. She has, over the past twenty years, brought a radical approach to Japanese design that has had a powerful impact on that country's popular imagery. Moving between the print, television and film media, Ishioka's imprint is visible throughout the art and fashion worlds of Japan. Her most recent production designs for the controversial film *Mishima* were a remarkable union of traditional form with a modern sensibility.

Arata Isozaki (b. 1931)
graduated from Tokyo University in architecture and in 1961 completed his doctoral course in architecture there. In addition to being a leading figure in current Japanese architecture, Isozaki has taught and written extensively in Japan and abroad. Visiting professorships in the United States have included the University of California, Los Angeles, Columbia, Harvard and Yale. He helped produce the *MA: Space/Time in Japan* exhibition and is the architect of, among many other things: Tsukuba Center Building (1983), Museum of Contemporary Art, Los Angeles, to be completed (1986), and the Sports Hall for the 1992 Olympics, Barcelona.

Toyo Ito (b. 1941)
is a graduate of Tokyo University. He later studied with Kikutake Kiyonari. Ito is one of the most individualistic designers in the forefront of Japanese architecture. His work is highly conceptual, using light elements that deny a sense of mass or material. Pattern, color and rhythm are common features. Principal works include: Hotel D (1977), Chuorinka house (1979), House at Kasama (1981).

Shiro Kuramata (b. 1934)
is a graduate of the Department of Living Design, Kurasawa Design Institute. He established Kuramata Design Office in 1965; in 1972 he won the Mainichi Design Award; and in 1981 the Japan Culture Design Award. Major projects of furniture and interior design include: Furniture in Irregular Forms (1970), Carioca Building, Tokyo (1971), Lamps (1972), Furniture with Four Legs (1977), the Issey Miyake Boutique, Tokyo (1982), and Issey Miyake, Bergdorf Goodman, New York (1984), and furniture for the Memphis Group.

Fumihiko Maki (b. 1928)
is a graduate of Tokyo University. He received his Masters degree from Cranbrook Academy of Art in 1953, and a Masters in Architecture at the Harvard Graduate School of Design in 1954. Maki established his own architectural practice in Tokyo in the early 1960s, and is Professor of Architecture at Tokyo University. His major works include: Hillside Terrace Apartments (1969-1978), Osaka Prefectural Sports Center (1972), Royal Danish Embassy, Tokyo (1979), Fujisawa Municipal Gymnasium (1984). His recent public projects were shown in a two-man exhibition with Arata Isozaki at Japan House Gallery (1985).

Kohei Sugiura (b. 1932)
is a graduate of the Tokyo University of Arts and Music. He has worked extensively with Buddhist images from India, Tibet and Indonesia and is the designer of a number of exhibitions, books and periodicals.

Tadanori Yokoo (b. 1936)
is one of Japan's leading graphic designers and is a painter and printmaker, as well. He has had a number of one-man exhibitions at Nantenshi Gallery, Tokyo and at The Museum of Modern Art, New York (1972), the Museum für Kunst und Gewerbe, Hamburg (1973), the Stedelijk Museum, Amsterdam (1974), and the Venice Biennale (1976). His work is in numerous private and public collections, and a museum in Hyogo, Japan, devoted to his work and designed by Arata Isozaki, was completed in 1984.

Authors

James R. Brandon,
Director of the Asian Theater Program, University of Hawaii, has been translating and directing English-language productions of Kabuki plays for twenty years. He has published *Chūshingura: Studies in Kabuki and the Puppet Theater* and *Kabuki: Five Classic Plays,* among other works. He is editor of the *Asian Theatre Journal.*

Ian Buruma,
Cultural Editor of the *Far Eastern Economic Review* in Hong Kong, studied Chinese and Japanese literature and history at Leyden University, and Japanese cinema at Nihon University College of Arts, in Tokyo. He has worked in Japan as a photographer and is the author of *Behind the Mask* (1983), a critical study of contemporary Japanese culture.

Rand Castile,
Director of Japan House Gallery from its founding in 1971 until 1986, studied with Grand Master Soshitsu Sen XV at the Urasenke School, Kyoto, and in 1971 his book *The Way of Tea* was published. He has organized many exhibitions, including: *The Tokugawa Collection: Nō Robes and Masks* (1977), and *Horyū-ji: Temple of the Exalted Law* (1981), and has been responsible for the presentation of the Grand Kabuki and other major Japanese performance groups in the United States. He is currently Director of the Avery Brundage Collection, Asian Art Museum of San Francisco.

William Coaldrake
was born in Tokyo. He received his doctorate from Harvard University and is a Lecturer in Fine Arts at Harvard University, where he teaches the history of Japanese architecture and cities. He is a founding member of the MIT East Asian Architecture and Planning Program. His current work includes books on Japanese gateway architecture and the Japanese carpenter, based on firsthand experience in the restoration of historical buildings in Japan. His translation of Hinago Motō's *Japanese Castles and Castle Building in Japan* is forthcoming.

Liza Dalby
received a doctorate in anthropology from Stanford University. As the only non-Japanese ever accepted into geisha life, she became the geisha Ichigiki during a year-long residency in Kyoto. Her doctoral dissertation documenting this experience became the book *Geisha* (1983). Her book on the history of the kimono is in preparation.

Richard Danziger
is a 1963 graduate of Yale Law School. He is a distinguished collector of Japanese art and is President of the Urasenke Tea Ceremony Society, Inc., New York. Danziger is also a member of the Board of Directors of Japan Society, and on the Visiting Committee of the Far Eastern Department, Metropolitan Museum of Art.

Chris Fawcett
received his architectural diploma from the Architectural Association, London (1979), and completed his Ph.D. at Essex University (1983) A resident of Kyoto, Fawcett lectured widely in Britain and Japan on architectural history and criticism. He wrote numerous articles and book reviews on architecture and planning and was the author of *The New Japanese House: Ritual and Anti-Ritual, Patterns of Dwelling* (1980). Fawcett's recent tragic death leaves the world of architecture without one of its most articulate younger voices, and leaves his friends bereaved.

Kenneth Frampton
is Professor of Architecture at the Graduate School of Architecture and Planning, Columbia University. He is the author of *Modern Architecture: A Critical History* (1980), and wrote the introduction to and edited *A New Wave of Japanese Architecture* (1978), the catalogue of a major exhibition that introduced the work of eleven leading architects to an American audience. He is the editor of *Tadao Ando: Buildings, Projects and Writings* (1984).

Martin Friedman,
as Director of Walker Art Center since 1961, has organized numerous exhibitions of American and international art. Among these are: *The Precisionist View of American Art* (1961), *Oldenburg, Six Themes* (1975), *Noguchi's Imaginary Landscapes* (1978), and *Picasso: from the Musée Picasso, Paris* (1980). He has written many catalogue essays related to these exhibitions and is the author of the books: *Charles Sheeler* (1975), and *Hockney Paints the Stage* (1983). Friedman is the co-curator, with Mildred Friedman, Design Curator, Walker Art Center, of the exhibition *Tokyo: Form and Spirit* (1986).

Mark Holborn
has been the Editor of *Aperture* magazine since 1983. He is the author of *The Ocean in the Sand; Japan, From Landscape to Garden* (1978), and *Black Sun, The Eyes of Four,* a study of post-World War II Japanese photography that is being published in conjunction with an exhibition of the same name that will tour the United States in 1986-1987.

Yūichiro Kōjiro
received his Ph.D. from Tokyo University and is Professor of Architecture and Design, Meiji University. He is the author of many studies on Japanese traditional and modern aesthetics, design, architecture and popular culture. Kōjiro is a member of the Committee for the Preservation of Cultural Properties (Ministry of Education, Agency for Cultural Affairs).

Amy Reigle Newland
received a Masters degree in Japanese Art History from the University of Washington, Seattle, and has done extensive research on early Japanese ceramics. A contributor to catalogues at institutions such as the Walker Art Center and Seattle Art Museum, she is also a staff writer for *Oriental Art* magazine.

Glossary

amado	sliding storm door
aragoto	grandiose acting style
bakufu	feudal government
bijin-ga	pictures of beautiful women
bunjin-ga	literati painting
Bunraku	Japanese puppet theater
byōbu	folding screen
Butō	Japanese avant-garde dance theater
chanoyu	Japanese tea ceremony
chigaidana	side-alcove shelves
chōnin	tradesman, merchant
daimyō	feudal lord
date	showy, dandyish
dōbōshū	teamaster
doma	earth-floored room
deshi	apprentice
Edokko	native Edoite
ema	wooden prayer tablet
furisode	"swinging sleeve" kimono
fusuma	opaque sliding door panel
geisha	professional female entertainer
giboshi	ornamental top of post railing
gohei (nusa)	pole with paper or cloth streamers, associated with Shinto
go	national board game of Japan
haiku	seventeen-syllabled poem
hanamichi	Kabuki theater runway
hashi	bridge (also *bashi*)
hiramaki-e	embossed lacquer decoration
iki	stylishness, chic
inu hariko	papier-mâché dog
ji or tera	temple
Jingū	Shinto shrine associated with Imperial family
Jinja	Shinto shrine
jinrikisha	wheeled passenger cart pulled by a man
Kabuki	popular classical theater
kagura	Shinto dances of worship
kami	Shinto deity
kamidana	Shinto household altar
kana	Japanese syllabary
kanban	shop sign
kanji	Sino-Japanese written character
Kanō	major school of painters from the fifteenth to nineteenth centuries; official artists to the Tokugawa government

kanjin Nō	subscription Nō
Kantō	region including Ibaraki, Gunma, Saitama, Kanagawa, Chiba, Tochigi and Tokyo Prefectures
karuta	game of cards
kimono	*ki* (to dress) *mono* (object); open garment like a dressing gown
Kinki	region including Shiga, Hyogo, Nara, Mie, Wakayama, Kyoto and Osaka Prefectures
kinpeki-ga	color and gold paintings
koinobori	carp banners
koto	Japanese harp
kura	warehouse, storehouse
kyōdo gangu	toys of the home region
Kyōgen	comic interludes in a Nō performance
machi-eshi	anonymous town painters
maki-e	design sprinkled in metal dust onto still-wet lacquer
matsuri	festival, a celebration
mie	posturing by Kabuki actor
mikoshi	portable Shinto shrine
nanga	"southern painting," imitating Chinese scholars' styles
Nihon-ga	Japanese-style painting
Nō	ancient drama using masks and splendid costumes
noren	slotted banner at shop entrance
obi	belt, sash with kimono
oku	interior; innermost space
onnagata	Kabuki actor of female roles
origami	art of folding paper into various forms
pachinko	pinball game
rikyū	detached palace
rōnin	masterless samurai
sakariba	clusters of facilities for shopping, eating, drinking and amusement
samurai	warrior
sankin kōtai	obligatory residence in Edo in alternate years
satori	spiritual awakening, enlightenment
sensei	master or teacher
shamisen	musical instrument, a kind of guitar with three strings
Shibaraku	popular Kabuki play, literally "Wait a Moment"

shibui	Zen belief that found beauty in restraint, the unassuming and durable
shimenawa	thick, twisted ropes hung at sacred Shinto areas
Shingeki	new drama, reference to foreign drama
Shinpa	new school of theater in rejection of "old style" Kabuki
Shinto	indigenous religion of Japan revolving around the worship of *kami*
shitamachi	downtown
shogun	military dictator, only nominally subservient to the emperor
shoji	sliding translucent door panel
shokunin	workmen
shunga	erotic prints
sudare	reed screen, rattan blind
sui	refined, elegant
sukiya	architectural style
suiboku-ga	ink paintings
sumo	Japanese wrestling
sushi	vinegared raw fish and rice
taiko	stick drum
takamaki-e	technique in which design is built up
tatami	straw floor mats
Tōkaidō	320-mile-long road that connects Edo and Kyoto
tokobashira	an alcove post
tokonoma	an alcove; recess in Japanese palace, house or tearoom for the display of objects
tōri	street (also *dori*)
torii	a Shinto shrine archway
tsū	connoisseurship, expertness
ukiyo-e	school of painting, book illustration and printmaking that burgeoned during Edo period
wabi	Zen aesthetic incorporating simplicity and humility, which sought inner beauty hidden under a wretched surface
yakusha	actor
yakusha-e	pictures of actors
yakuza	gangster
yo-ga	Western-style painting
Yoshiwara	red-light district of Edo
Zen	Japanese sect of Mahayana Buddhism

Reproduction Credits

Courtesy Tadao Ando Architects and Associates: pp. 123, 240, 241
Courtesy Art Gallery of Greater Victoria: p. 203
Courtesy Boston Children's Museum: p. 206
James R. Brandon: p. 166
Courtesy The Brooklyn Museum: pp. 156, 215
Courtesy The Cleveland Museum of Art: p. 61
William Coaldrake: p. 64 (left)
Courtesy Dr. and Mrs. Robert Dickes: p. 192
Patricia J. Dunn: p. 208
Alai Elai, courtesy Alan Kennedy: p. 12
Courtesy Elvehjem Museum of Art: pp. 6, 20, 36 (bottom), 45, 90, 106, 200, 210
Courtesy Folk and Craft Art Museum, Los Angeles: p. 202
Courtesy Freer Gallery of Art, Smithsonian Institution: p. 35
Y. Futagawa, courtesy Retoria, Y. Futagawa & Associated Photographers: p. 52
Victoria Gibbs (drawing of giboshi after Y. Kōjiro): p. 44
Courtesy Henry Art Gallery: p. 159
Ethan Hoffman/Archive: pp. 8 (top), 72, 95, 99, 145 (bottom), 147, 176, 177, 186, 209, 210
Courtesy Honolulu Academy of Fine Arts: pp. 213 (bottom), 214
Yasuhiro Ishimoto, courtesy Arata Isozaki: pp. 220, 222 (bottom)
Courtesy Arata Isozaki: p. 222 (top)
Courtesy Toyo Ito: pp. 234, 237
Courtesy Japanese Travel Bureau (JTB): p. 62
Courtesy Yūichirō Kōjiro: pp. frontispiece, 41, 42, 43, 44, 46
Kiyonori Komma: p. 164
Barry Korn, courtesy Richard R. Silverman: pp. 212, 213 (top)
Jocelyn Kwei: pp. 113, 121
Schecter Lee: pp. 126, 127, 128, 129, 130, 131
Courtesy Mr. and Mrs. Leighton R. Longhi: pp. 25, 26
Courtesy Mainichi Daily News: pp. 28, 75, 143, 144, 145 (top)
Courtesy Fumihiko Maki: pp. 226, 228
Courtesy The Metropolitan Museum of Art: pp. 83, 141, 192
Courtesy The Minneapolis Institute of Arts: pp. 17, 23, 36 (top), 60, 178
Masayuki Miyahara, courtesy Takashi Yanagi: pp. 16, 76, 84
Takashi Miyamoto: p. 89 (right)
Koji Morooka, courtesy Kodansha: p. 70

Osamu Murai: p. 71
Courtesy Musées royaux d'Art et d'Histoire, Brussels: p. 138
Courtesy Museum of Fine Arts, Boston: p. 204
Carl Nardiello, courtesy Urasenke Tea Ceremony Society, New York: pp. 122, 127, 128
Courtesy The Nelson-Atkins Museum of Art: pp. 81, 82
Taisuke Ogawa, courtesy Shinkenchiku: p. 229
Tomio Ohashi, courtesy Hiroshi Hara: pp. 150-153, 230, 237
Courtesy Osaka Municipal Museum of Art: p. 139
Courtesy Retoria, Y. Futagawa & Associates: pp. 110 (bottom), 125, 232, 235
Donald Richie: pp. 94, 96
Courtesy Seattle Art Museum: pp. 79, 84 (bottom)
Mark Sexton, Courtesy Peabody Museum of Salem: pp. 10, 31, 92, 93 (top), 98 (bottom), 136
Henry Smith: p. 24
Takeshi Taira: pp. 89, 134, 135, 198, 199
Y. Takase, courtesy Retoria, Y. Futagawa & Associated Photographers: pp. 18, 188, 190, 238
Courtesy Masami Teraoka: p. 242
Courtesy Tiger Collection: pp. 104, 105, 170, 171
Richard Todd, courtesy Mrs. Hans Conried: p. 212 (right)
Courtesy Tokyo Metropolitan Central Library: pp. 22, 33, 69, 161
Marc Treib: pp. 110 (top), 114, 117, 118, 124
Courtesy Virginia Museum of Fine Arts: pp. 55, 56, 57, 58
Courtesy Victoria and Albert Museum: pp. 50, 51
Courtesy Wadsworth Atheneum: pp. 148, 249
Walker Art Center: pp. 8 (bottom), 9, 11, 66, 67, 93 (bottom), 94 (right), 97, 179, 180, 181, 191, 193, 194 (left), 207, 211, 225
Neil Warren: pp. 98 (top), 163, 182, 183, 194, 195
Courtesy Widener Library, Harvard University: pp. 64 (right), 74
Courtesy Tadanori Yokoo: cover, pp. 102, 103
Shuji Yamamoto: pp. 174, 175
Chiaki Yoshida, courtesy Kabuki-za, Tokyo: pp. 154, 157, 158
Courtesy Yoshikawa Kobunkan: pp. 108, 116